DEDICATED TO MY GRANDSONS

KAI AND ARUN.

THEY ARE THE FUTURE!

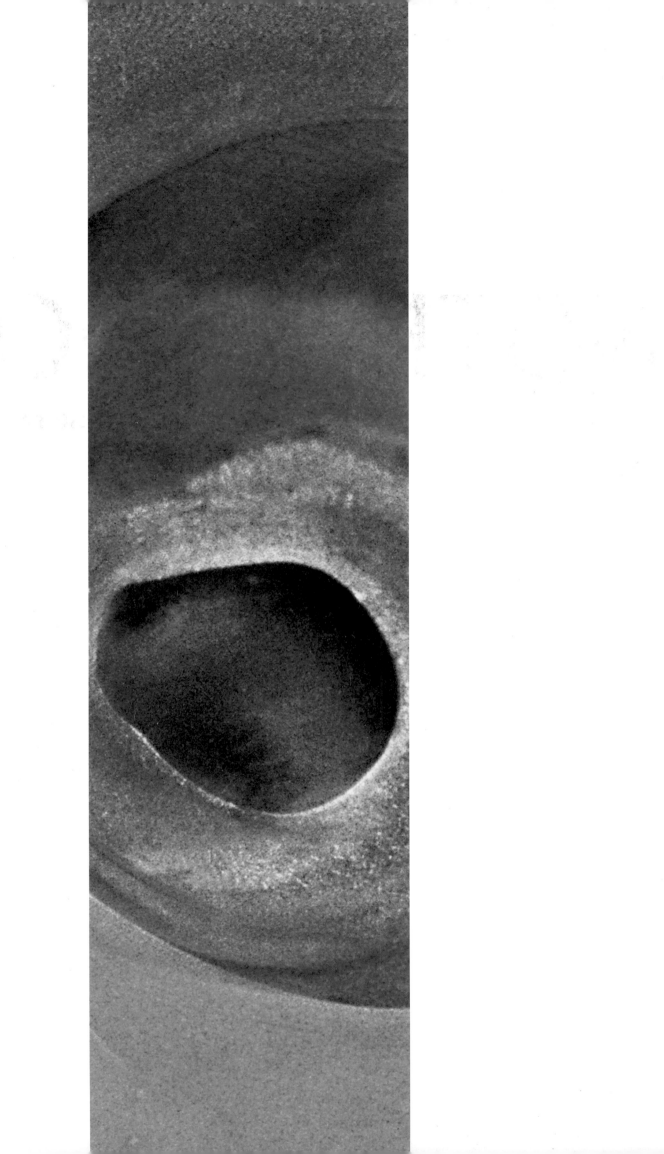

DOS WINKEL

ANOTHER WORLD

COLOURS, TEXTURES AND PATTERNS OF THE DEEP

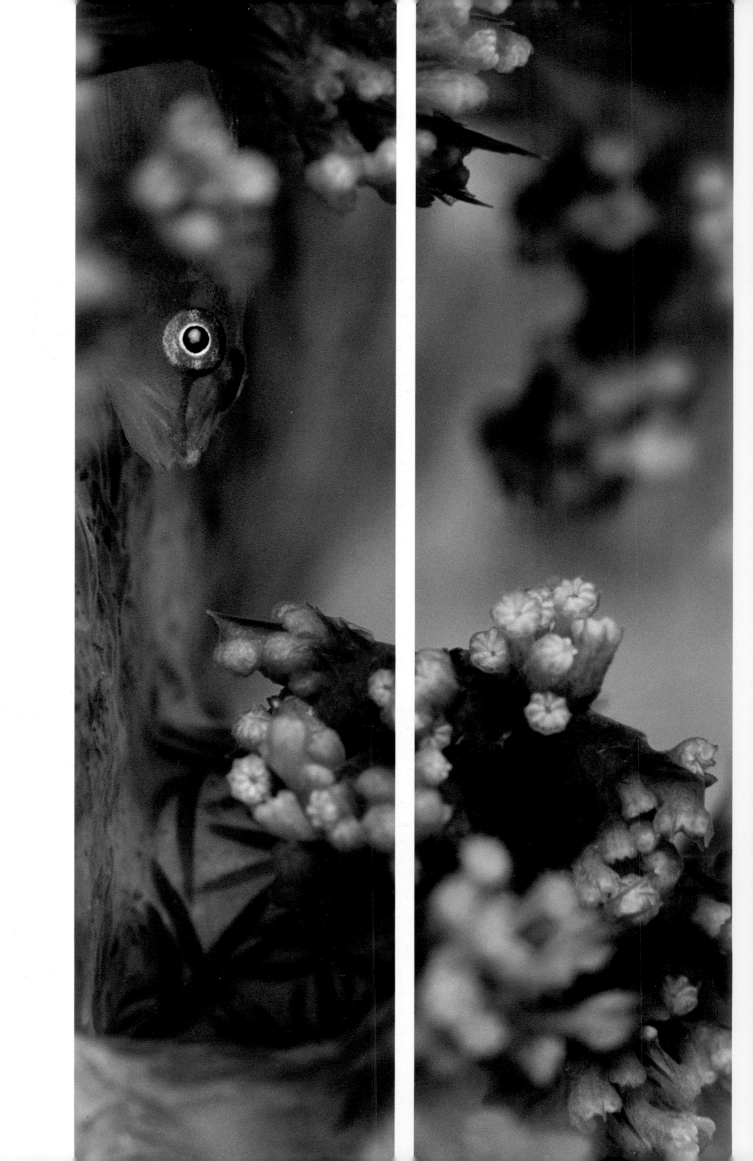

FOREWORD

More than one hundred years before Nicolaus Copernicus first conceived the structure of the universe, our planet was given the name "Earth." This may have been one of the great mistakes in scientific history.

It's difficult to fault humans in the fifteenth century for their decision to label our globe after the firm ground upon which they walked. Yet, had they the perspective of looking at our planet from space, they would have realised that the globe was covered almost three-quarters by water. Our planet should have been named "Ocean," and that different identity may well have altered how we see ourselves and where we live.

Today, in much the same way, we characterise our ocean by its vastness and depth. We fathom the ocean literally in fathoms. This gigantic scale can be misleading. The ocean is far more than a dark, limitless void inhabited by mono-chromatic creatures of enormous size. Again, it's all a matter of perspective.

By focusing solely on the expanse of the ocean, we can miss the wonder and beauty of those things small and intricate within it. The ocean is a fabulous kaleidoscope of abstract shapes, brilliant colours, iridescent reflection, undulating textures, and sometimes bizarre patterns.

It truly is "another world," and that is what Dos Winkel has captured in his ocean cosmos of macrophotography. In this volume Winkel has shown us what we often don't notice – the amazing detail that creates a world within a world. This is a dazzling array of mountains, crevasses, caverns, peaks, plains and mesas that may only be millimetres in size and actually reside within an anemone, an eye of a fish, a branch of coral or a blade of kelp.

These photographs are like receiving images from some undiscovered planet with extra-terrestrial life forms. But they exist right here, and have for centuries, under the waves of the sea.

I am particularly pleased that life among coral reefs is so prominently documented. Coral reefs are really "cities under the sea." They are vibrant ecosystems that team with activities and function much like a symphony orchestra where each member has a singular role to play in creating music. When the orchestra operates in unison and harmony, the music is magnificent. When there is discord or members of the orchestra fail, the notes turn sour.

So it is with our coral reefs. They are greatly endangered from global warming, pollutants and sediment runoffs loaded with fertiliser and pesticides, and the cumulative effects of irresponsible human behaviour. Nearly 30 per cent of the ocean's coral reefs are already dead and, without significant, positive change in our abuse of these habitats, the percentage of reefs lost for ever will reach up to 60 per cent by 2030.

The decline of coral reefs has disastrous implications for our planet, humans and our global economy. Coral reefs are critical to the balance of ocean life. They are a protective barrier for island nations from strong wave action during storms, hurricanes and tidal waves. Reefs are vital to the tourism economies of countries throughout the world. And many of the compounds that we know of, or have yet to discover, to cure or treat human illnesses, are components of coral reefs. We have the capacity to change our behaviour and protect this incredible and valuable resource. If the images within this volume raise individuals' awareness of these complex and bountiful structures and call people to action, then it will accomplish a stunning achievement – art as a motivation for preservation.

I challenge you to immerse yourself in these images and drink in the descriptions that will enlighten and thrill you. We can all learn and marvel at how profound small can be. There is another world waiting for you here. Dive in.

Jean-Michel Cousteau
Founder and President of Ocean Futures Society
www.oceanfutures.org

TRANSLATION
Jeannette van Ditzhuijzen

EDITORIAL COORDINATOR
Laura Maggioni

EDITOR
Primrose Elliott

DESIGN AND LAYOUT
Lara Gariboldi

COLOUR SEPARATION
Cross Media Network (Milan)

PRINTED IN AUGUST 2005
by Leva Arti Grafiche, Sesto San Giovanni (Milan)

www.dos-bertie-winkel.com
dos.winkel@skynet.be

Published by ACC Books, a Division of
the Antique Collectors' Club Ltd.
www.antiquecollectorsclub.com

ISBN: 1 905377 00 2

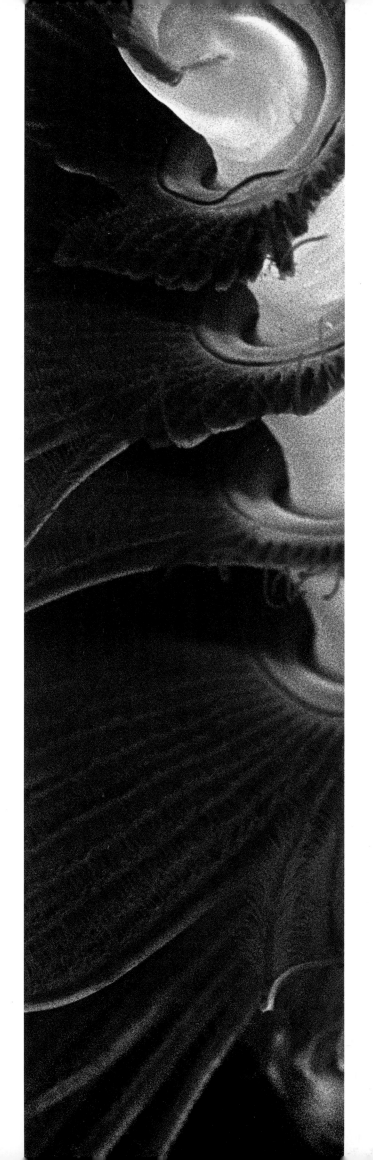

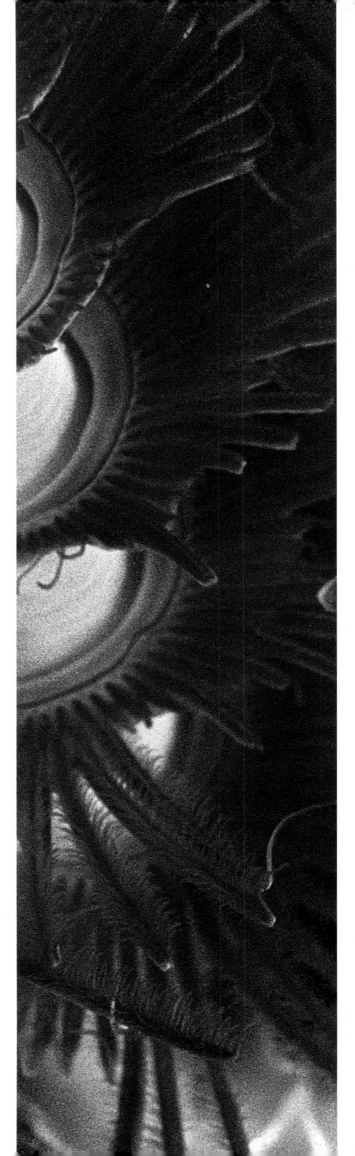

TABLE OF CONTENTS

DOS WINKEL

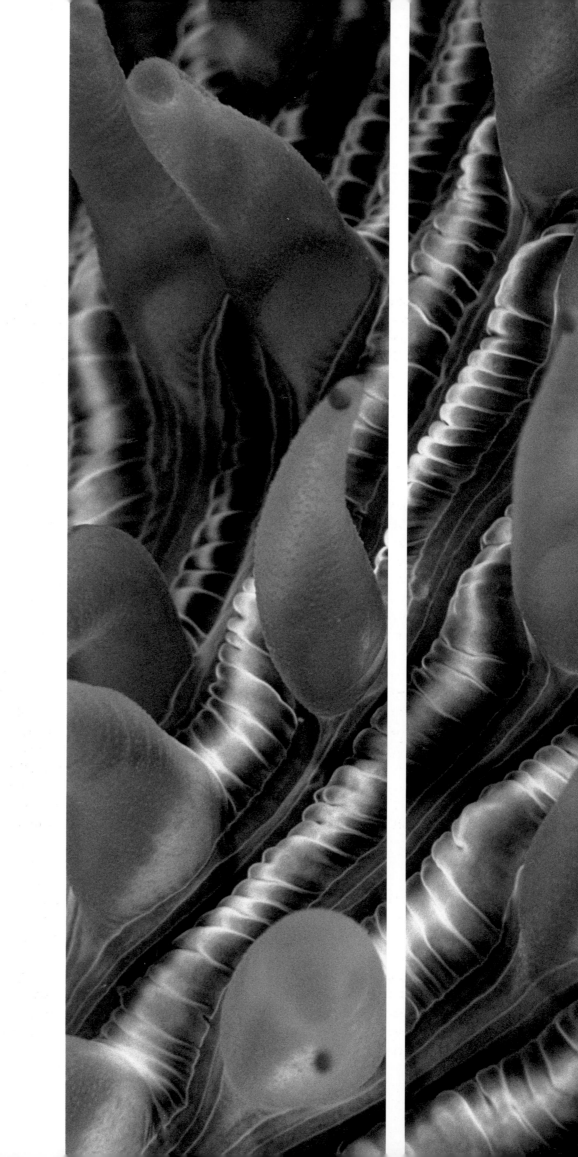

PROLOGUE

Coral reefs are ecosystems in which millions of animals coexist in a very complex way. For dozens of years scientists have tried to unravel this complexity, but it is a slow process. Not only do scientists descend to the coral reefs with compressed air tanks; scuba diving is becoming more and more popular in general. Most divers enjoy the beautiful seascapes and many try to capture the beauty photographically. But the average diver or snorkeller only sees the obvious: the impressive coral formations, the many different species of corals, sponges and anemones, and an array of colourful fish and crustaceans. That's immensely enjoyable, but there is infinitely more to be seen in a square foot or even a square inch of the reef. Divers on a tropical coral reef are surrounded by colours that have inspired many artists. Since these colours have a subtle way of varying and melting into one another, they can never be copied. For decades, scientists have tried to understand why these animals exhibit such extraordinary colour combinations.

In many anemones, for example, small shrimps or lobsters find a home, living symbiotically with their hosts. To avoid attracting the attention of potential enemies, they assume the anemone's colours or are almost transparent. On closer inspection, though, these mostly tiny animals are creatures of exceptional beauty. The anemones themselves, with their sultry pastel shades, also provide an excellent subject for photography, especially their body structure and certain parts such as their tentacle tips.

And then there are the corals. Both hard stone corals and soft corals display structures, shapes and patterns inconceivable to the human mind. To enjoy the coral polyps' exceptional beauty one has to visit the reef at night, since most species are nocturnal. As soon as the sun disappears and darkness inhabits the reef, a totally new world comes alive. Coral polyps emerge to catch plankton with their sticky little tentacles. In addition, one sees many species of crustaceans and shells. Fish active by night are easily recognisable by their extra large eyes. Starfish, crinoids, tunicates, nudibranchs and many other marine invertebrates possess colours and structures of an indescribable fragile beauty as well. To enjoy them, however, one has to study these animals from very close range.

The display of colours seen in the photographs in this book may seem unnaturally vivid, since the human eye has its own perception of the underwater world. The deeper we descend into the sea, the more colours are absorbed by the water; gradually we reach a world turning blue. Only by adding an artificial light source, such as an underwater lamp or the camera flash, will the true colours be revealed.

Many of the animals portrayed in this book, such as corals and sponges, are firmly fixed on the reef and thus relatively easy to photograph. Good focus is important, and a natural look to shadows. Photographing fish – especially fish eyes – is a totally different matter. To do this the photographer has to move very close to the fish and the subject is seldom willing to wait quietly until the picture has been taken.

I am immensely fascinated by fish eyes. The colours of these tiny organs represent impossible rainbows. Photographing them is certainly not easy; "Tools and Techniques" on page 10 will give you more details.

As a photographer I also capture the splendid seascapes and sea creatures in a more typical and recognisable form. The same is true for other underwater worlds such as mangrove forests, seagrass beds, seaweed reefs, rivers and lakes. That, however, is the theme of my next book. In this one I want to show the beauty that non-divers and even most accomplished divers never notice. It's my hope that this book will stimulate its readers to approach the undersea world with a more artistic view. Since this approach requires very close proximity to the subject to be studied, a warning is called for. Divers who don't have perfect buoyancy might be tempted to hold on to the corals – especially when there is a strong current. Please, never do this! The extremely vulnerable coral polyps might be damaged, usually resulting in their death. Merely damaging the slime coating can allow in bacteria which will harm the coral and such damage can occur whether or not the creatures are inside their limestone homes (corallites). So don't touch anything when under water – both for the animals' well-being and your own; many of these harmless looking marine creatures, such as some coral polyps, anemones and even some fish species, are equipped with poisonous substances. When touched they will inject the poison through the attacker's skin, with potentially serious health consequences.

TOOLS AND TECHNIQUES

The underwater photographer has to be an excellent diver who doesn't have to worry about the technicalities of diving; thus, the mechanics of diving become subordinate to photography. Obviously the photographer has to have perfect buoyancy; he or she must be able to go up or down from respiration changes only, without inflating or deflating the buoyancy control device.

The underwater photographer must have a steady hand, since he or she has no tripod and often shutter speed is very slow. However, in addition to knowing all about the camera and the flash, a thorough knowledge of the animals concerned is equally vital. In the distance one might see an explosion of colour such as a Queen Angelfish, a desirable photo subject. Usually this fish will swim in a certain direction from which it will seldom deviate. Only after a few hundred yards, at the end of its territory, will it turn around. Also, the Queen Angelfish will seldom move vertically. With this in mind, one can anticipate the passing of this jewel by focusing the camera on shutter speed and aperture and taking up the right position. Since most fish don't like bubbles, it is essential to hold your breath or breathe very slowly when taking the picture.

For my underwater photography I use Nikon cameras and two Nikon flashes. The F5 and F90X cameras are equipped with Subal underwater housings. To me these compact housings are just perfect. All camera functions can be operated from outside. For each lens I need a "lens case", separately attached to the camera housing.

Under water the natural light vanishes swiftly. At a depth of 60 feet (18 metres) the actual colours are only dimly discernible, if at all. To capture true colours you will need artificial light. For that, I use the two flashes, covering one flash with a special diffuser, thus spreading the light more. Since the other flash gives more light, this will result in natural looking shadows.

In my opinion flash techniques are more complex than camera operation. Courses can teach you a lot, but in the end experience is essential.

Generally I use ASA 100 Fuji slide films (Sensia, Provia, Velvia) because I consider Fuji's colour saturation best for underwater photography. I do not do digital photography. This has to do with fear of the unknown and reluctance "to have to start all over again". Besides, I want to be free to print my pictures as large as I like without losing quality. Up until now that has been impossible with digital photography. All pictures in this book were taken with a 105mm lens, sometimes with a 4 + diopter. The distance between camera and subject was usually between two and four inches (five to ten centimetres).

A WORD OF THANKS

When photographing, one is on one's own. Under water, however, there should be a dive buddy. My buddies usually help me look for photo subjects. Thank you for your patience! It's not always fun to dive with a photographer…! Capturing a beautiful object generally takes a lot of time and afterwards little time is left to find other themes. After all, time is limited under water – subject to depth, the air is used up after one hour or so, unfortunately forcing one to ascend. Unlimited diving is no option because of the danger of too much nitrogen in the blood, with all that entails. During intensive dive trips I try not to dive more than three times in twenty-four hours and even that is not entirely without risk.

It's impossible to mention all my buddies from the past twenty years, but I would like to name a few: Jim Thistleton from Kangaroo Island (South Australia) who did a fantastic job in helping me find the peculiar Leafy Sea Dragons and the Weedy Sea Dragons; the Kararu Divers' people from Bali, Indonesia; Lisa Michelle Crosby, Sascha Dambach and Antony Rubin Rhodes who showed me large parts of the Indonesian Archipelago's underwater world; Marc Strickland from Phuket, Thailand and last but not least Larry Smith, the legendary dive guide who found lots of unusual animals, particularly in Northern Sulawesi's Lembeh Strait, Indonesia. Dirk Milo from Milo Profi (Belgium) had all my slides digitalised, a task chiefly performed by Waldo Peeters. With the patience of a saint he tried to stay as close as possible to the transparent, almost three-dimensional beauty of the slides.

I want to thank my publishers, Eric Ghysels and Marco Jellinek from 5 Continents, who understood exactly what I wanted and were able to put my ideas into practice; my brother Bau, a graphic designer, who advised on the book design; and especially Kalli De Meyer, for writing "The Coral Reef"; my friends and former neighbours on Bonaire, Laura and Ben Buchbinder, for editing my part of the text.

Dr. Steven Weinberg, marine biologist at the European School, Luxemburg and Hubertine (Tiny) Heremans, PhD in science at Leuven University (Belgium), helped me identify many of the invertebrates. She in turn was helped by Dr. Tom Schils, phycologist of the Phycology Research Group, Biology Department of the Ghent University and Dr. Claude Massin, Chief Scientist at the Royal Belgian Institute of Natural Sciences.

François Desmet from Aqua Sport Deurne-Antwerpen, who for more than twenty years has advised me when buying dive equipment and who is excellent in repairs; Rudi Pommé and his Pommec team (www.pommec.com) for their technical advice on diving throughout the years; the De Rooij family (www.bonairefuntravel.nl) for taking care of my travels to Bonaire; Abel den Hartogh and his team (www.civingholidays.nl) for taking care of other dive trips and Pascal De Meyer for being an excellent manager of my former dive school on Bonaire (www.dive-friends-bonaire.com).

Last but not least I want to pay tribute to my parents, Tine and André, who brought me up with a deep love for nature, and my "life buddy", my wife Bertie. She is a photographer as well and she has not only stimulated me in "classical" underwater photography but has also stressed the importance of a more artistic approach.

I thank everyone who has helped me enjoy the privilege of gliding into Another World's briny deep.

Dos Winkel
Spring 2005

KALLI DE MEYER

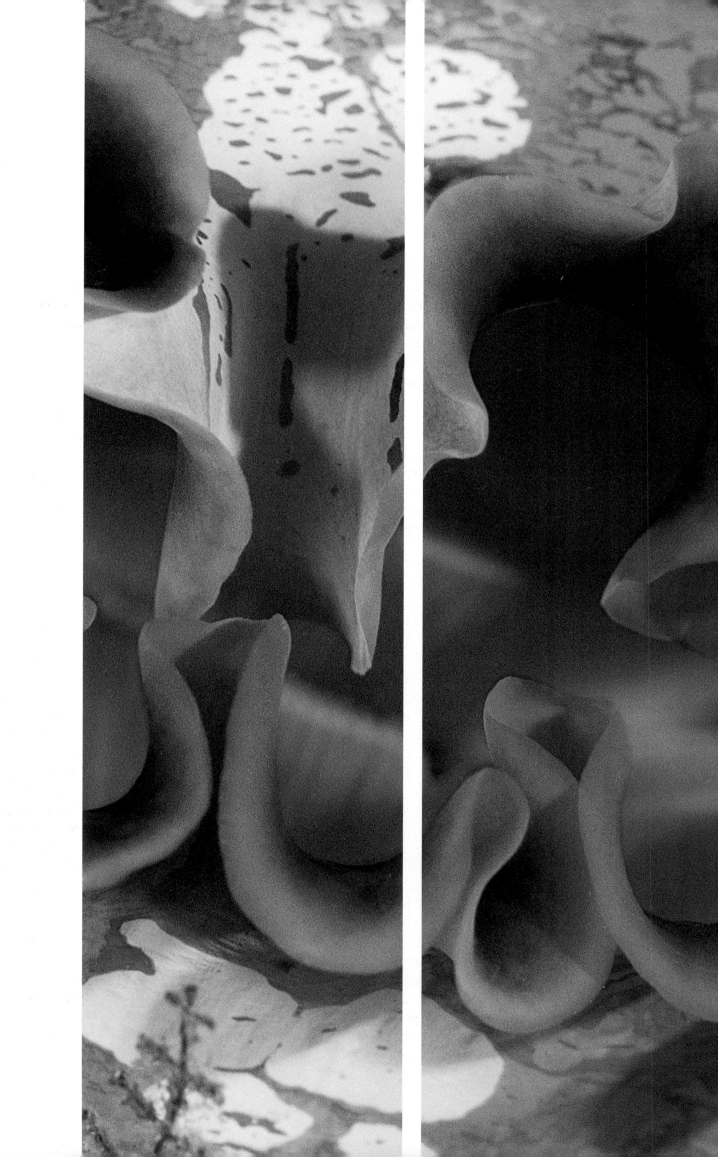

THE CORAL REEF

Photographs can give you a sense of the colours, shapes and forms of a coral reef. A biology course can help you understand how a coral reef is formed and teach you about the plants and animals that populate it. But nothing can really prepare you for your first encounter with a living coral reef. For someone who has never snorkelled or dived over a tropical coral reef it is almost impossible to imagine the sheer restless energy, the breathtaking colour, and the beauty of a reef. Waves crash, currents drift, tides ebb and flow drawing a ceaseless rain of food and fresh seawater across the reef. There are fantastically shaped corals from dome-like brain corals to mountainous pagodas, prickly tables, perfect spheres, thickets of branching corals and sheets of corals like scrolling plates. Soft corals and sea fans sway gently back and forth. Brightly coloured vases and blankets of sponges litter the bottom. And this wonderful sunlit world is populated by the ceaseless flitting and darting of numberless vividly coloured reef fish.

Corals reefs have been likened to tropical rainforests in terms of the incredible diversity of life which they house. Reef scientists believe this is due to the intense competition for space and food on the reef. Competition causes speciation, or an increase in the number of species, by forcing each creature to exploit increasingly narrow ecological niches. Many lifetimes have been devoted to trying to unravel the mysteries of life on a coral reef and to afford us glimpses into the workings of this most fascinating of ecosystems. But we are still in ignorance of all but the most basic processes at work on a reef.

TYPES OF REEF

In 1842 Charles Darwin laid the foundation of a classification system for coral reefs which is still in use today. Reefs which form close to land, following the contours of the coastline, are called fringing reefs. Where the reef is separated from land by a lagoon or open water it is called a barrier reef. Coral reef atolls, found almost exclusively in the Pacific, consist of rings of coral up to several kilometres in diameter around sandy islands.

Despite enormous differences among coral reefs, they all have the same basic needs: warm, clear, sunlit water (with an absence of sediment which could choke and kill them)

and a hard substrate on which to grow. They are found only in tropical seas where the year round water temperature is between 64.5° and 86°F (18° and 30°C), generally located between 30 degrees north and 30 degrees south of the equator.

The Great Barrier Reef is the world's largest coral reef system and a relative newcomer. Most of it is less than one million years old. It lies up to 40 miles (65km) off the coast of Queensland, Australia and is nearly 1,500 miles (over 2,300 km) in length. It includes approximately 2,100 reefs and 540 islands. This coral reef system has created a geological feature so large that it is the only living structure which is visible from space. Yet the animals that built it are tiny invertebrates which grow no more than a few millimetres a year.

BUILDING A CORAL REEF

Coral reefs are painstakingly constructed by a humble group of invertebrate animals belonging to the cnidarian *phylum*. Scleractinian (stony) corals are closely related to anemones but different from them in that they form huge interlinked colonies consisting of hundreds and thousands of individual coral polyps. Coral polyps are incredibly delicate and very slow growing. The fastest species of branching coral grows at only 4in. (10cm) a year, and other corals take years to grow a few millimetres. Coral colonies can reach immense sizes and are extremely long lived. There are colonies alive today which are believed to be over seven hundred years old.

Stony corals have developed the remarkable ability to extract calcium carbonate from sea water and use it to build complex limestone homes which form the solid framework, or matrix, of the reef. Around this framework there co-exists a complex web of life. Calcareous algae help to build the reef up, while animals such as boring sponges, worms, grazing fish and urchins work to erode it. In their eagerness to graze on algal (plant) turf, parrotfish recycle huge amounts of reef: up to 75% of their stomach content is ground-up coral reef. Still other creatures find shelter on the reef and for them it is home. This multitude of life is what we know as the coral reef. But what has long fascinated scientists is how corals could build such immense cities full

of life in the aquatic equivalent of a desert. Oceanic water is remarkably low in food (plankton) and nutrients.

LIMESTONE HOMES

Corals are able to build reefs because they have forged an impressive symbiotic relationship with a type of single celled algae plant called dinoflagellates, each about the diameter of a human hair. Corals allow their symbionts to live within the tissues of their body where they produce oxygen and energy rich sugars. This is the reason that reefs flourish in warm sunlit waters as the symbiotic algae require sunlight for photosynthesis. It is their symbionts which give corals their colours, without which they would be white. A coral's symbionts can make up almost 50% of the weight of the coral animal, and they provide an estimated 80% of the coral's nutritional needs. In return the coral polyp provides a safe and sheltered environment.

Seawater is rich in dissolved calcium carbonate. Coral polyps are able to take this up and secrete it beneath themselves as microscopic crystals. The polyps of each type of coral build according to its own innate plan. And even though coral heads are incredibly plastic, forming radically different shaped colonies according to the amount of wave action, current and light, their polyps always build identical limestone homes.

THE VALUE OF REEFS

Coral reefs are special because they protect tropical shorelines from damage by storm waves. In addition, reefs provide substantial economic benefits. For example, a recent World Bank study determined that each square metre of coral reef in the Caribbean protects $47,000 in property. Reefs provide hundreds of thousands of people with income and food from fishing. A coral reef in prime condition can produce over twenty tons of protein per square kilometre each year. Tourism is a major source of income for many tropical island nations and Caribbean reefs alone are worth about $140 billion per year in tourism dollars.

At the global level scientists believe that by taking up calcium carbonate from seawater corals create carbon sinks which lessen the impact of the greenhouse gases involved in global warming. Coral reefs are home to such a vast array of animals and plants that only a small fraction of them have so far been described. More and more medical compounds, useful for combating HIV, cancer and other diseases, are being isolated from coral reef creatures, and sterilised coral skeletons are already being used as a bone substitute for implants.

But, most of all, coral reefs give us an unparalleled opportunity to marvel at the wonder of life and the beauty and complexity of the world we live in.

REEF FISHES

Many people find the dazzling array of fish the most amazing aspect of their first encounters with a reef. The restless beauty and the sheer abundance of colourful and exotic reef fish make visiting a reef a memorable experience. Out of an estimated 28,800 known species of fish, over 40% live densely packed on or around the world's coral reefs. Not only are there more fish per square metre on coral reefs than anywhere else, but they are at their most flamboyant and most highly specialised. An average Caribbean reef is home to about 250 different kinds of fish – in the Pacific this number can be as high as 2,200.

Literally every crevice, ledge, nook and cranny is home to one fish or another. Scientists believe that coral reef fish diversity presents a classic example of speciation through niche separation. In other words, because they have been crowded together into a limited space over long time periods, fish have become more and more specialised so as to minimise direct competition with one another.

While divers tend to categorise fish by their shapes, scientists like to arrange them into functional groups, usually according to what they eat. The first and most basic division is between herbivores (plant eaters), carnivores (meat eaters) and planktivores (plankton eaters). But these categories are by no means clear cut. For example, parrotfish, which are classed as herbivores, will routinely eat animals such as corals and sponges.

HERBIVORES

On coral reefs, plants (algae) and corals exist in a state of dynamic equilibrium or balance and both compete fiercely for space in which to live and grow. Since corals are slow growing and algae grow very swiftly, it is an unequal race and the outcome would be inevitable except that corals have hardworking allies. The reef's grazers or herbivores help to maintain this crucial balance between plants (algae) and animals (corals).

A coral reef is capable of producing a phenomenal amount of plant material (about 2–11lb per square yard per year – 1–5kg per square metre). In cases where the reef's grazers have been removed intentionally the reef has rapidly degenerated into an algal wasteland. An exclusion experiment in Florida resulted in dense stands of fleshy algae which parrotfish and surgeonfish picked clean in under two hours.

Through their unstinting dedication to algal consumption damselfish (*Pomacentridae*), parrotfish (*Scaridae*) and surgeonfish (*Acanthuridae*), along with roving urchins (*Diadema antillarum*), reduce algae to a harmless turf on a daily basis. This equates to some of the highest grazing rates on earth. Indeed roving bands of brightly coloured

parrotfish and large shoals of blue tangs are one of the most common sights on Caribbean reefs. Although there are relatively few species of herbivores they are often the most numerous fish on the reef, easily making up a quarter of the resident fish population.

CARNIVORES

Carnivores are by far the most noticeable and diverse fish on any reef. This abundance of hunters has impacted on the evolution of many smaller reef fish, which have developed a host of camouflage and protection techniques to aid their escape. In an attempt to create order out of chaos, reef scientists divide carnivores into two categories. Depending on how they hunt, carnivores can be classified as roving predators or ambush predators.

Classical roving predators are the ones you are likely to see high in the water above the reef or out in blue water cruising in search of prey. They include sharks, mackerel (*Scombridae*), jacks (*Carangidae*), seabass, tarpon and several types of snappers. They are built for speed with streamlined bodies and highly forked tails. Jacks and mackerel (including tuna and wahoo) are strong swimmers which hunt in the open ocean, though it is not uncommon to see them pass across reefs in search of small fish and crustaceans.

Other roving predators prefer to hang motionless in the water waiting to pounce on their unsuspecting prey. They include the barracuda (*Sphyraenidae*), cornetfish (*Fistulariidae*), trumpetfish (*Aulostomidae*) and needlefish (*Belonidae*). Each of them has a long snout and an impressive array of sharp teeth. Perhaps the most entertaining of them are the trumpetfish which simply cannot resist aligning themselves with, and matching their colour to, just about any long thin object on the reef, including mooring lines. Their second favourite occupation is to join hunting parties of morays, hogfish, parrotfish or grouper which systematically prowl the bottom.

The crevice feeding eels are another group of roving predators. These include morays (*Muraenidae*), congers (*Congridae*) and snake eels (*Ophichthidae*), all of which have long slender bodies and narrow heads suitable for searching for food in every nook and cranny on the reef.

The fish that prey on invertebrates are some of the most conspicuous fish on the reef. They include butterflyfish (*Chaetodontidae*), wrasse (*Labridae*), pufferfish (*Tetraodontidae*) and boxfish (*Ostraciidae*), each of which has a very highly specialised diet of sponge, coral, tunicates, urchins or snails. Parrotfish are inadvertent coral eaters in that they mostly target turf algae on or near the coral, not the coral itself, except when marking territory.

Ambush predators conceal themselves on or around the reef. Included are: grouper (*Serranidae*) which lurk in the shadows under ledges and overhangs, lizardfish (*Synodontidae*), flounder (*Bothidae*) which hide on sandy bottoms, and scorpionfish (*Scorpaenidae*). Grouper are adept at making themselves blend into the background so that other fish cease to notice them. They are, however, able to move at lightning speed over short distances and suck their prey into their large tooth-lined mouths, swallowing them whole. Lizardfish, flounder and scorpionfish rely on camouflage to put them within striking distance of their prey.

Frogfish (*Antennariidae*) go one step further and are not only superbly well camouflaged, but display a lure to entice unsuspecting fish into their vicinity. It is a strategy which clearly works, as 75% of their diet is composed of other fish. And frogfish have eyes which are truly bigger than their stomachs. Not only do they have mouths which can be opened to the width of their body, but size seems to be no object as a shocked scientist discovered when he found a 4in. (102mm) long Caesar Grunt in the stomach of a 3³/₄in. (97mm) long frogfish.

Then there are the cleaning fish. Cleaners are in the business of keeping the reef free of parasites. Wrasse and gobies are the most common cleaners, although many juvenile fish go through a cleaner phase. They set up specialised cleaning stations on the reef where fish will sometimes literally line up for the chance to be pampered and cleaned of parasites.

PLANKTIVORES

Finally there is a whole group of fish that live exclusively on plankton (microscopic plants and animals) which drifts in the water above the reef. Making this microscopic food the mainstay of your diet is not limited to small fish, as whale sharks have shown. The whale shark (*Rhincondon typus*), which reaches lengths of 50 feet (15 metres), is a dedicated filter feeding planktivore, ploughing its way through the ocean with its mouth wide open, collecting plankton as it goes. Manta rays (*Manta birostris*) employ a similar strategy and can be seen executing graceful loops and turns in the process.

Nearly all young fish are dependent on plankton for at least some part of their life, and nearly every family of fish has one or two members that have developed a permanent taste for these microscopic nibbles. Planktivores are either "pickers" which slurp up their prey or filter feeders like mantas and whale sharks.

Many planktivores have had to compromise. Since they need to spend time in open water away from the safety of the reef, they have developed a taste for speed and have become some of the reef's most streamlined swimmers. The faster they are, the further they can safely shoal away from the reef. In the Caribbean the most conspicuous planktivores are Brown Chromis (*Chromis multilineata*), Creole Wrasse (*Clepticus parrae*), Creole Fish (*Paranthias*

furcifer), Black Durgeon (*Melichthys niger*) and Sergeant Majors (*Abudefduf saxatilis*).

After dark a new group of planktivores emerges which includes cardinal fish, bigeyes, Black Bar Soldier Fish (*Myripristis jacobus*), Glassy Sweepers (*Pempheris schomburgki*) and silversides.

REEF INVERTEBRATES

When we visit coral reefs we are often overwhelmed by the number, colour and diversity of fish. But, for every fish you see on a reef, there are hundreds of invertebrates, most of which you may never see at all. They exist in numbers which defy description. In a single square metre of reef scientists have found nearly 39,000 different invertebrate plankton eaters, excluding the corals themselves. Invertebrates provide critical services to the reef ecosystem, such as keeping algae (plant material) in check, cleaning the bottom, recycling waste and purifying the water. We miss seeing them because we are usually too hasty in our explorations of the reef and the resident invertebrates are often small and cryptic.

Reef invertebrates range in size from enormous barrel sponges and towering coral heads to microscopic plankton, which drift above the reef. By any standards their diversity is impressive. The most obvious invertebrate groups include: brightly coloured sponges and corals; molluscs, shrimps, crabs and lobsters which are mostly nocturnal; worms which hardly look like worms at all; and the echinoderm family which includes sea stars, brittle stars, urchins, sea cucumbers and feather stars. Each family has its unique characteristics as well as its own surprises.

CNIDARIANS — THE REEF BUILDERS

Without reef invertebrates there would be no coral reefs as we know them. Millions of years ago reefs were built mainly by calcareous algae (plants), but today's reefs are primarily constructed by corals. Corals belong to a phylum which includes hydroids, jellyfish and sea anemones. If there is one thing that cnidarians have perfected it is how to sting. They have an amazing seventeen different kinds of nematocysts (stinging cells) in their arsenal, with a variety of whip-like ends, barbs and sticky secretions, as well as toxins. Add to this their waving tentacles and the sheets of sticky mucus which cover their bodies and you have a veritable killing machine. Corals may look like pretty coloured rocks, but they are in fact voracious predators and their ability to remove plankton from the water is legend. It takes just thirty seconds for food particles dropped on to the Lesser Starlet Coral (*Siderastrea radians*) in shallow water, to be completely devoured by a sheet of mucus.

SPONGES

Sponges are some of the most colourful and distinctive invertebrates on the reefs, ranging from encrusting sponges and iridescent vases to enormous barrels and massive orange elephants. Sponges are ancient animals which have survived for approximately seven hundred million years. Since they don't move around, sponges have had ample opportunity to perfect their defence systems and some of the most unusual biochemical properties of any animal group have evolved in sponges. Perhaps not surprisingly they have remarkably few natural predators. Sponges are not just ancient, they are primitive as well, but they have the capability quite literally to rebuild themselves. This was demonstrated decades ago when scientists put a sponge through a blender, strained it and left it to stand, only to find the sponge had reassembled itself a day later.

The holes covering sponges are no accident. Sponges play a vital role on the reef in maintaining water quality by filtering enormous quantities of water through those holes. They can pump four to five times their own body's volume of water in just one minute, which equals thousands of litres a day. They are incredibly efficient filter feeders. Most importantly, they have minimised competition by concentrating on bacteria and other organics which are too small for most other filter feeders to consume. Up to 80% of the material they filter out of the water is too small to be seen even under a microscope.

WORMS

Worms on coral reefs are definitely at their most extravagant, sporting brightly coloured whirls and fans of filtering arms. Christmas tree worms and feather dusters are two of the most conspicuous segmented worms which have developed specially modified head parts to filter food out of the water. Then there is the infamous fireworm, a voracious predator which has devised the perfect defence in its toxin laden bristles. It will devour anything in its path, including anemones ten times its size, and has the peculiar habit of ingesting the ends of soft corals and practically skewering itself in the process. But if there is carrion to be found on the bottom you can be sure it will be swarming with these brightly coloured worms.

Worms are one of several groups of creatures that, for every one you see, you can be sure there are thousands lurking out of sight. In a single small coral head on the Great Barrier Reef, scientists extracted over 1,400 worms belonging to over one hundred different species. These are the invisible creatures which bore and chew their way into coral heads, pulverising and dissolving their stony skeleton. Still others live by the thousands within the tissues of sponges, nibbling away incessantly at their host.

MOLLUSCS

This Latin name means "soft bodied", as one of the characteristics of this phylum is that they have no true internal skeleton. Soft bodied in turn translates to mean "tasty treat" to a whole host of fish and other predators. For this reason molluscs by and large are well camouflaged, unprepossessing, cryptic creatures which only emerge at night to feed. Most live in beautifully constructed calcium carbonate homes. Gastropods like conch, flamingo tongues, cowries and cone shells have a single shell and rows of chitinous teeth with which to rasp and grind food. Long before the evolution of fish, the Chambered Nautilus, a mollusc, hunted the world's oceans as one of its foremost predators.

Bivalve oysters, clams, scallops and pen shells, on the other hand, lead a sedentary life as filter feeders sucking plankton out of the water. But nudibranchs have chosen quite a different path; they walk naked and often very conspicuously around the reef and have swapped a shell for sophisticated chemical defences which make them toxic or at least unpalatable to would-be predators.

The surprise members of the mollusc family are the cephalopods – the world's smartest invertebrates. These include cuttlefish, squid and octopus. They have well-developed eyes, can change their colour at will and are active predators. In the laboratory, octopus outperform lab rats in their ability to learn and reproduce complex tasks. The biggest problem is keeping them contained since they are also natural escape artists.

CRUSTACEA

We are usually aware only of a tiny fraction of the crustacea that actually live in and around coral reefs. In reality they are the dominant phylum on any coral reef, but there is a good reason we do not see more of them – crustacea are a highly sought-after food item. Most of the crustacea we see are decapods (ten legs), including shrimps, crabs and lobster, which can be spotted emerging from their crevices at night to hunt. There exists another world of miniature shrimps, crabs and mysids which live in close symbiotic relationships with everything from sponges and corals to urchins and molluscs. Above the reef there is another microscopic world of plankton which is teeming with crustacea. On the reef crustacea are the equivalents of their cousins the insects on land and fill all of the same ecological niches.

The characteristic shared by all crustacea is their jointed exo-skeleton which they wear like a suit of armour. They have the ability to regenerate their limbs and actually have a sacrificial joint where they are able voluntarily to discard a limb that has been attacked or damaged.

ECHINODERMS

Echinoderms have the distinction of being the only phylum of invertebrates which is exclusively marine. They consist of starfish, brittle stars, urchins, sea cucumbers and feather stars. The Latin name means "spiny skin", but one of the unique attributes of this otherwise very dissimilar group of creatures is that they are pentate (built in units of five). They also have inspiring powers of regeneration which allow them to shed legs, or in the case of sea cucumbers their innards, without a second thought. A whole new brittle star can regenerate from just part of the central disc and one bristled arm.

Molluscs are the favourite food of most starfish, with the notable exception of the coral munching starfish, *Acanthaster*, which has become notorious throughout the Indo-Pacific for devastating reefs. During Crown of Thorns outbreaks their numbers reach plague proportions, but scientist are not sure why this happens. They theorise that it is either part of their natural "boom-bust" cycle or that too many of their natural enemies, Tritons, have been taken for sale as souvenirs.

Urchins are either algal (plant) grazers or detritivores cleaning up debris off the bottom. They include not only the famous black spiny urchin (*Diadema* sp.) but also sand dollars and heart urchins which spend their lives buried in the sand. Sea cucumbers play an invaluable role as marine vacuum cleaners, reworking vast quantities of sediment from which they extract all the organic material. Finally, feather stars or crinoids and basket stars are amazing filter feeding webs that come alive after dark to perch atop corals and sponges, spreading a deadly sticky trap for passing plankton

TUNICATES

Tunicates are another of the largely overlooked groups of creatures living on the reef. They have one very notable attribute. In their larval stage they possess a primitive notochord (spine) which they lose as they mature but which gives them the distinction of forming the halfway house between the vertebrate and invertebrate worlds. Tunicates or sea squirts look much like sponges and are equally colourful. They can form solitary upright structures or encrusting colonial mats. But whereas sponges are entirely unreactive, tunicates possess a primitive nervous system and will close if touched.

SYMBIOSIS

On coral reefs we find many more examples of symbiosis than in practically any other aquatic environment. Intense competition for space and food on reefs has forged some unlikely alliances between reef creatures. Often the body of one creature becomes home to another. Minute

examination of the undersides of starfish and urchins will reveal tiny crabs and shrimps scuttling for cover. Mysid shrimp can be found living on just about anything bigger than themselves from soft corals to sea urchin spines. Remora have developed a specially flattened sucker-like head so that they can hitch a ride on strong swimming sharks, rays, turtles and even divers. Whales are smothered in barnacles. But animals such as the pearlfish (*Carapidae*) have given symbiosis a whole new meaning. They make their home up the anus of their sea cucumber host.

TYPES OF SYMBIOSIS

Even though we tend to think of symbiosis as something beneficial, it is actually a blanket term for any kind of "live-in" relationship between different creatures. Symbiosis therefore encompasses mutualism (where both creatures benefit from the relationship), commensalism (where only one creature benefits but the other is essentially unharmed) and parasitism (where one creature benefits at the expense of the other). Most symbiotic relationships are poorly understood. At best we can only watch and wonder at reef creatures which manage to co-exist in such a myriad of different and inventive ways.

ANEMONES

While the most important mutually beneficial relationship on the reef is the one between corals and their symbiotic algae, the most famous is probably between the Pacific clownfish (*Amphiprion* sp.) and its host anemone. Clownfish somehow acquire limited immunity to the anemone's lethal stinging tentacles. But take a clownfish from one anemone and place it in another or take it away from its host for a day and it will no longer be recognised – often with fatal consequences. Both benefit by sharing food: clownfish are messy eaters and the unfussy anemone even mops up clownfish excrement. The clownfish, which is a poor swimmer, acquires the ultimate secure home and in return will tenaciously defend its anemone from attack.

But sneak up on just about any anemone and you will discover that they are prime real estate for many creatures such as small crabs, and shrimps. The corkscrew anemone (*Bartholomea annulata*) and the red snapping shrimp (*Alpheus armatus*), for example, are virtually inseparable.

CORAL CONDOS

Molluscs, worms, crabs, shrimps and gobies, to name a few, can be found squeezed into the cracks and crevices of a coral head. Even the encrusting sponges, which coat the exposed underside of coral heads where the coral polyps receive insufficient sunlight to grow, serve a valuable purpose – preventing corals from being attacked by boring organisms. One special relationship involves porcelain crabs, which

often live in and around corals. The crabs, which would otherwise make a tasty snack, hide amongst the branches and crevices of coral heads and gain a safe haven, but the corals benefit too. Not only can they utilise the crab's excreta but their tiny symbiotic friends can become very attached to home. Crabs have been known to defend their host coral so fiercely that they have even driven away the dreaded Crown of Thorns starfish by severing its hydraulic feet.

SPONGES

Sponges are veritable condominiums filled to capacity with worms and brittle stars, shrimps and crabs, gobies and blennies, all seeking shelter from the hostile world of the reef. The most common crustacea in residence are the pistol shrimp (*Synalpheus* sp.), and they are not found in ones and twos. In three common loggerhead sponges (*Spheciospongia vesparium*) scientists extracted between 5,000 and 16,000 shrimps per sponge. Another researcher found forty-three juvenile spiny lobster in a single tube sponge (*Spinosella* sp.). But sponges have another interesting symbiont. While they have been able to make themselves disagreeable to predators in any number of ways, mostly pharmaceutical, they are still routinely eaten by butterflyfish, angelfish, filefish and roving hawksbill turtles. This seems to have led them into an odd alliance with colonial anemones (*Parazoanthus* sp.), which can make the sponge look as if it is covered in brightly coloured flowers. The anemones insinuate themselves into the body of the sponge and offer yet another form of protection – they sting. The Rock Beauty (*Holacanthus tricolour*), for example, will not eat a sponge which has a resident anemone.

STINGING FRIENDS

It seems that the protection afforded by stinging cells is in great demand. Various hermit crabs can be found with anemones on their shells. This relationship seems to be so beneficial to both parties that it can be initiated either by the crab tapping on the base of the anemone or by the anemone grabbing the hermit crab's shell in passing. The advantage to the hermit crab has been established beyond doubt. When attacked by octopus, hermit crabs without anemones are attacked faster and more frequently and the attacks are always fatal to the crab. It is not so when the lucky hermit crab has an anemone friend in residence.

OBLIGATE SYMBIONTS

While there are many varied examples of temporary symbiotic relationships, there are also what are called obligate symbionts or species that simply cannot survive without their host. This is true not only for most stony corals and their symbiotic algae but also for a host of other creatures which host zooxanthellae such as sea anemones, giant clams, some sponges and sea squirts.

The situation of obligate symbionts is typified by the relationship between the Masked Shrimp Goby (*Amblyeleotris gymnocephala*) and its purblind Snapping Shrimp partner (*Alpheus* sp.). Both find one another early in life. Although the shrimp may be functionally blind, it has a distinct talent for excavating burrows. The goby meanwhile does the hunting, bringing back food and acting as an early warning device if danger threatens. Neither can live long without their partner.

Another example is the beautiful flamingo tongue which can only live on sea fans and soft corals where, in true commensal fashion, it farms the swaying branches of the coral, eating their flesh at precisely the right rate for the tissue to grow back again leaving the host coral unharmed.

CLEANING STATIONS

The most visible and entertaining mutualistic relationship on the reef must be cleaners and their hosts. It is estimated that over forty-eight different species of fish, many of them wrasse and gobies, act as cleaners for all or part of their lives. Their invertebrate counterparts include Pederson Cleaning Shrimp (*Periclimenes pedersoni*), Banded Coral Shrimp (*Stenopus hispidus*)and Scarlet Ladies (*Lysmata debelius*).

Many cleaners set up highly visible cleaning stations on the reef. Queues of fish waiting patiently to be groomed advertise the best cleaning station spots. Here you can see tiny cleaners swimming boldly into the fearsome jaws of grouper to clean their teeth or peck at dead tissue and studiously remove parasites. Fish seem to go into a trance, hanging motionless in the water with their mouths wide open to allow cleaners access to their fragile gills or rolling on to their sides to have their fins nibbled.

Sometimes it seems that the distinctive markings and coloration of the cleaner fish give them this free pass; however, both client and cleaner engage in a ritualised yawning, fin flaring dance to seal the contract before the cleaning begins. Cleaners seem to be a vital part of a healthy reef. When the cleaners have been experimentally removed from reefs, most of the less territorial reef fish have moved out in a matter of days. Those that remained quickly showed how much they needed them back.

CAMOUFLAGE – COLORATION – MIMICRY

The world of the coral reef is densely packed with life, forcing predator and prey to live next to if not on top of one another. Within this fiercely competitive world some creatures survive by becoming nocturnal and only scuttling out to find food after the rest of the reef has retired for the night. Others hide out in holes and crevices. But, for many, camouflage holds the key to survival and has become their way of life.

It is paradoxical that, with sharp teeth all around, many fish on coral reefs exhibit bright and flamboyant colours. This may be explained by the fish's need to be seen and recognised by other members of its clan. However, since it doesn't want to be eaten in the process, disguise is the game, and there seems to be no end to the inventiveness and cunning with which it is pursued.

Many of the most brightly coloured fish are able to mask or dull their colours at will. Three parrotfish (*Sparisoma aurofrenatum*, *rubripinne* and *radians*) evade predators by freezing and completely losing their distinctive coloration to become pale and mottled. Dusk is the time when predators are most active and many fish throw off their gaudy daytime garb and try hard instead to blend in. As the sharp nose pufferfish (*Canthigaster rostrata*) settles down for the night its distinctive eye markings, vivid fluorescent blue spots and bars fade completely. The four-eye butterflyfish (*Chaetodon capistratus*) similarly loses its distinctive eye bar at bedtime, as do many other butterflyfish.

Nevertheless, the way whole families have evolved to match their habitat perfectly tends to indicate that at least some fish have excellent daytime vision. Ornate ghost pipefish (*Solenostomus paradoxus*) change not only their colour but their texture to match their environment, whether it is a soft coral, feather star or a seagrass bed. Many shrimps match their host coral or crinoid so well that you would never know they were there. Small, potentially vulnerable fish are often masters of disguise. Filefish (*Monachantidae*) and pipefish (*Syngnathidae*), batfish (*Ogcocephalidae*), gobies (*Gobiidae*), and especially blennies (*Blenniidae*), are groups which have invested in camouflage in a big way. The slender filefish (*Monacanthus tuckeri*) has a habit of hiding amongst identically coloured gorgonians where it drifts head down, virtually undetectable.

The advantages of camouflage have not been lost on predators either. Scorpionfish (*Scorpaenidae*) and stonefish blend in so well with their surroundings that their eye is usually the only thing to give them away. Not only do they match their mottled coloration to that of their habitat but they even reproduce the uneven contours with flesh appendages to mimic the "lumpiness" of the bottom. Peacock eye flounders at rest can only be spotted by the faint outline of their fins and their protruding eye because in every other aspect they blend perfectly with their surroundings. At least one species of flounder (*Paralichthys albigutta*) has even been induced experimentally to match its coloration with the black and white squares of a chequerboard.

Frogfish have taken this one step further and added mimicry

to their wardrobe. Frogfish are mostly found on sponges in a variety of colours – red, pink, orange, yellow, green, tan and black. It can take a frogfish several hours to perfect its disguise but, when finished, it is nearly impossible to distinguish it from its host. Then, to entice unwary victims within striking distance, frogfish have modified their first dorsal spine into a thin dangling lure. These harmless looking ugly little fish are actually voracious ambush predators capable of ingesting fish their own size or even larger.

But the award of Master of Mimic should undoubtedly go to the octopus. If excited or startled octopi send waves of colour flashing along their bodies, producing an astonishing light show. When they hide octopi not only perfectly match the colour and brightness of their surroundings but also reproduce the texture of their environment, puckering up their skin to mimic the natural unevenness of their surroundings. Mimic octopi found in the Western Pacific are remarkably versatile in imitating their neighbours and cousins, posing as anything from a jellyfish to an anemone, a flounder, sea snake or cuttlefish and morphing from one to the other while also mimicking the movements of their subject.

And, if all else fails, invertebrates have learned that hijacking camouflage works well too. Urchins routinely cover themselves with leaves, rocks and other bits and pieces they find amongst coral rubble. Crabs scuttle around with sponges on their backs or covered in algae and have even been known to hijack anemones.

CORAL REEF MANAGEMENT

Coral reefs have survived on earth for over two hundred million years. They have witnessed widely fluctuating sea levels, the uplifting of land masses, periods of widespread warming and repeated glaciations and been battered by short term natural disasters such as storms and cyclones. Coral reefs have shown that they are remarkably robust.

Actually coral reef management is not about managing coral reefs but about the need to manage our interactions with them. The sad fact is that coral reefs are under threat. The threats are direct and immediate and they are caused by us. The loss of coral reefs over the past decades has been unprecedented. Scientists currently estimate that over 25% of the world's coral reefs have been lost and that fully 80% of the coral reefs in South-east Asia and over 50% of the reefs in the Caribbean are "at risk" from human activity.

THREATS

The threats to coral reefs range from over-exploitation and habitat alteration to pollution and the introduction of non-native species.

Coral reefs are threatened by the over-harvesting of fish and other reef creatures for food, souvenirs, sale to the aquarium trade and use in traditional eastern medicines. In addition, the reef itself may be used for building material.

Habitat alteration includes direct physical damage to reefs by things like mining, destructive fishing practices and anchoring, trampling and impacts of visiting tourists. It includes changes to coastal and inland environments for agricultural purposes and logging or development which directly and indirectly affects the water quality of reef environments.

Pollutants which impact on coral reefs include nutrients and sediments deposited on the reef as a result of changed land use, dumping of sewage waste, land clearance and construction. Also problematic is the discharge of highly toxic substances like hydrocarbons (oil), heavy metals, solid waste and garbage which find their way on to coral reefs.

Non-native species are also beginning to threaten reefs. They are particularly dangerous since introduced species have no natural predators to keep their numbers in check and they may quickly out-compete the native reef creatures and cause their extinction. Lionfish, which are exclusively Pacific and Indian Ocean fish, for example, have already been found on the reefs of Florida and the Bahamas.

WHY SHOULD WE CARE?

Ethically we have no right to eradicate other living creatures, let alone cause the demise of entire ecosystems. Since humans pose the most immediate threat to the future of coral reefs, the responsibility rests with us to manage our activities in ways and within timeframes which will secure a future for coral reefs.

From an aesthetic point of view, each reef creature is a work of art. Each has made a long journey through time to become perfectly adapted to its world and every one is unique and irreplaceable. What a terrible tragedy it would be to lose them for ever.

Practically speaking, coral reefs are an exceedingly valuable commodity. They provide food, medicine, jobs and tourism dollars. In addition there is still so much that we don't know about them that we would be destroying a complex web of life which we are only just beginning to understand and appreciate.

Reefs are exceedingly fragile. Corals are sensitive to changes in nutrient levels and pollutants which are hardly even detectable. They can also be seen as the "canary" for the global environment. Corals are finely tuned to carbon levels. Scientists can only guess at what will happen when corals can no longer cope with the enormity of the changes we have caused through the continued emission of greenhouse gases which are not only slowly turning up the thermostat but also altering the carbon balance of the oceans.

That coral reef damage is not always caused by humans was recently demonstrated during the huge tsunami of Boxing Day, 2004. The Similan Islands and Phuket suffered major destruction, but fortunately many beautiful spots are still there. There is no reason whatsoever *not* to book for a diving vacation there. While Sri Lanka and Aceh were left devastated, the Maldives reefs survived without much damage. The tsunami even reached the Seychelles, but there too damage was limited.

WHAT CAN WE DO?

As visitors to coral reefs follow this basic code of conduct to minimise your impact:

- Choose destinations which take coral reef conservation seriously and have established marine parks or taken similar measures to protect their coral reefs
- Try to find "green" resorts which have programmes in place to minimise their energy consumption and which responsibly dispose of waste – they exist!
- Look for dive and water sports operations which maintain high standards of environmental protection, for example, using moorings instead of anchoring, educating their guests about coral reef environments and supporting local protected areas
- Never buy souvenirs made of coral or other marine creatures
- Take an interest in any marine conservation initiatives and protected areas. Pay fees – even if they are voluntary – which go towards supporting protected areas
- Report damage, poaching or bad practices to local conservation groups, dive operations or protected area staff

When out in a coral reef environment make sure you do not:

- Step on, kick or touch anything you see in the water, especially corals
- Remove anything you find such as shells or marine life
- Disturb, harass, chase or ride marine creatures

For those who live far from reefs remember that everywhere on earth is linked by air and water. What is dumped in the seas of Europe or North America will in time find its way into the tropics and on to coral reefs. There is a huge volume of information including waste prevention shopping lists and internet based recycling consumer guides for the discerning consumer. Be a responsible citizen: reduce, reuse and recycle

CORAL RESOURCE MANAGEMENT

Our coral reefs can be saved through sound management. Coral Resource Management focuses on educating people about coral reefs and working with local parks and protected area staff and users to provide training and support, advice, and access to resources, so that they can do the best possible job of protecting their reefs from harm. Check out our website www.coralresourcemanagement.org for details of our projects and to make donations which will allow us to continue to support not only the Marine Park on Bonaire, but to reach out to other needy parks around the world.

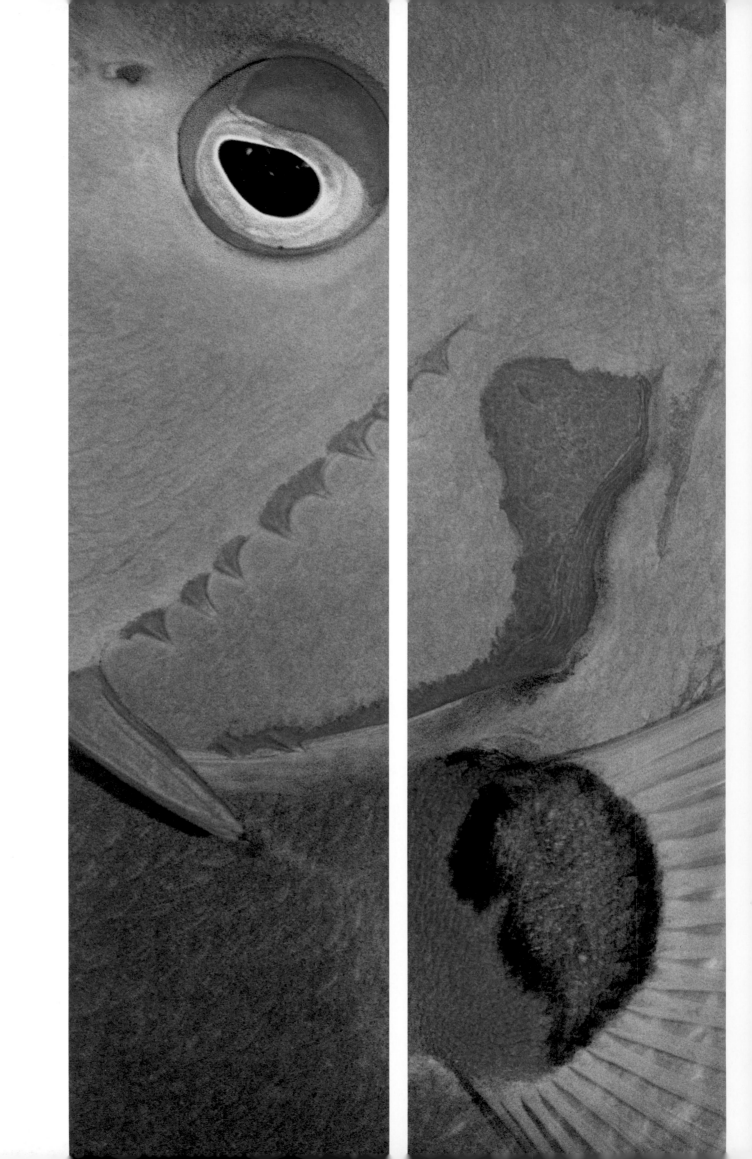

COLOURS, TEXTURES, PATTERNS

CENTRAL BODY OF A STARFISH
Nectria pedicellogera

STARFISH SIZE 6 INCHES (15.24CM).
PICTURE SIZE 1 INCH (2.54CM).

KANGAROO ISLAND, SOUTH AUSTRALIA; 55 FEET (16.8M) DEEP.

The reefs around Kangaroo Island mainly consist
of plants; an enormous variety of more than 2,000 species
of sea weeds and algae. In between one can find colourful
nudibranchs, anemones and starfish, of which this one
is especially beautiful.

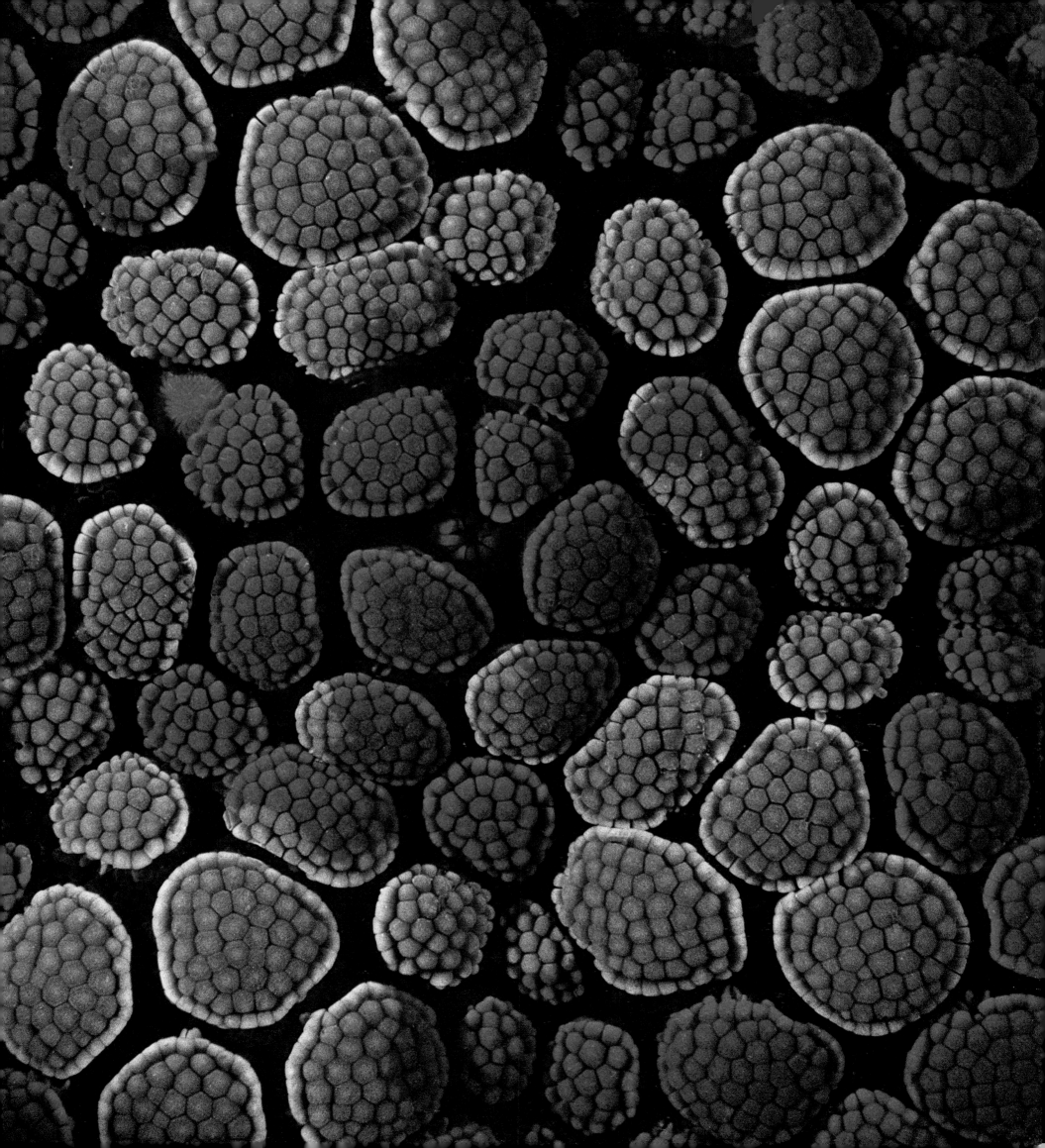

ANEMONE CORAL
Heliofungia actiniformis

ANEMONE CORAL SIZE 6 INCHES (15.24CM).
DETAIL SIZE 2¹/₂ INCHES (6.35CM).

MILNE BAY, PAPUA NEW GUINEA; 40 FEET (12.2M) DEEP.

Belonging to the family of one-polyp Mushroom Corals, this species – like all Mushroom Corals – is nocturnal. When I found it during a night dive I was very surprised to see this rare colour variation.

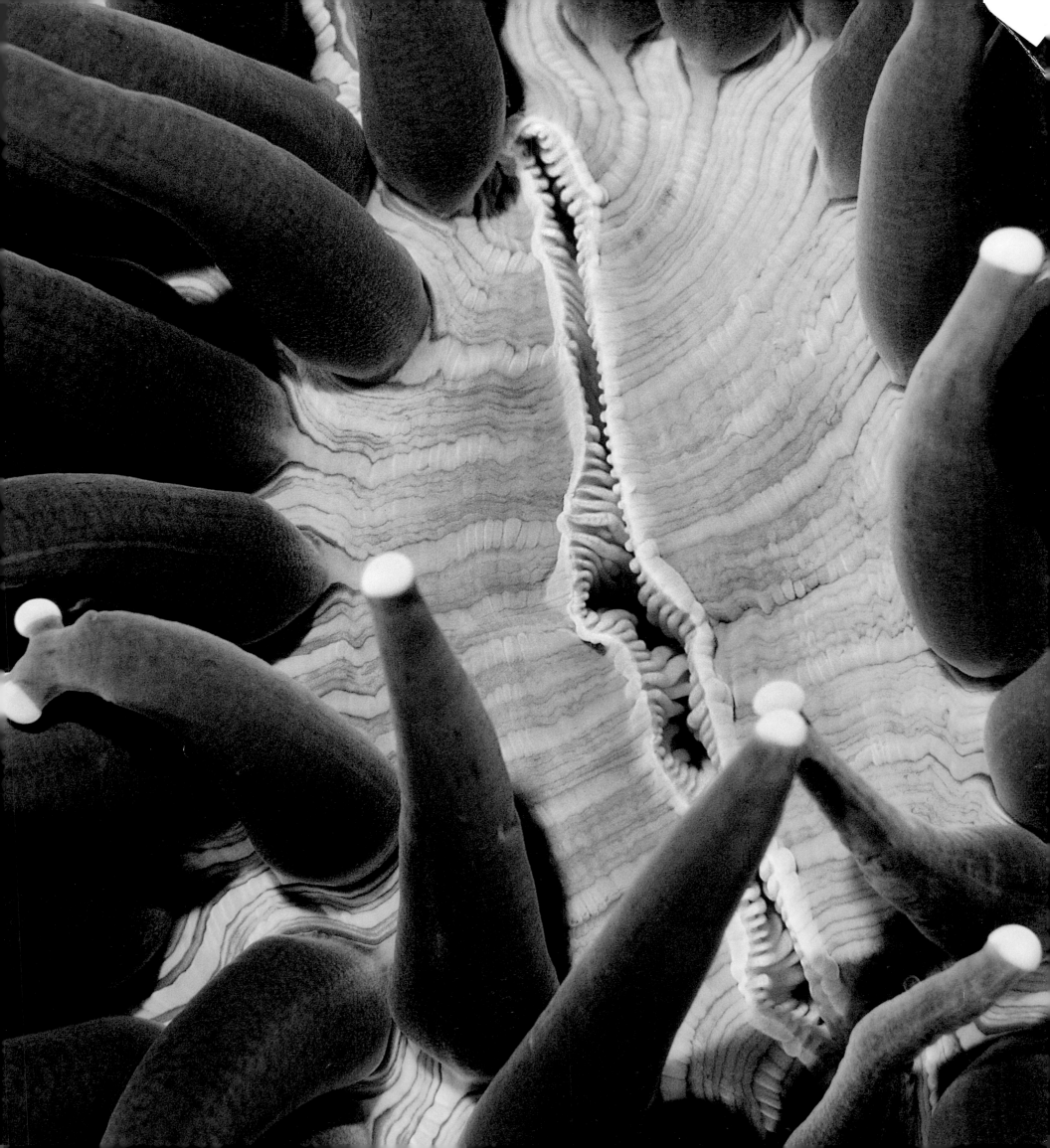

DETAIL OF THE TAIL OF A BLUEBARRED PARROTFISH
Scarus ghobban

PARROTFISH SIZE 18 INCHES (45.72CM).
DETAIL SIZE 1$\frac{1}{2}$ INCHES (3.81CM).

MARSA ALAM, RED SEA, EGYPT; 40 FEET (12.2M) DEEP.

I hope artists will be inspired by looking at these wonders of nature. This is a detail of the body and the dorsal fin of an adult male. Parrotfish colours change from the day they are born until they are adults. Not much is understood about this process.

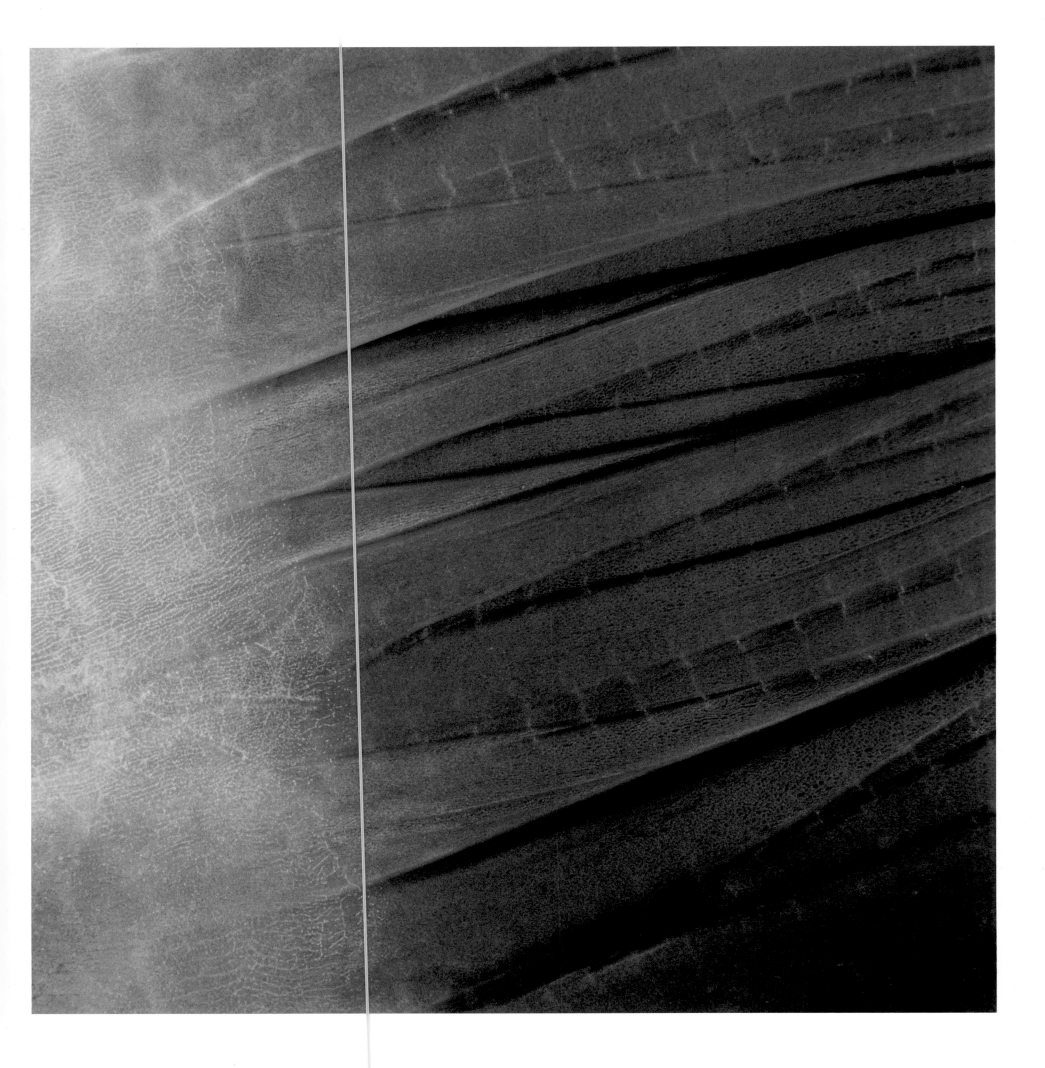

EYE OF A BLUEBARRED PARROTFISH
Scarus ghobban

PARROTFISH SIZE 18 INCHES (45.72CM).
DETAIL SIZE $3/8$ INCH (1.02CM).

MARSA ALAM, RED SEA, EGYPT; 50 FEET (15.2M) DEEP.

This eye is an amazing collection of pastel colours.
The question is why? Scientists hardly know anything
about why even a small organ such as an eye is so
multi-coloured.

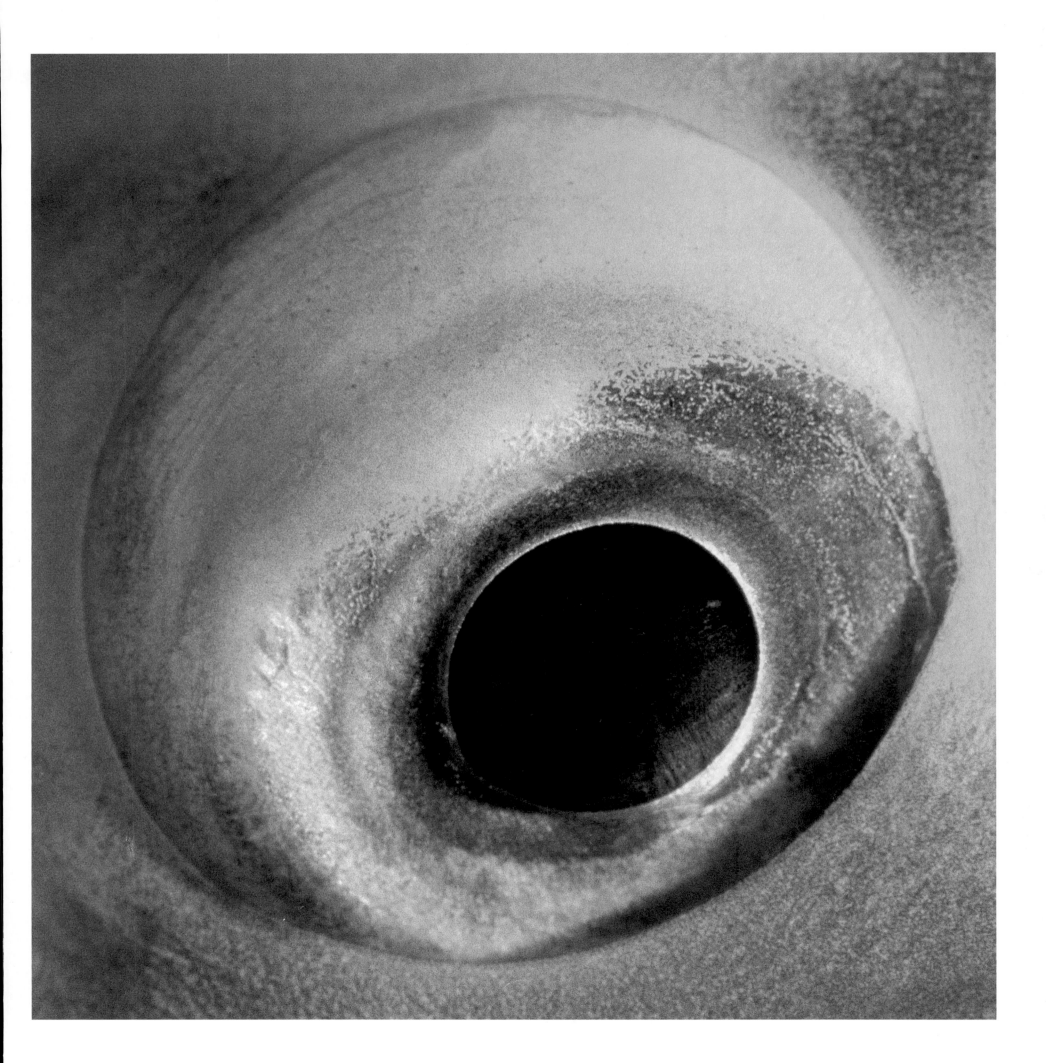

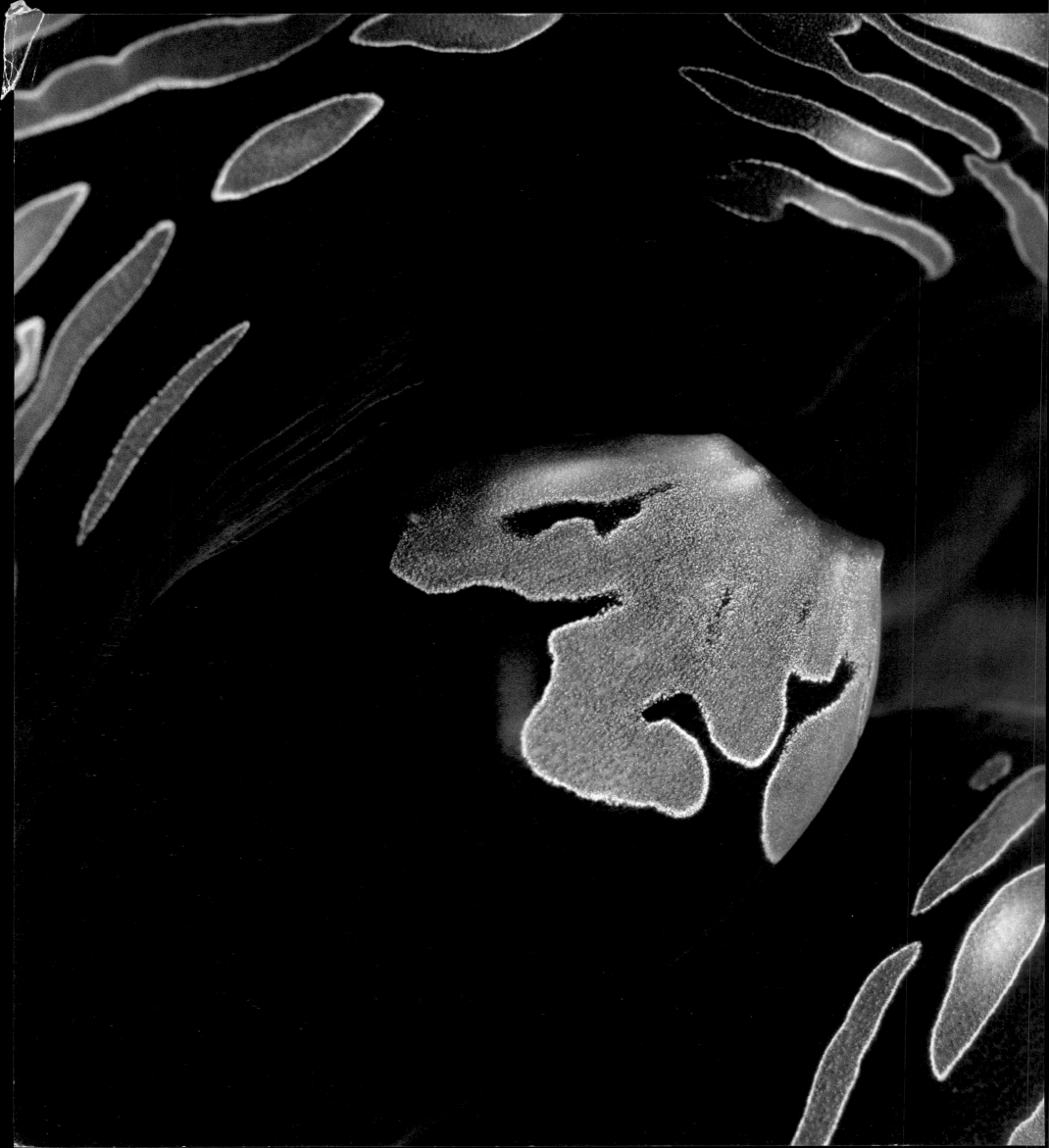

SIPHON OF SQUAMOSE GIANT CLAM
Tridacna squamosa

CLAM SIZE 12 INCHES (30.48CM).
DETAIL SIZE 1¼ INCHES (3.05CM).

MARSA ALAM, RED SEA, EGYPT; 55 FEET (16.8M) DEEP.

Water is pumped into the mantle cavity through an
incurrent siphon and pumped out via a separate excurrent
siphon. Clams get their colour from photosynthetic algae
growing symbiotically in the flesh of their mantle, as do
corals. To improve photosynthesis the mantle has small
openings to let extra light penetrate into the mantle flesh.
This clam can be found only in shallow water, seldom
deeper than 3o feet (9 metres). It lives embedded in coral
and when it grows it becomes stronger than the coral.
Under water one can find all conceivable colours,
but gold seems to be restricted to this gem.

OLD WIFE SIZE 12 INCHES (30.48CM).
SIZE OF THE EYE ¼ INCH (0.76CM)

KANGAROO ISLAND, SOUTH AUSTRALIA; 50 FEET (15.2M) DEEP.

The Old Wife is a common species either in schools or pairs. It is the only member of a family endemic to the temperate waters of southern Australia.

Fish eyes are fabulous and many fish have superb vision. Fish eyes function very like our own; they have a cornea and lens for focusing light on to the retina. The retina is composed of photoreceptors (rods and cones) which absorb light and transform it into neural signals.

The rods help fish to see in low light conditions and the cones give them daytime vision. Just like us their visual acuity or ability to see is determined by the "graininess" of their retina and the pigments in their rods and cones.

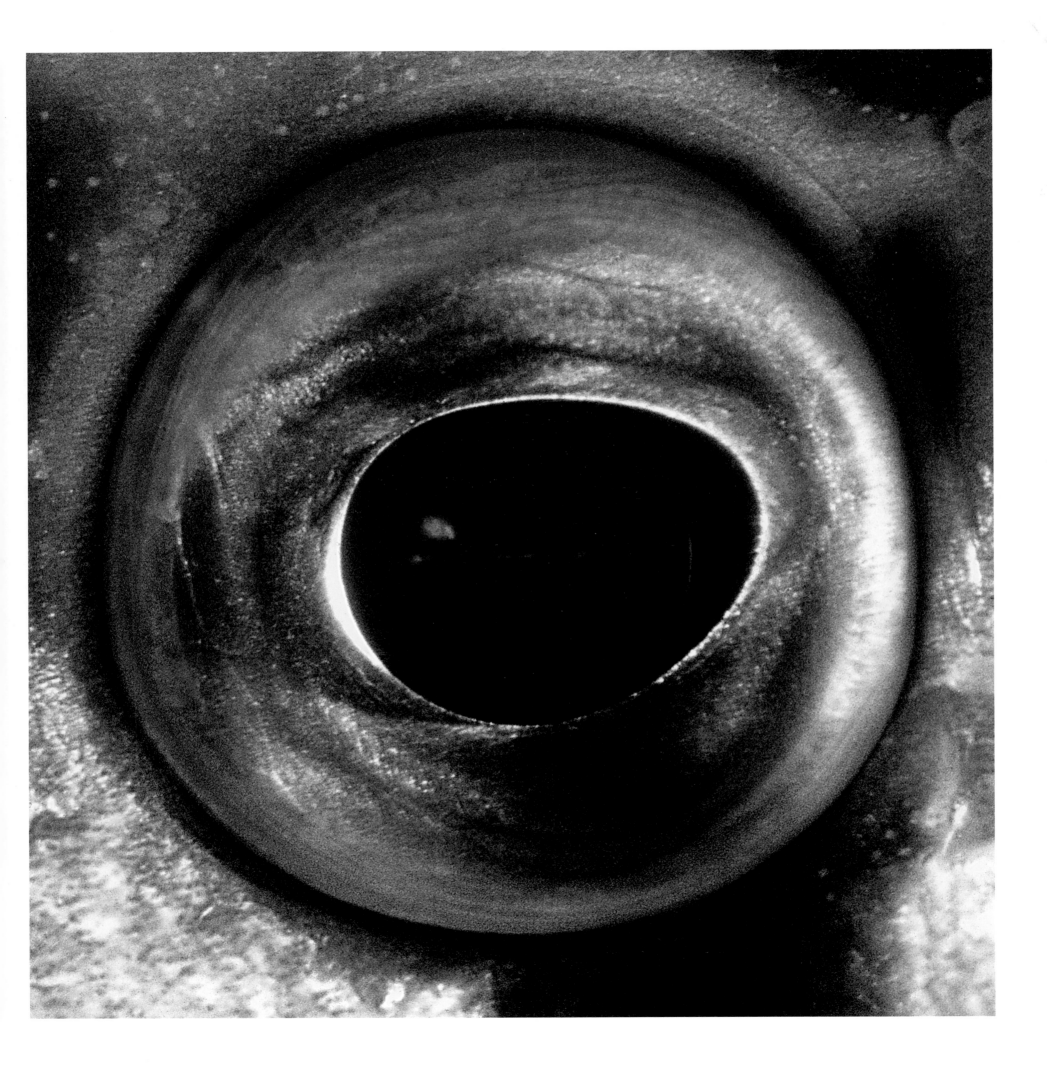

COMMENSAL SHRIMP IN A SOFT CORAL
Periclimenes psamathe | Dendronephthya sp.

SHRIMP SIZE ³/₄ INCH (2.03CM).
PICTURE SIZE 2 INCHES (5.08CM).

SIMILAN ISLANDS, THAILAND; 45 FEET (13.7M) DEEP.

During a night dive in a sheltered bay of the Similan Islands, I found this rare shrimp. This tiny animal is very well camouflaged; the body is transparent and the red stripe on its side has the same colour as the soft coral it lives in.

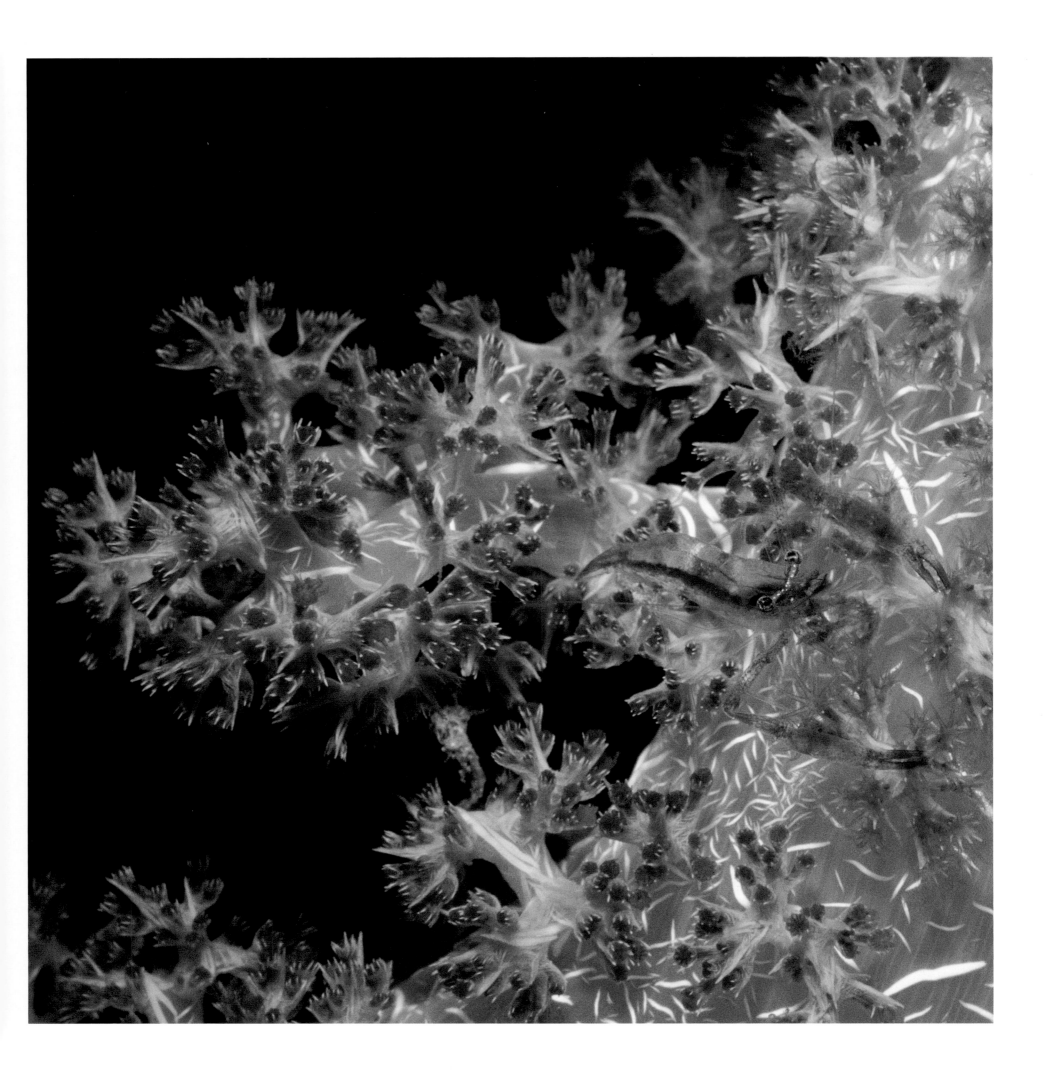

VARICOSE WART SLUG
Phyllidia varicosa

SLUG SIZE 3 INCHES (7.72CM).
DETAIL SIZE $3/4$ INCH (2.03CM).

SHARM EL SHEIKH, RED SEA, EGYPT; 90 FEET (27.4M) DEEP.

A member of the nudibranch species, this wart slug
is a master of chemical defence. In a stress situation
it will produce a strong poison. There is not even one
marine organism that will eat this slug!

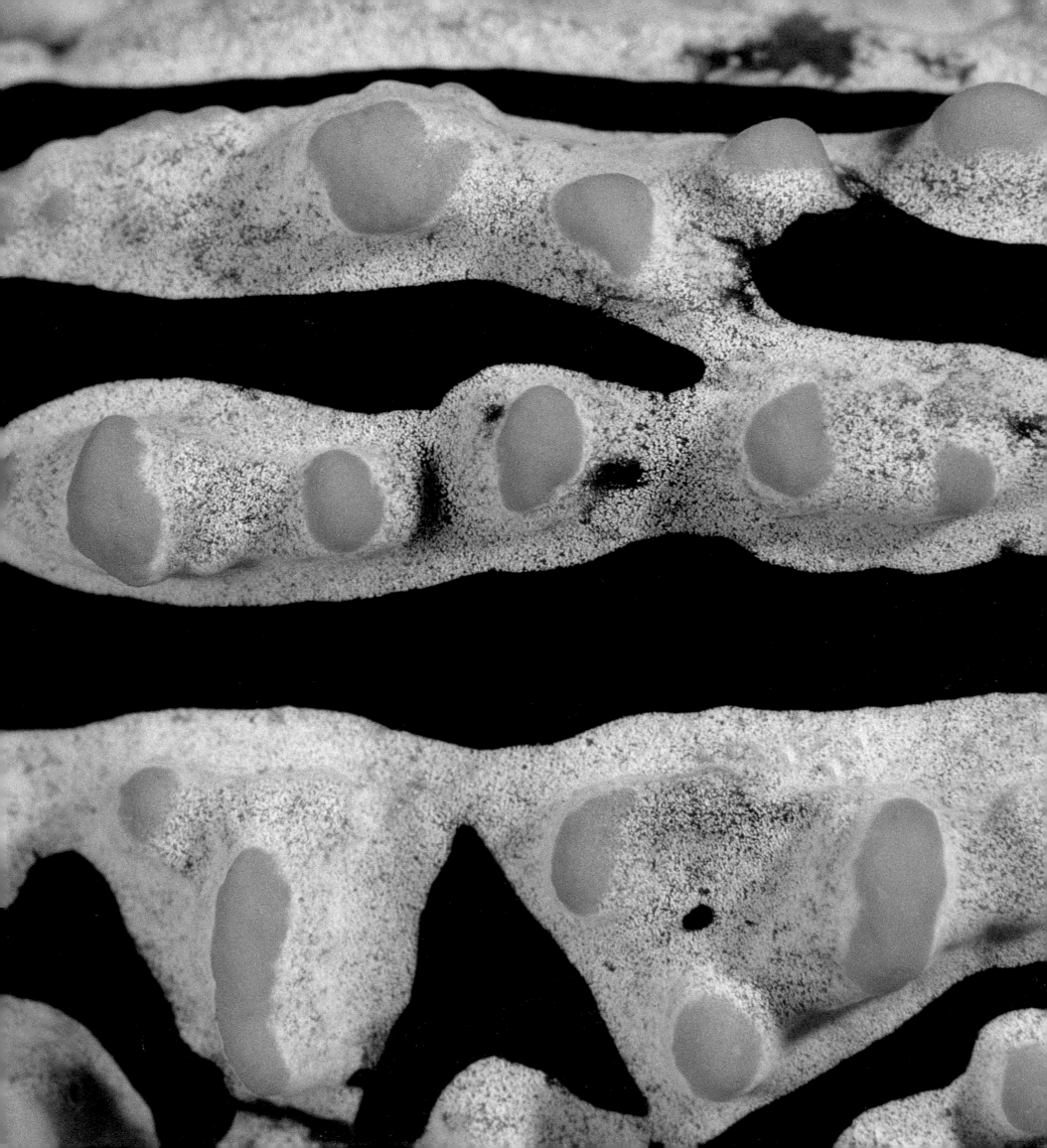

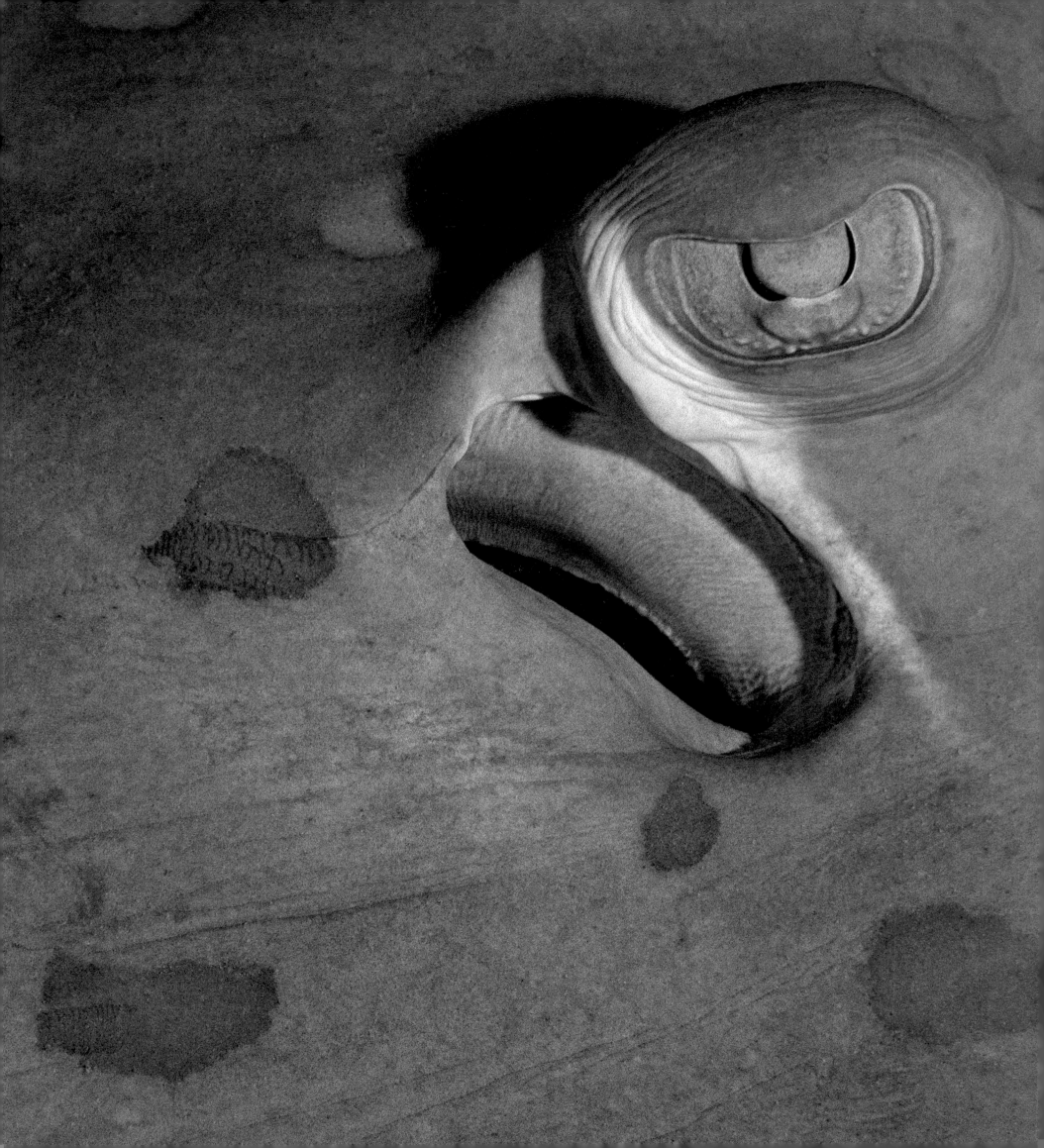

◂ **DETAIL WITH EYE OF A BLUESPOTTED STINGRAY**
Taeniura lymma

STINGRAY SIZE 2 FEET (60.96CM) INCLUDING TAIL.
DETAIL SIZE 2½ INCHES (6.35CM).

MARSA ALAM, RED SEA, EGYPT; 70 FEET (21.3M) DEEP.

During the day, this nocturnal animal can be found sleeping under ledges, or in the sand. It takes in water through the hole behind the eye, and the water leaves the body through the gill openings on its belly. Its food consists of hermit crabs, shrimp and worms living on the sandy bottom.

▾ **STONY CORAL WITH POLYPS RETRACTED**
Favia sp.

CORALLITE SIZE ¾ INCH (1.78CM).
PICTURE SIZE 1½ INCHES (3.81CM).

MARSA ALAM, RED SEA, EGYPT; 60 FEET (18.3M) DEEP.

Corals come in a huge variety of colours, textures and structures. Over 3,000 species have been described, but many more exist. Very often – as with this species – one can only tell to which family the species belongs: many corals of the same species exist in somewhat different colours and shapes.

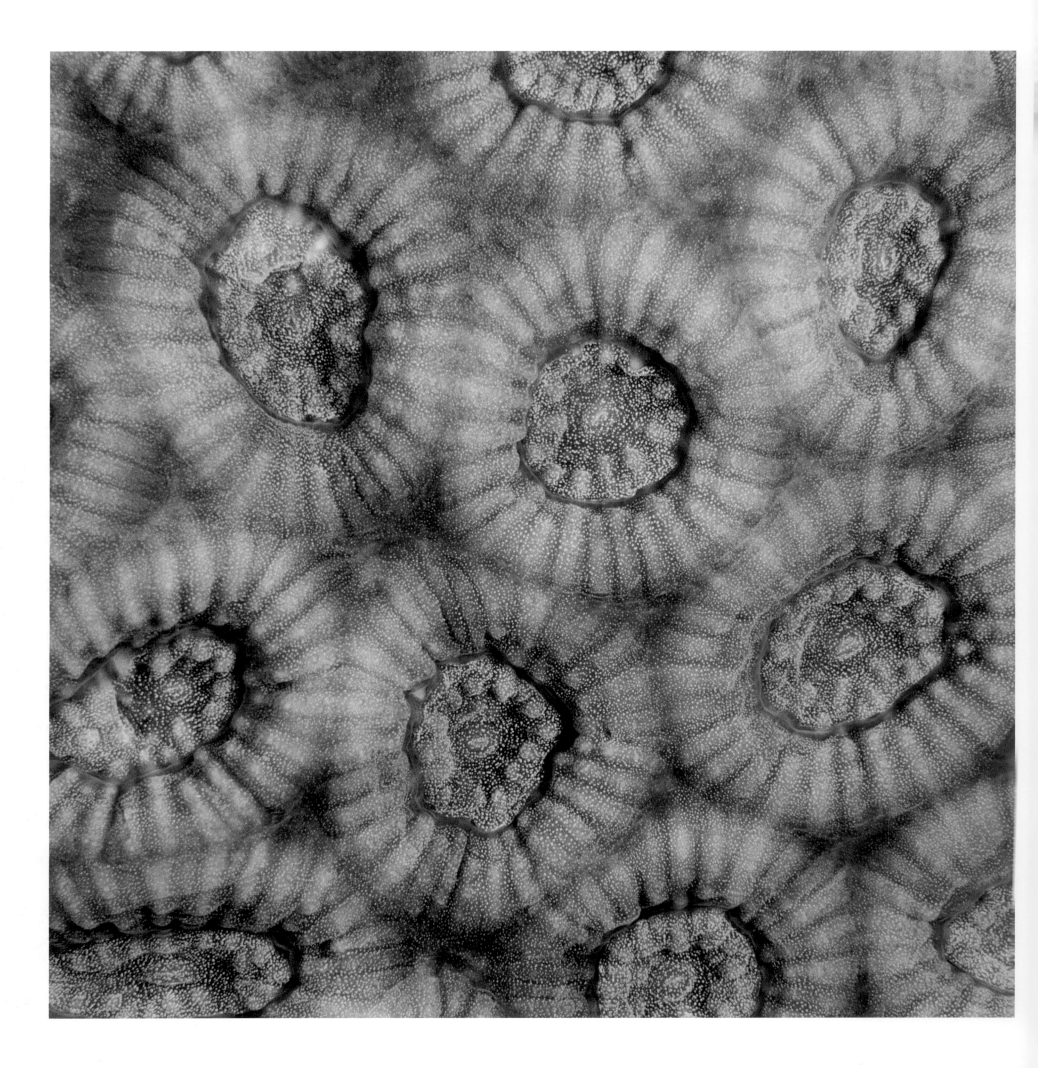

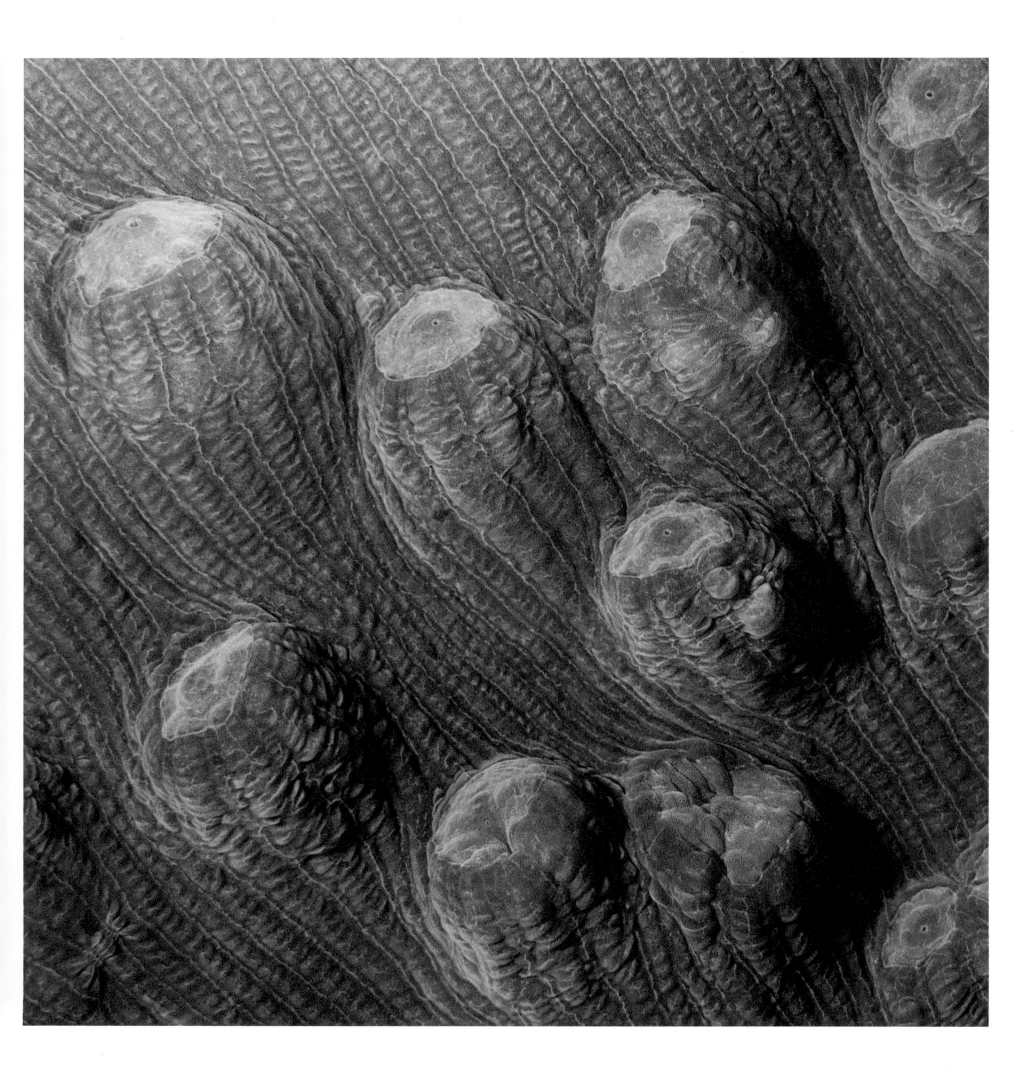

The colour of corals is caused by single-celled algae (*zooxanthellae*) living in the polyps' tissue. In order to produce carbon enriched organic matter – the most important food for corals – these algae use sunlight and carbon dioxide. Without the algae corals cannot survive. However, continuing high water temperature may cause the algae's death, revealing the white colour of the corals' skeleton (coral bleaching).

This beautiful, almost completely transparent shrimp lives in symbiosis with sea anemones and Bubble Coral. They belong to the family of cleaner shrimp which wave with their antennae to advertise to passing fish that they are ready to remove parasites and damaged skin from the fish. This Anemone Coral is the biggest one-polyp coral in the world.

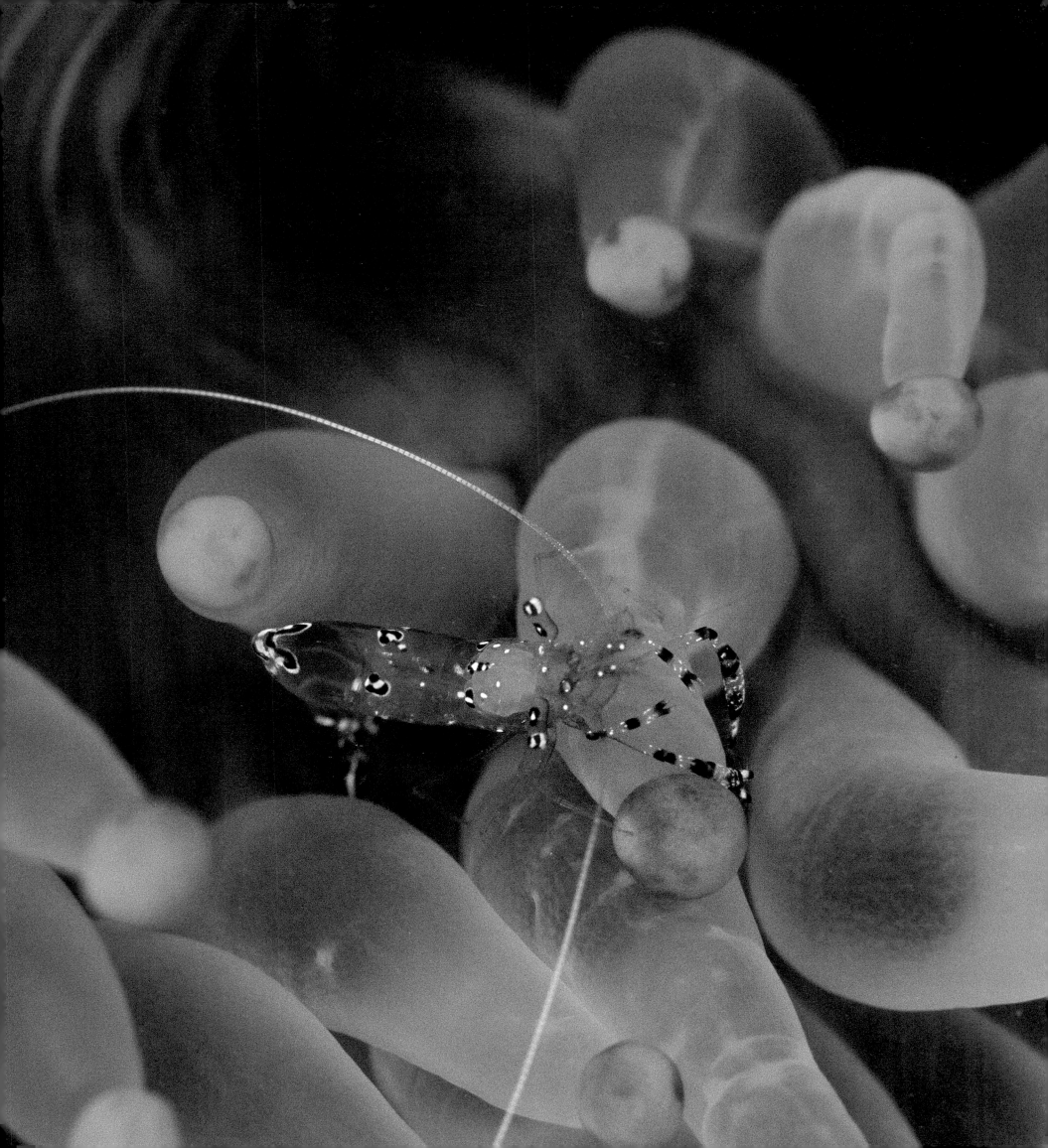

**MOZAMBIQUE HOST GOBY OR COMMON GHOST GOBY
IN A SOFT CORAL**
Pleurosicya mossambica | *Dendronephthya* sp.

GOBY SIZE ³/₄ INCH (1.78CM) (HEAD ONLY ¹/₈ INCH – 0.25CM).
PICTURE SIZE 1¹/₂ INCHES (3.81CM).

LEMBEH STRAIT, NORTH SULAWESI, INDONESIA; 60 FEET (18.3M) DEEP.

Twice daily a strong current sweeps through Lembeh
Strait. Under those conditions I tried to photograph
a small camouflaged crab in a soft coral, and this tiny
fish appeared before my lens.

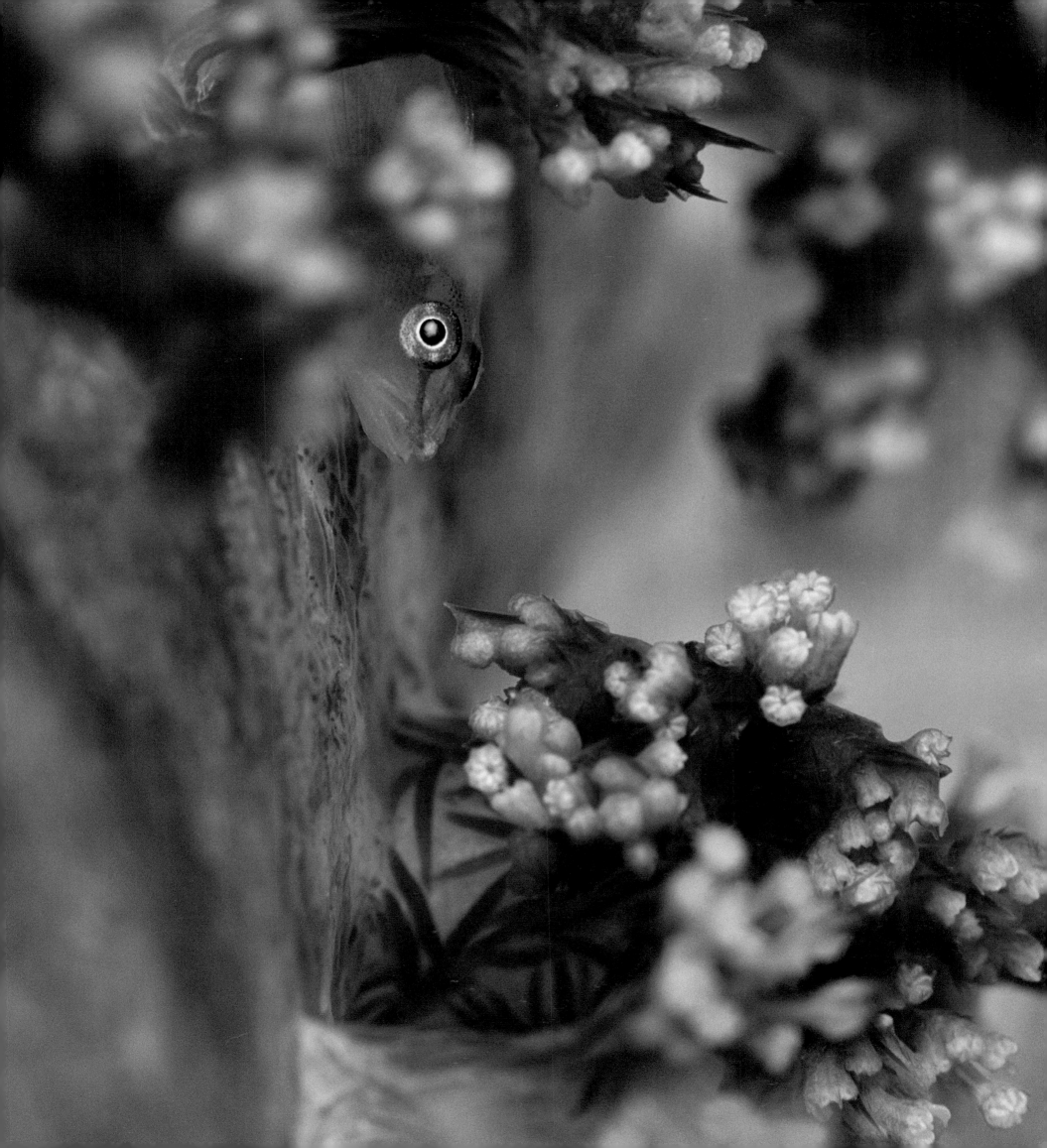

This goby often appears on corals, anemones and clams. Here it is hosted by a very rare green anemone-like *Corallimorph*. The little fish lives on the spillover from the *Corallimorph's* meals.

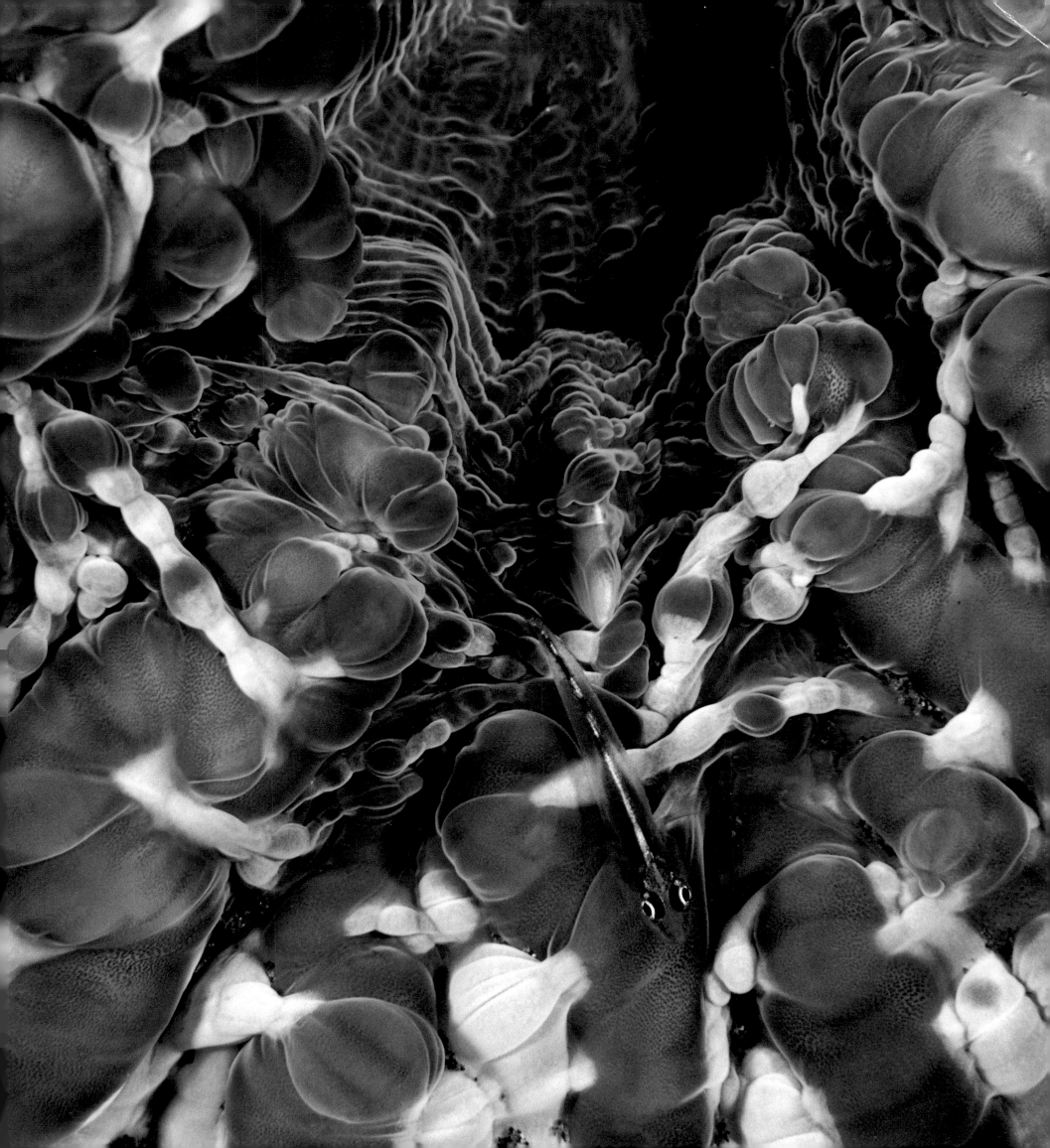

DETAIL OF A TUBE ANEMONE
Cerianthus sp. *or Pachycerianthus* sp.

ANEMONE SIZE 4 INCHES (10.16CM).
DETAIL SIZE 1¹/₂ INCHES (3.81CM).

MABUL ISLAND, SULAWESI SEA, MALAYSIA; 20 FEET (6.1M) DEEP.

There are many different members of the *Cerianthidae*
family. They can be recognised by the double wreath
of tentacles. The outside wreath catches the food
and transports it to the inner tentacles, which in turn
transport the food to the mouth. Exact identification
is only possible by dissection. Tube Anemones live in
a tube built in sand or rubble. Most species of this family
are nocturnal, but I found this one during a midday dive.

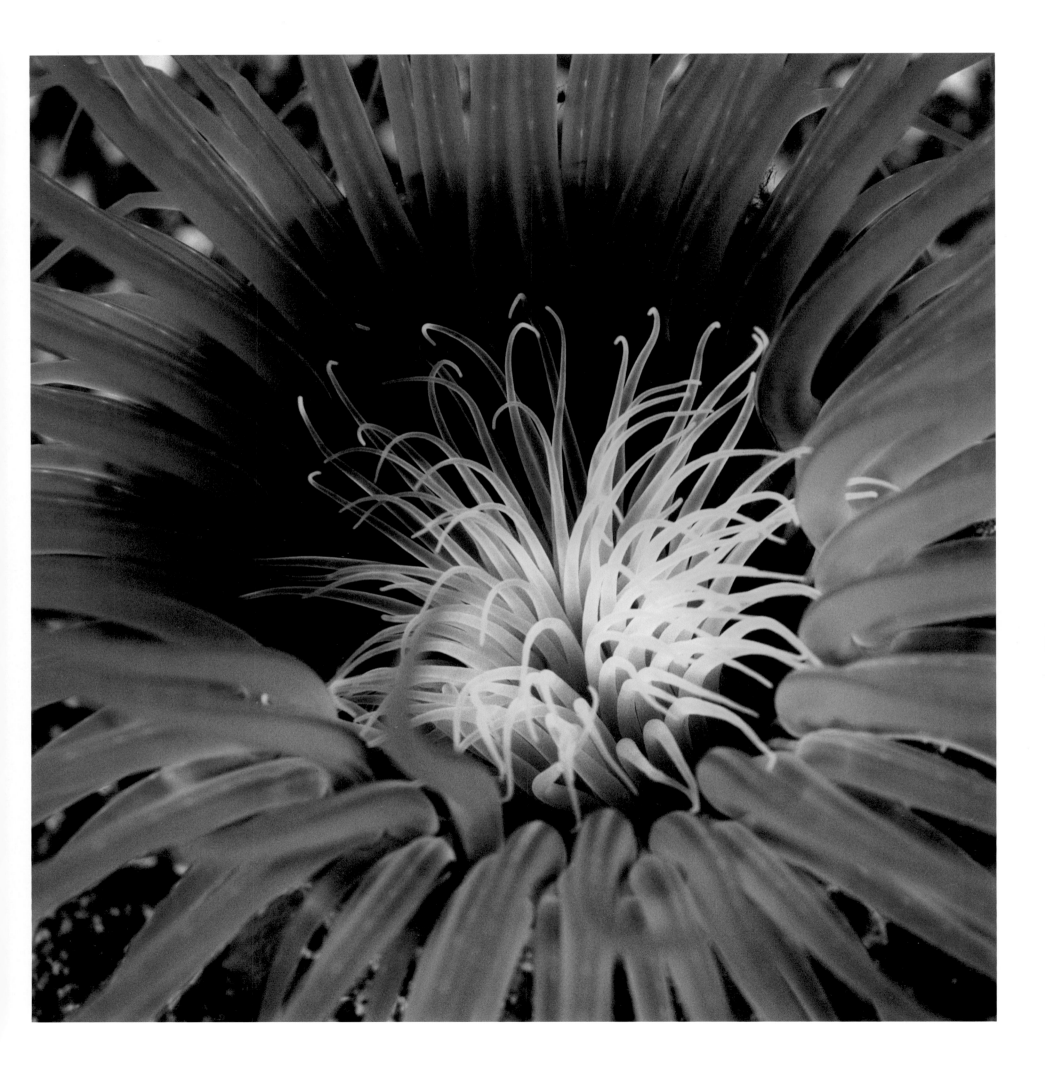

DETAIL OF THE PECTORAL FIN OF A QUEEN ANGELFISH
Holacanthus ciliaris

ANGELFISH SIZE 16 (40.64CM) INCHES.
DETAIL SIZE 1 INCH (2.54CM).

BONAIRE, NETHERLANDS ANTILLES, CARIBBEAN; 40 FEET (12.2M) DEEP.

This beautiful blue spot can be found on the base of the pectoral fin of the adult Queen Angelfish. The colour combinations of juveniles differ from those of fully-developed animals. The lips of a baby fish, for example, are yellow, while those of a fully-grown animal are blue.

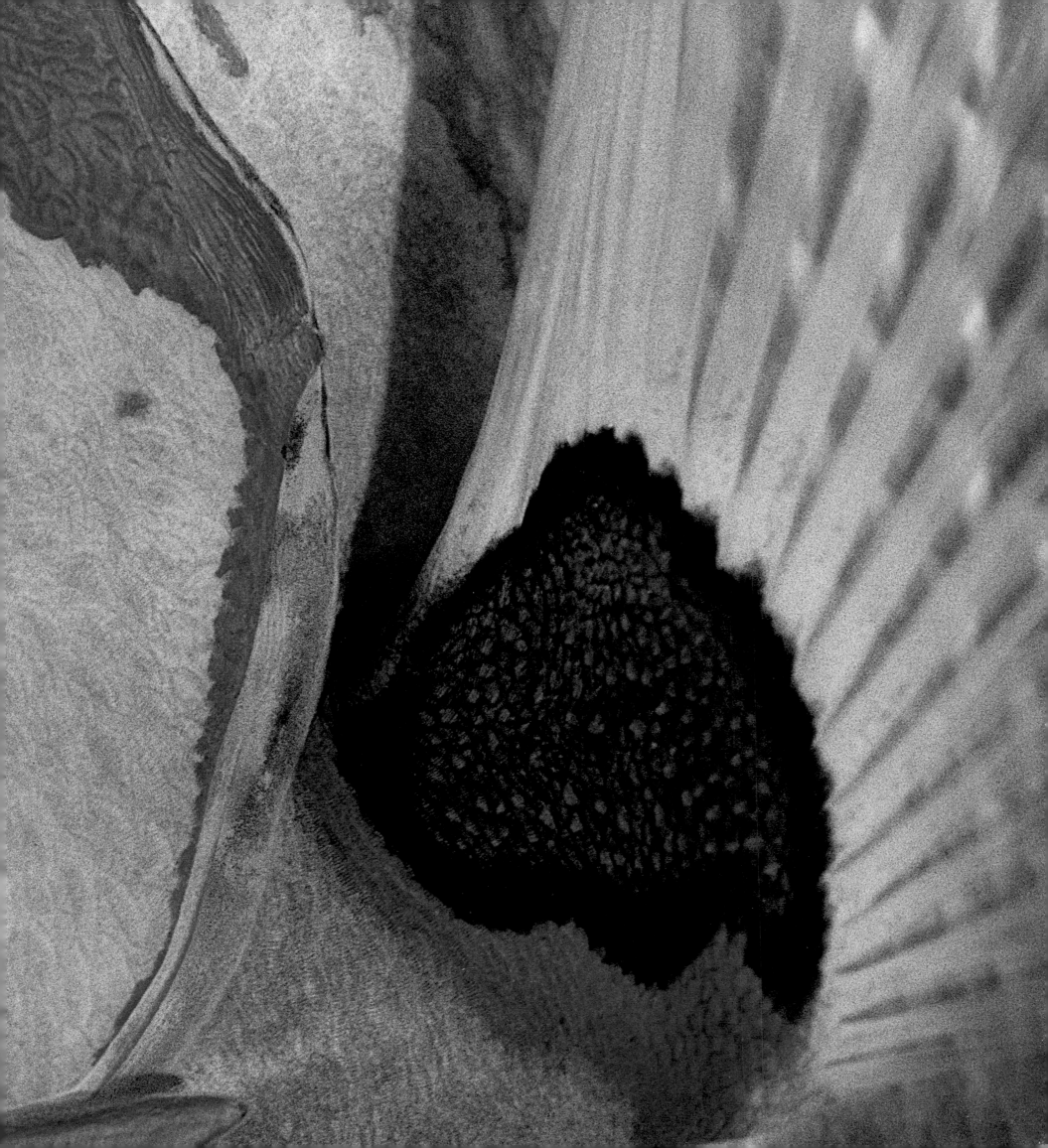

MOZAMBIQUE HOST GOBY OR COMMON GHOST GOBY
ON STONY CORAL
Pleurosicya mossambica | *Favites* sp.

GOBY SIZE ¼ INCH (0.76CM).
PICTURE SIZE 1 INCH (2.54CM).

MARSA ALAM, RED SEA, EGYPT; 65 FEET (19.8M) DEEP.

Mozambique Host Gobies can reach a size of
1 inch (2.54cm), so this must be a juvenile. This species
lives a solitary life, until mating, and thereafter, when
the male and the female take turns in guarding
the eggs which are laid on hard or soft corals.

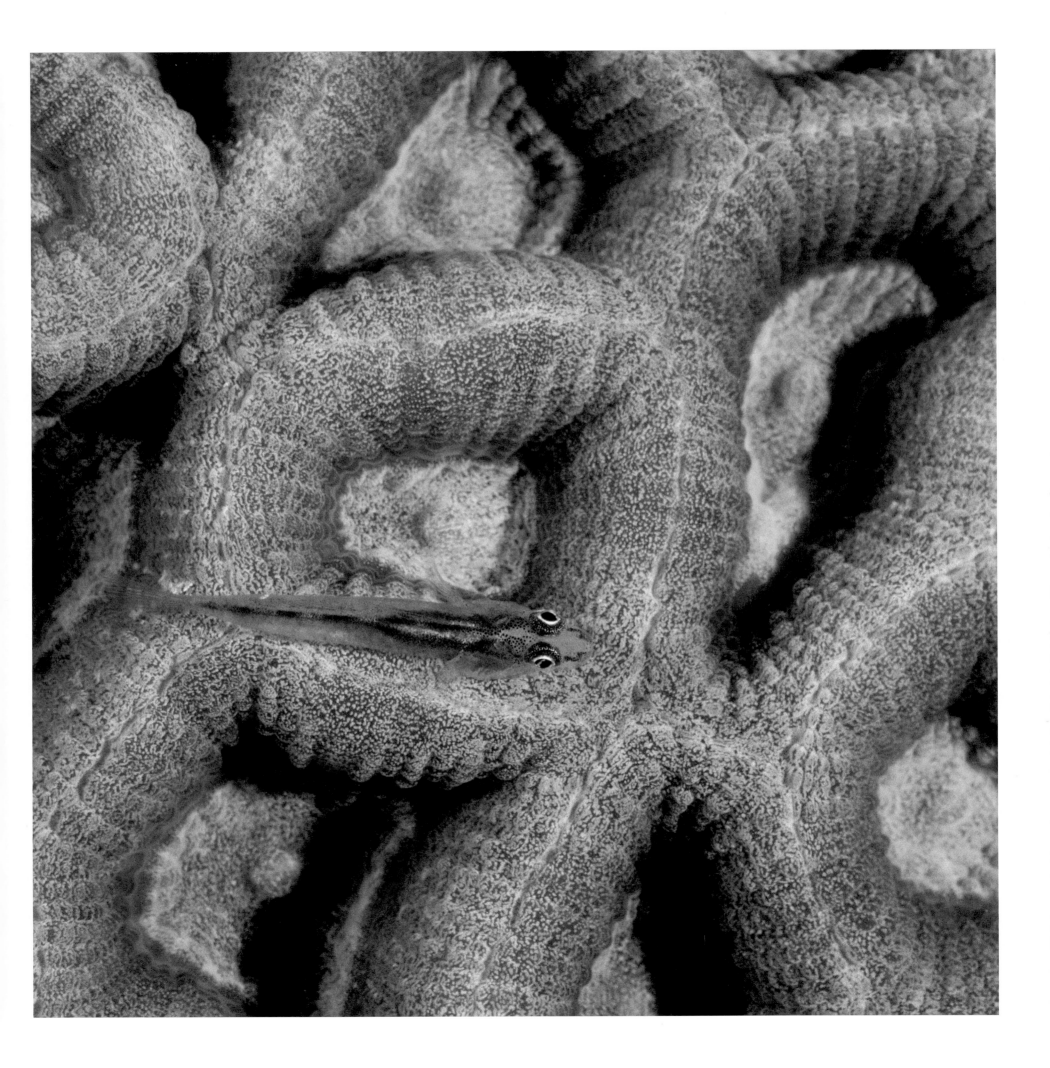

DETAIL OF A FEATHERSTAR OR CRINOID
Oxycomanthus bennetti

CRINOID SIZE 12 INCHES (30.48CM).
DETAIL SIZE 2½ INCHES (6.35CM).

MILNE BAY, PAPUA NEW GUINEA; 16 FEET (4.9M) DEEP.

Milne Bay is one of the best spots for "muck diving". Quite regularly, solitary Crinoids can be found on the muddy bottom. To me, the diversity of commensals living with them, such as tiny Clingfish and Crinoid Shrimp, makes them interesting.

Echinoderms' bodies are segmented into five frogs which can be clearly seen in starfish and sea urchins. Their "legs", known as *cirren,* are located under their rather flat and round body or calyx, measuring no more than 2 inches (5 centimetres). Five arms or multiples thereof originate from the top of the calyx and the mouth is situated in its centre.

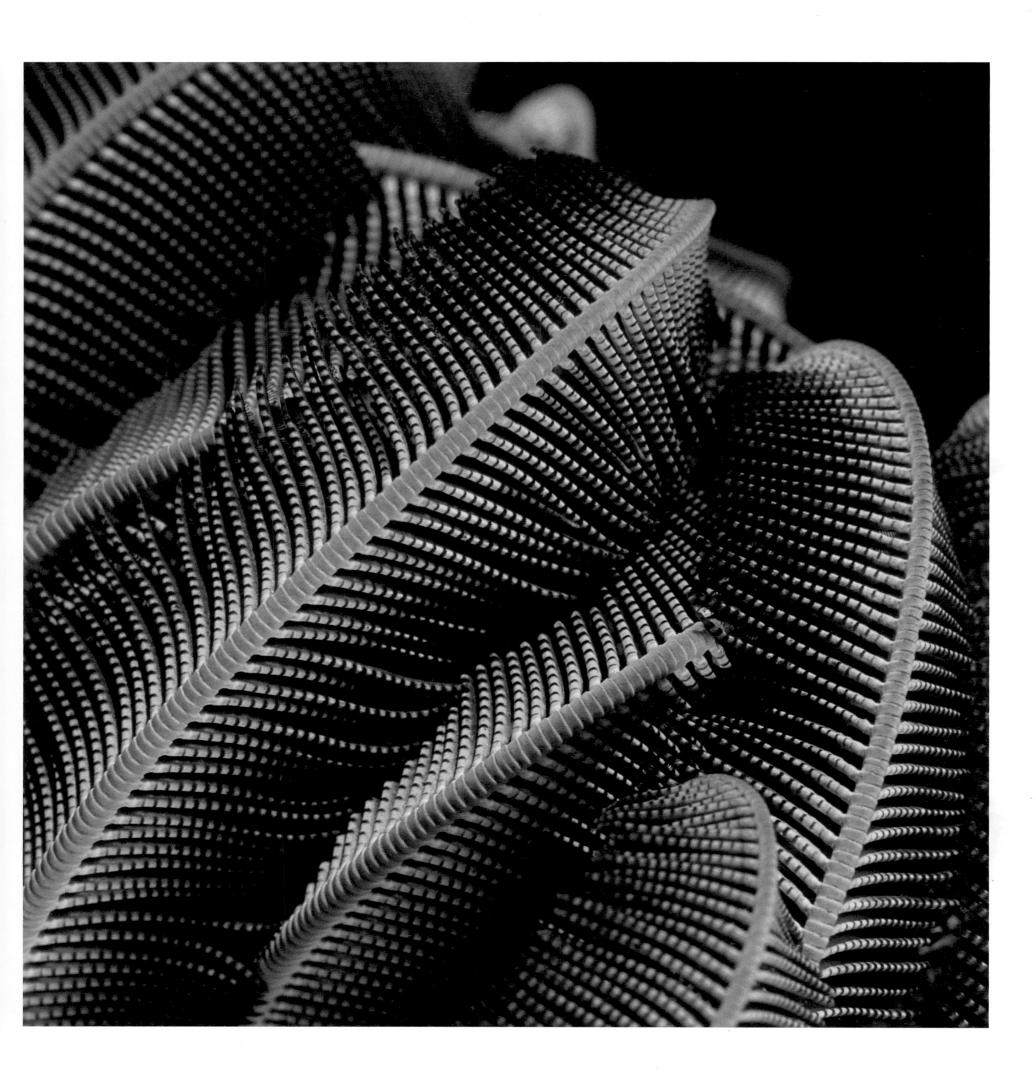

SHRIMP SIZE ½ INCH (1.27CM).
PICTURE SIZE 2 INCHES (50.08CM).

KOMODO NATIONAL PARK, INDONESIA; 90 FEET (27.4M) DEEP.

Exactly why this shrimp has a symbiotic relationship with the Bubble Coral is unknown. It has probably entirely adapted its way of life to the coral's shape. As a Stone Coral it shows these water-filled bubbles during the day, whereas it displays its polyps at night.

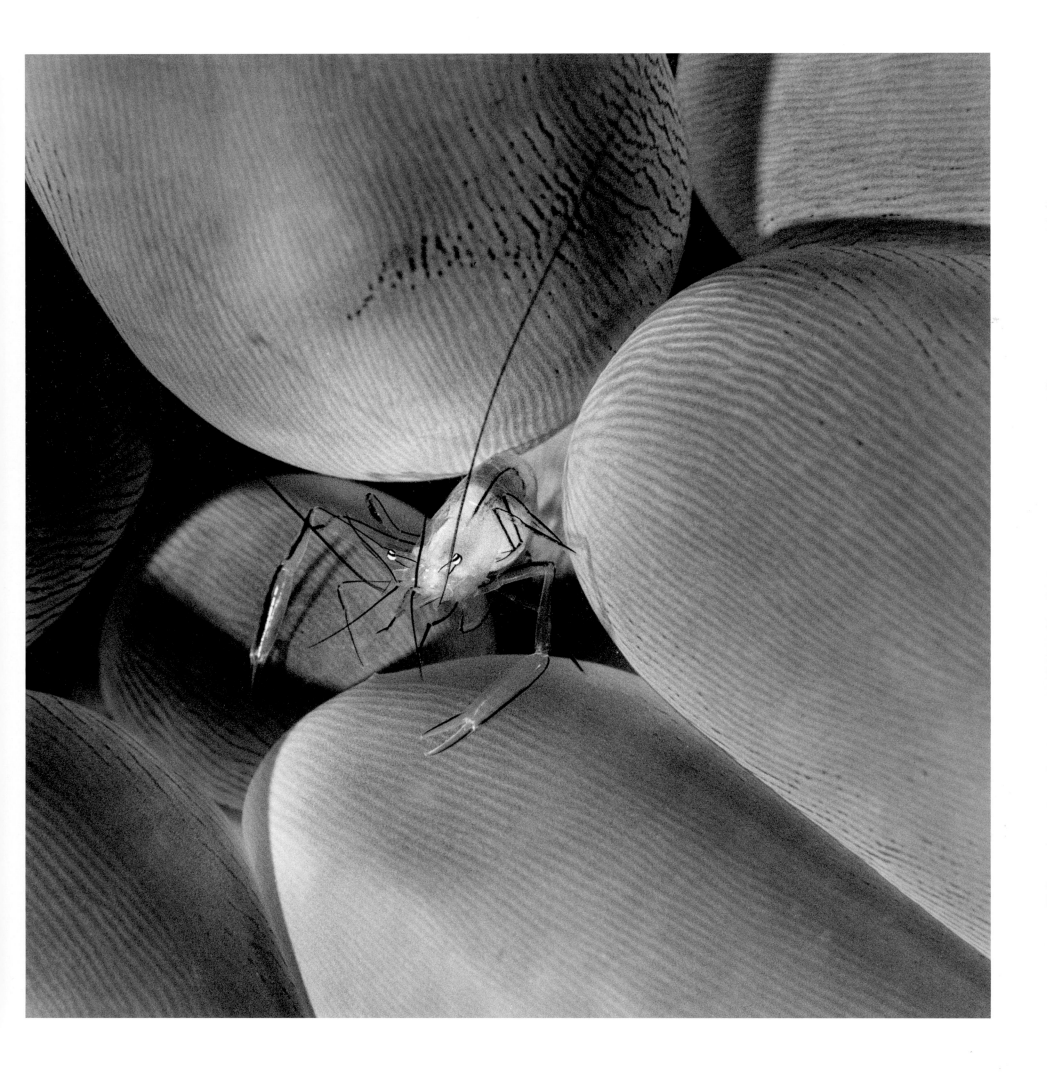

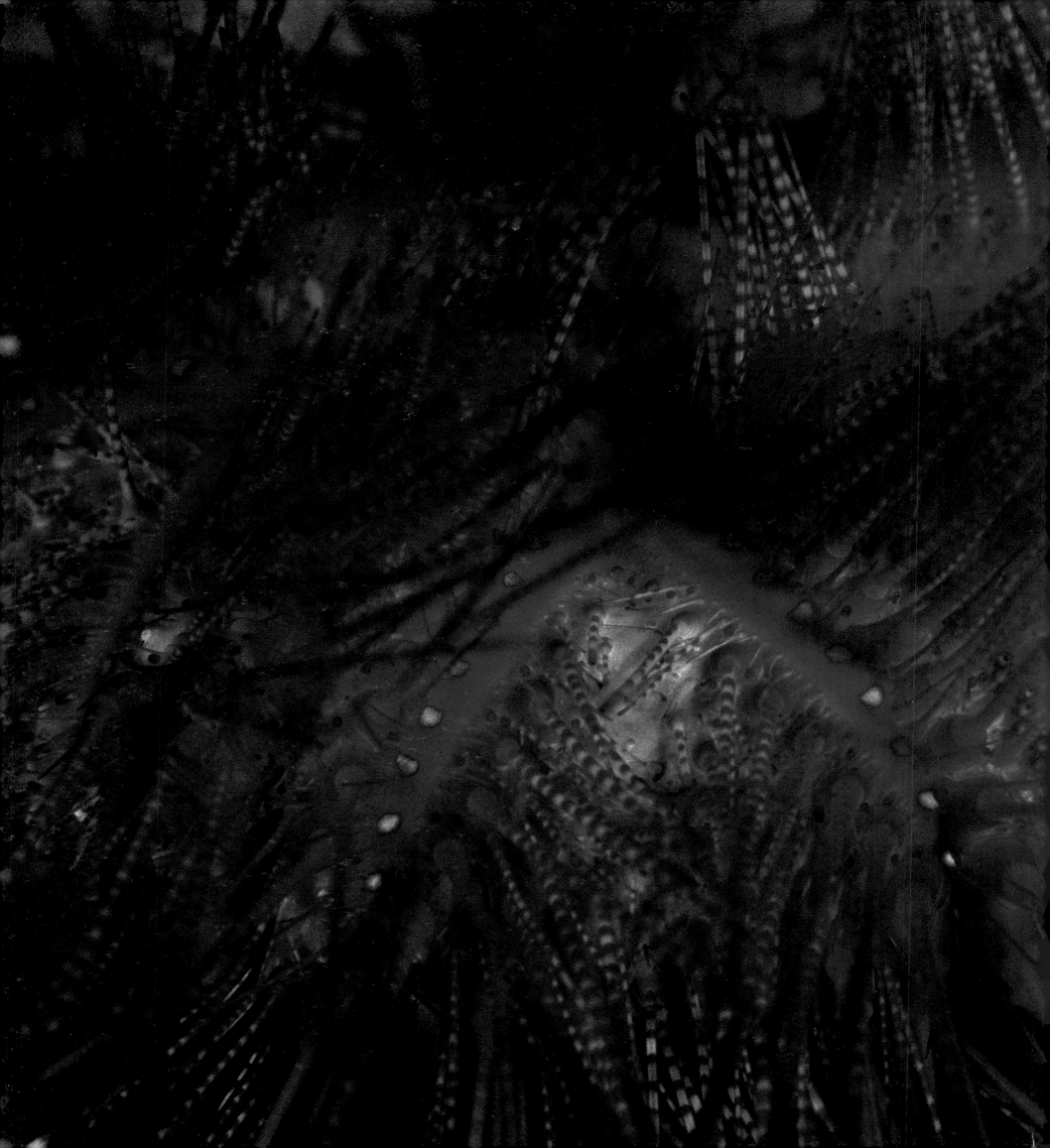

SEA URCHIN SIZE 3 INCHES (7.64CM), JUVENILE; AN ADULT CAN GET
AS BIG AS 8 INCHES (20.32CM).
DETAIL SIZE 1 INCH (2.54CM).

LEMBEH STRAIT, NORTH SULAWESI, INDONESIA; 26 FEET (7.9M) DEEP.

During a night dive I was taking pictures of the beautiful blue spots of this Diadema Sea Urchin, when suddenly it moved very quickly over a distance of approximately 3 feet (1 metre). There was no current and I did not understand how this was possible. I started photographing again and then the same thing happened. Was I witnessing a miracle? The fastest sea urchin in the world? Then I had a very good look and found out that the sea urchin was on top of a crab, a so-called Carrier Crab, which uses the sea urchin for camouflage and protection…!

TRUMPETFISH SIZE 2 FEET (60.96CM).
SIZE OF THE EYE ¼ INCH (0.76CM).

BONAIRE, NETHERLANDS ANTILLES, CARIBBEAN; 32 FEET (9.8M) DEEP.

Like chameleons, Trumpetfish can adapt their colours
to the environment. Strangely enough, their eyes change
colour as well. This fish and its eye had a silvery reddish
brown colour just before I came really close. Not only do
Trumpetfish change colours, they also can stand vertically
between sea rods without moving, making it easier to
approach their prey.

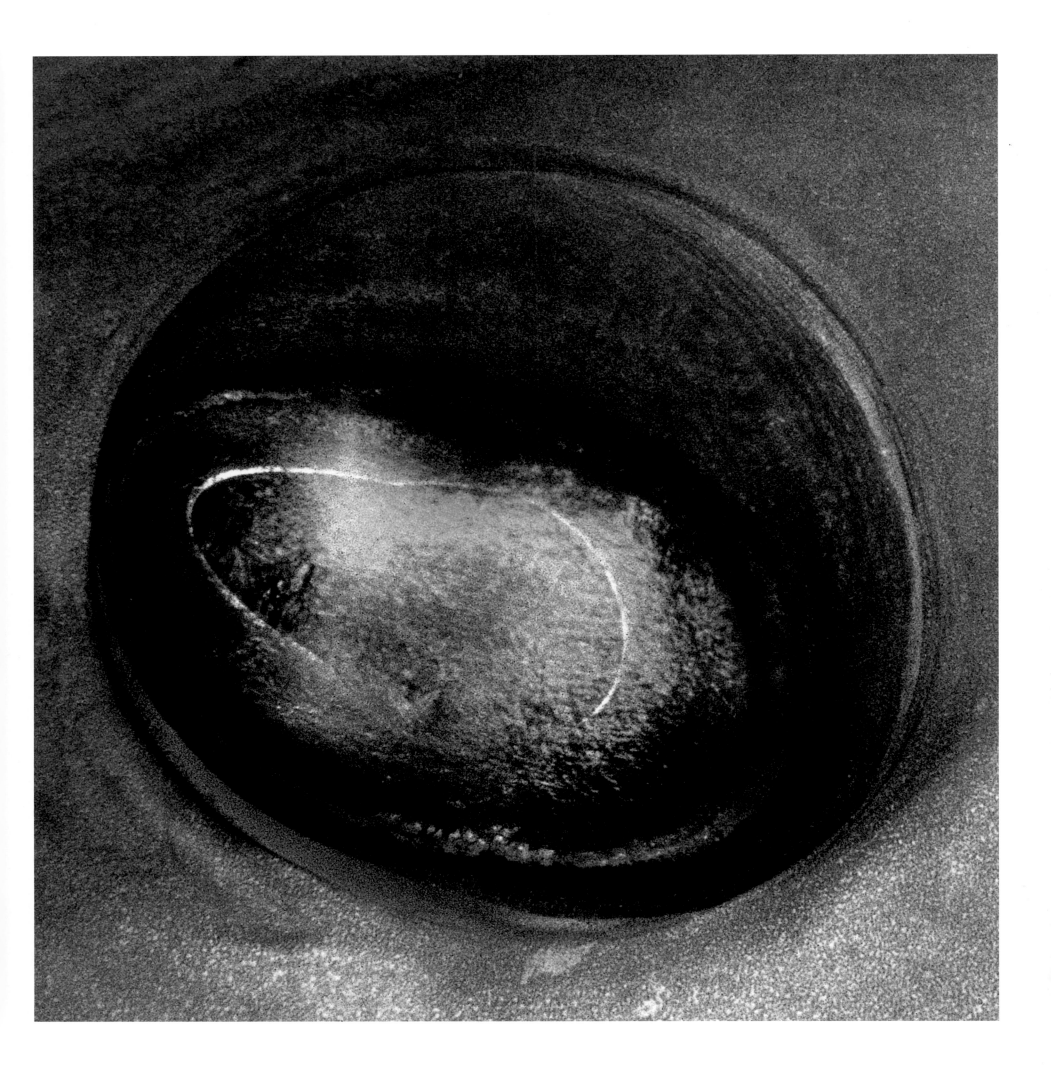

As a bottom dweller, the Flying Gurnard "walks"
on its ventral fins over the sandy bottom looking for food.
Only when swimming will it spread out its pectoral fins
like wings. This fish can pale or darken dramatically.

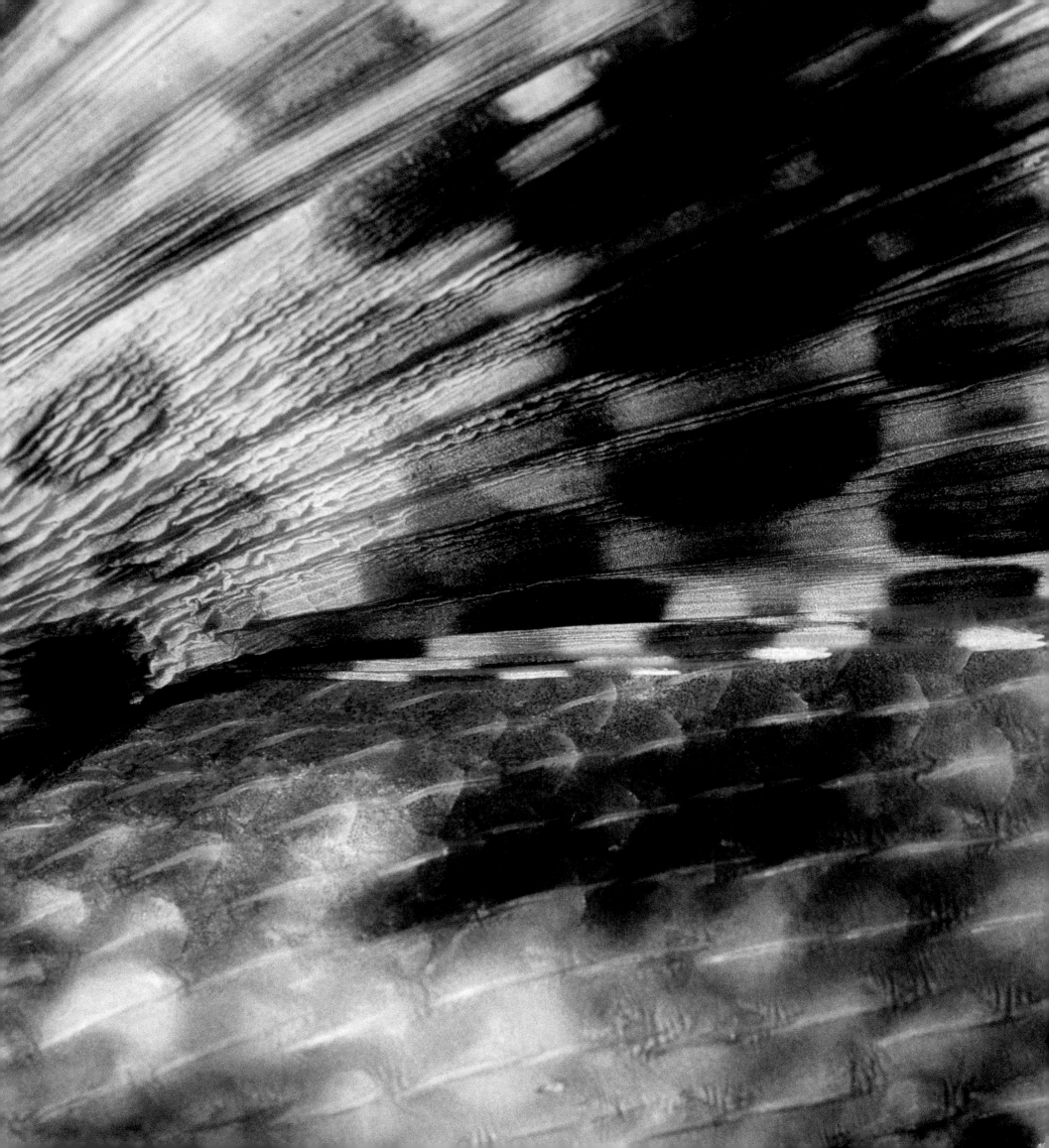

FIREFISH SIZE 8 INCHES (20.32CM).

DETAIL SIZE 2½ INCHES (6.35CM).

LEMBEH STRAIT, NORTH SULAWESI, INDONESIA; 3 (1M) FEET DEEP.

Just in front of the Kungkungan Bay Resort at a depth of only 3 feet (1 metre), I almost stepped on this beautiful member of the scorpionfish family while I was putting my fins on. It let me come so close that I could take beautiful pictures of its face and pectoral fin.

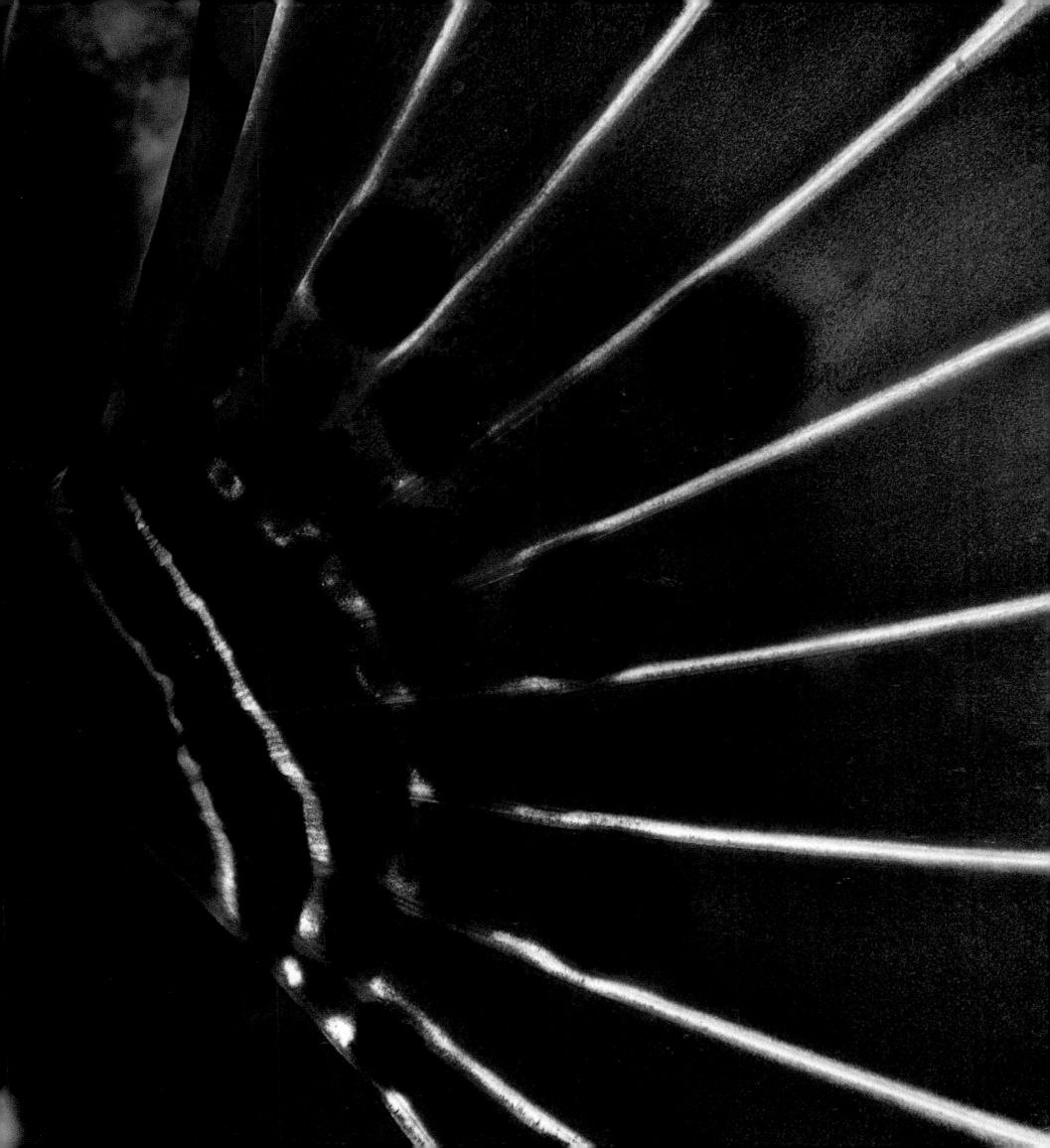

PARROTFISH SIZE 2 FEET 6 INCHES (76.2CM).
DETAIL SIZE 1$\frac{1}{2}$ INCHES (3.81CM).

MARSA ALAM, RED SEA, EGYPT; 30 FEET (9.1M) DEEP.

During a night dive, I found this adult male Bicolor Parrotfish hiding in a small cave in a coral formation. I could not see its head or its tail, but the part I saw was beautiful enough to warrant a picture. This is a detail of the body and anal fin. The dark blue female with a broad yellow line just below the dorsal fin looks completely different from the male.

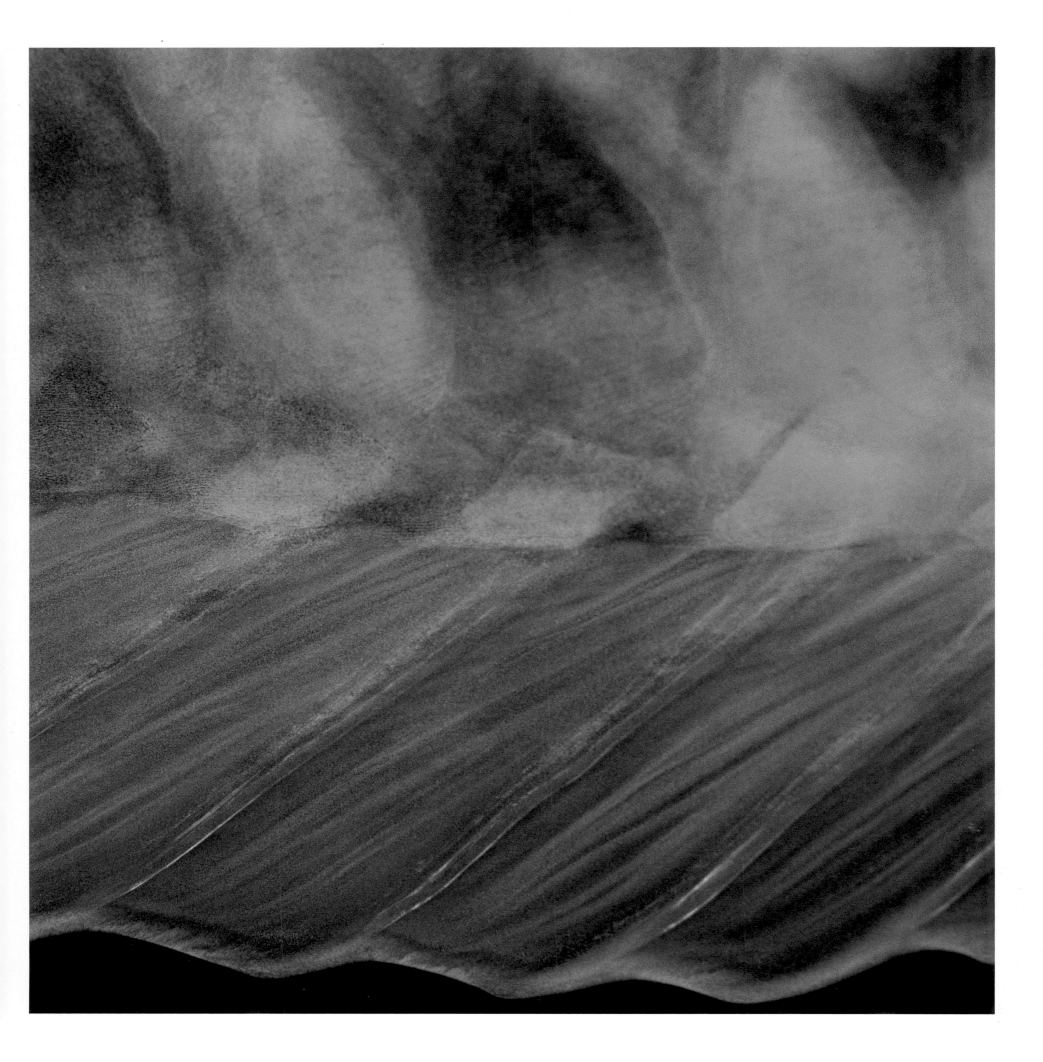

JELLYFISH SIZE 3 FEET (1M) INCLUDING TENTACLES.
PICTURE SIZE 4 INCHES (10.16CM).

KANGAROO ISLAND, SOUTH AUSTRALIA; 8 FEET (2.4M) DEEP.

My buddy signalled to me that he saw a big shark in the open water, so we swam away from the reef where I was taking pictures of Leafy Sea Dragons. I saw a huge shark getting closer, but suddenly it disappeared. At that moment I discovered this pair of beautiful translucent jellyfish. Their tentacles contain a strong poison.

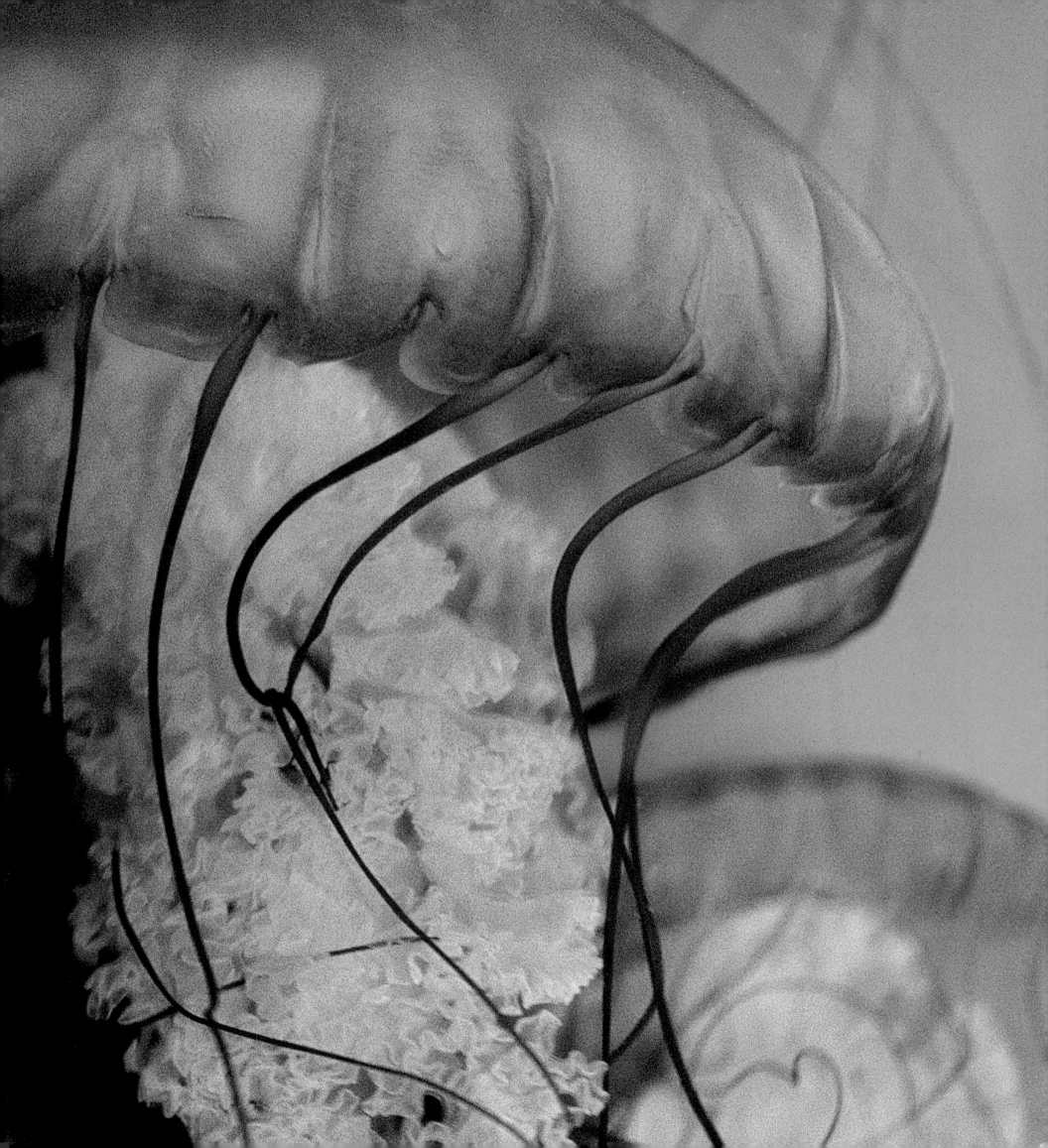

Starfish have fabulous colours, textures and patterns and therefore are ideal subjects for this book. I only found this species once. It was during a late afternoon dive on a beautiful reef with some small patches of sand.
The starfish was grazing on a rock covered with small algae.

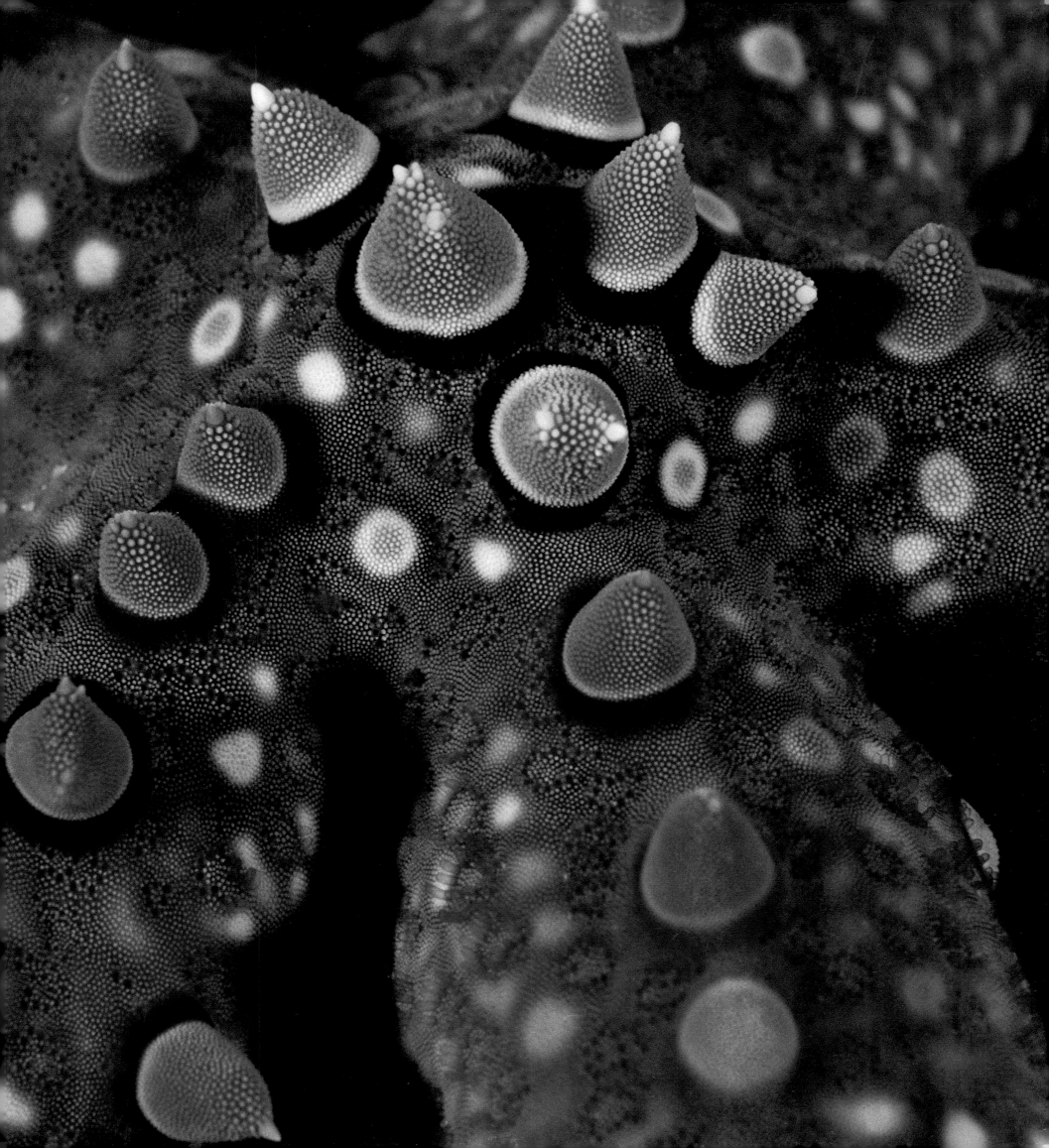

SPINES OF ORANGESPINE UNICORNFISH
Naso elegans

UNICORN FISH SIZE 18 INCHES (45.72CM).
DETAIL SIZE 3 INCHES (7.62CM).

MARSA ALAM, RED SEA, EGYPT; 65 FEET (19.8M) DEEP.

In spite of its name, this fish lacks the typical "corn" that most other unicorn species have. It belongs to the family of surgeonfish named after the razor sharp spines at the junction of the body and the tail. When attacked, it can inflict severe wounds with these spines.

74

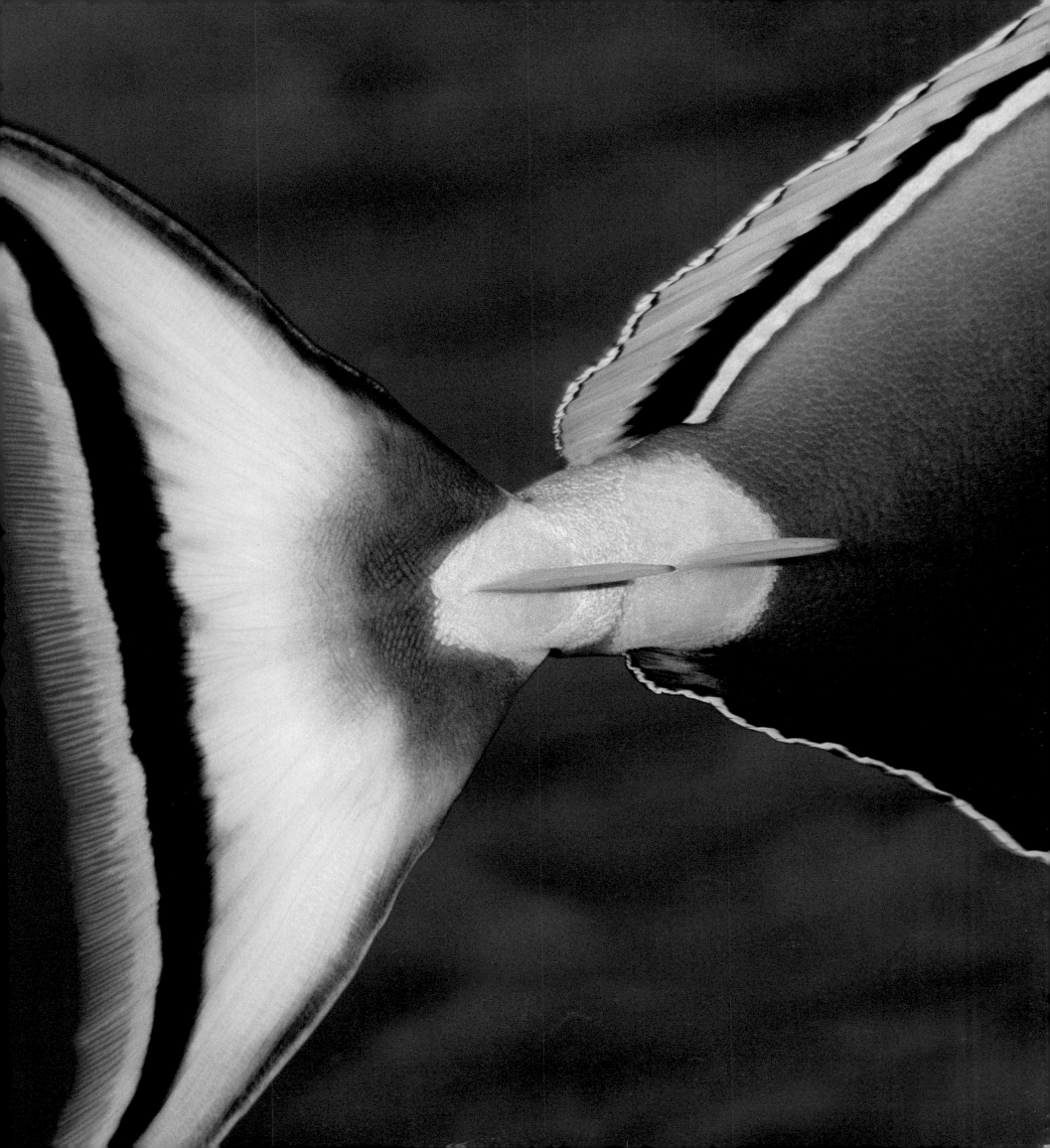

STONY CORAL WITH POLYPS HALFWAY EXTENDED
Favites sp.

CORALLITE SIZE ¹/₂ INCH (1.27CM).
PICTURE SIZE 1¹/₂ INCHES (3.81CM).

MARSA ALAM, RED SEA, EGYPT; 40 FEET (12.2M) DEEP.

Most corals are nocturnal animals. At night they catch plankton and secrete calcium carbonate, with which they form their hard cups, called corallites. Once the tentacles are completely out there is a field of transparent white tipped tentacles, making the corallites invisible.

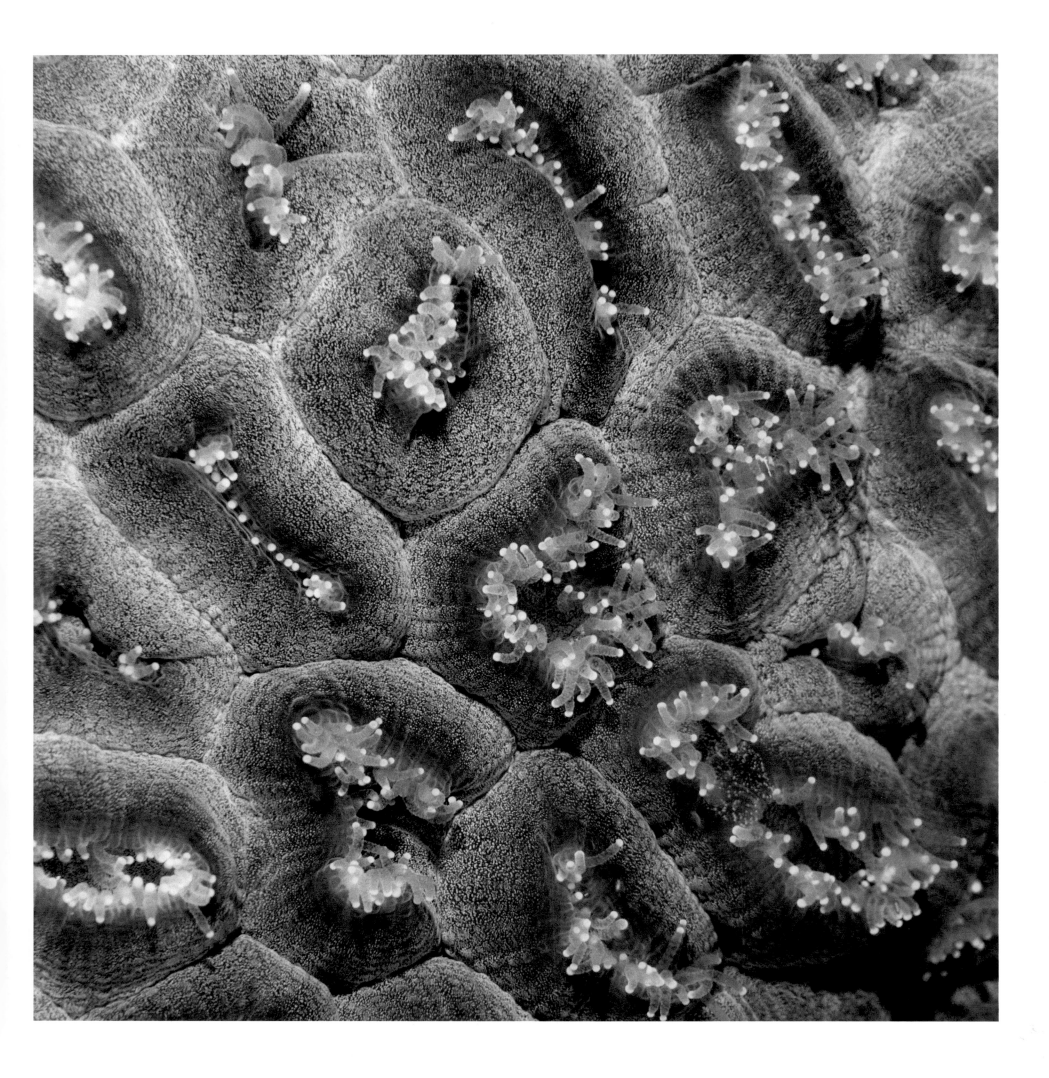

MOZAMBIQUE HOST GOBY OR COMMON GHOST GOBY
ON A GIANT CLAM
Pleurosicya mossambica | Tridacna maxima

GOBY SIZE ³/₄ INCH (2.03CM).
PICTURE SIZE 2¹/₂ INCHES (6.35CM).

SANGALAKI, SULAWESI SEA, INDONESIA; 45 FEET (13.7M) DEEP.

Clams have an unusual special attraction for me because of the endless variations in their colours and structures, and also because of their symbiotic relationship with tiny gobies. Stories of divers or snorkellers who got their feet stuck in a Giant Clam are well-known. Whether they are true, I couldn't say, but they might be. These clams can grow up to 7 feet (2 metres) in width and have powerful constrictors; once the clam is closed, manpower will never be able to open it.

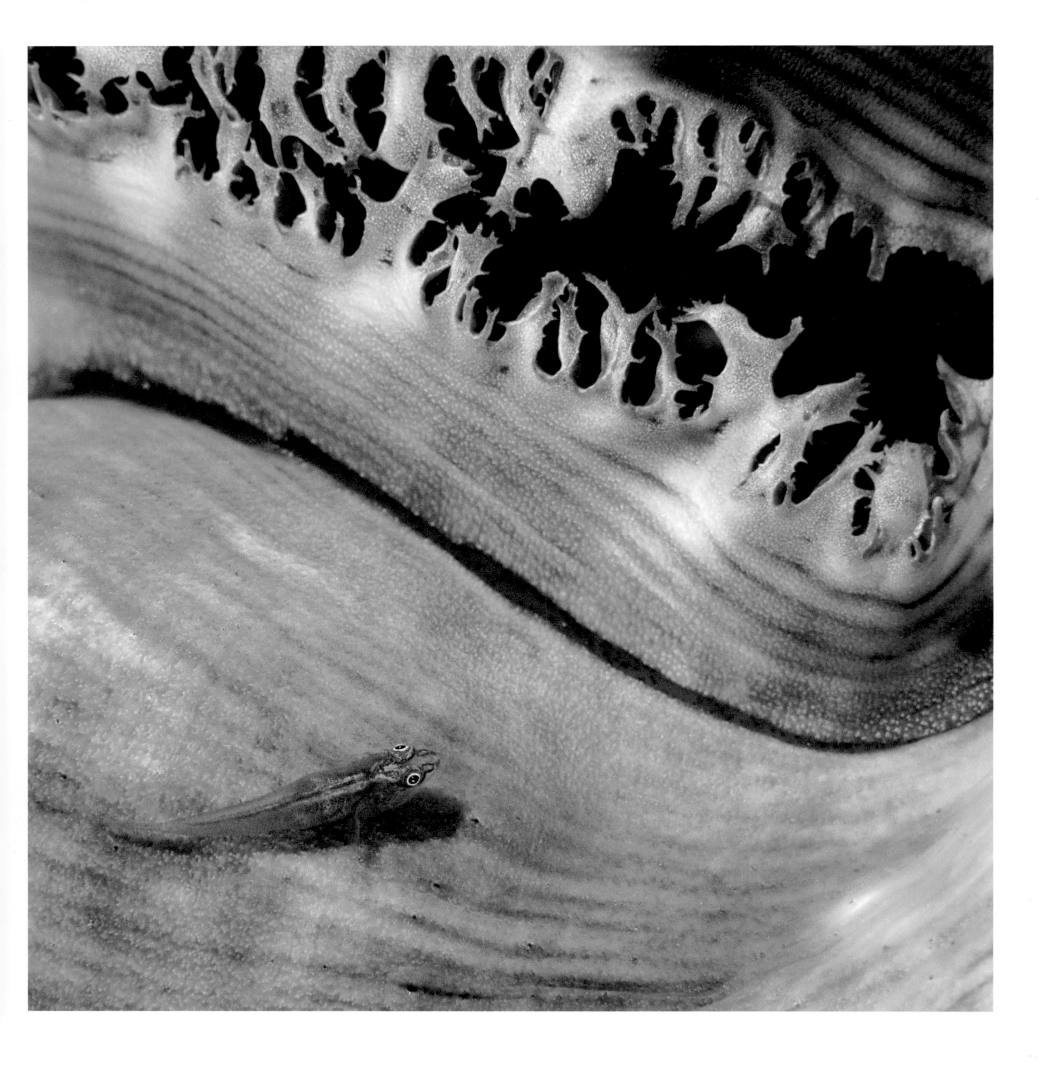

COMMENSAL SHRIMP ON A MAGNIFICENT SEA
ANEMONE MOUTH
Periclimenes tosaensis | Heteractis magnifica

SHRIMP SIZE 1 INCH (2.54CM).
PICTURE SIZE 2 INCHES (5.08CM).

LAYANG-LAYANG ATOLL, SOUTH CHINA SEA, MALAYSIA;
56 FEET (17.1M) DEEP.

Sea anemone mouths can adopt many colours. Usually the mouth is not visible, or only partly so, because it is covered by tentacles. I was in luck when this anemone did me a favour. While I tried my best to make a beautiful composition, my view was suddenly enriched by this transparent little shrimp living in symbiosis with the anemone protecting it.

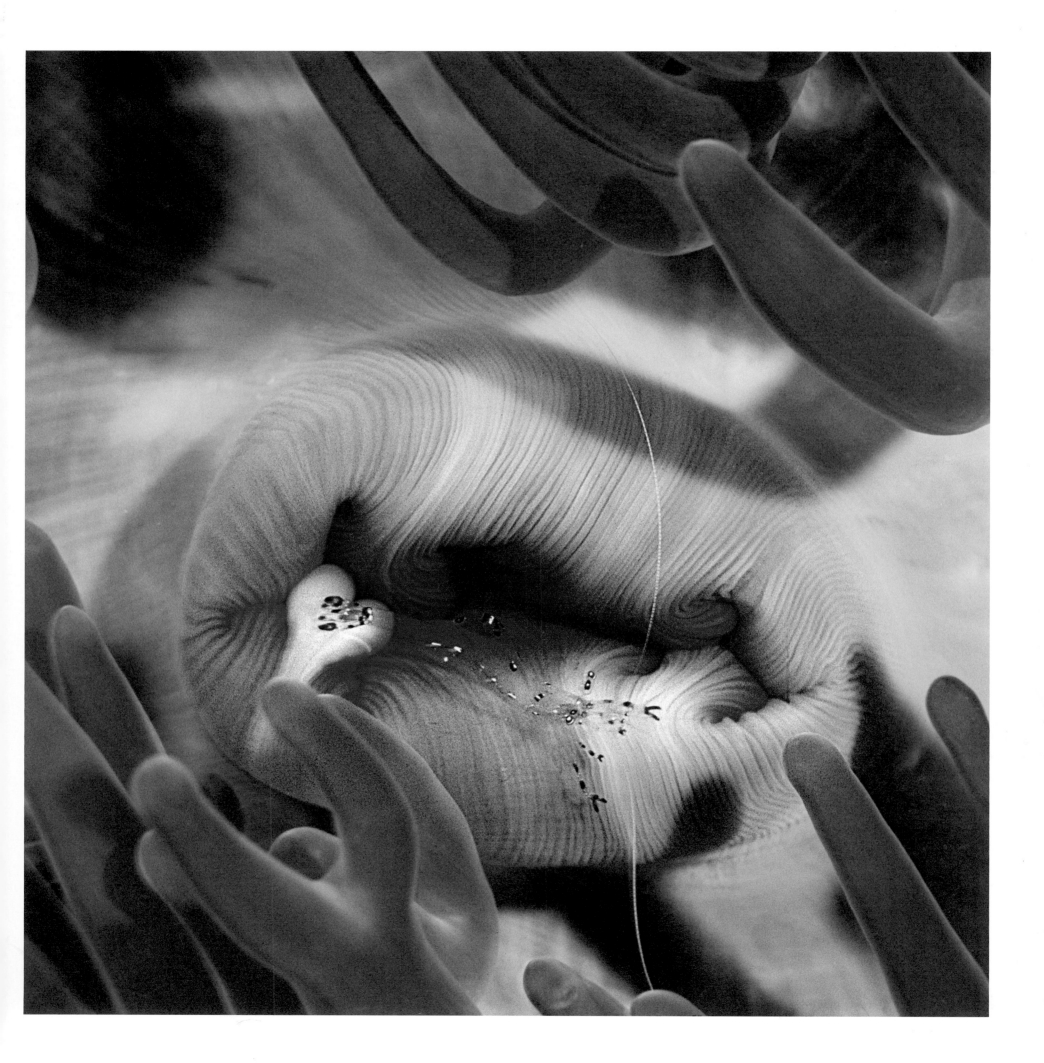

ANEMONE SIZE 10 INCHES (25.4CM), BUT CAN GROW UP TO 3 FEET (1M).
DETAIL SIZE 2 INCHES (5.08CM).

SHARM EL SHEIKH, RED SEA, EGYPT; 50 FEET (15.2M) DEEP.

Home to several species of Anemonefish (also called
Clownfish) and Commensal Shrimp, every anemone I see
is carefully examined for their presence, but sometimes
a detail of the animal itself is beautiful enough.

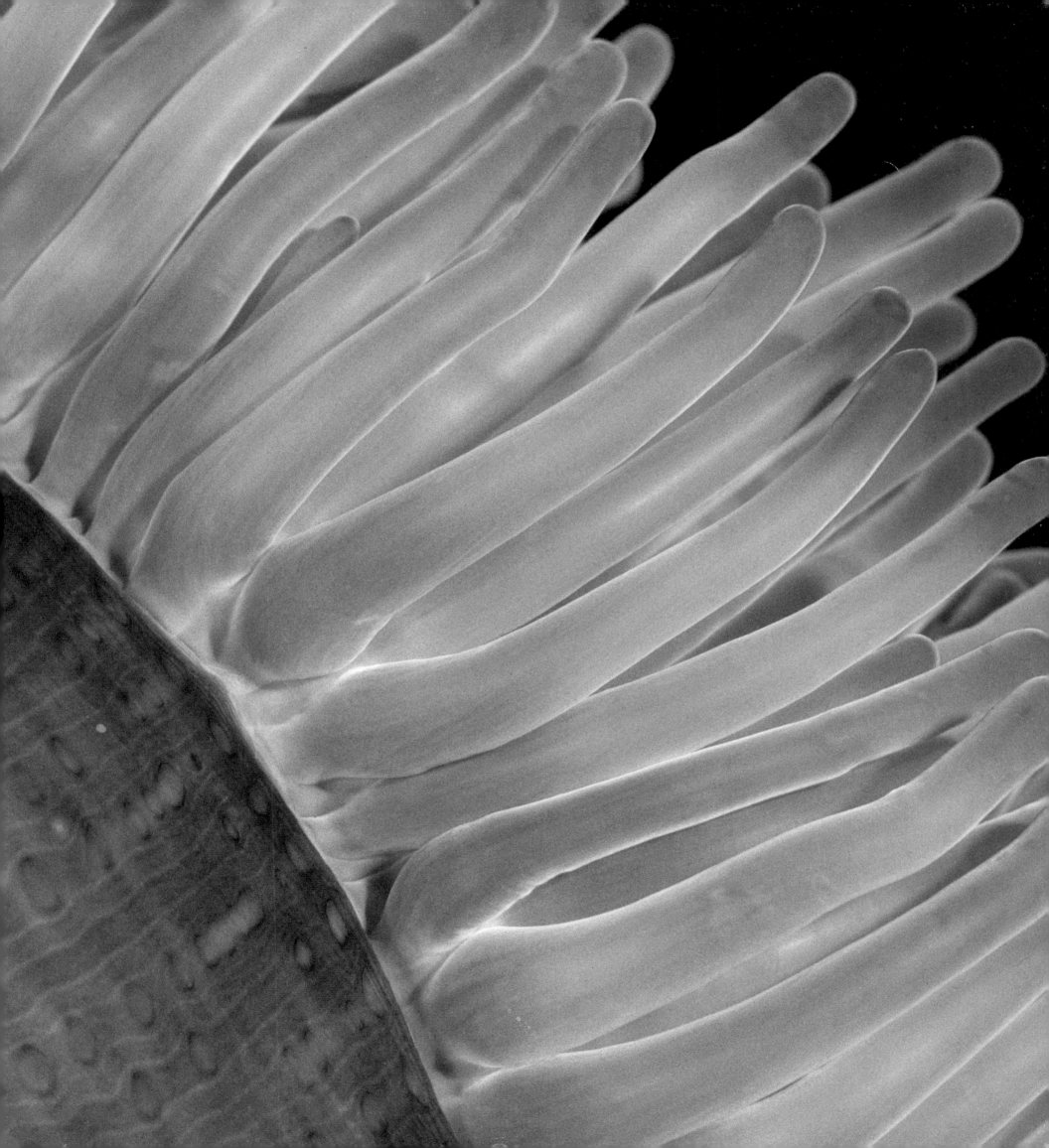

PARROTFISH SIZE 13 INCHES (33.52CM).
DETAIL SIZE 1¹/₂ INCHES (3.81CM).

MARSA ALAM, RED SEA, EGYPT; 40 FEET (12.2M) DEEP.

Parrotfish are my favourite fish because of their amazing colours and patterns. It is a real challenge to photograph details, which – in my opinion – are more beautiful than the fish as a whole. The best chance is at night, when the fish is fast asleep, but then the problem is that it is usually hiding in a crevice or under a ledge. This detail belongs to an adult male.

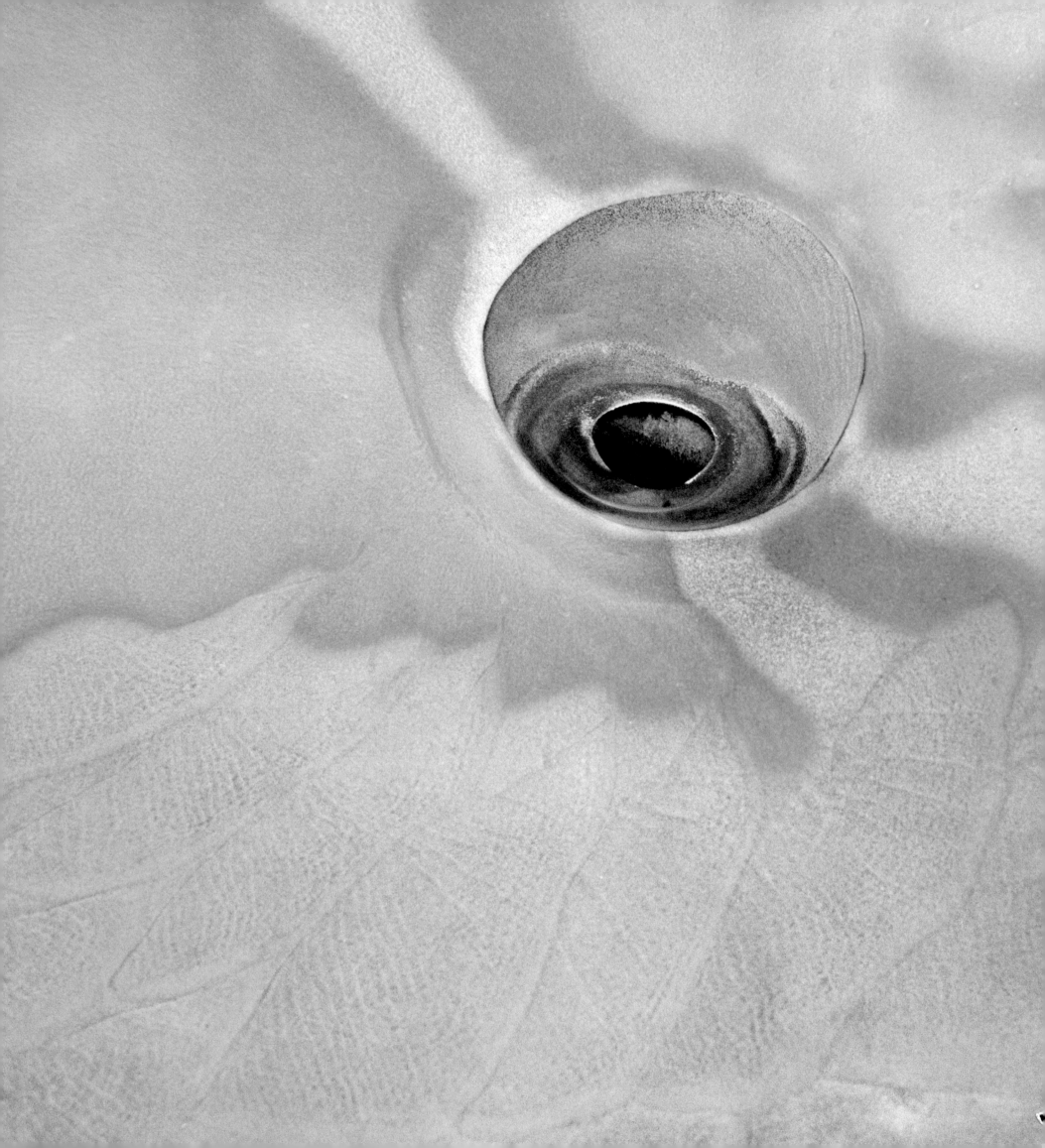

COMMENSAL SHRIMP ON A MUSHROOM CORAL
Periclimenes venustus | *Fungia* sp.

SHRIMP SIZE ³/₄ INCH (2.03CM).
PICTURE SIZE 2 INCHES (5.08CM).

MANADO, NORTH SULAWESI, INDONESIA; 55 FEET (16.8M) DEEP.

This shrimp lives in symbiosis with anemones and some species of Mushroom Coral. They come in different colour patterns. There is still a lot to be learned about the exact function of the symbiosis.

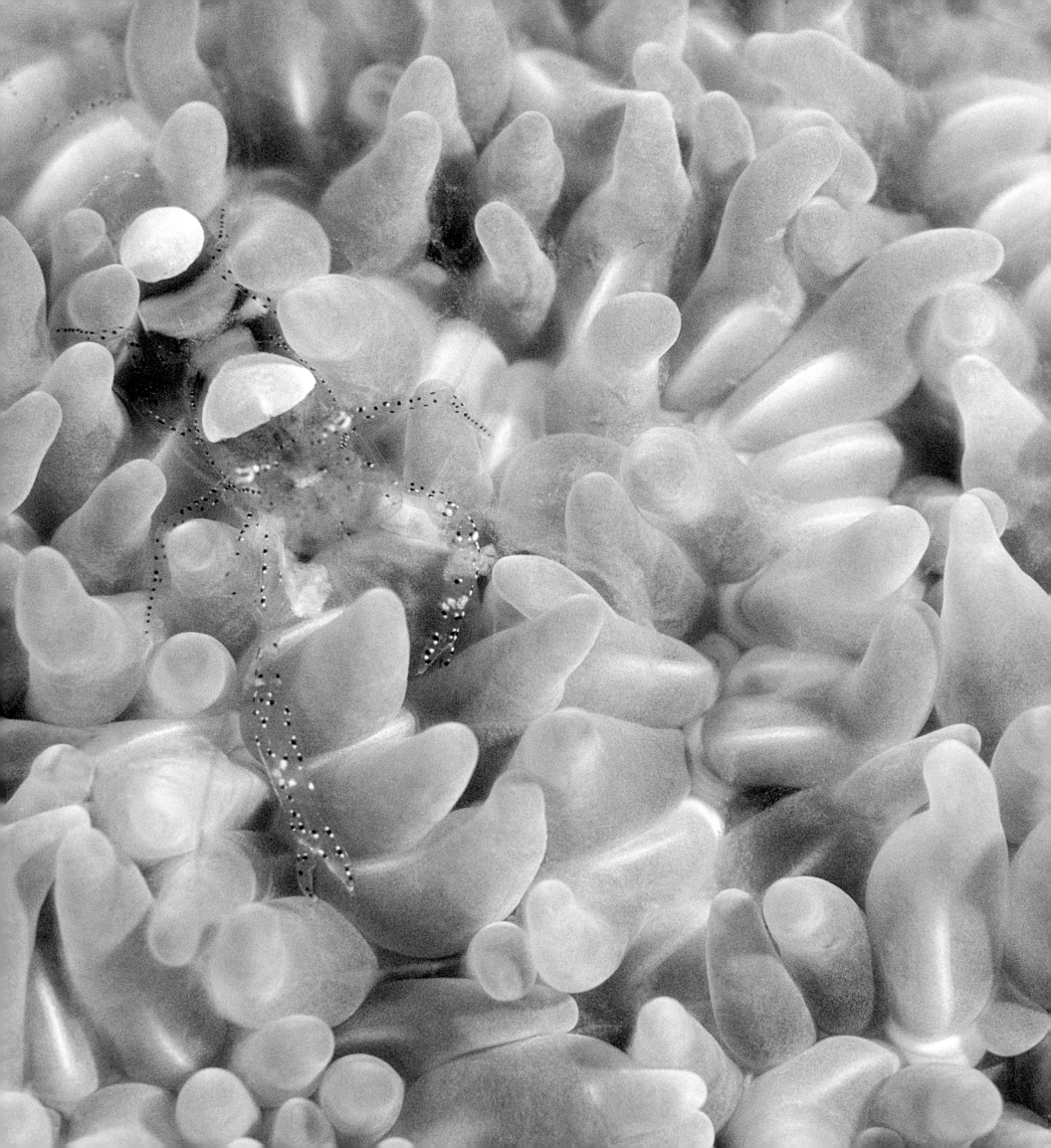

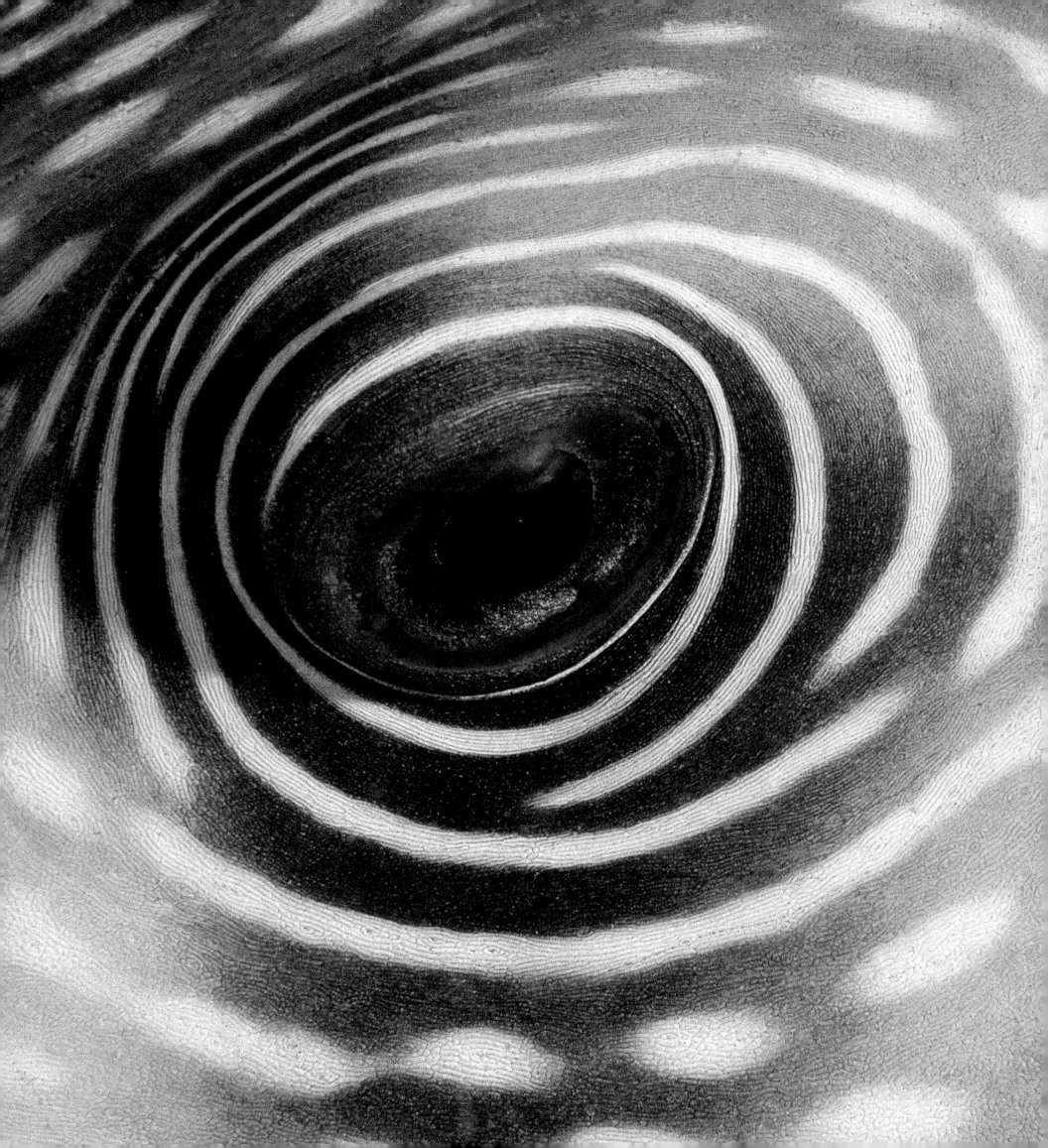

WHITE−SPOTTED PUFFER EYE
Arothron hispidus

PUFFER SIZE 12 INCHES (30.48CM).
DETAIL SIZE ⅝ INCH (1.52CM).

MARSA ALAM, RED SEA, EGYPT; 25 FEET (7.6M) DEEP.

Almost immobile on the sand, this puffer looks as if it is not healthy, but this is the way it behaves. If approached slowly, it allows very close encounters. The food consists of living and dead organisms from the sea floor.

HUMPBACK PRAWN EYE
Metapenaeopsis lamellata

PRAWN SIZE 2 INCHES (5.08CM). SIZE OF THE EYE $\frac{1}{4}$ INCH (0.51CM).

LEMBEH STRAIT, NORTH SULAWESI, INDONESIA; 30 FEET (9.1M) DEEP.

During a night dive I spotted a bright red shrimp in my light beam. It was sitting upright and did not move, probably confused because of my torch light. I was able to come very close and shot half a roll of film.

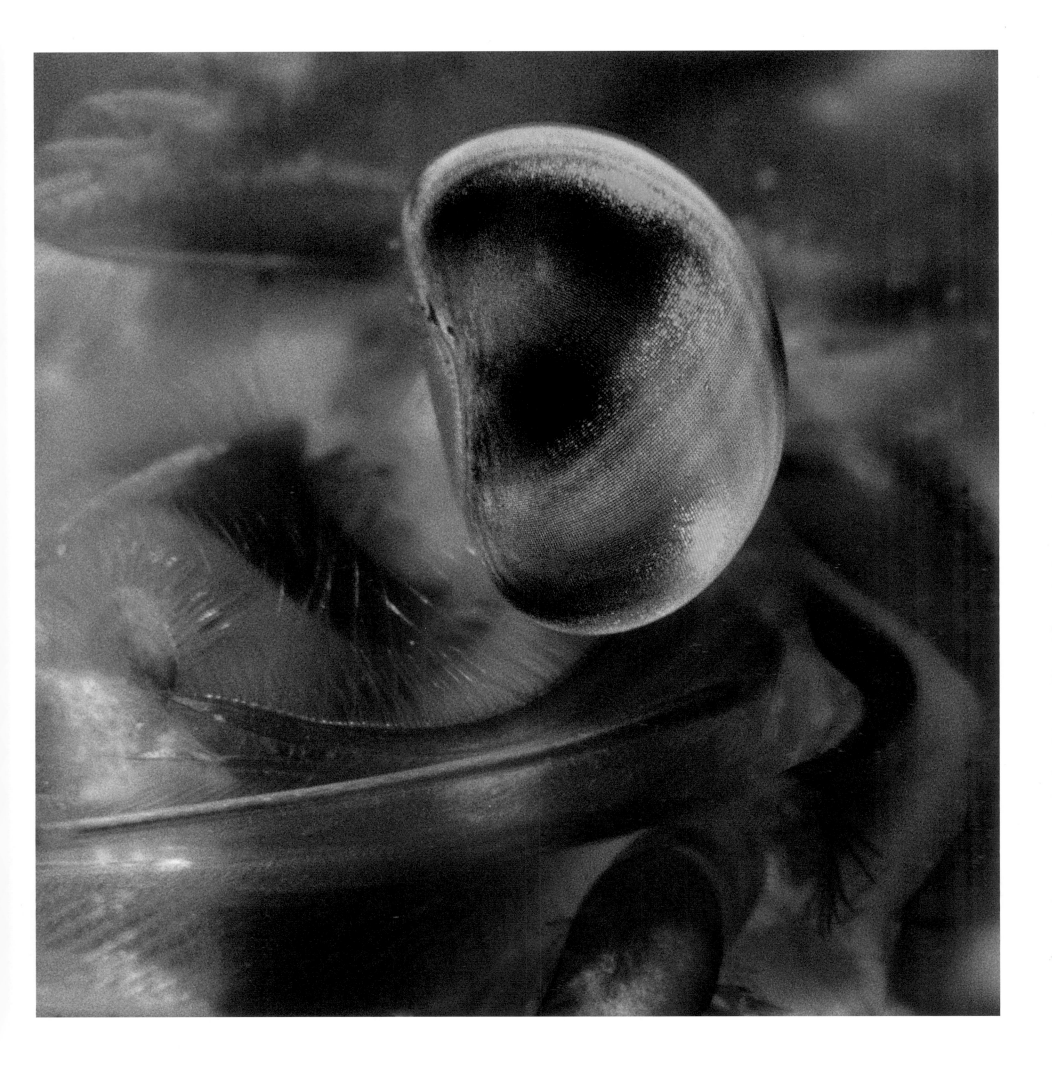

ALLIED COWRY ON A SOFT CORAL
Primovula bellica | Dendronephthya sp.

COWRY SIZE ¼ INCH (0.51CM). PICTURE SIZE 1½ INCHES (3.81CM).

SIMILAN ISLANDS, THAILAND; 80 FEET (24.4M) DEEP.

Allied Cowries live in symbiosis with soft corals.
Like this species, they are usually very well camouflaged
by adopting the colour of their host. This tiny Allied
Cowry is pink and its mantle displays beautiful pink spots,
making the animal almost invisible.

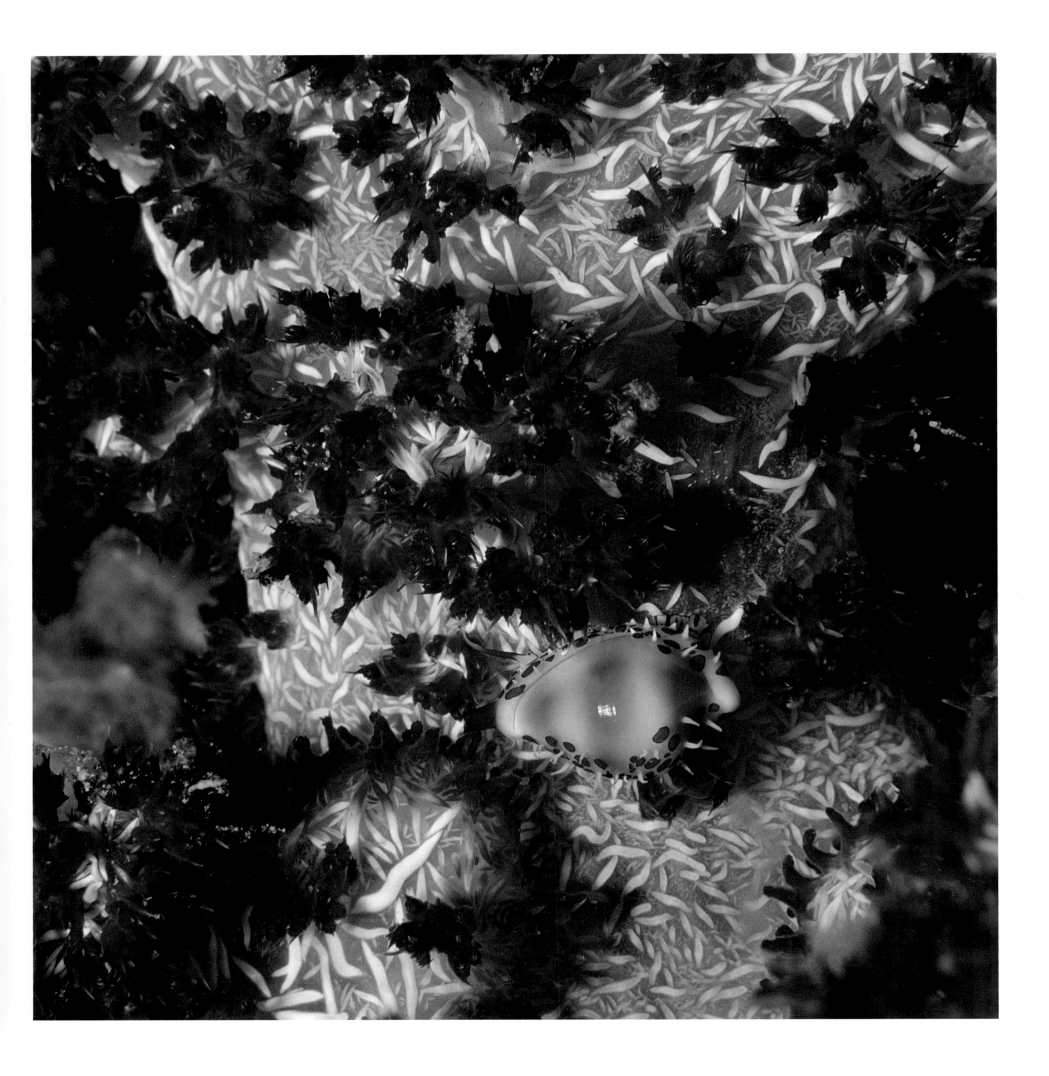

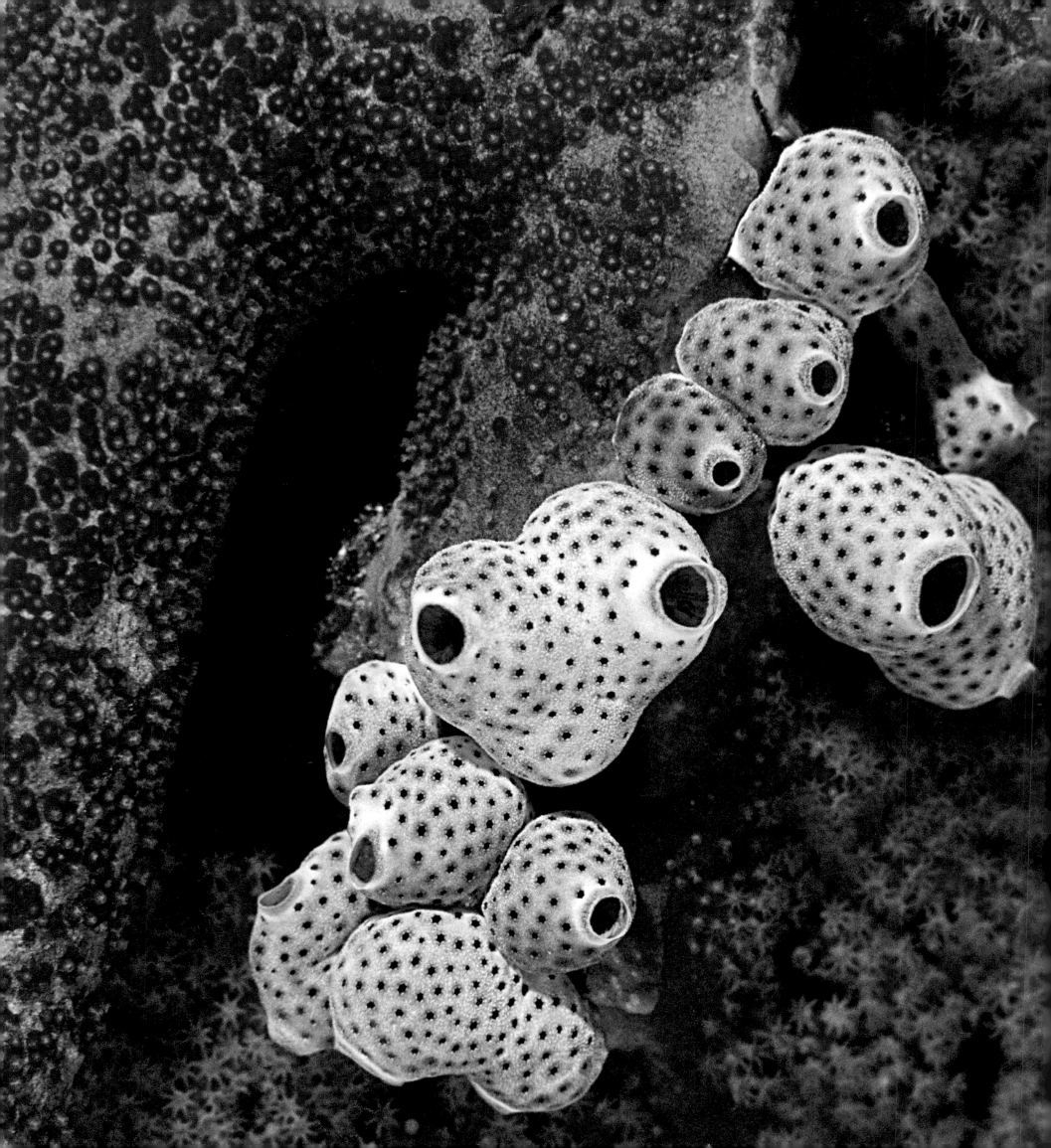

◂ASCIDIANS, ALSO KNOWN AS TUNICATES
OR SEA SQUIRTS, ON A GORGONIAN SEA FAN
Didemnum molle | *Melithaea* sp.

SIZE OF ONE ASCIDIAN ¼ INCH (0.76CM).
PICTURE SIZE 2½ INCHES (6.35CM).

SANGALAKI, SULAWESI SEA, INDONESIA; 65 FEET (19.8M) DEEP.

Strangely enough, Ascidians belong to the Phylum Chordata, or animals with a "spinal cord". Although they have little in common with vertebrates, their larval tail is strengthened with a rod of cells just like the embryonic backbone of a vertebrate and. like the gills of a fish, the pharynx of an Ascidian is perforated.

▾**HARD CORAL**
Euphyllia s sp.

PICTURE SIZE 1 INCH (2.54CM).

LAYANG–LAYANG ATOLL, SOUTH CHINA SEA, MALAYSIA;
80 FEET (24.4M) DEEP.

As can be seen in this photograph, coral polyps are incredibly delicate. They are covered with a slimy bubble-like layer which can easily be damaged by touching. Most hard corals, such as this species, are very slow growing.

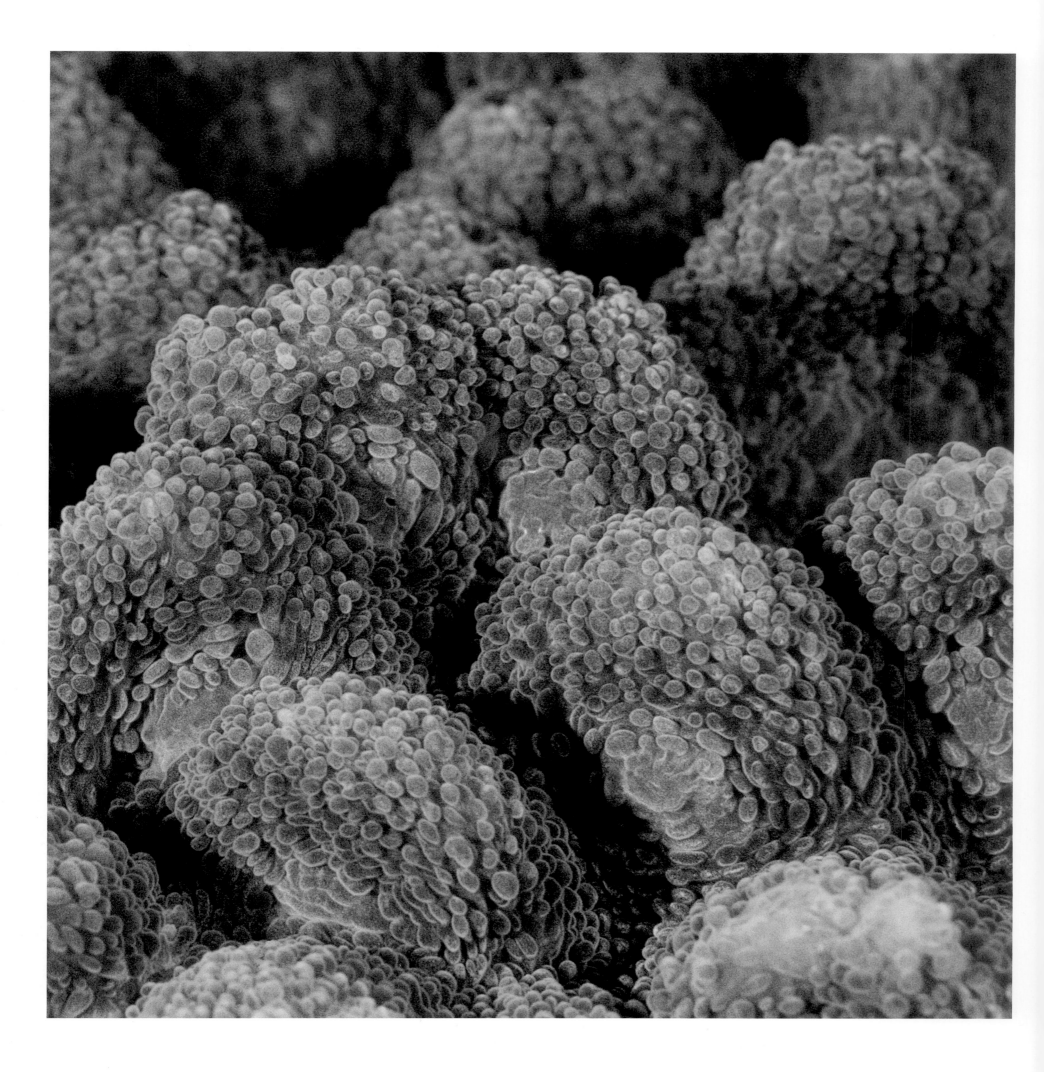

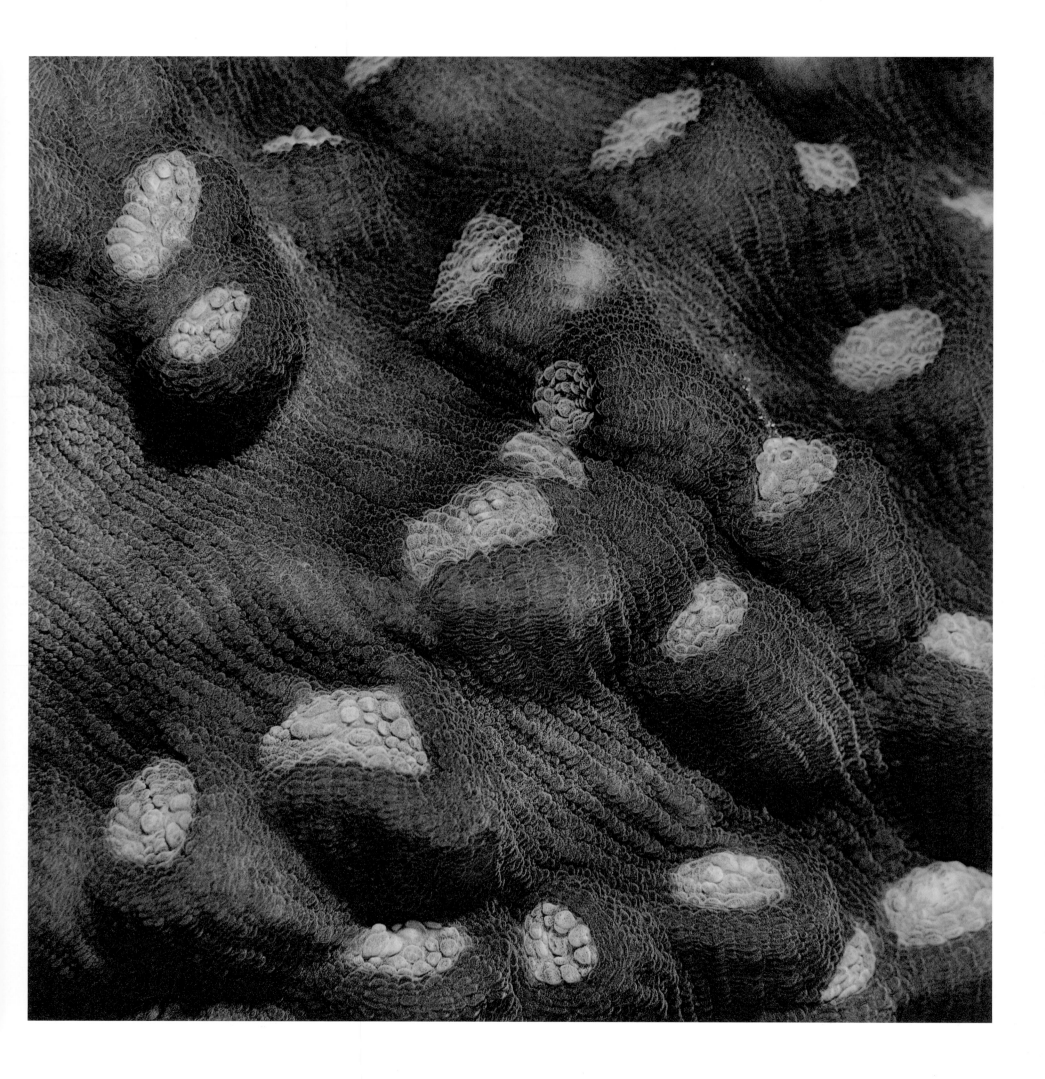

This is a very slow growing hard coral; it takes years to grow only a few millimetres. Still, coral colonies can reach immense sizes, and are extremely long lived. There are colonies alive today which are believed to be between 700 and 1,000 years old.

▸ DETAIL OF AN AZURE VASE SPONGE
Callyspongia plicifera

SPONGE SIZE 15 INCHES (38.1CM).
DETAIL SIZE 1 INCH (2.54CM).

BONAIRE, NETHERLANDS ANTILLES, CARIBBEAN; 65 FEET (19.8M) DEEP.

Sponges are the most primitive of the multi-cell animals. Although there are cells with more or less specialised functions, there are no true tissue layers or organs.

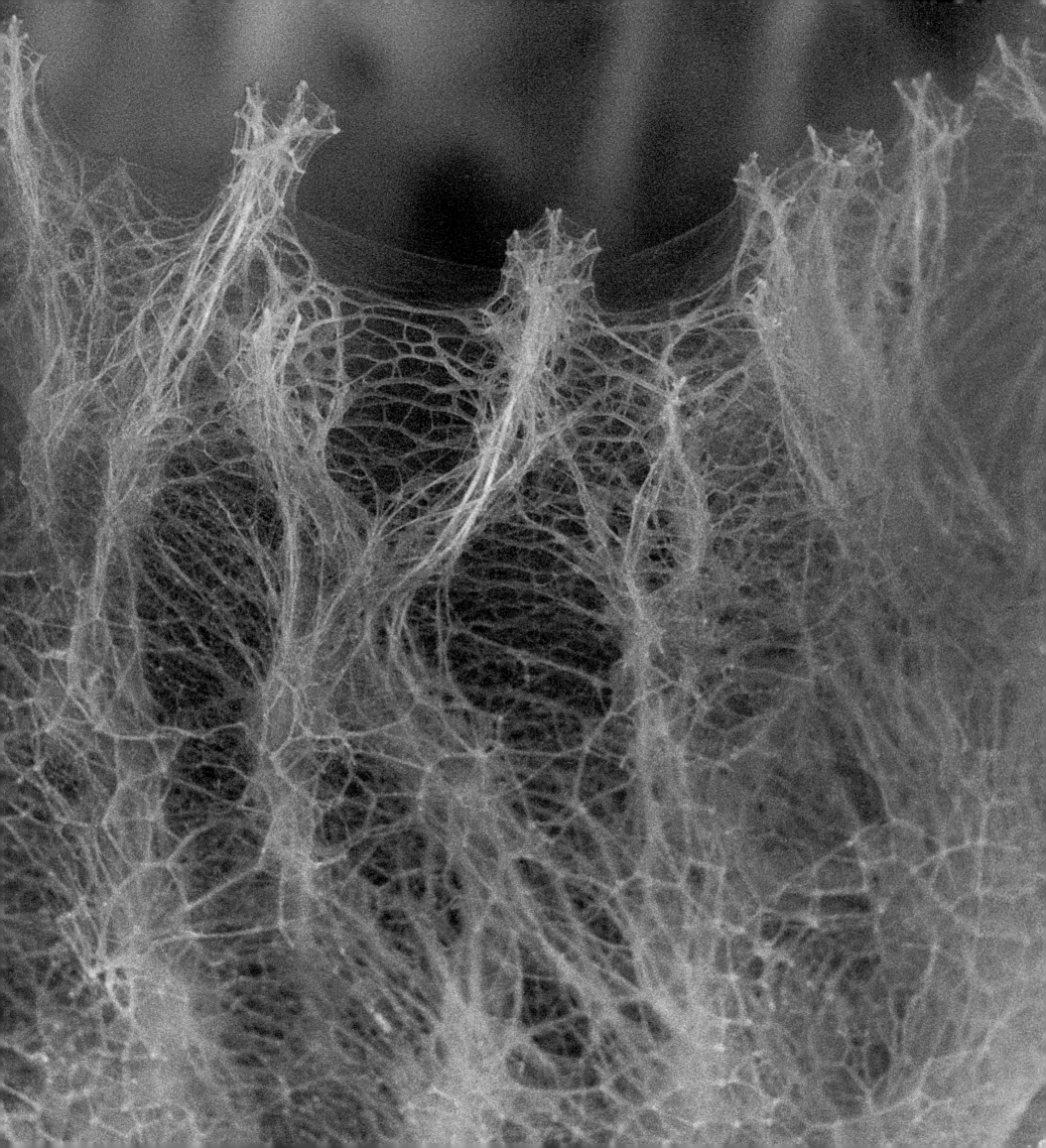

CORAL COD
Cephalopholis miniata

COD SIZE 12 INCHES. DETAIL SIZE 1½ INCHES (3.81CM).

SIMILAN ISLANDS, THAILAND; 70 FEET (21.3M) DEEP.

Coral Cods are found all over the Indian Ocean and up to the Central Pacific. This beautifully coloured fish is a member of the grouper family. It mainly feeds on small fish. I found this one lying on a big boulder in between red soft corals where it was waiting for potential prey to swim by.

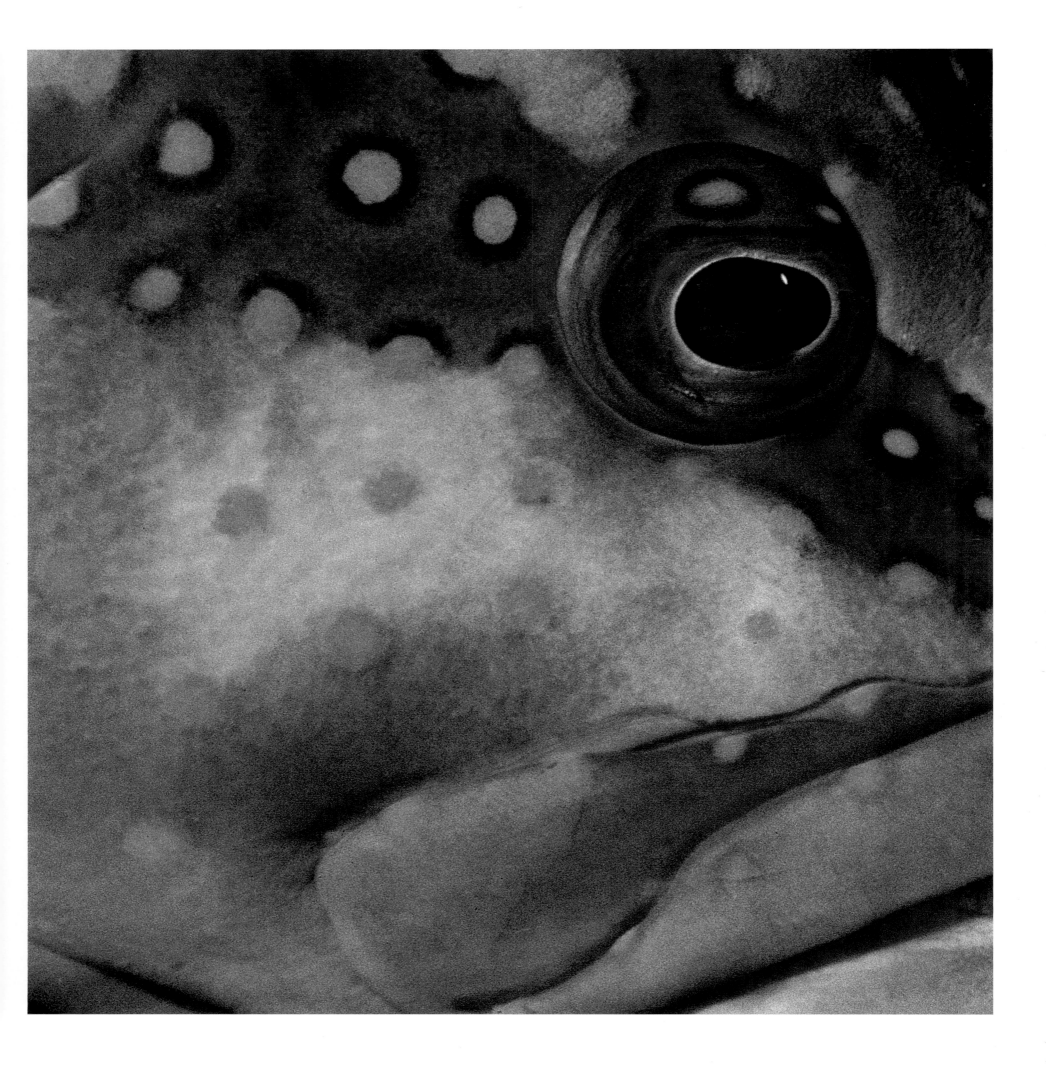

PECTORAL FIN OF A QUEEN PARROTFISH
Scarus vetula

PARROTFISH SIZE 14¹/₂ INCHES (36.58CM).
DETAIL SIZE 2 INCHES (5.08CM).

BONAIRE, NETHERLANDS ANTILLES, CARIBBEAN; 34 FEET (10.4M) DEEP.

Queen Parrotfish seem to be unconcerned when a diver approaches, but as soon as you come into "photo range", they turn and swim away. It took me a long time to record this detail.

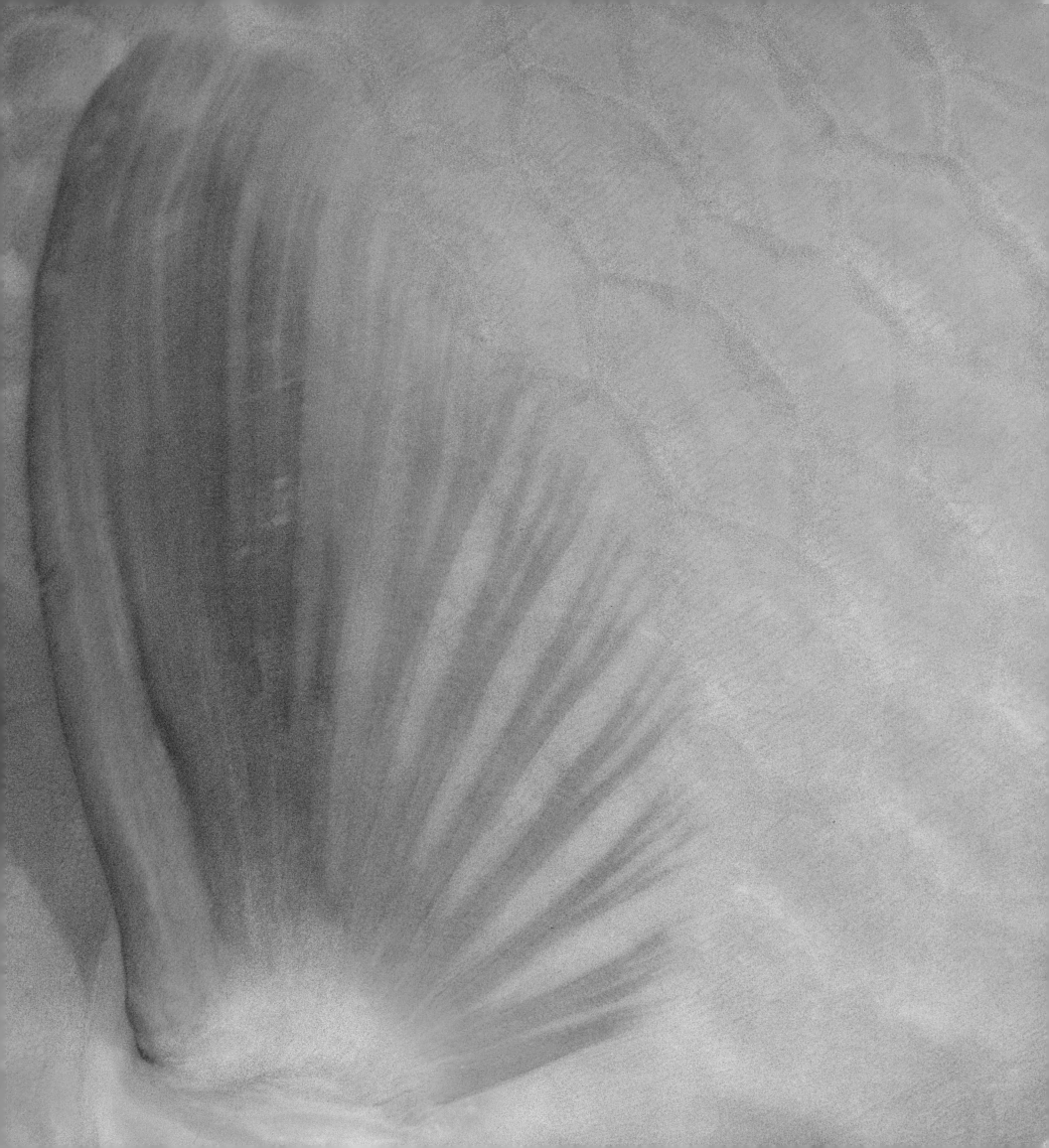

PASTEL SEA SQUIRT (ALSO ASCIDIAN OR TUNICATE)
AND CORAL POLYPS
Rhopalaea crassa | *Xenia* sp.

SEA SQUIRT SIZE 1 INCH (2.54CM).
CORAL POLYP SIZE ¾ INCH (2.03CM).

LAYANG-LAYANG ATOLL, SOUTH CHINA SEA, MALAYSIA;
50 FEET DEEP (15.2M).

There is an enormous variety of reef invertebrates ranging in size from huge Barrel Sponges and towering coral heads to microscopic plankton. By any standard their diversity is impressive.

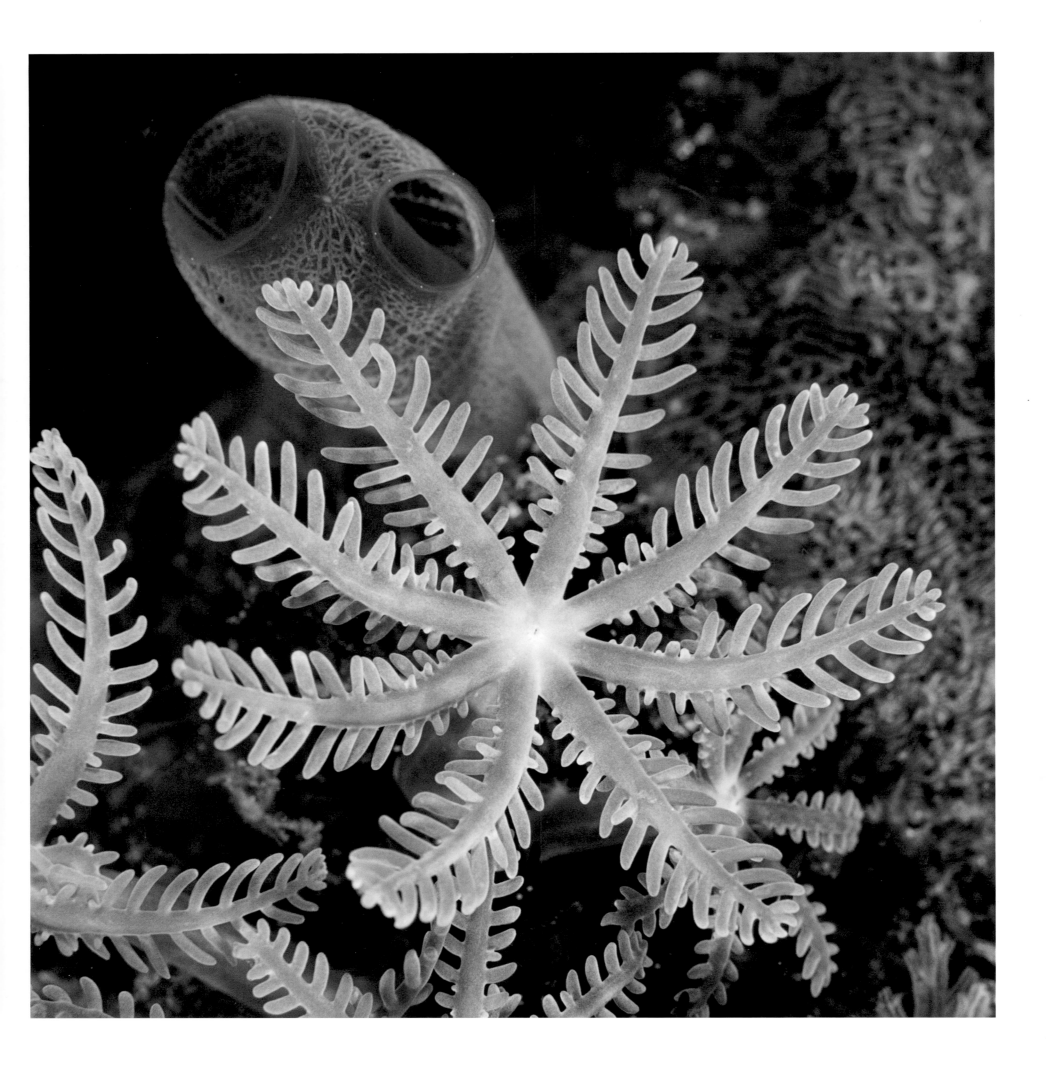

CORAL POLYPS
Goniopora sp.

POLYP SIZE ¼ INCH (0.76CM).
PICTURE SIZE 1½ INCHES (3.81CM).

SUMBAWA, TANJUNG BRENTI, INDONESIA; 90 FEET (27.4M) DEEP.

Goniopora polyps belong to the coral species that shows its polyps during the day. These corals have a hard skeleton, which is invisible when the polyps are extended. *Goniopora* do not like strong currents; they catch plankton when there is a light current or none at all.

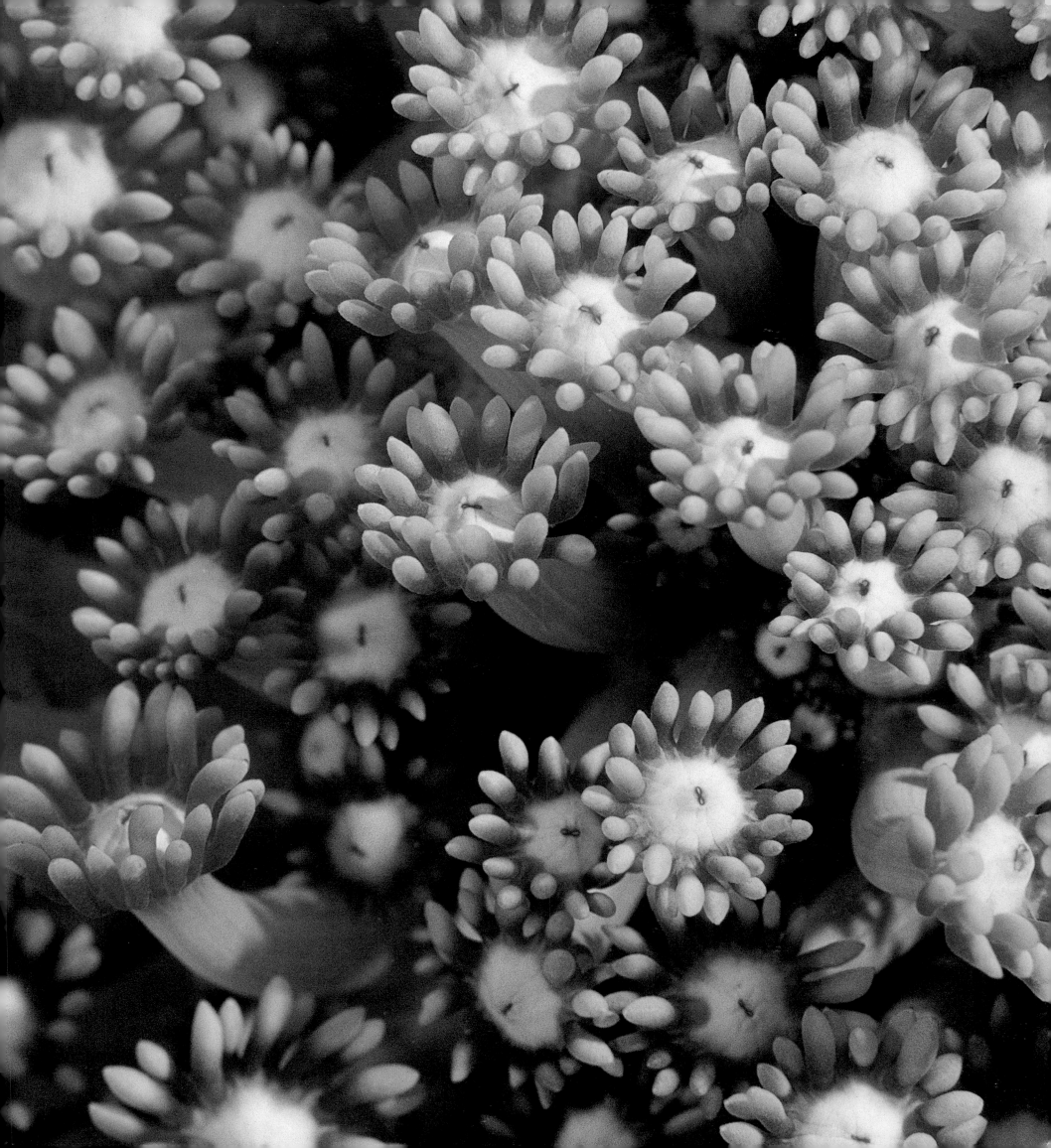

GROUPER SIZE 3 FEET (1M). SIZE OF THE EYE ½ INCH (1.27CM).

CURAÇAO, NETHERLANDS ANTILLES; CARIBBEAN; 105 (32M) FEET DEEP.

It was only because this grouper was being cleaned by a pair of shrimps that I could carefully approach close enough to take a picture of the eye of this shy fish. Fish, by and large, have excellent and very discriminating vision. Their eyes tend to be large and to bulge outwards giving them perfect panoramic vision. Some fish are quite literally able to see behind themselves. Those that can't quite look behind have developed undulating swimming movements which allow them to take a quick peek behind them as they swim.

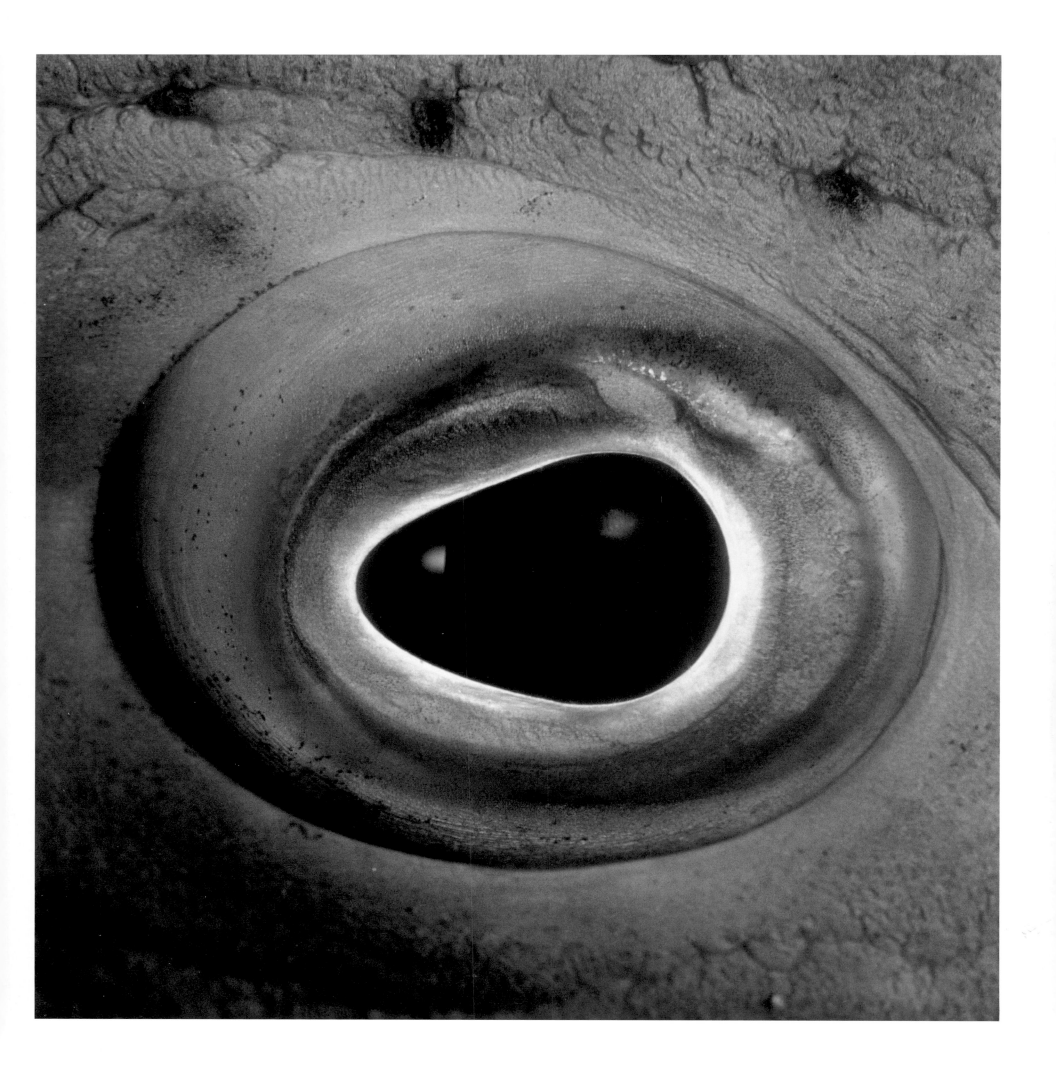

WEB BURRFISH EYE
Chilomycterus antillarum

BURRFISH SIZE 8 INCHES (20.32CM).
SIZE OF THE EYE 1/2 INCH (1.27CM).

SABA, NETHERLANDS ANTILLES; CARIBBEAN; 50 FEET (15.2M) DEEP.

The Web Burrfish is a member of the puffer family, which means that it can inflate if in danger. It is a shy animal that is difficult to photograph, especially its eye.

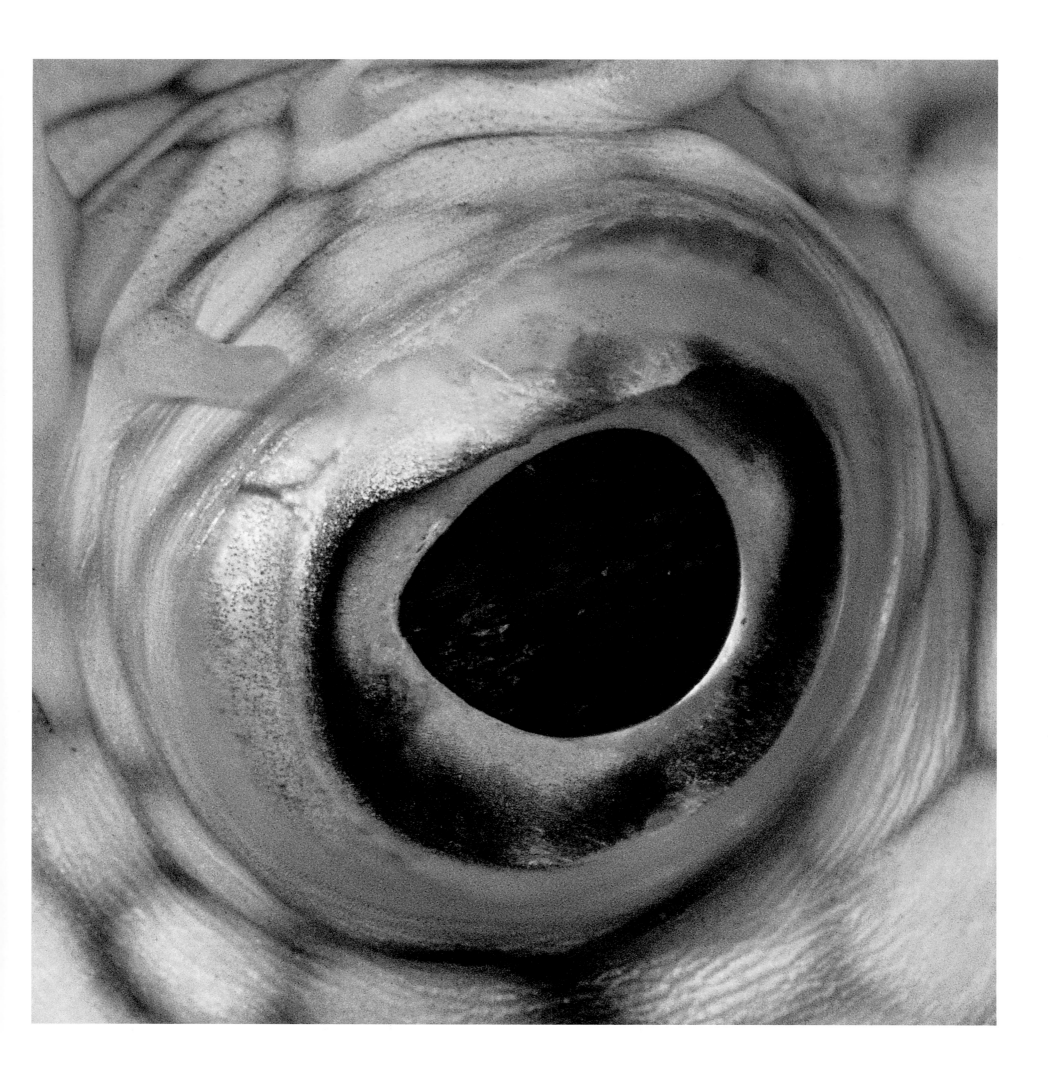

DETAIL OF A MUSHROOM CORAL
Fungia scutaria

CORAL SIZE 3 INCHES (7.62CM).
DETAIL SIZE 1 INCH (2.54CM).

MABUL ISLAND, SULAWESI SEA, MALAYSIA; 40 FEET (12.2M) DEEP.

The solitary single polyp Mushroom Corals are part of a group of Stony Corals living unattached on the bottom and forming round or oval colonies of 4 to 12 inches (10 to 30cm). The polyps' tentacles appear only at night, to catch plankton. The elongated mouth is centrally located in the coral.

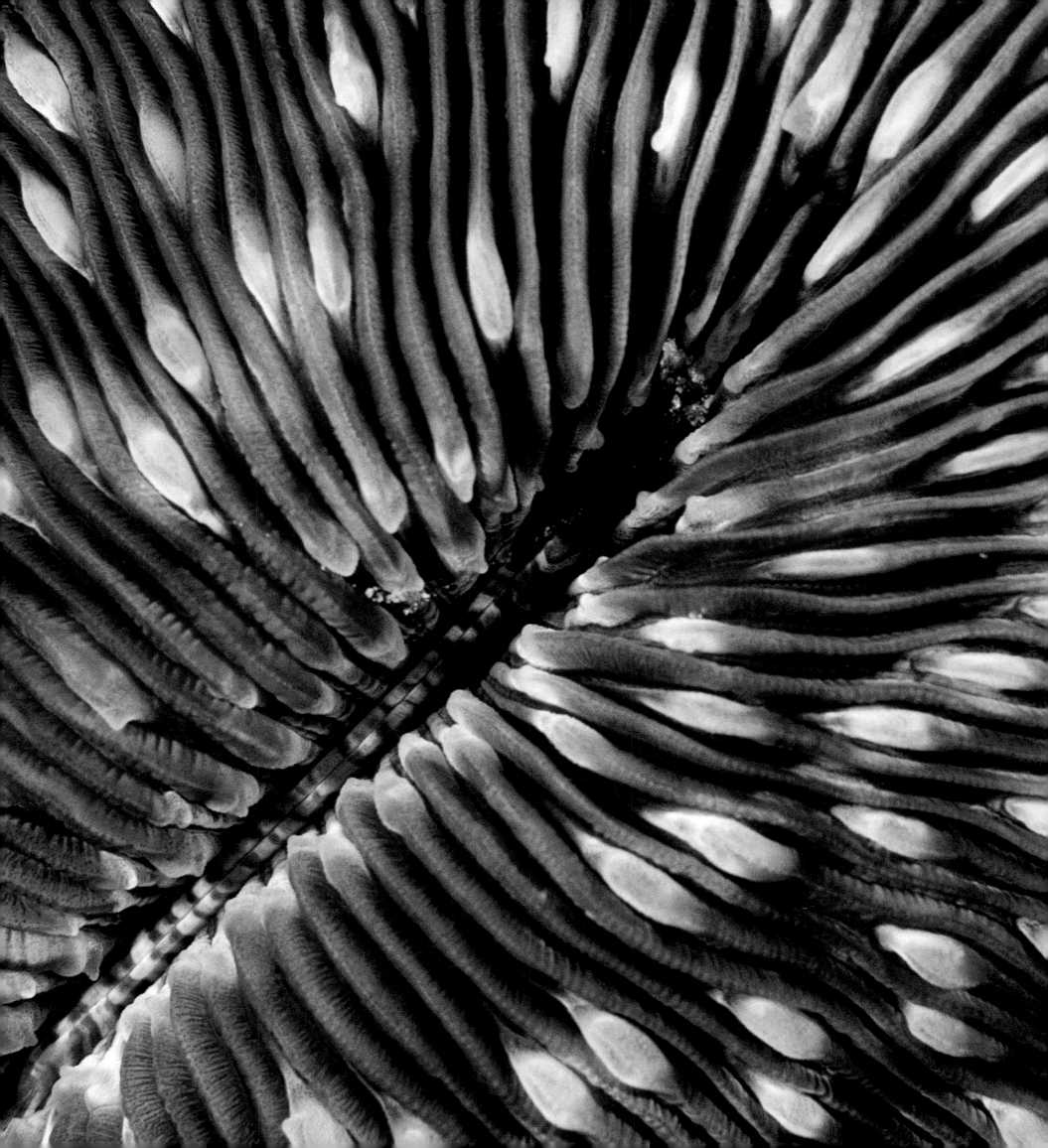

DETAIL OF A BLUEBARRED PARROTFISH
Scarus ghobban

PARROTFISH SIZE 18 INCHES (45.72CM).
DETAIL SIZE 1¼ INCHES (3.05CM).

MARSA ALAM, RED SEA, EGYPT; 40 FEET (12.2M) DEEP.

Male and female parrotfish usually have different patterns.
This is a detail of the body and dorsal fin of an adult
female, photographed during a night dive.

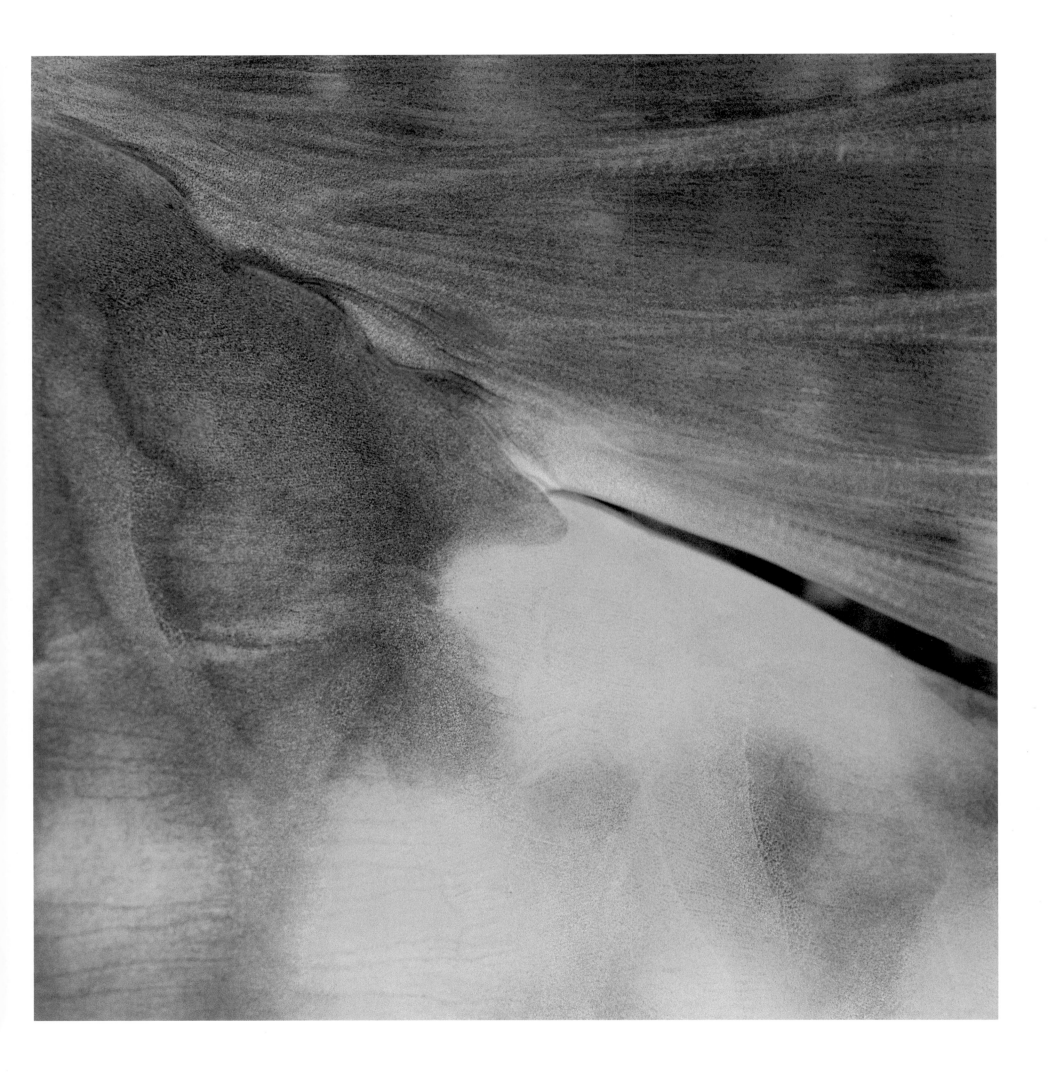

DETAIL OF KLUNZINGER'S WRASSE
Thalassoma rueppellii

WRASSE SIZE 8 INCHES (20.32CM).
DETAIL SIZE 1 INCH (2.54CM).

MARSA ALAM, RED SEA, EGYPT; 20 FEET (6.1M) DEEP.

Endemic to the Red Sea, this wrasse is one of the most colourful fish. It is very inquisitive and often swims between me and my subject when I am busy taking pictures. It is not easy to get a sharp image because it is a very fast swimmer and constantly changes direction.

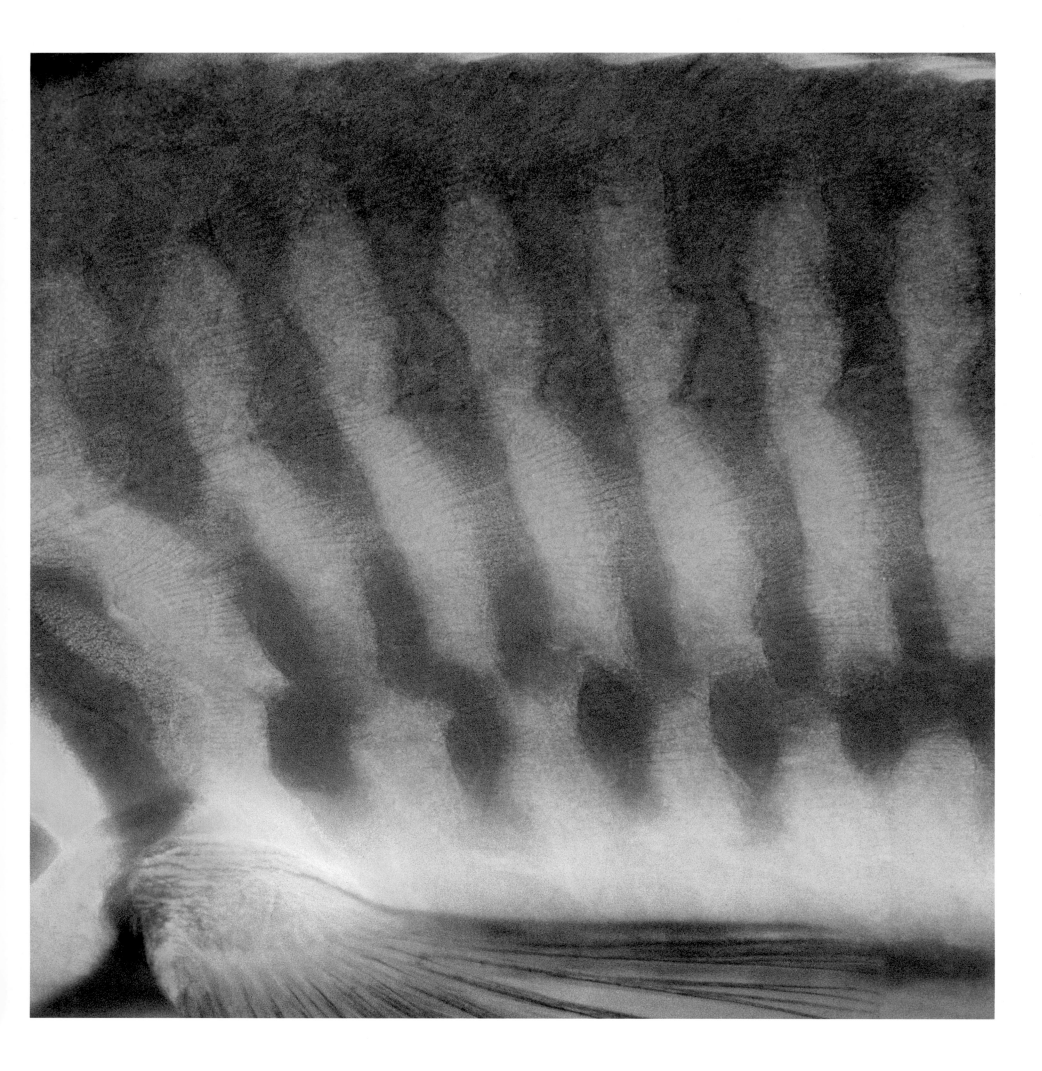

SEA APPLE
Pseudocolochirus violaceus

SEA APPLE SIZE 8 INCHES (20.32CM.
DETAIL SIZE 1 INCH (2.54CM).

KOMODO NATIONAL PARK, INDONESIA; 65 FEET (19.8M) DEEP.

Sea Apples are Sea Cucumbers (*Holothurians*).
This animal uses its feeding arms to catch zooplankton.
The food is then brought to the mouth, one arm at a time.
Komodo is one of the best places on earth to find these
brilliantly coloured animals.

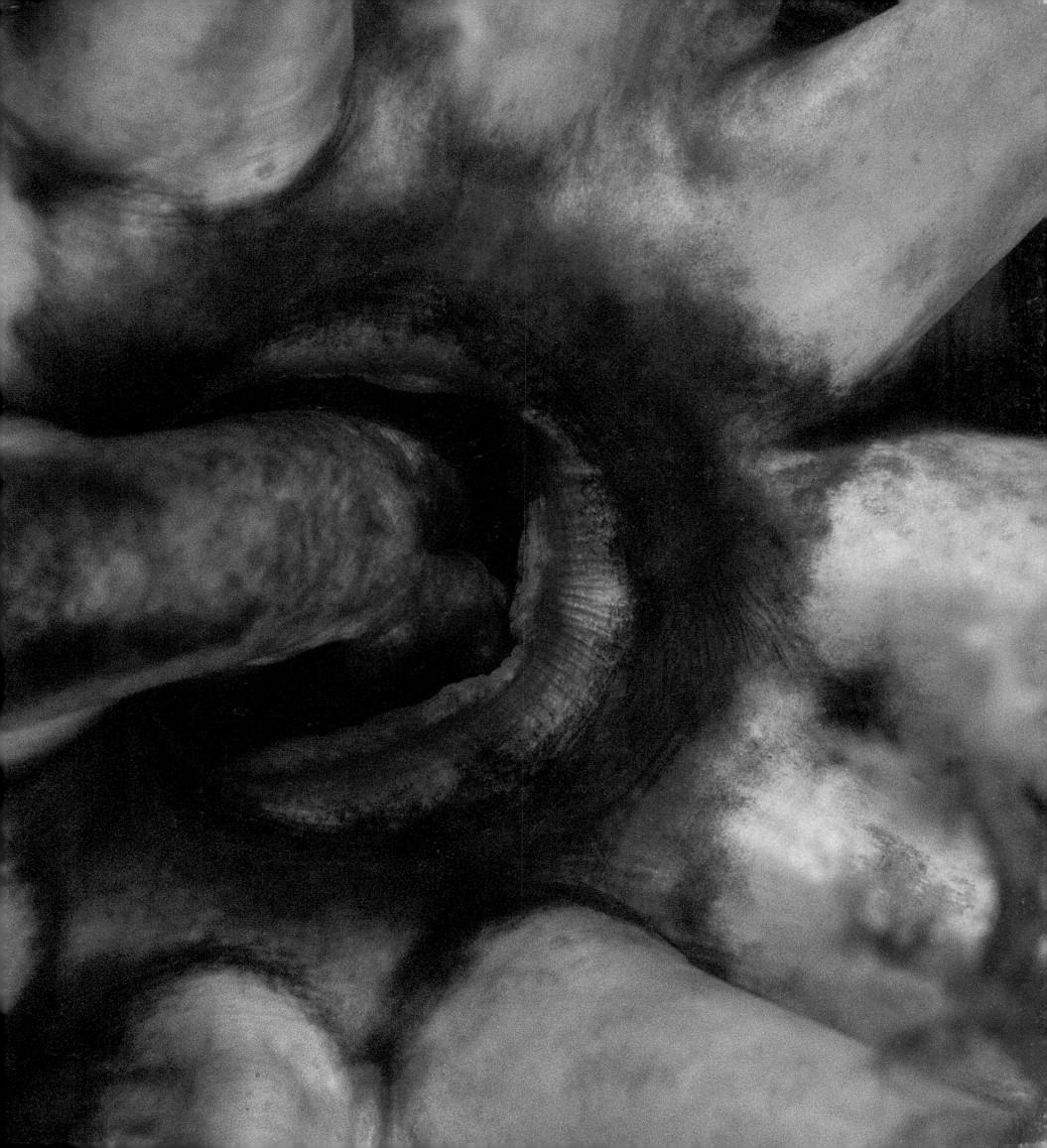

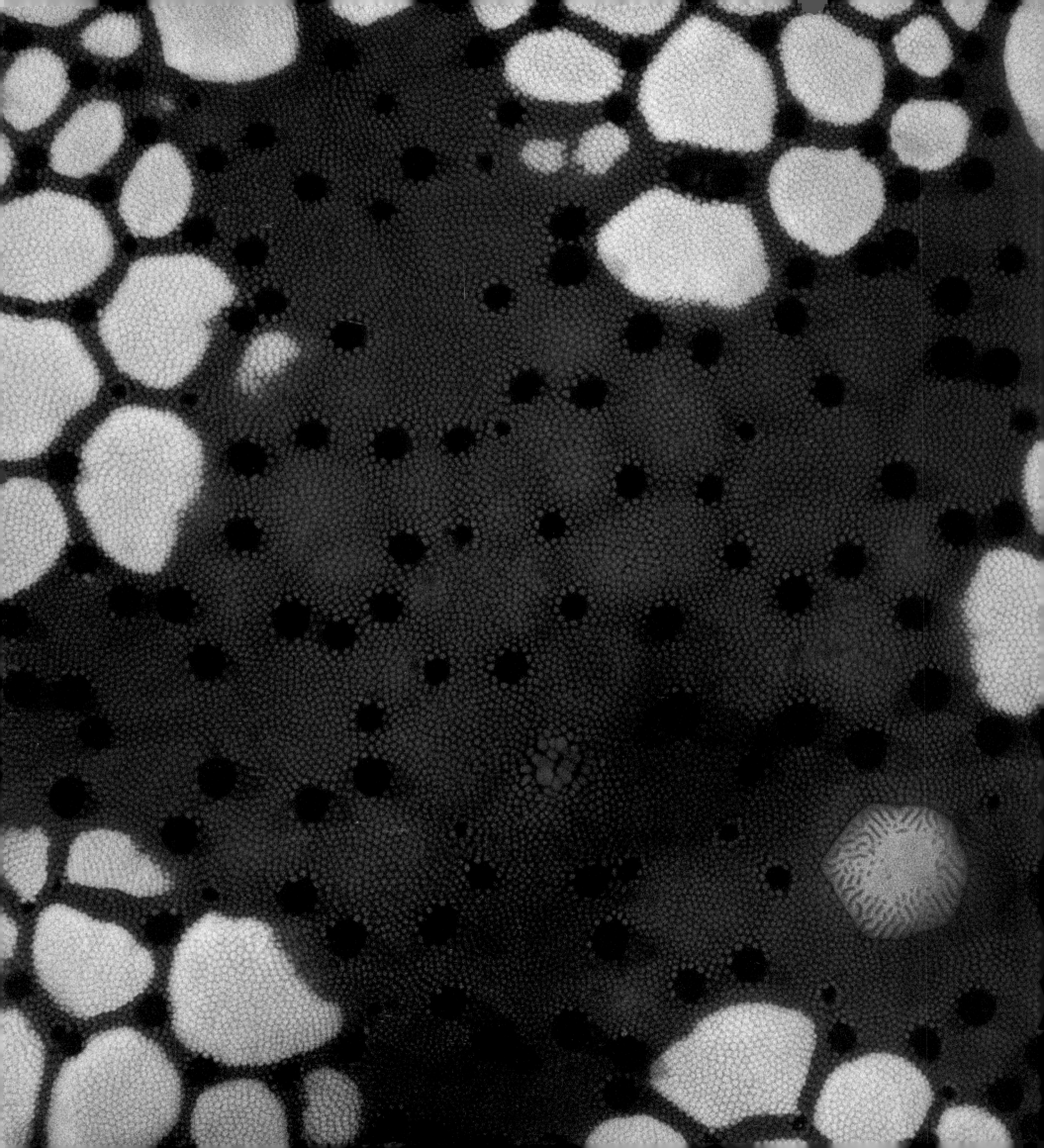

◄ **DETAIL OF A NECKLACE STARFISH**
Fromia monilis

STARFISH SIZE 5 INCHES (12.7CM).
DETAIL SIZE ⅝ INCH (1.52CM).

MILNE BAY, SOLOMON SEA, PAPUA NEW GUINEA;
50 FEET (15.2M) DEEP.

The anus is located near the centre of this starfish, which, like most starfish, has five arms. The body consists of five equal segments, each containing a duplicate of various internal organs. The mouth is situated on the underside of the animal.

▼ **COLONIAL DISC ANEMONE**
Palythoa sp.

PICTURE SIZE 2 INCHES (5.08CM).

NEW BRITAIN, BISMARCK SEA, PAPUA NEW GUINEA;
90 FEET (27.4M) DEEP.

The Colonial Disc Anemone belongs to the *Zoanthids*, which are closely related to sea anemones and corals. The polyps of most species resemble small anemones or coral polyps, but they lack the hard skeleton. This species, however, looks totally different.

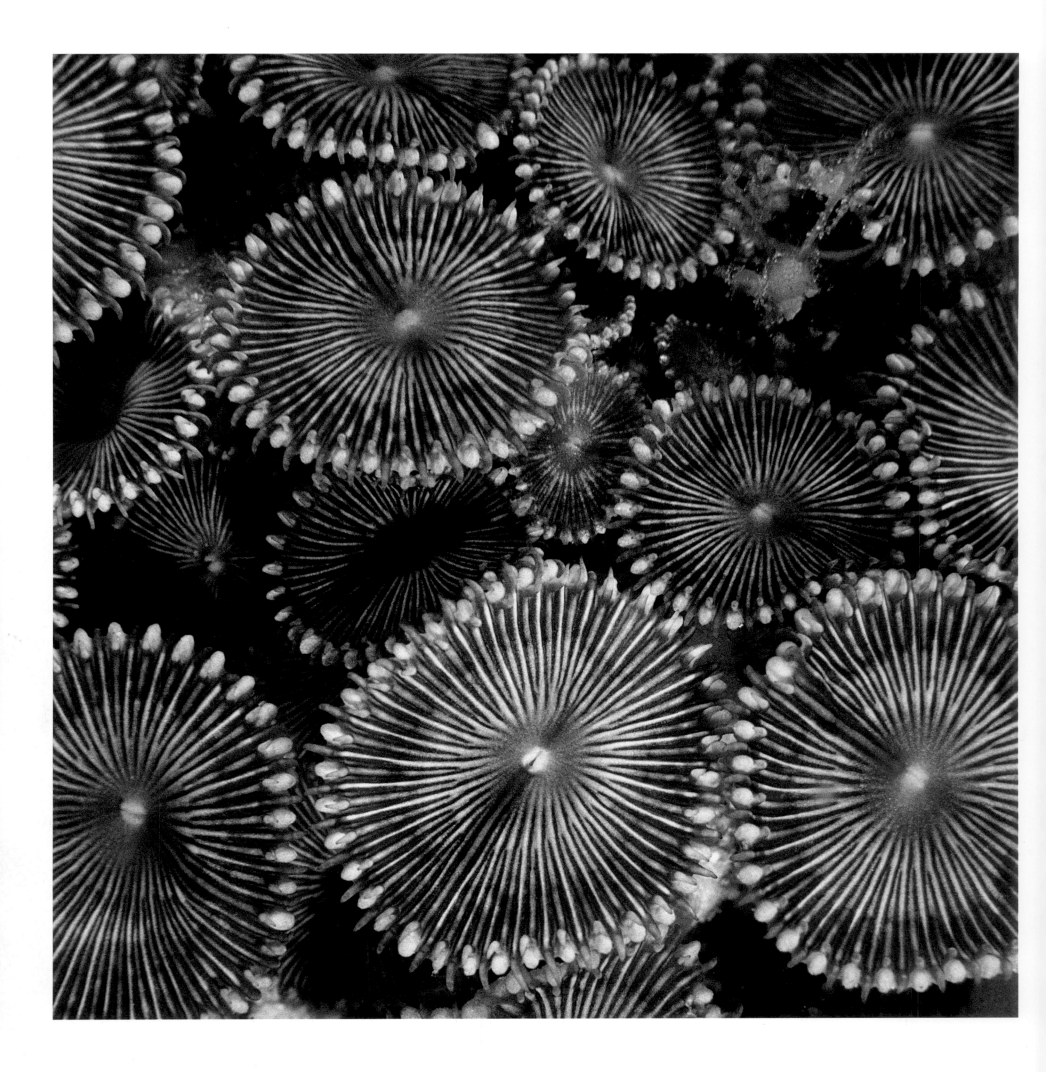

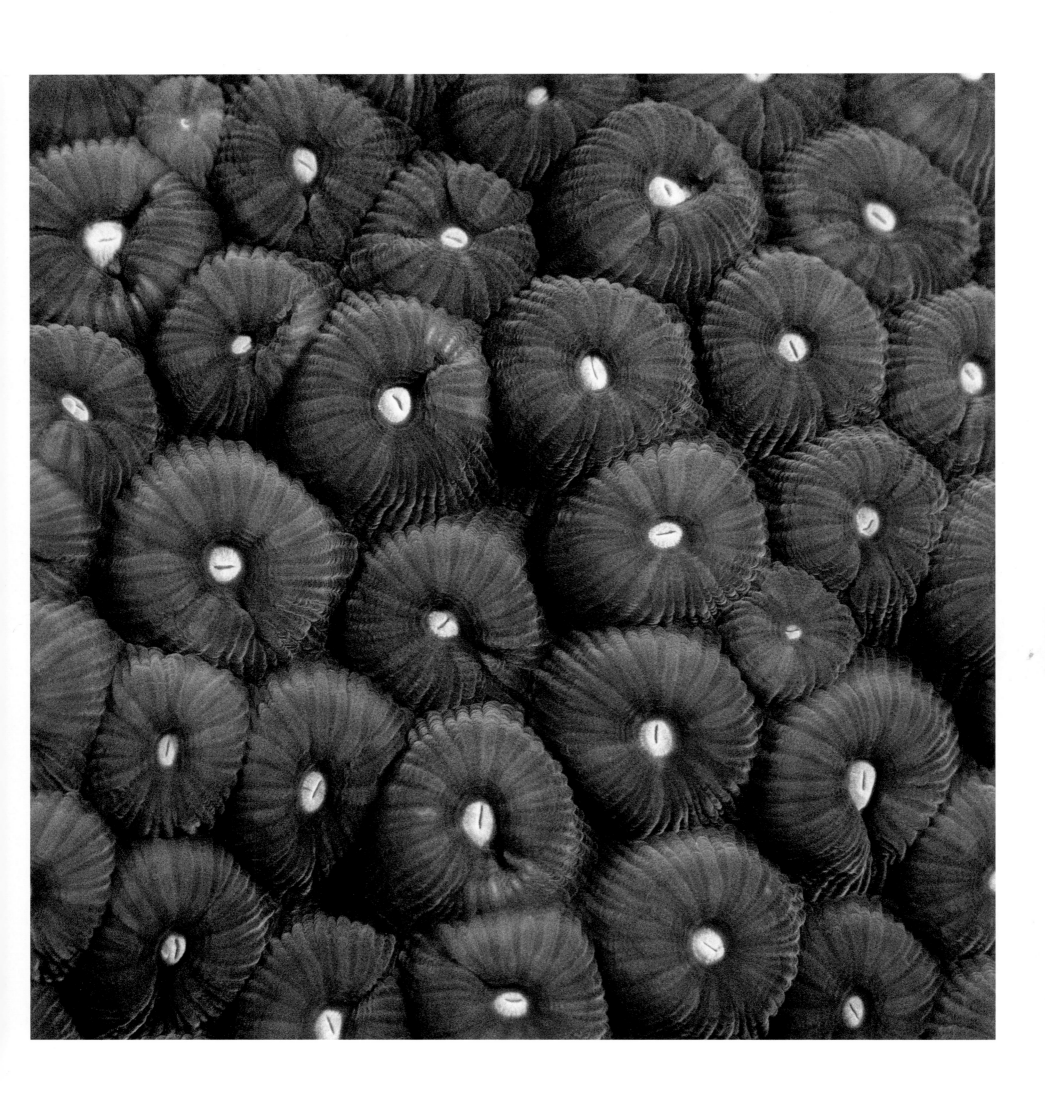

▴ **GREAT STAR CORAL**
Montastraea cavernosa

PICTURE SIZE 2 INCHES (5.08CM).

BONAIRE, NETHERLANDS ANTILLES, CARIBBEAN; 45 FEET (13.7M) DEEP.

Colonies can form huge dome-shaped boulders in the clear waters of the Caribbean. Sometimes the corallites have a fluorescent reddish or orange colour, which is not visible in a picture. Also, when illuminated, this fluorescent colour disappears.

▸ **MOZAMBIQUE HOST GOBY OR COMMON GHOST GOBY ON A GORGONIAN SEA FAN**
Pleurosicya mossambica | *Melithaea* sp.

GOBY SIZE $5/8$ INCH (1.52CM).
PICTURE SIZE 2 INCHES (5.08CM).

HURGHADA, RED SEA, EGYPT; 80 FEET (24.4M) DEEP

Living its entire life on this sea fan, this tiny goby feels perfectly safe because its amazing camouflage makes it almost invisible.

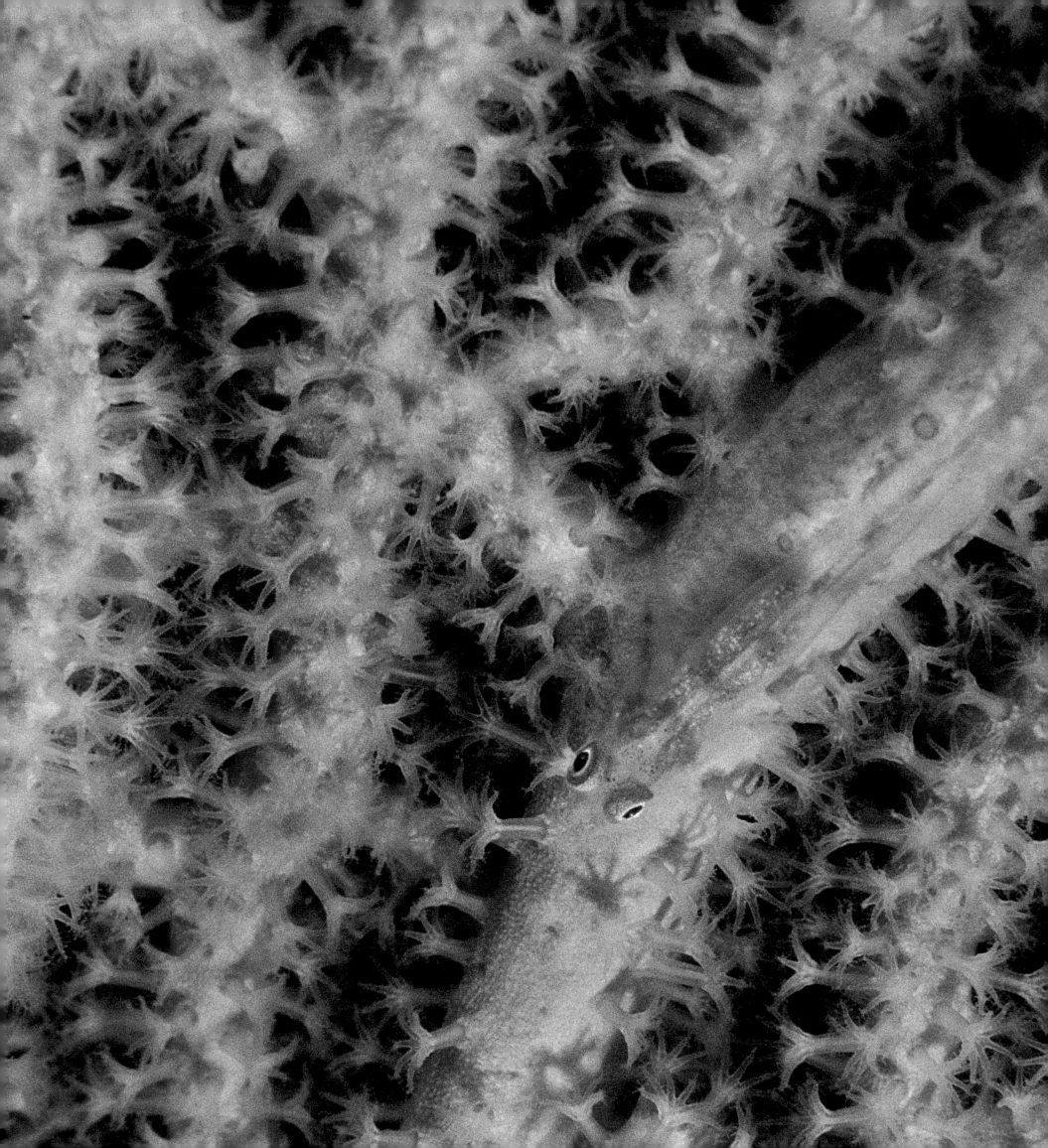

COWFISH SIZE 10 INCHES (25.4CM).
DETAIL SIZE 1½ INCHES (3.81CM).

BONAIRE, NETHERLANDS ANTILLES, CARIBBEAN; 25 FEET (7.6M) DEEP.

A member of the boxfish family, this cowfish
– so called because of two horn-like spines above the eyes –
is protected by a triangular bony box of armour. They can
change colour, darken, or turn pale within a fraction of
a second. I took this picture when the fish was in clear
shallow water and its colours were in top shape.

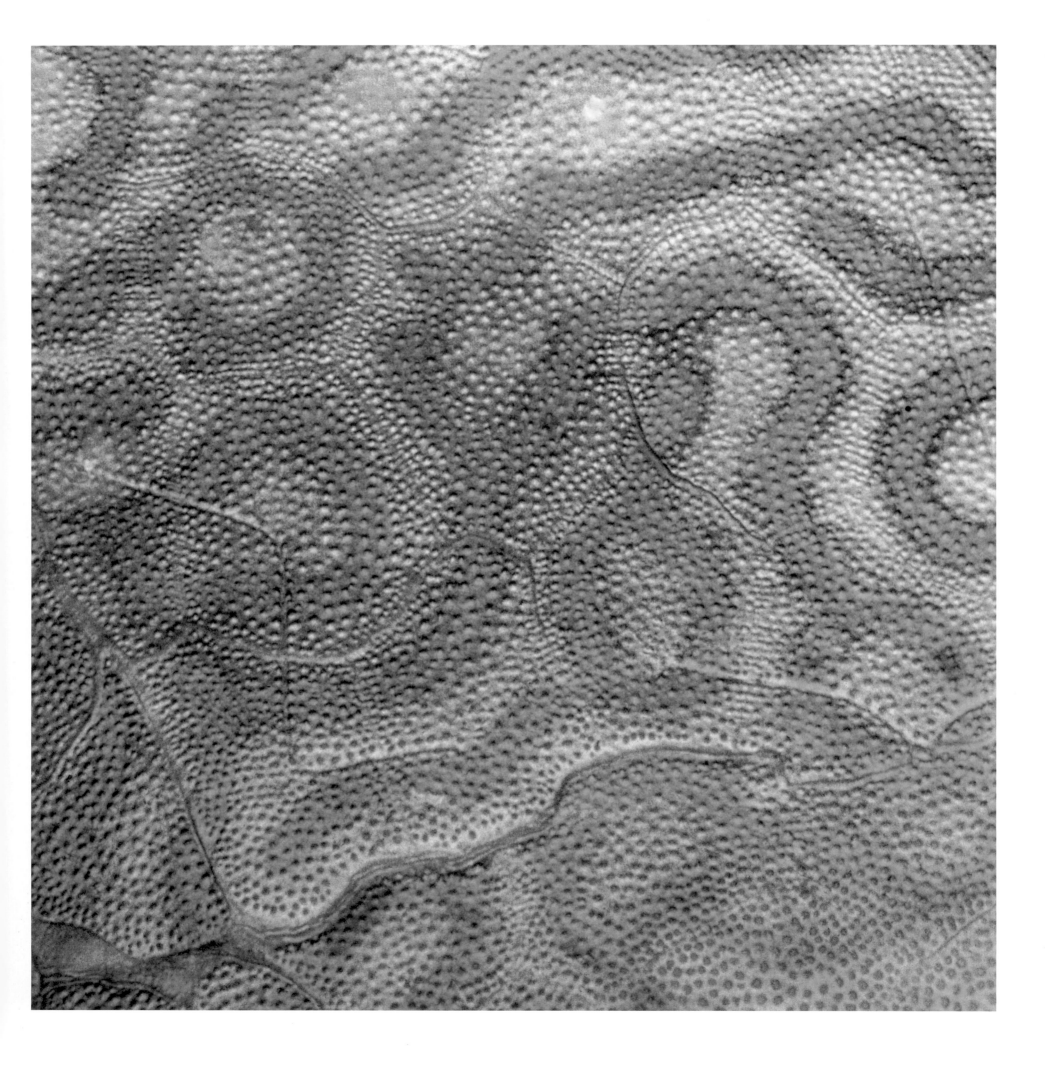

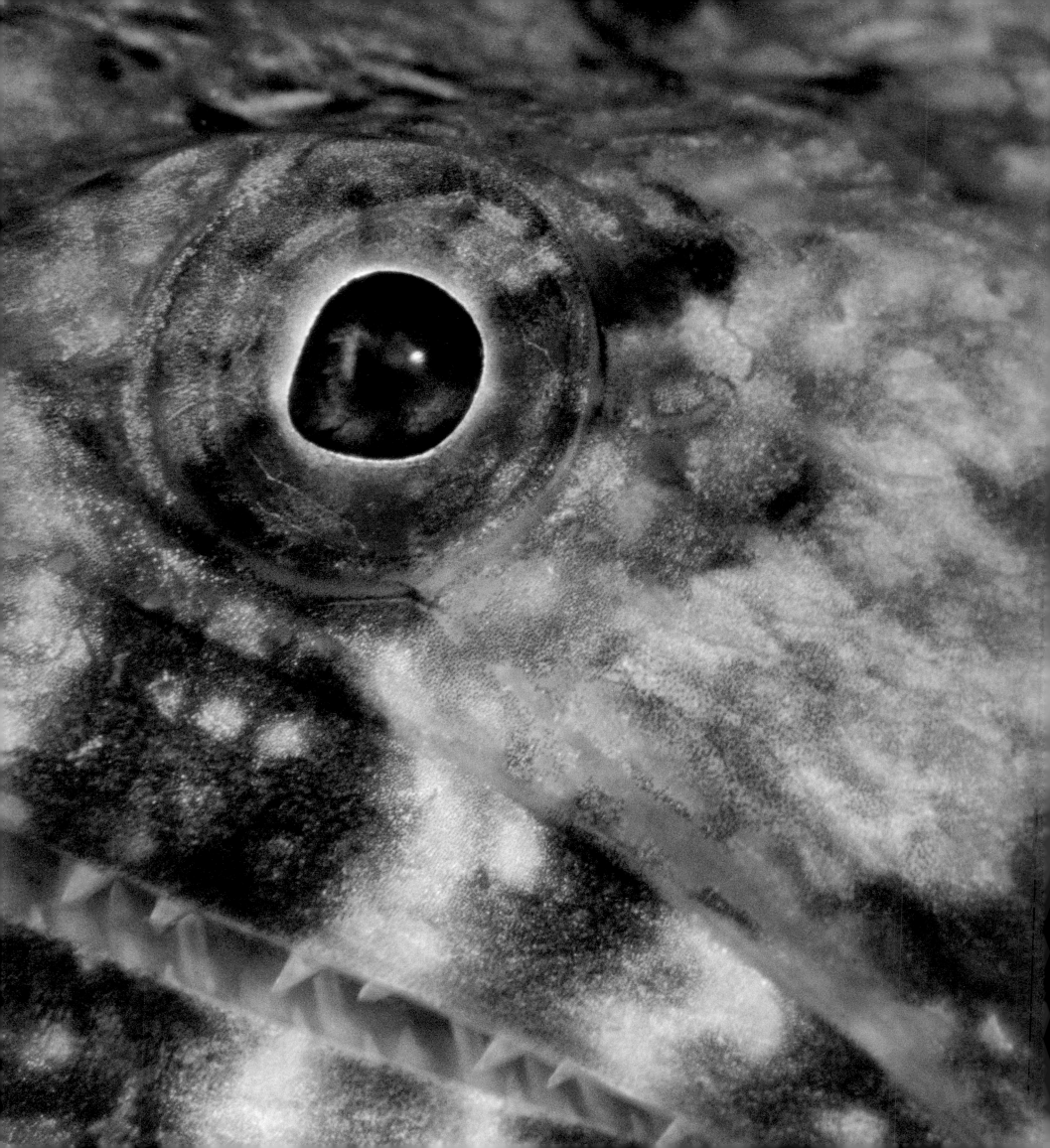

◄ **DETAIL OF A REEF LIZARDFISH**
Synodus variegatus

LIZARDFISH SIZE 10 INCHES (25.4CM).
DETAIL SIZE 1 INCH (2.54CM).

LAYANG–LAYANG ATOLL, SOUTH CHINA SEA, MALAYSIA;
80 FEET (24.4M) DEEP.

Genuine predators with sharp teeth, lizardfish usually lie motionless, on the bottom or on a coral head, until unsuspecting prey swims past.

▼ **DETAIL OF A JUVENILE GIANT CLAM'S MANTLE**
Tridacna crocea

CLAM SIZE 5 INCHES (12.7CM).
DETAIL SIZE 1½ INCHES (3.81CM).

SANGALAKI, SULAWESI SEA, INDONESIA; 90 FEET (27.4M) DEEP.

Although this brilliant blue clam is called "Giant", its maximum size is 6 inches (15 centimetres), whereas its big brother, the *Tridacna gigas*, can reach a diameter of more than 6 feet (2 metres).

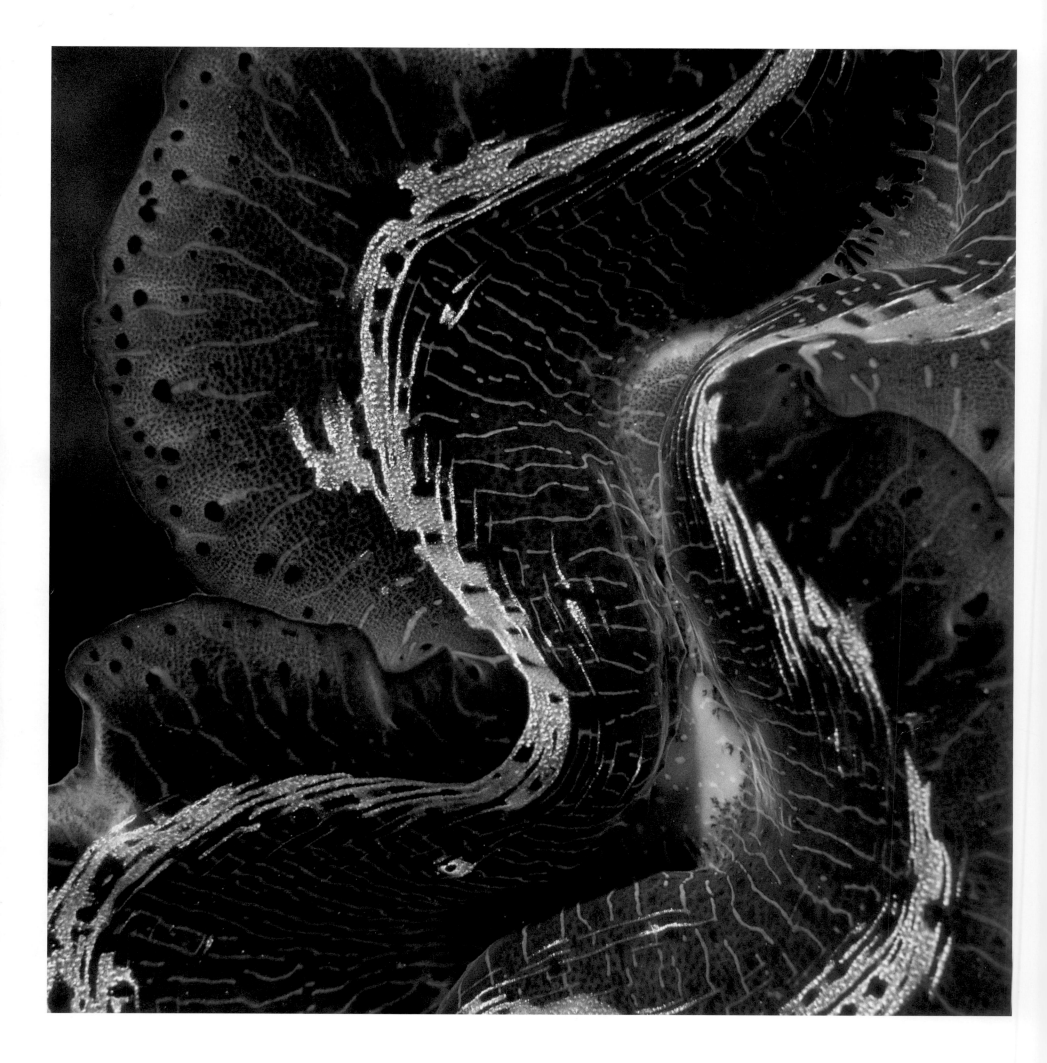

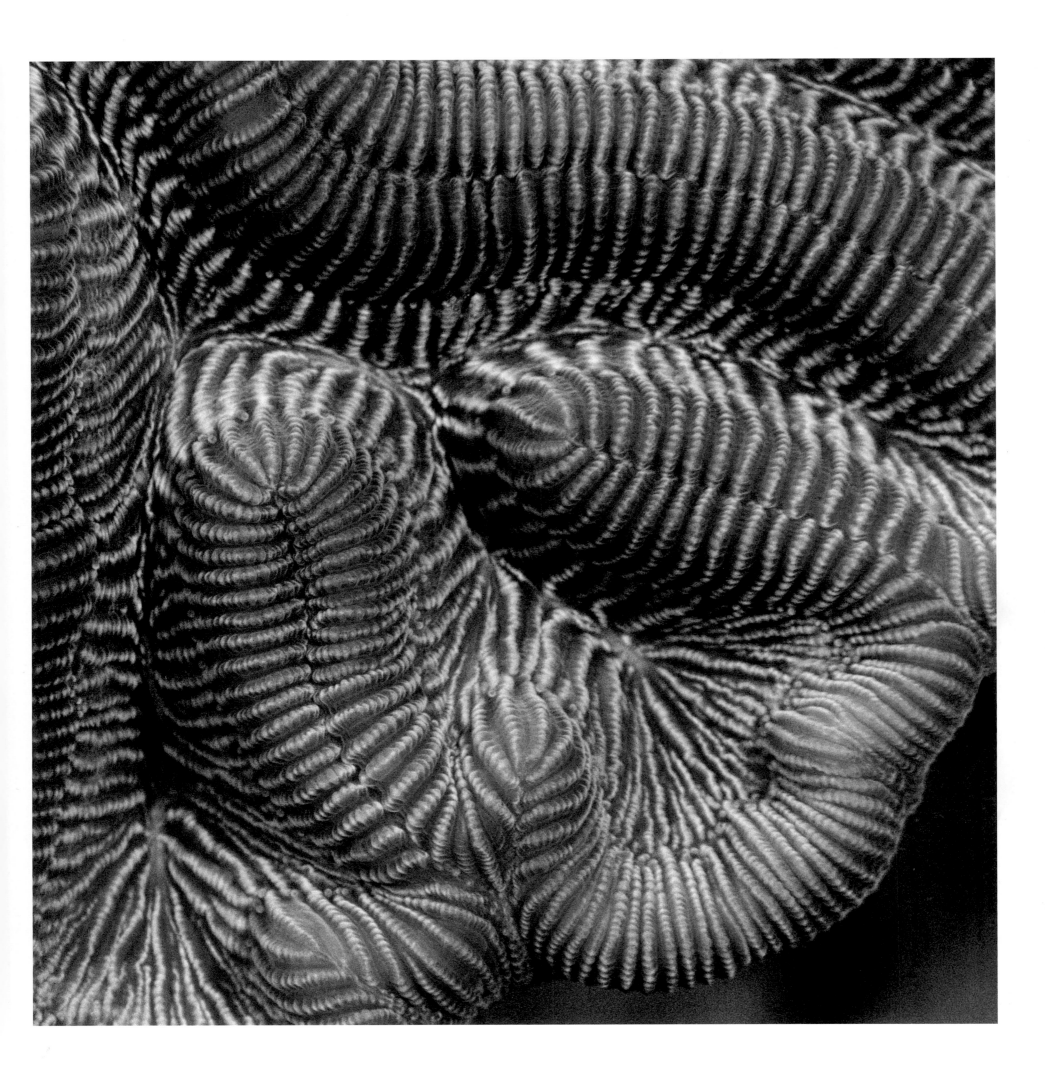

▲ **SYMMETRICAL BRAIN CORAL**
Diploria strigosa

COLONY SIZE VARIES BETWEEN 6 INCHES AND 6 FEET (1.5CM AND 2M).
DETAIL SIZE $5/8$ INCH (1.52CM).

BONAIRE, NETHERLANDS ANTILLES, CARIBBEAN; 60 FEET (18.3M) DEEP.

Symmetrical Brain Coral can form smoothly contoured plates to hemispherical domes. In the healthy Caribbean waters surrounding Bonaire, several huge domes can be found. The name brain coral is derived from its similarity to the structure and texture of the brain.

▶ **CHRISTMAS TREE WORM**
Spirobranchus giganteus

WORM SIZE $1/2$ INCHES (3.81CM).
DETAIL SIZE $1/2$ INCH (1.27CM).

NEW BRITAIN, BISMARCK SEA, PAPUA NEW GUINEA;
40 FEET (12.2M) DEEP.

Christmas Tree Worms are found in all tropical seas around the world. Their colour is highly variable. The brighter colours, such as bright blue or red, are found in the Indo-Pacific. This worm consists of two spiralled crowns of *radioles* and they are fixed on hard coral with a calcareous tube. When approached they instantly retract their crowns into the tube and close the opening with an *operculum*.

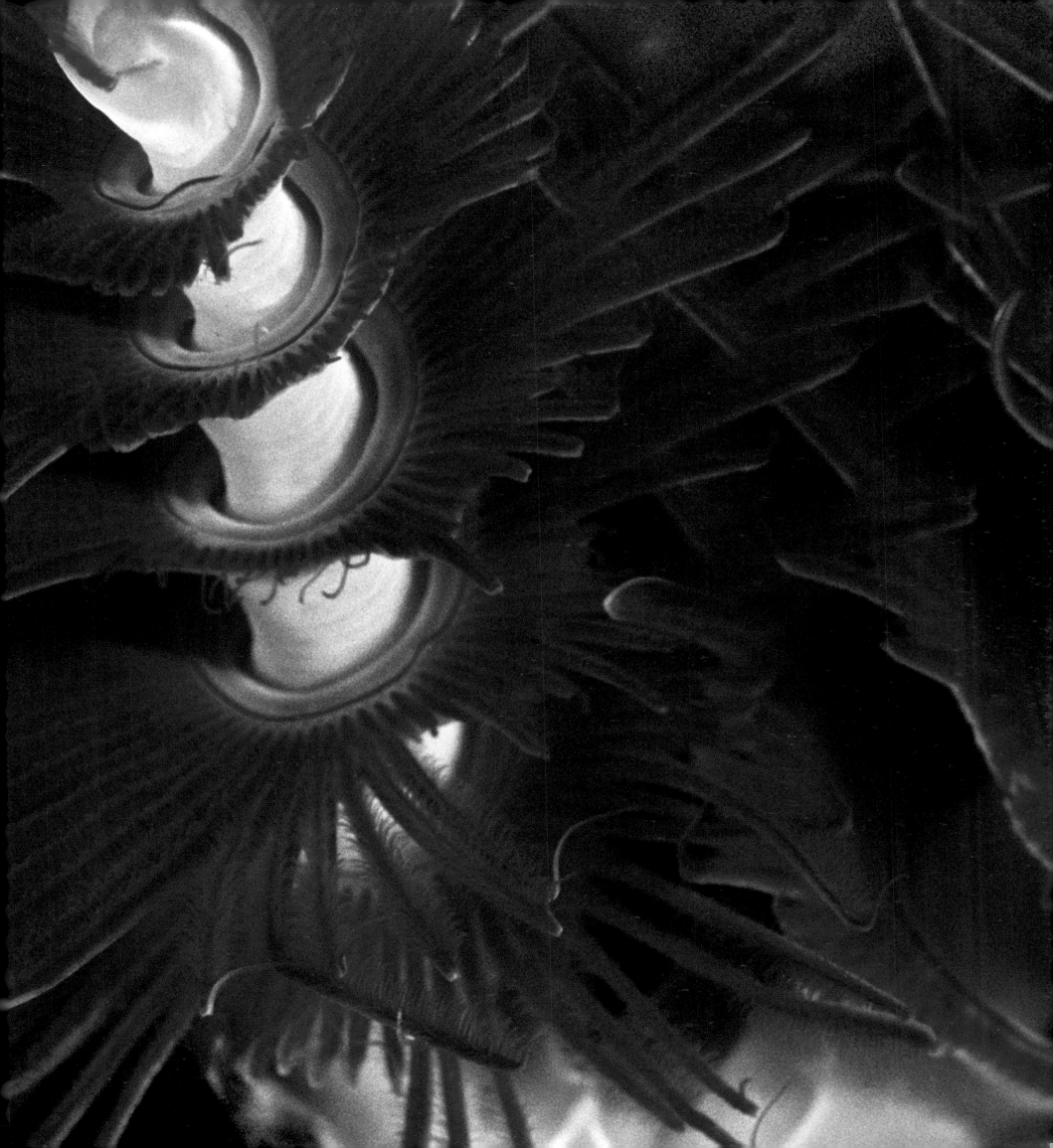

POLYP OF ORANGE CUP CORAL
Tubastraea faulkneri

POLYP SIZE $^3/_4$ INCH ^2.03CM).

BALI, INDONESIA; 18 FEET (6.3M) DEEP.

Tubastraea will grow exclusively in places without broad daylight, such as under ledges, in wrecks and on pillars. They seldom form huge colonies and don't belong to the reef forming corals.

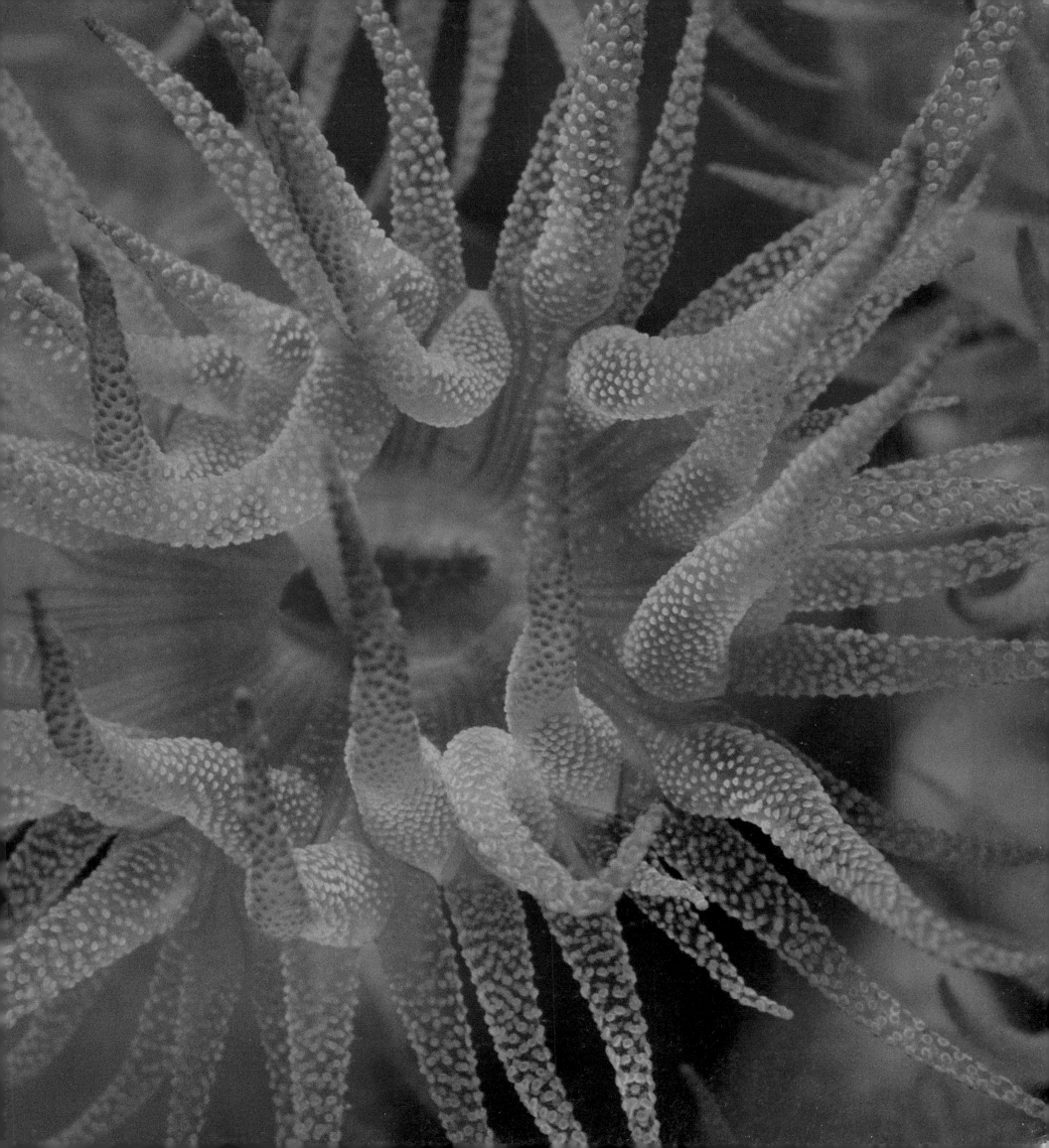

ANEMONE SIZE 2 INCHES (5.08CM).

SHARM EL SHEIKH, RED SEA, EGYPT; 65 FEET (19.8M) DEEP.

These beautiful anemones mostly grow on the branches of dead soft corals. As with most coral polyps, the anemone's tentacles contain a special type of algae, named *zooxanthellae*. They utilise sunlight and carbon dioxide to produce high-energy substances that are leaked to the host anemones, thus providing an important dietary supplement.

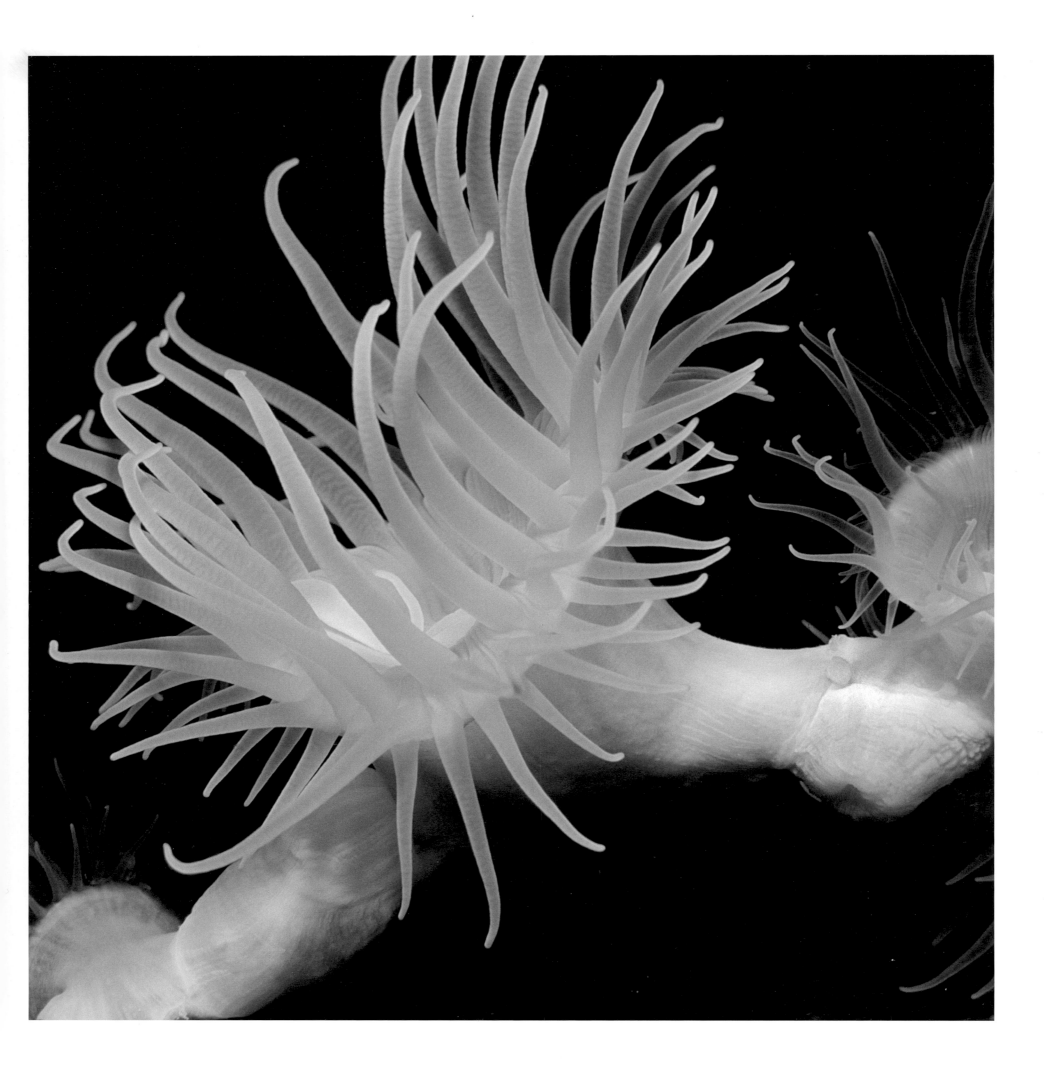

The inner white-dotted tentacles contain calcium
which makes their tissue hard, hence the name "prickly".
The outer greenish wreath consists of soft tentacles.
Like most stony or hard corals, this coral is nocturnal.

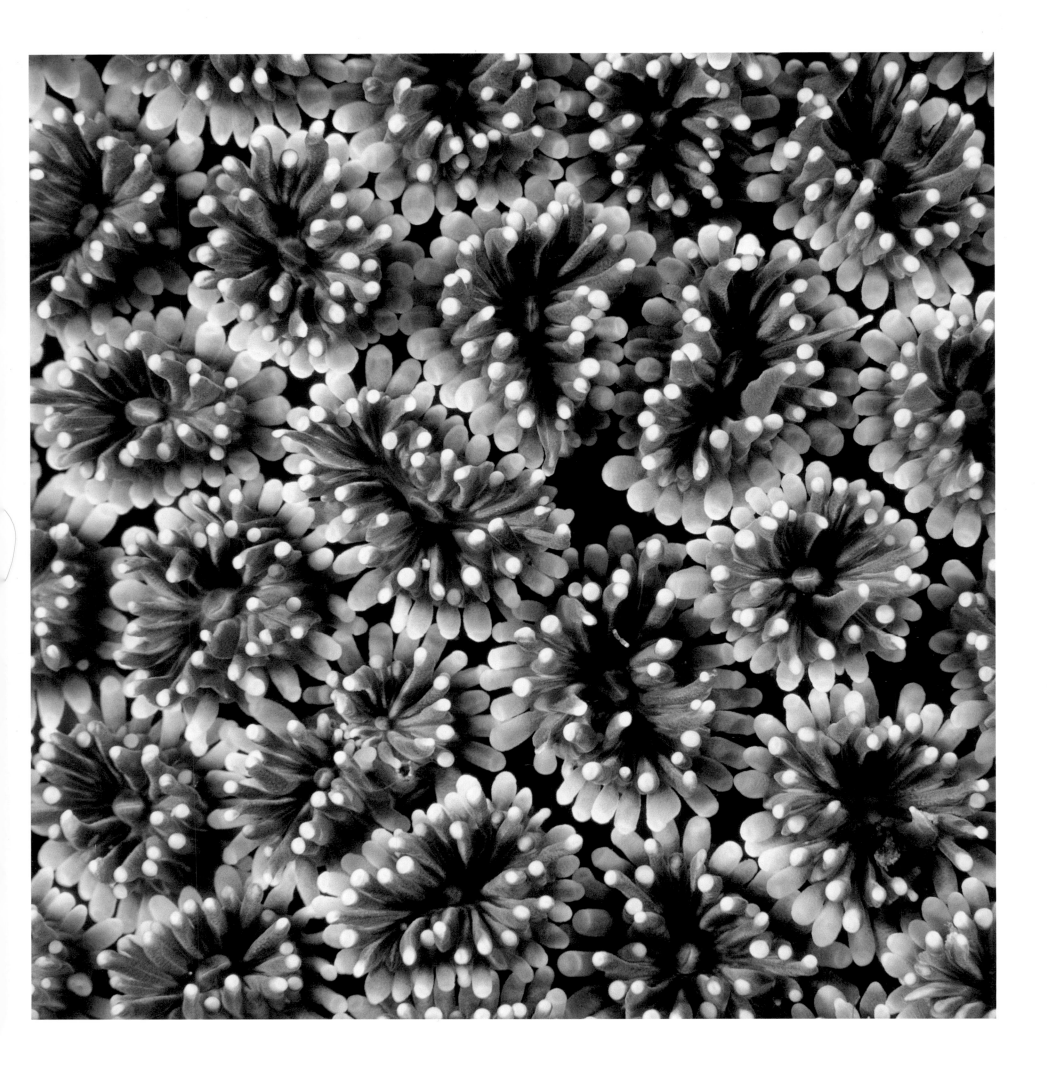

**STRIPED OR NEON TRIPLEFIN ON OYSTERS COVERED
WITH AN ENCRUSTING SPONGE**
Helcogramma striatum

TRIPLEFIN SIZE 1¼ INCHES (3.05CM).
PICTURE SIZE 1½ INCHES (3.81CM).

MANADO, NORTH SULAWESI, INDONESIA; 65 FEET (19.8M) DEEP.

Triplefins get their name from their three-part dorsal fin.
The family is little known and many species have no
scientific description. This small fish can often be found
motionless on a sponge or coral, suddenly shooting
off to capture a tiny alga or invertebrate, imperceptible
to the human eye.

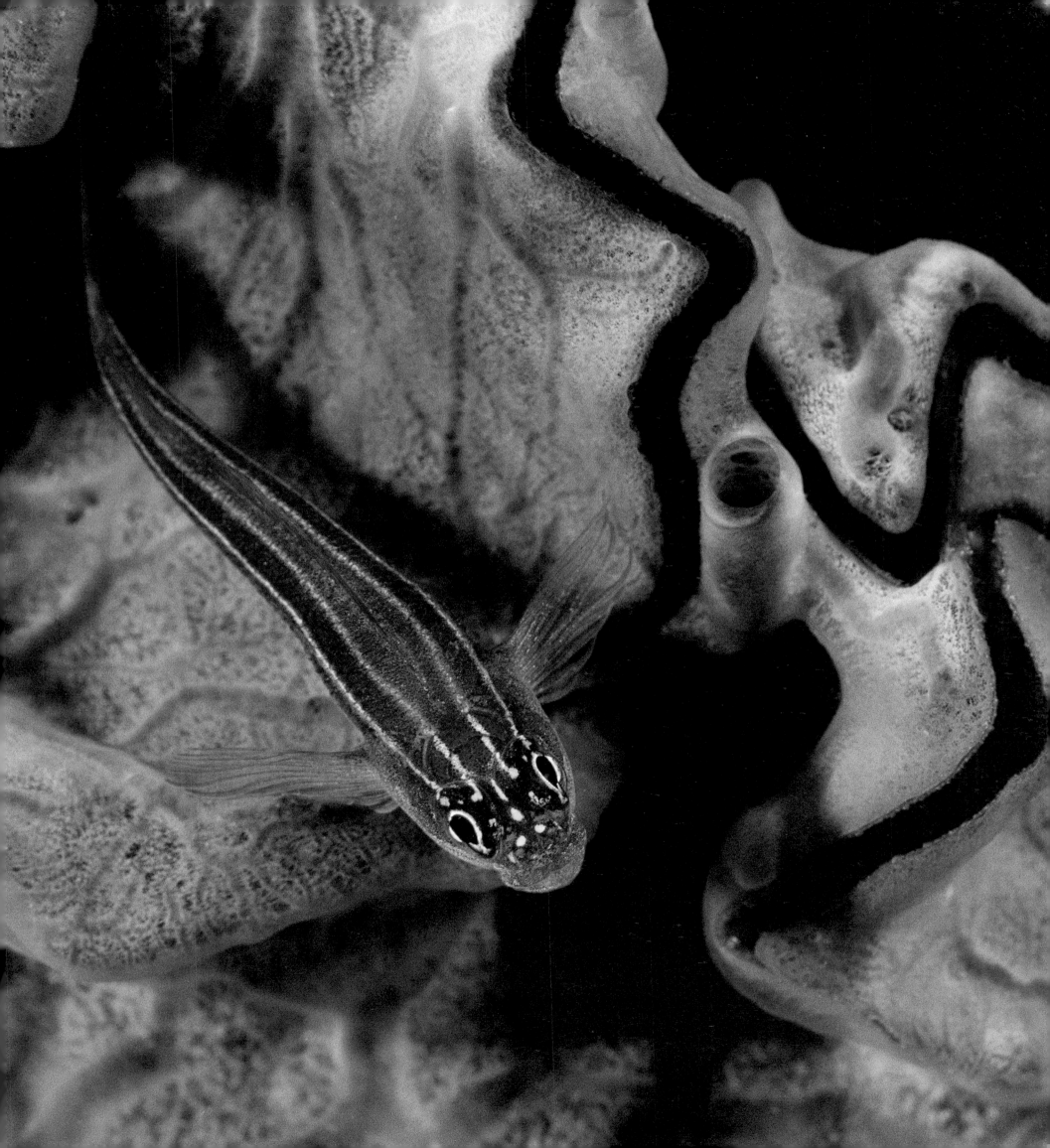

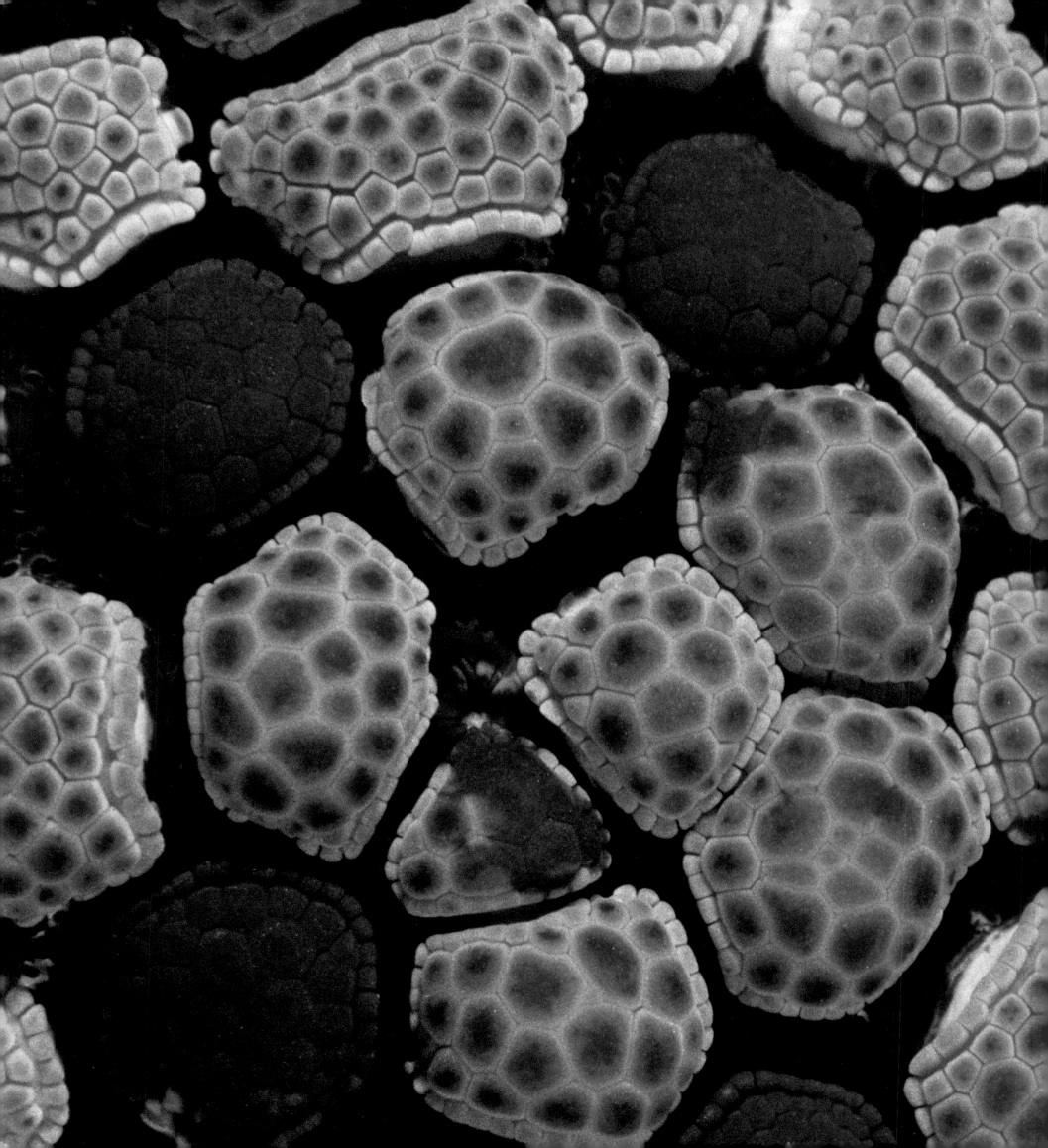

CENTRAL BODY OF A STARFISH
Nectria ocellata

STARFISH SIZE 4 INCHES (10.16CM).
PICTURE SIZE 1 INCH (2.54CM).

KANGAROO ISLAND, SOUTH AUSTRALIA; 60 FEET (18.3M) DEEP.

When I photographed this starfish I was surrounded by young Australian Sea Lions. One touched my mask several times; he obviously wanted to play. Then, suddenly he took the starfish and started to play with it, offering it to me several times. Finally he left, leaving the starfish upside-down on the bottom. I inspected it and it turned out to be undamaged. I returned it to exactly the spot where I had been photographing it.

This member of the sea bass family usually rests quietly on the bottom of the sea waiting for prey. The greenish eye colour indicates that this juvenile fish has almost reached maturity.

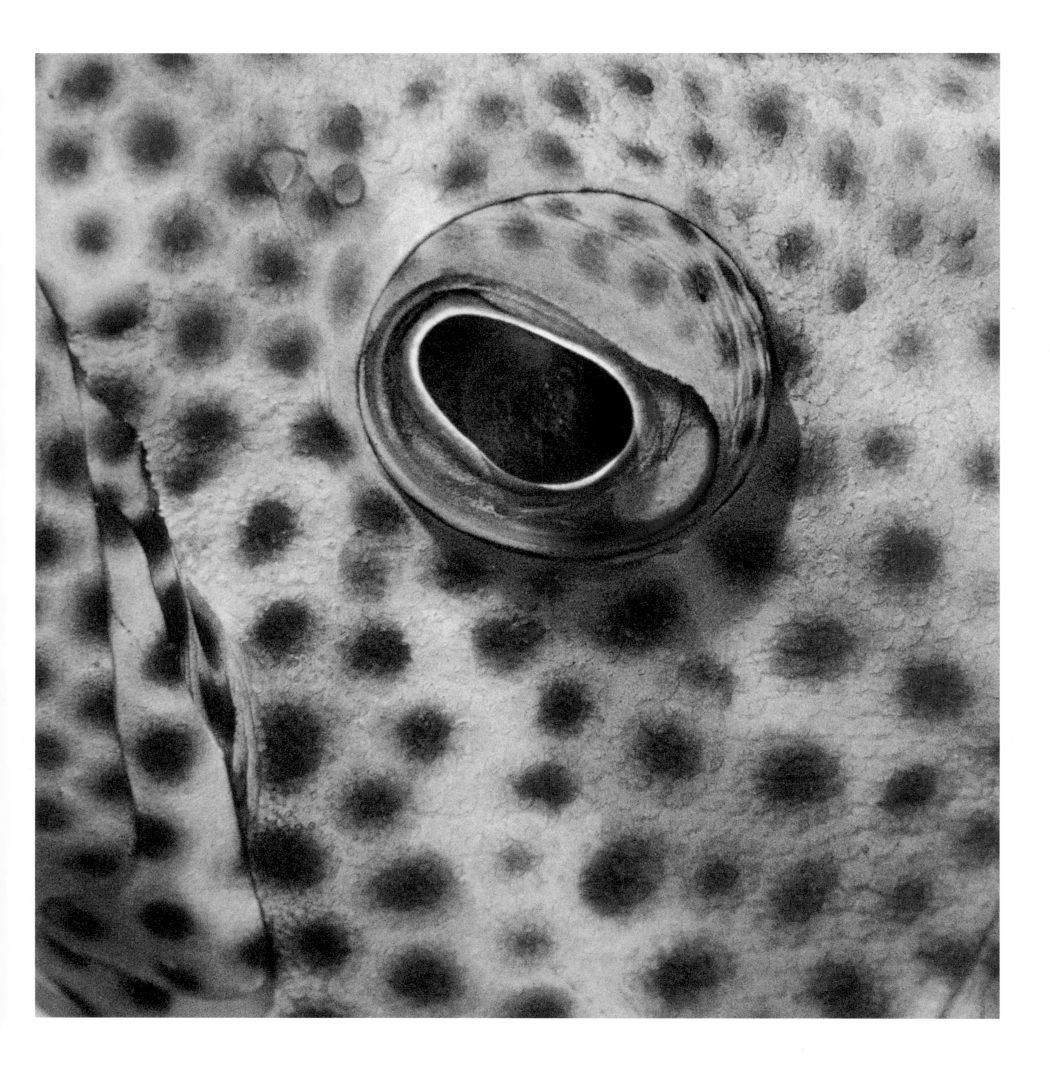

DETAIL WITH EYE OF A BLUEBARRED PARROTFISH
Scarus ghobban

PARROTFISH SIZE 18 INCHES (45.72CM).

DETAIL SIZE 1¹/₂ INCHES (3.81CM).

MARSA ALAM, RED SEA, EGYPT; 50 FEET (15.2M) DEEP.

Whenever I find a parrotfish not in its deepest sleep, I will not disturb it and immediately stop photographing, since the light of the flash at night is very frightening to non-sleeping fish. I have seen the fish swim away and bump against the coral, sometimes injuring themselves, when other photographers tried to take pictures.

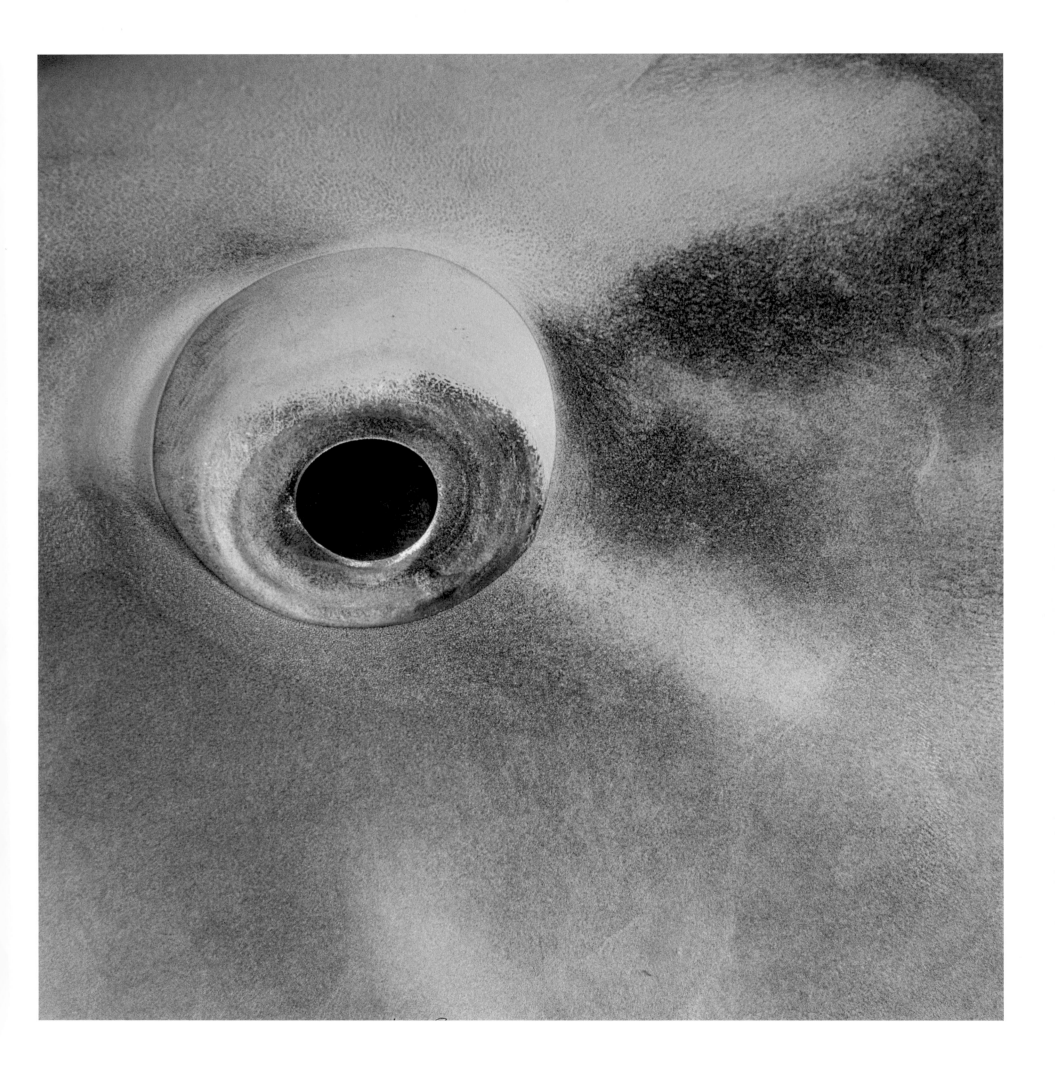

MOZAMBIQUE HOST GOBY (COMMON GHOST GOBY)
ON STONY CORAL
Pleurosicya mossambica | *Favia* sp.

GOBY SIZE ³/₄ INCH (1.78CM).
PICTURE SIZE 2¹/₂ INCHES (6.35CM).

SUMBAWA, TANJUNG BRENTI, INDONESIA; 80 FEET (24.4M) DEEP.

Common on all kinds of corals, this goby species shows many different colour variations from yellow to brown. However, the eyes are usually red, although the intensity of the red may vary.

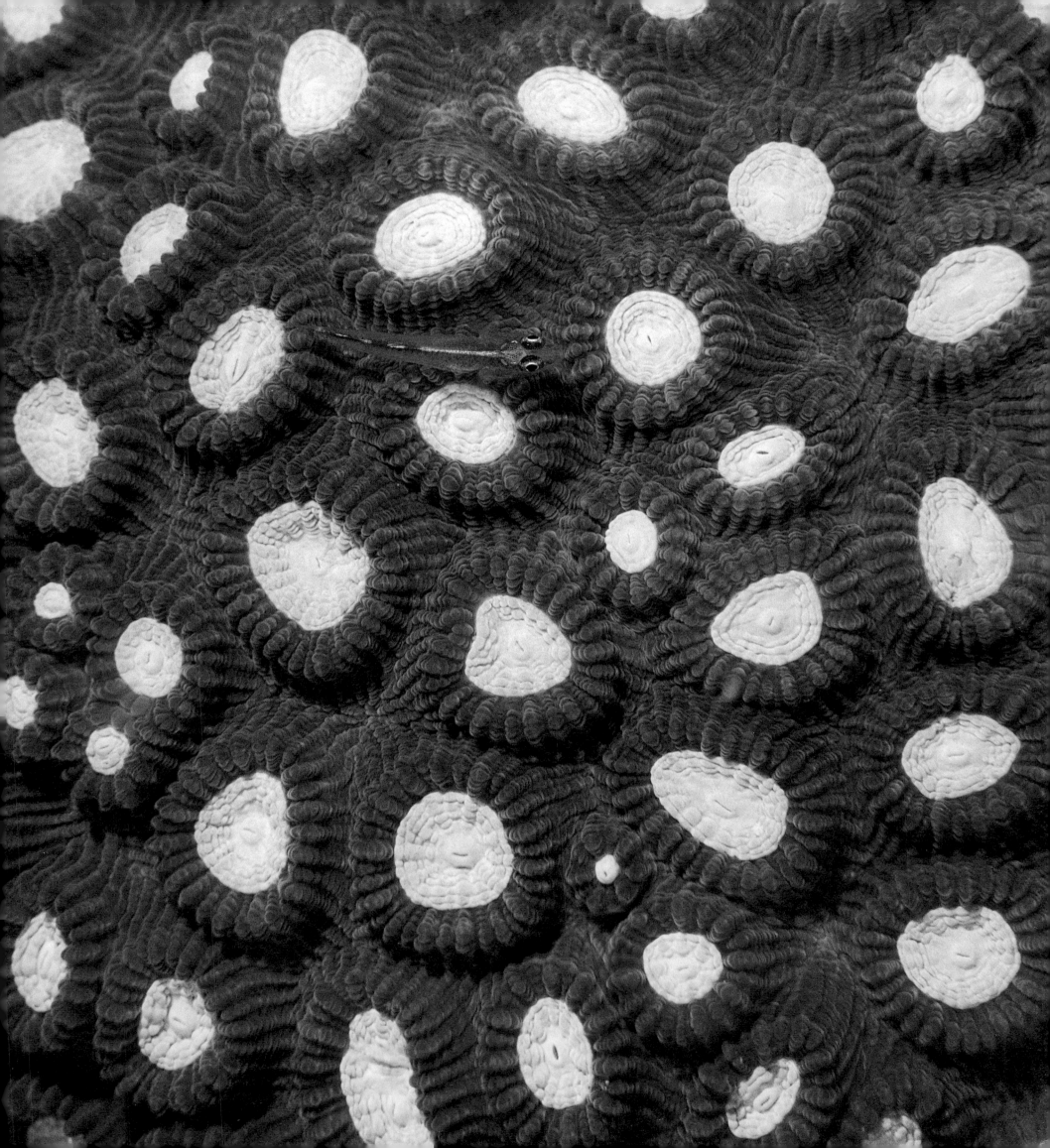

MAGNIFICENT SEA ANEMONE'S MOUTH
Heteractis magnifica

ANEMONE SIZE 18 INCHES (45.72CM).
PICTURE SIZE 2 INCHES (5.08CM).

HELENGELI, MALDIVES; 45 FEET (13.7M) DEEP.

Tentacles, located on the oral disc, the sea anemone's most conspicuous feature, are used to catch food, usually plankton plants and zooplankton, and to transport these to its mouth. The number of tentacles varies depending on the species.

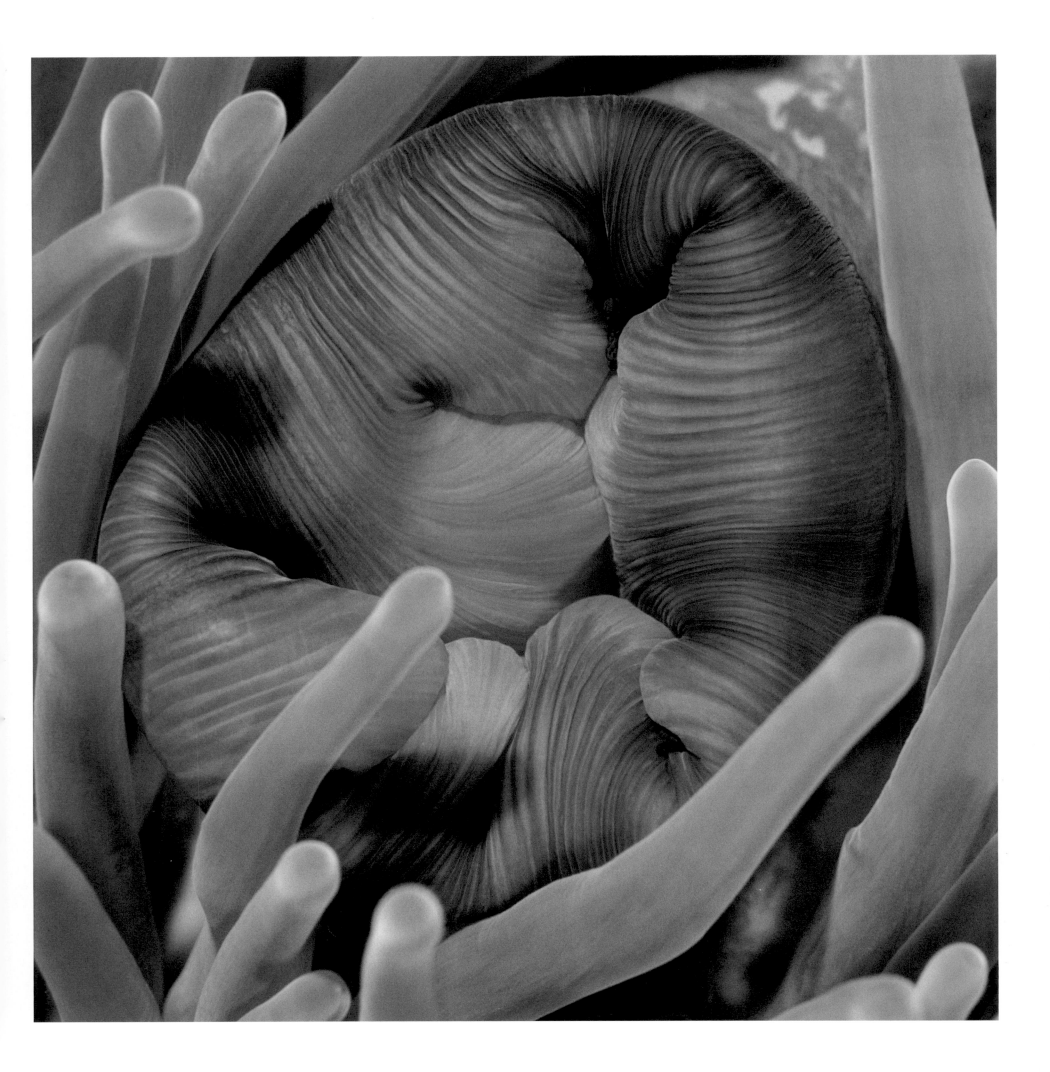

COMMON REEF CUTTLEFISH EYE
Sepia latimanus

CUTTLEFISH SIZE 15 INCHES (38.1CM).
SIZE OF THE EYE $\frac{1}{2}$ INCH (1.27CM).

BIRMA BANKS, INDIAN OCEAN; 60 FEET (18.3M) DEEP.

Due to its ability to change colours in a split second,
this member of the cephalopod class is not always easy to
find on the reef. When in danger, the animal spouts
a dark, ink-like substance to disorient its attacker.

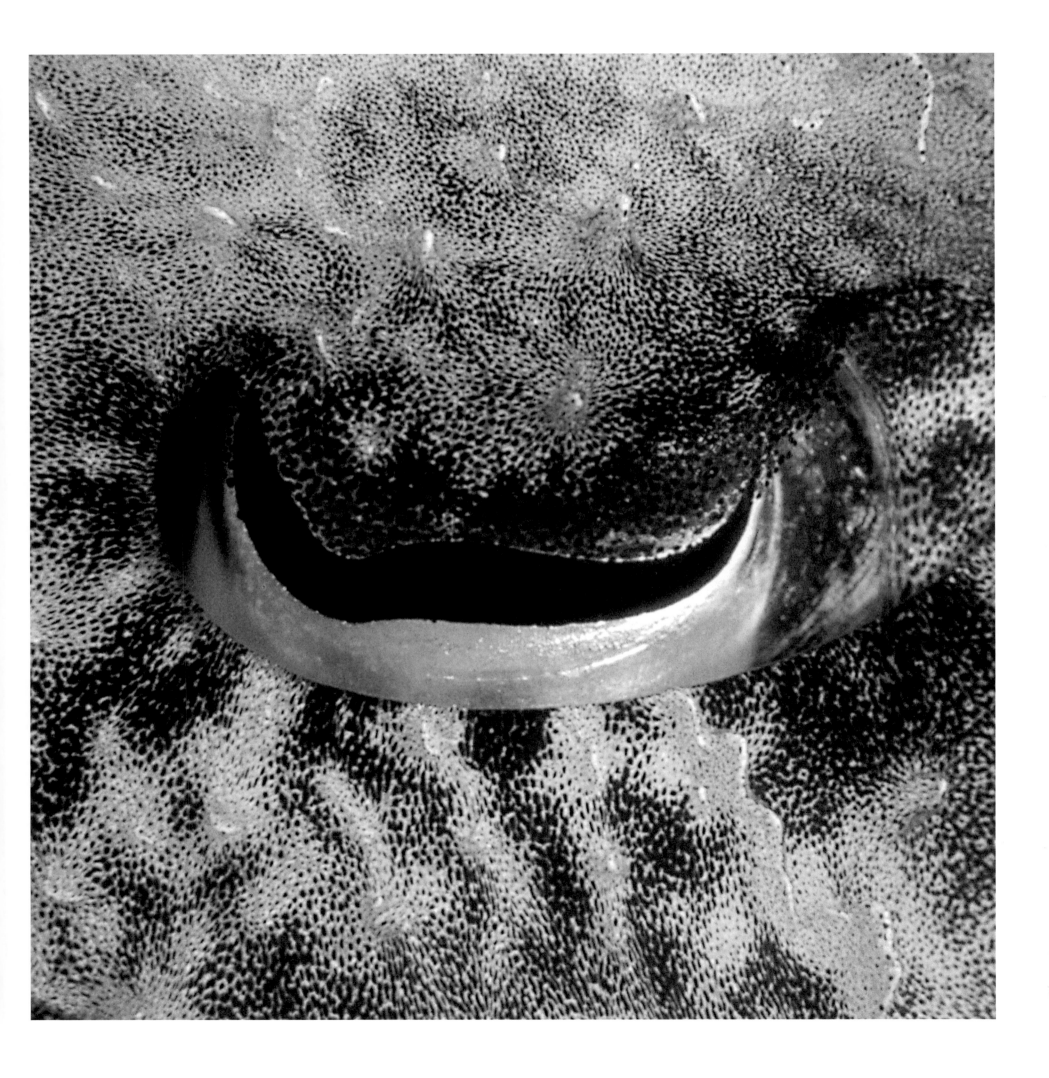

PECTORAL FIN OF A WHITE-SPOTTED PUFFER
Arothron hispidus

PUFFER SIZE 12 INCHES (30.48CM).
DETAIL SIZE $3/4$ INCH (2.03CM).

MARSA ALAM, RED SEA, EGYPT; 25 FEET (7.6M) DEEP.

Like a second eye, this puffer has a striking circle around the base of its pectoral fin. Maybe this is to confuse possible predators: they will attack this false eye instead of the more vulnerable, real one.

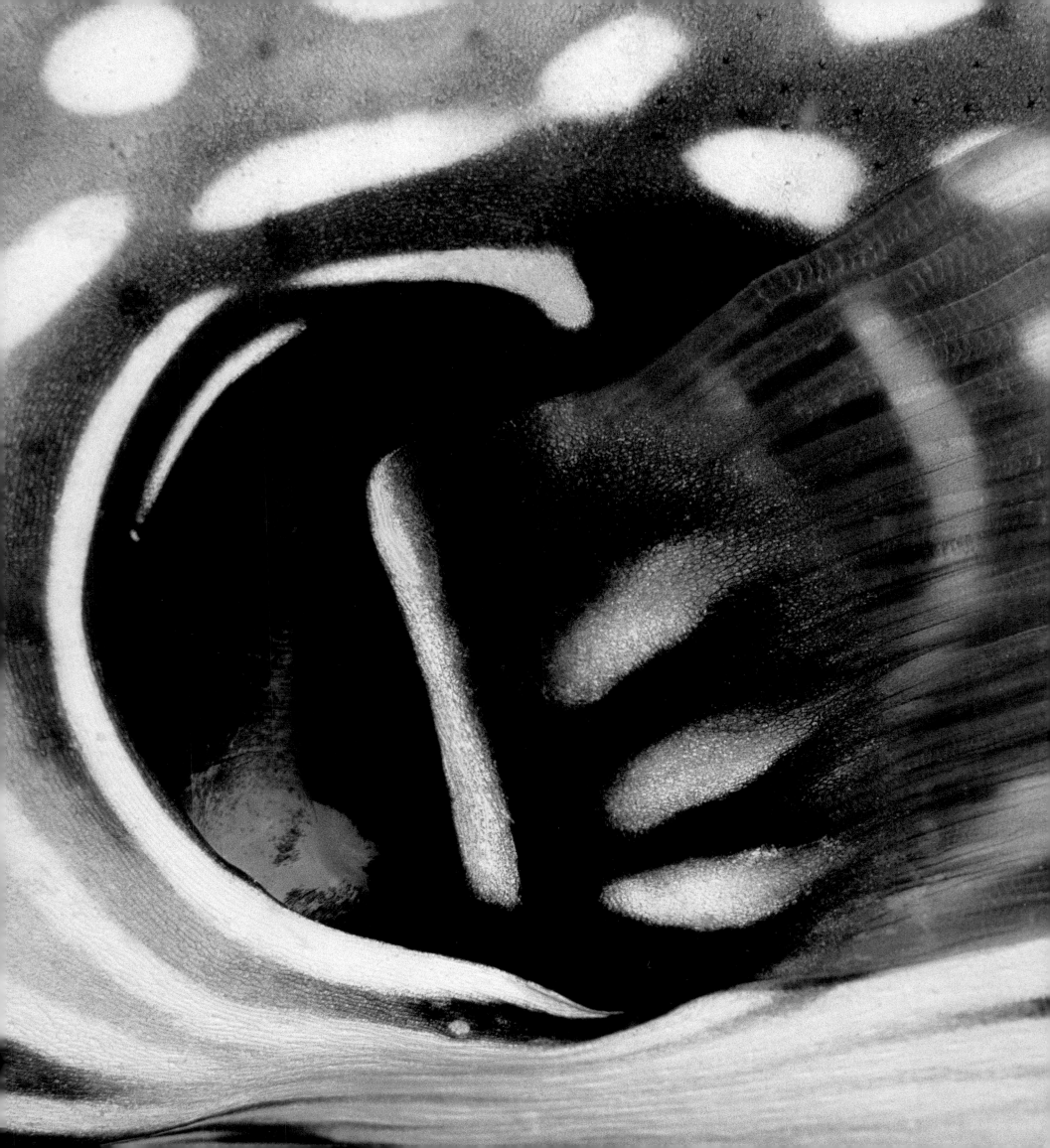

DETAIL OF A STONE CORAL
Montipora confusa

PICTURE SIZE 1 INCH (2.54CM).

LAYANG-LAYANG ATOLL, SOUTH CHINA SEA, MALAYSIA;
40 FEET (12.2M) DEEP.

Not many corals show this lilac colour which is present
only on the coral's outside. The rest of the colony
is yellowish brown, a common colour for Stone Corals.
The detail shown in the photograph was captured during
the day. The polyps have retired, awaiting the night.

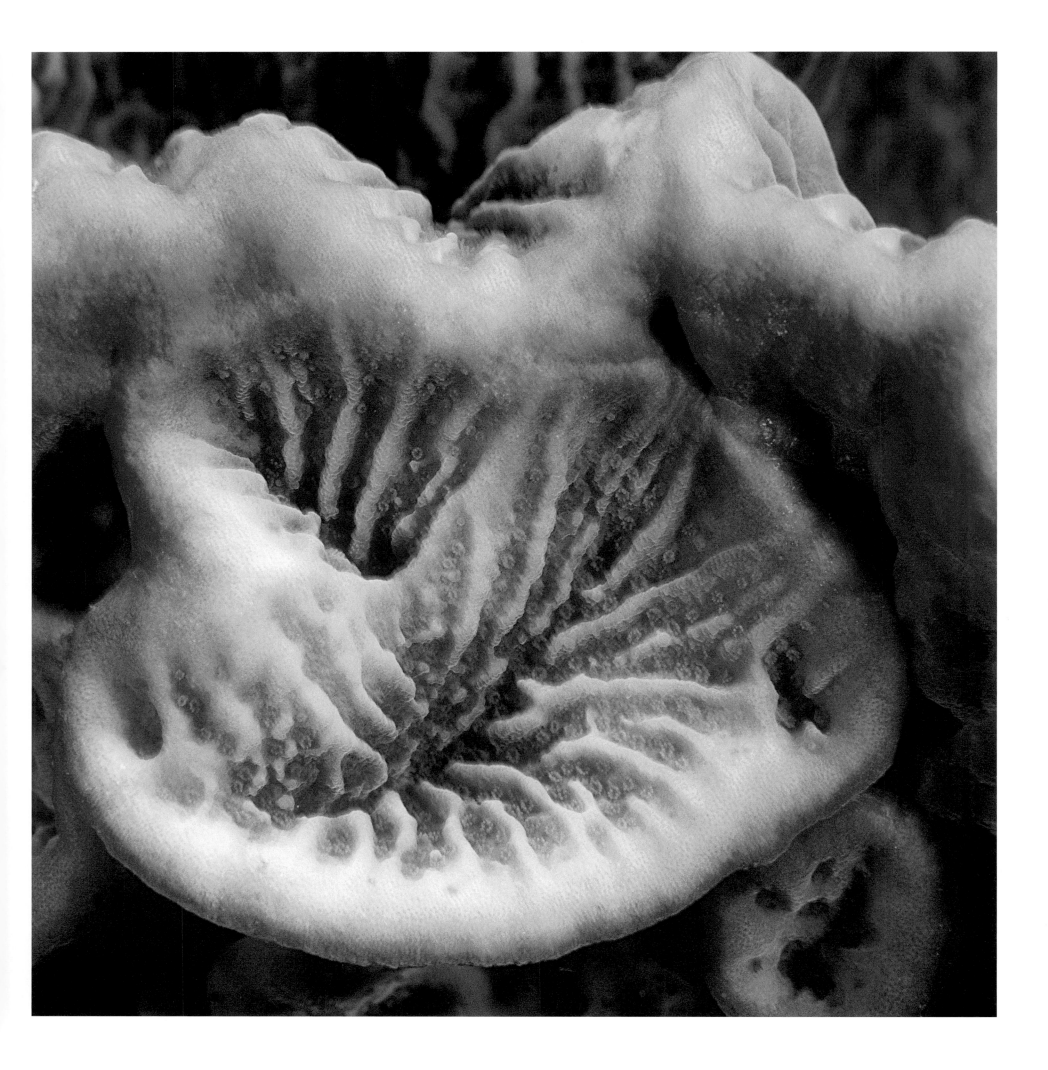

Leaf Oysters can make themselves invisible by allowing encrusting red sponge to grow on their surfaces. Sponges are characterised by numerous tiny incurrent pores or *ostia*. The water is then pumped through the interior and oxygen and food are filtered out. Finally the water leaves the sponge through the larger excurrent opening or *osculum*, clearly visible on this photograph.

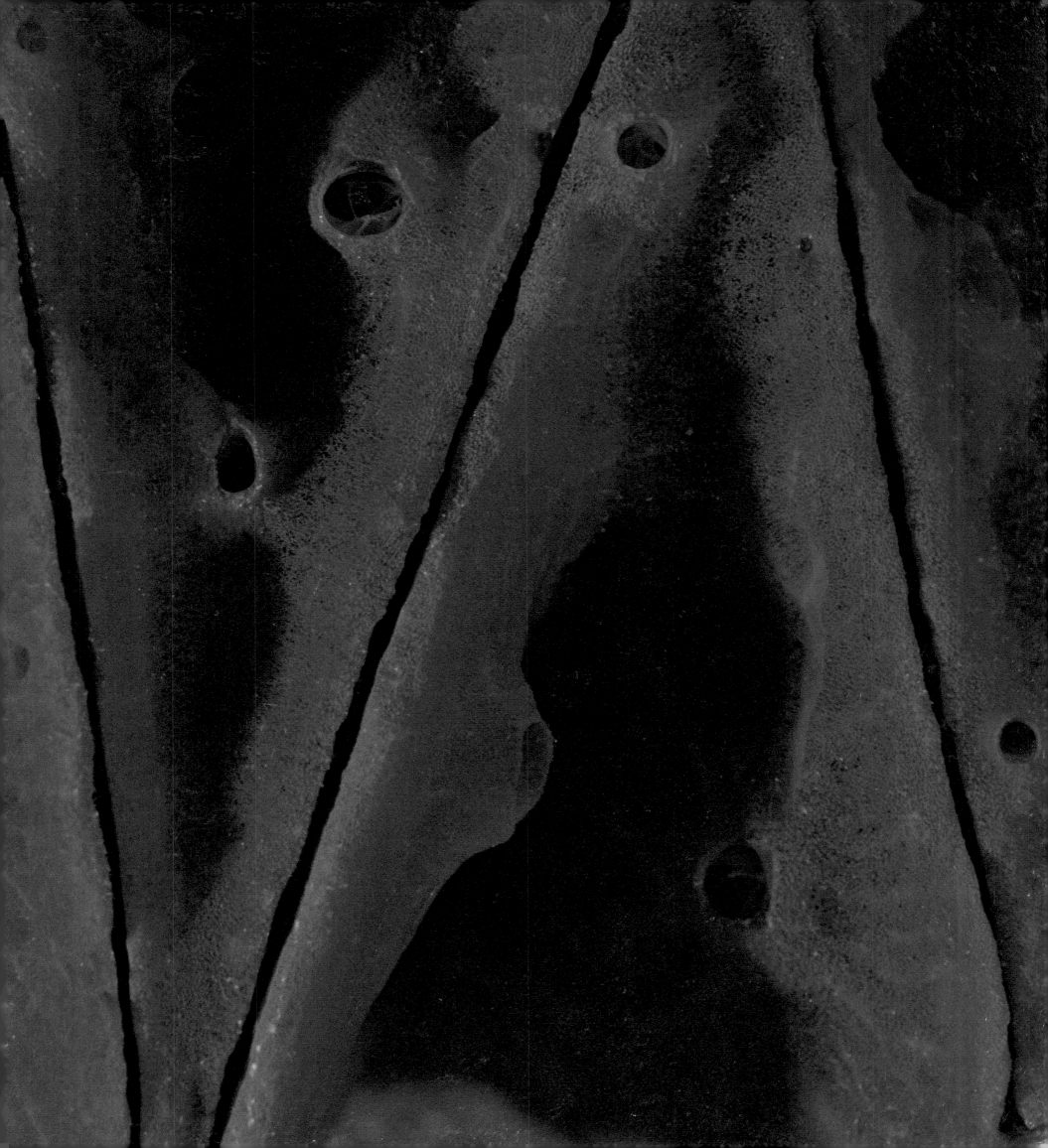

DETAIL OF A MUSHROOM CORAL
Fungia fralinae

CORAL SIZE 4 INCHES (10.16CM).
PICTURE SIZE 1 INCH (2.54CM).

LAYANG–LAYANG ATOLL, SOUTH CHINA SEA, MALAYSIA;
40 FEET (12.2M) DEEP.

During the day, this solitary single-polyp Mushroom Coral
has its polyp retracted. At night the polyp emerges.
The tentacles then visible all belong to the same polyp.

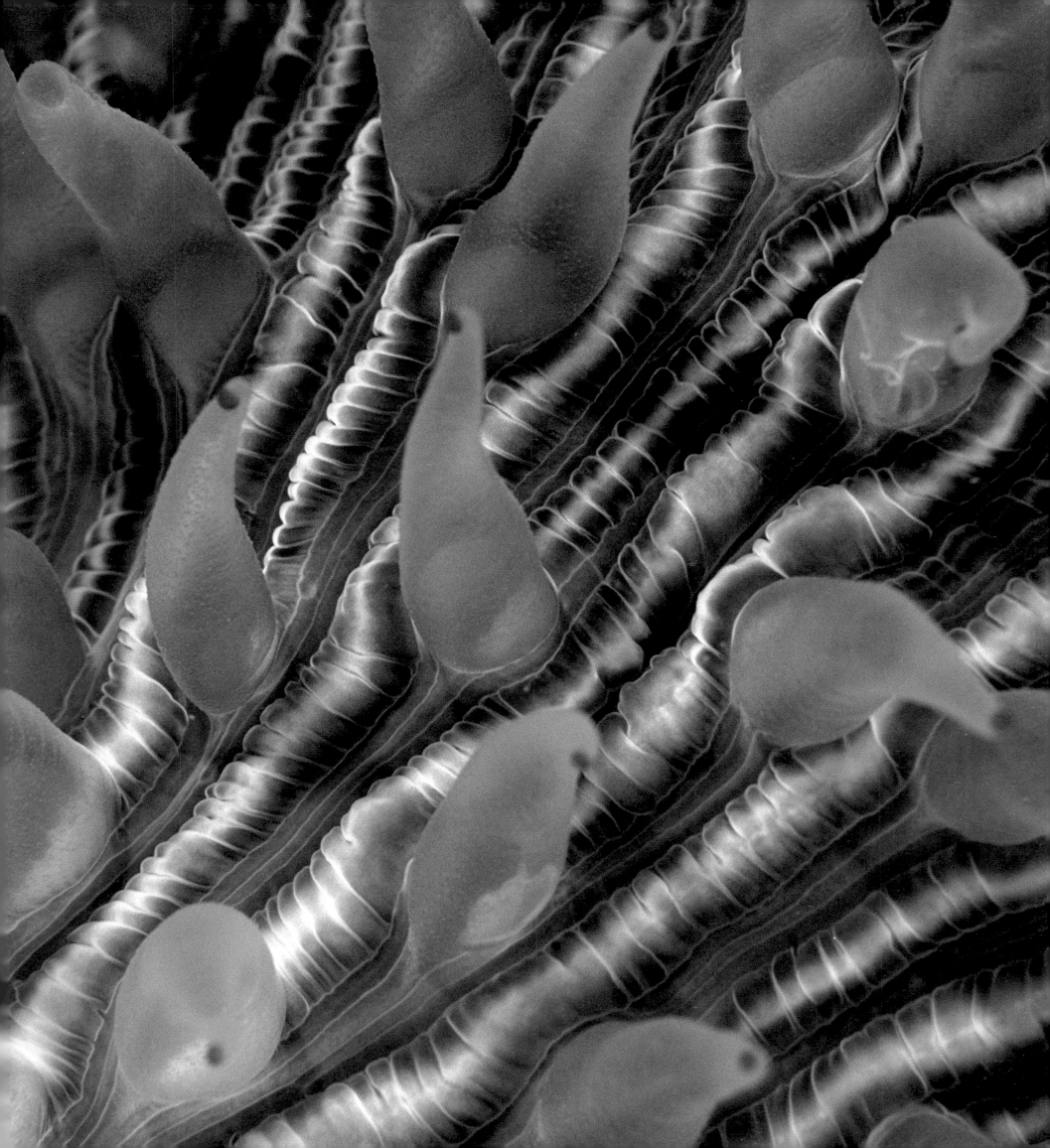

**ANEMONE SHRIMP ON THE TENTACLES
OF A MAGNIFICENT SEA ANEMONE**
Periclimenes tosaensis | Heteractis magnifica

SHRIMP SIZE ³/₄ INCH (2.03CM).
PICTURE SIZE 2 INCHES (5.08CM).

SATONDA, INDONESIA; 50 FEET (15.2M) DEEP.

With its long, white antennas this shrimp signals that it is a "cleaner". Fish recognise this signal and they patiently let the "cleaners" do their job. At times there is a line of fish patiently awaiting their turn. Thus, fish get rid of their nasty parasites and shrimp eat their meal.

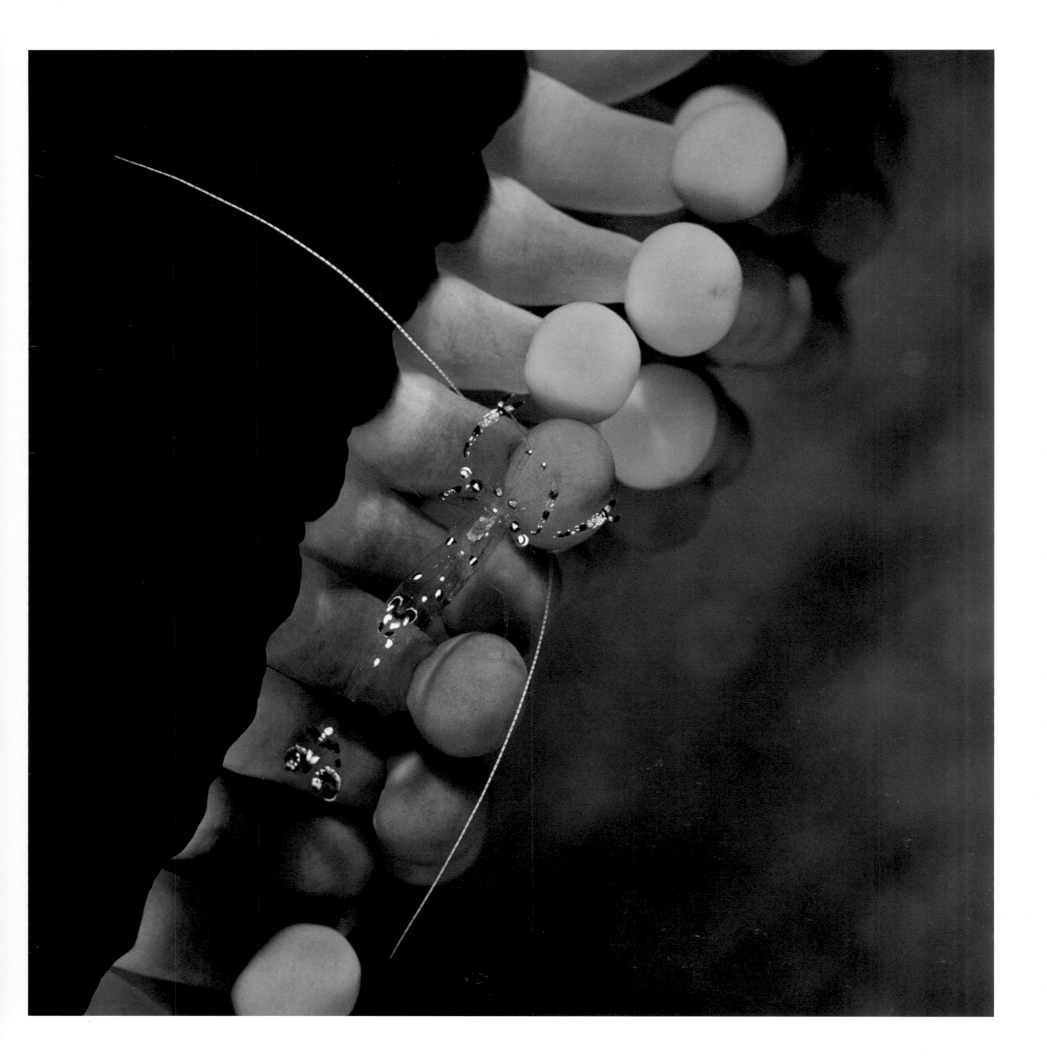

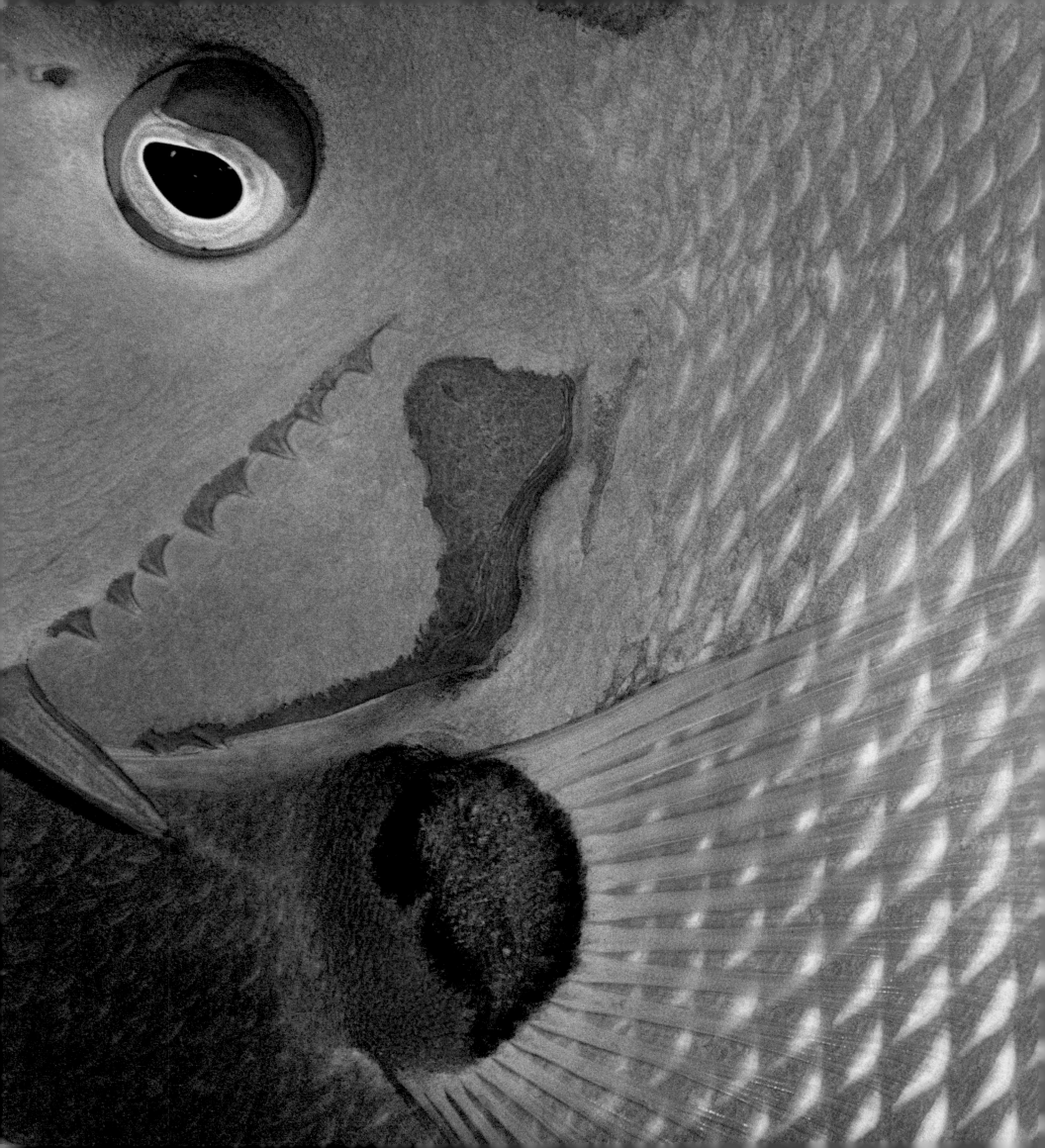

DETAIL OF A QUEEN ANGELFISH
Holacanthus ciliaris

ANGELFISH SIZE 14 INCHES (35.56CM).

DETAIL SIZE 3 INCHES (7.62CM).

BONAIRE, NETHERLANDS ANTILLES, CARIBBEAN; 65 FEET (19.8M) DEEP.

This somewhat shy fish is my favourite photo object in the waters surrounding the island of Bonaire. It's a real challenge to come as close as possible and pictures of each part of its body deserve an entry in this book.

DETAIL OF A PRINCESS PARROTFISH
Scarus taeniopterus

PARROTFISH SIZE 12 INCHES (30.48CM).
DETAIL SIZE 2 INCHES (5.08CM).

BONAIRE, NETHERLANDS ANTILLES, CARIBBEAN; 65 FEET (19.8M) DEEP.

Parrotfish colour combinations can be incredibly beautiful. Their teeth are grown together and they use them to scrape algae from corals and rocks. Their droppings are the most important source of sand in tropical seas.

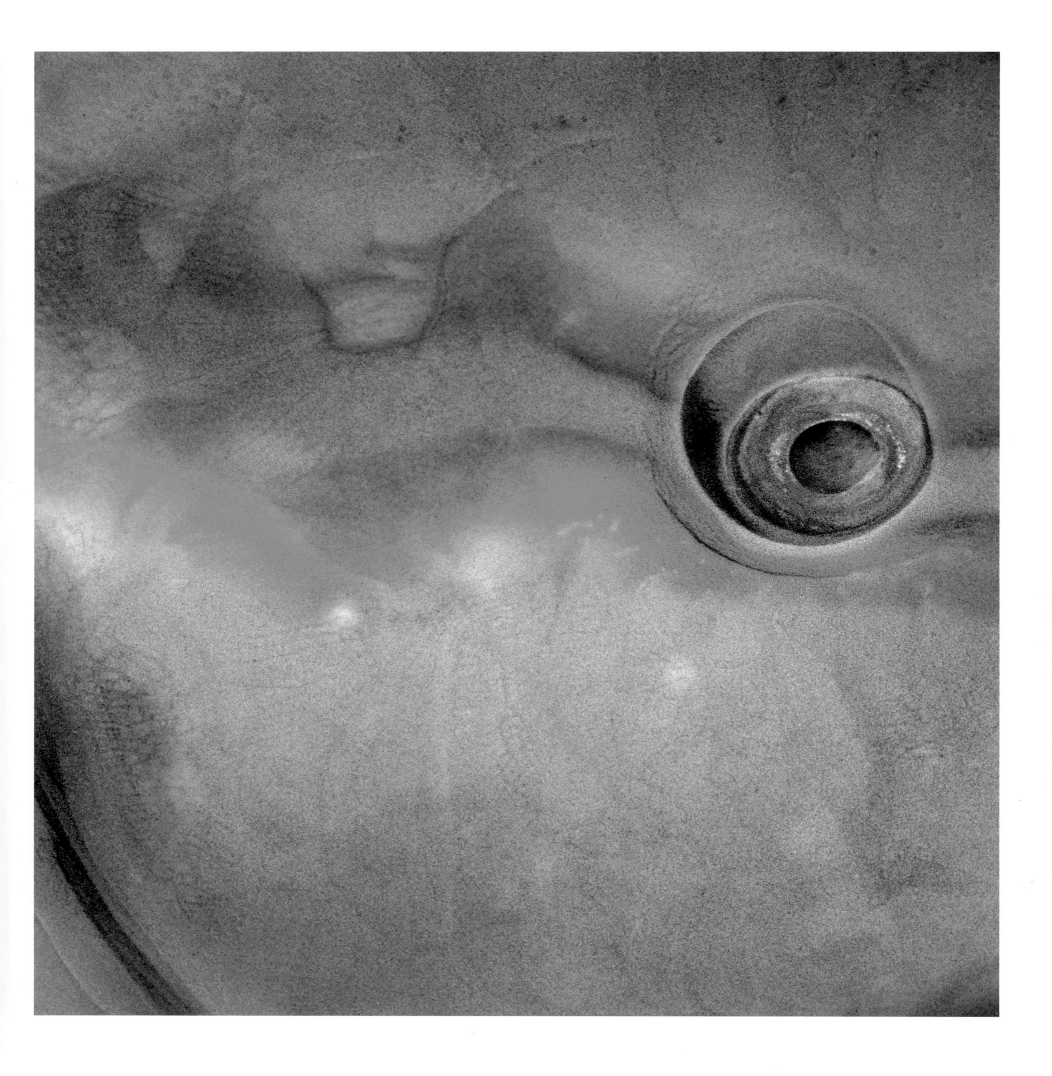

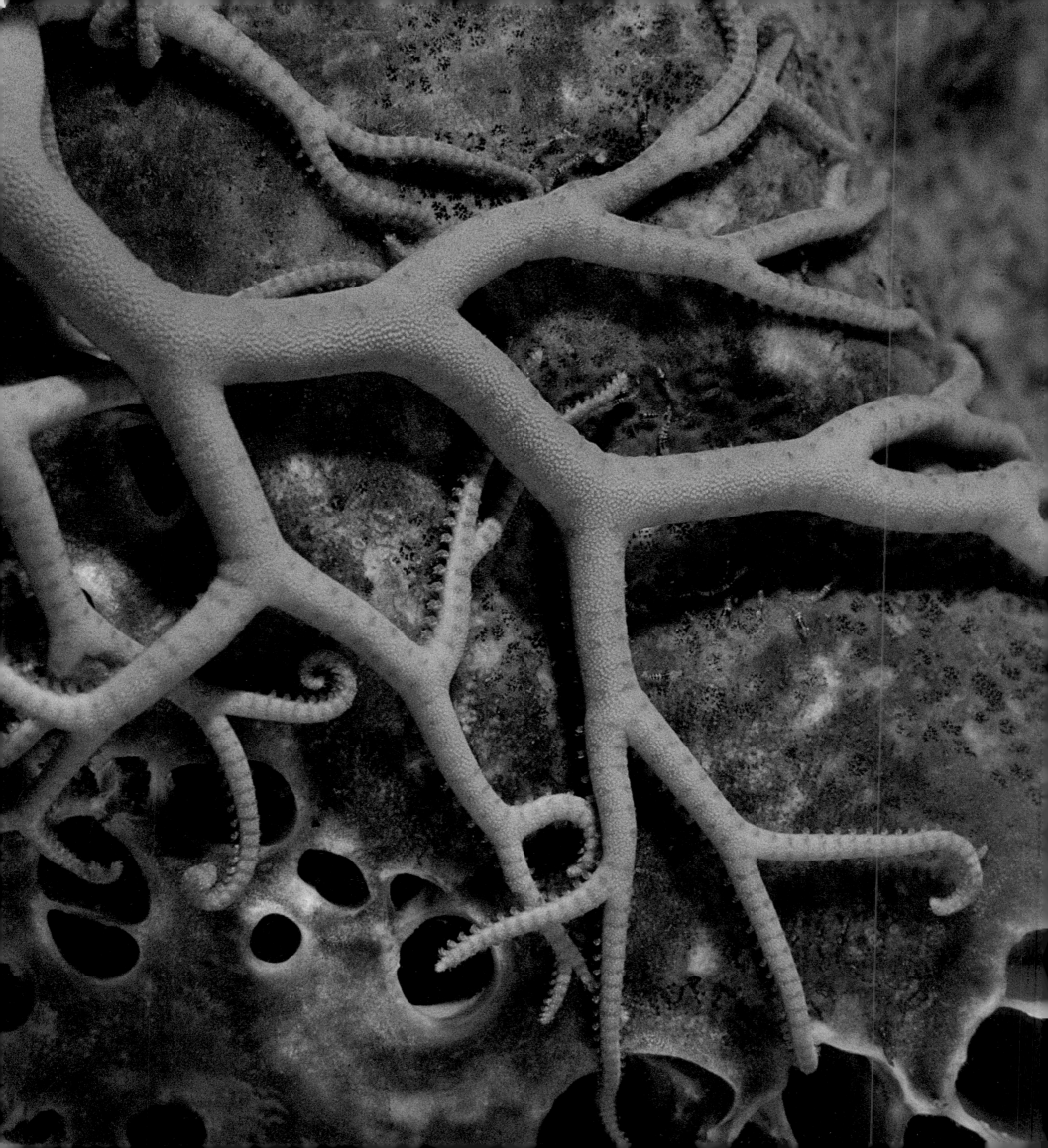

◄ **BASKET STAR ON A SPONGE**
Astroboa ernae

STAR SIZE 18 INCHES (45.72CM).
DETAIL SIZE 1½ INCHES (3.81CM).

KANGAROO ISLAND, SOUTH AUSTRALIA; 65 FEET (19.8M) DEEP.

Basket stars are a specialised type of Brittle Stars. They possess very complex branched arms which they use at night to catch plankton, preferably in a position exposed to strong current. During the day they fix themselves on a coral or sponge.

▼ **DETAIL OF A SIDE–GILLED SLUG**
Pleurobranchus grandis

SLUG SIZE 3 INCHES (7.62CM).
PICTURE SIZE 1 INCH (2.54CM).

NEW BRITAIN, REST ORFF, BISMARCK SEA, PAPUA NEW GUINEA;
20 FEET (6.1M) DEEP.

Pleurobranchs are slugs with gills located on the side under the mantel, as opposed to nudibranchs, which have gills on top of their bodies. They are nocturnal animals, sliding over the sand when looking for food. Though these animals don't change texture, their colours may vary from white to all shades of brown and brownish red.

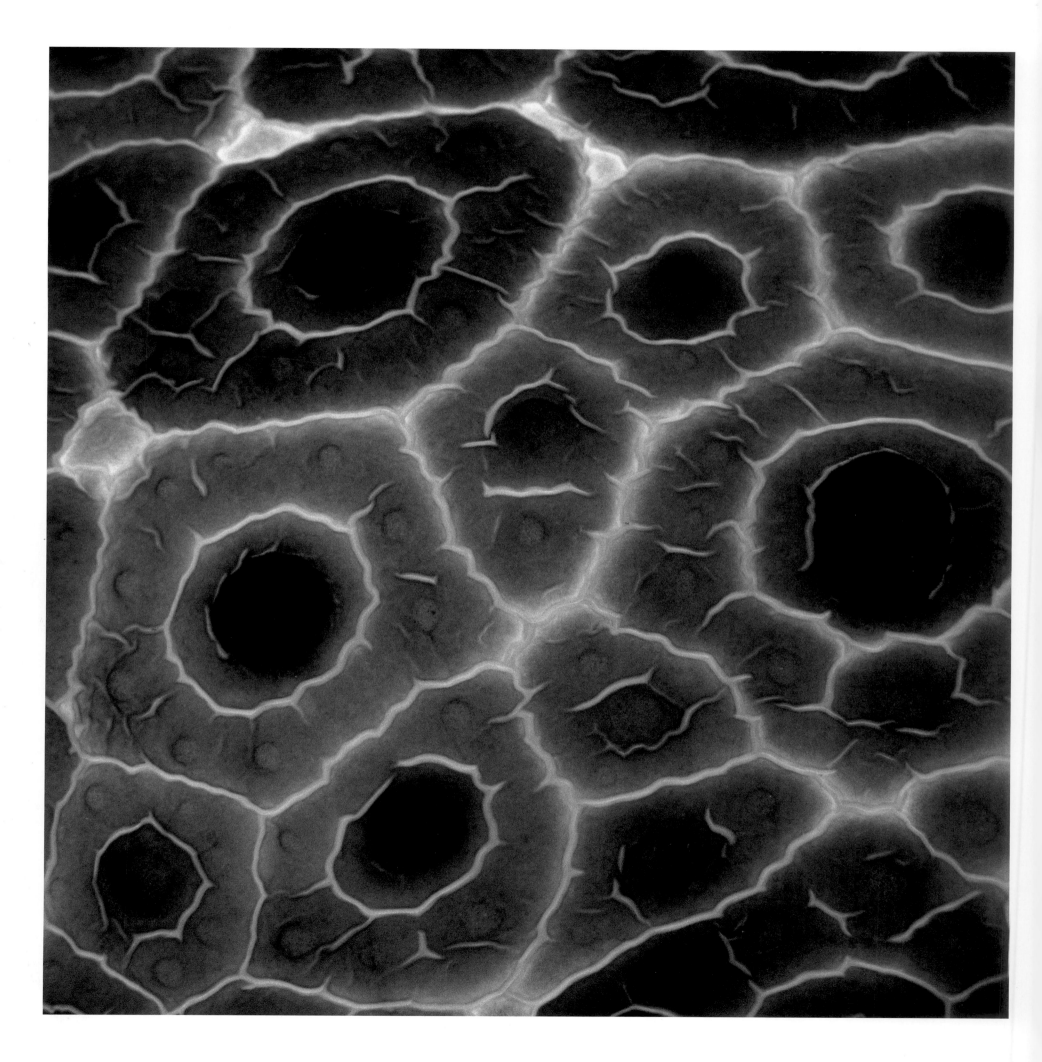

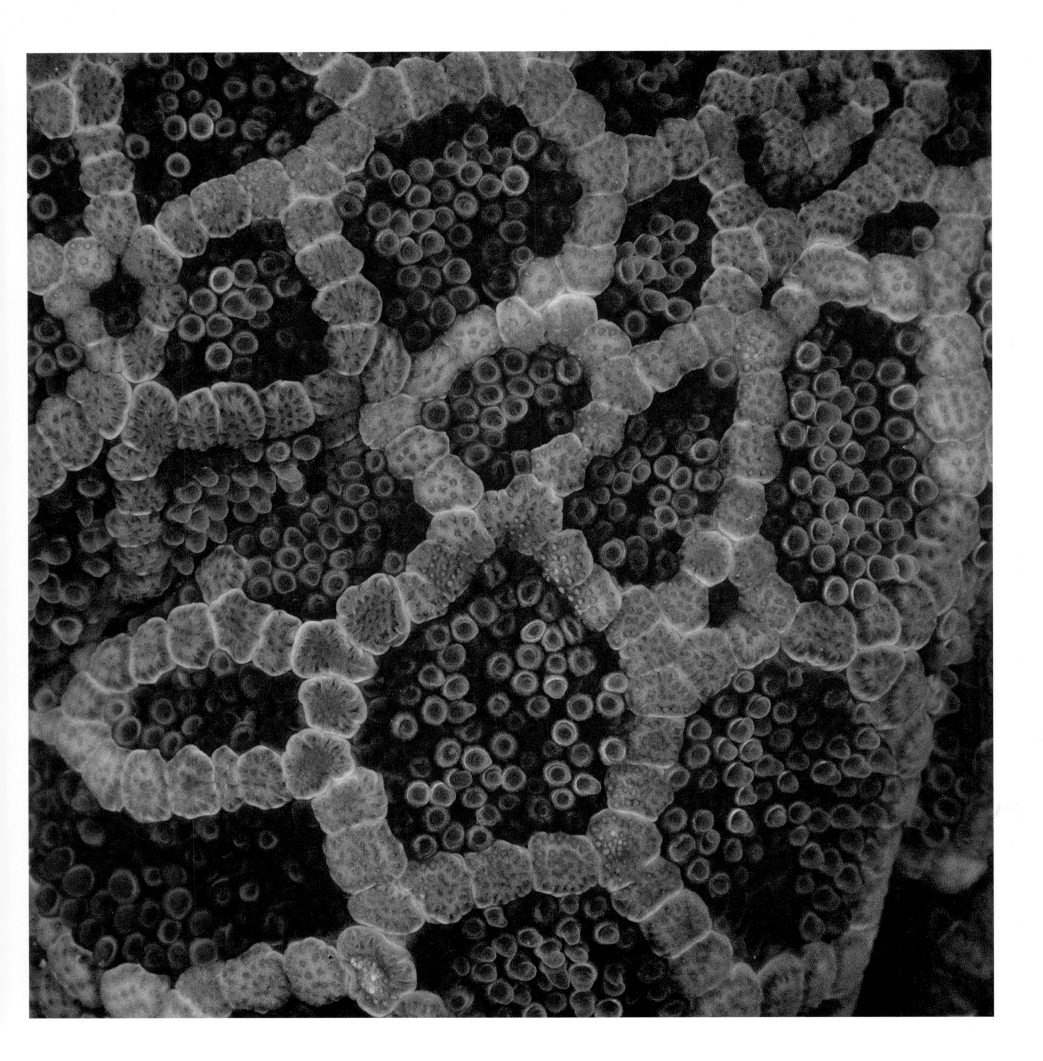

Plecaster decanus

STARFISH SIZE 8 INCHES (20.32CM).
PICTURE SIZE 1¹⁄₂ INCHES (3.81CM).

KANGAROO ISLAND, SOUTH AUSTRALIA; 70 FEET (21.3M) DEEP.

The Mosaic Starfish is one to be wary of. It can cause a skin rash if handled by bare hands. They have numerous tube feet equipped with tiny suckers which expand and contract, resulting in the animal's slow movement.

▸ **DECORATOR CRAB ON A SOFT CORAL**
Hoplophrys oatesii | *Dendronephthya* sp.

CRAB SIZE ¹⁄₄ INCH (0.76CM).
PICTURE SIZE 2¹⁄₂ INCHES (6.35CM).

D'ENTRECASTEAUX ARCHIPEL, FERGUSSON ISLAND,
PAPUA NEW GUINEA; 70 FEET (21.3M) DEEP.

This Decorator Crab is a real master of disguise. It lives in symbiosis with soft coral and, in order to become almost completely invisible, it has cut off some coral polyps and attached them to itself for optimal camouflage.

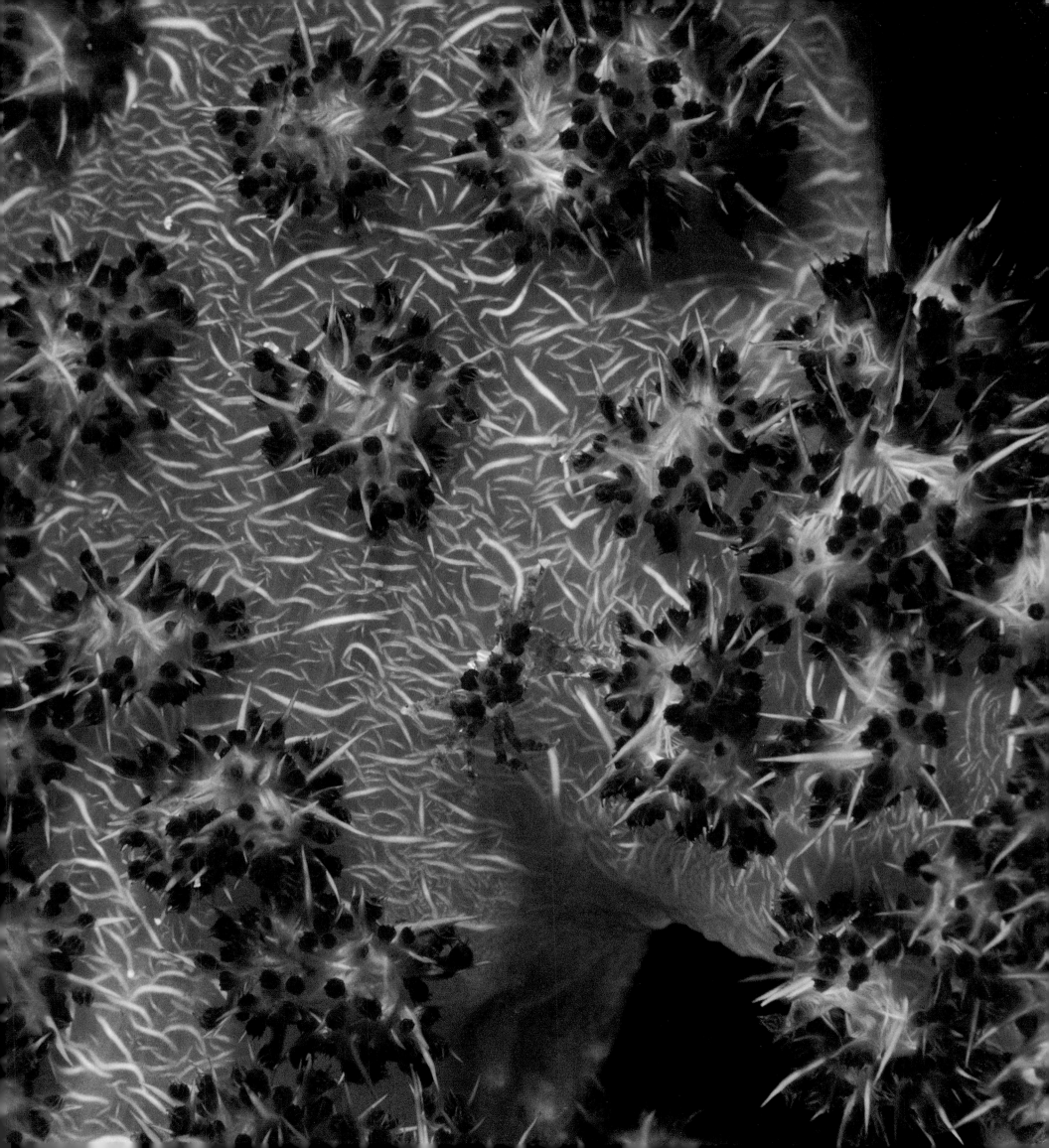

SHARK SIZE 6 FEET (2M). SIZE OF THE EYE ⅝ INCH (1.52CM).

SABA, NETHERLANDS ANTILLES, CARIBBEAN; 50 FEET (15.2M) DEEP.

Approaching it very carefully, I was able to take a picture of this Nurse Shark's eye. Sharks and rays have an eye adaptation not shared with other fish: their pupils can dilate so that in bright environments they can cut down on the amount of light reaching their retinas. If given the chance to gaze into sharks' eyes, you will quickly notice that not all pupils are equal. If the pupil is a vertical slit, you are greeting a Lemon Shark, a horizontal slit introduces you to a Bonnet Head Shark, and an oblique slit as in this photograph means you are nose to nose with a Nurse Shark.

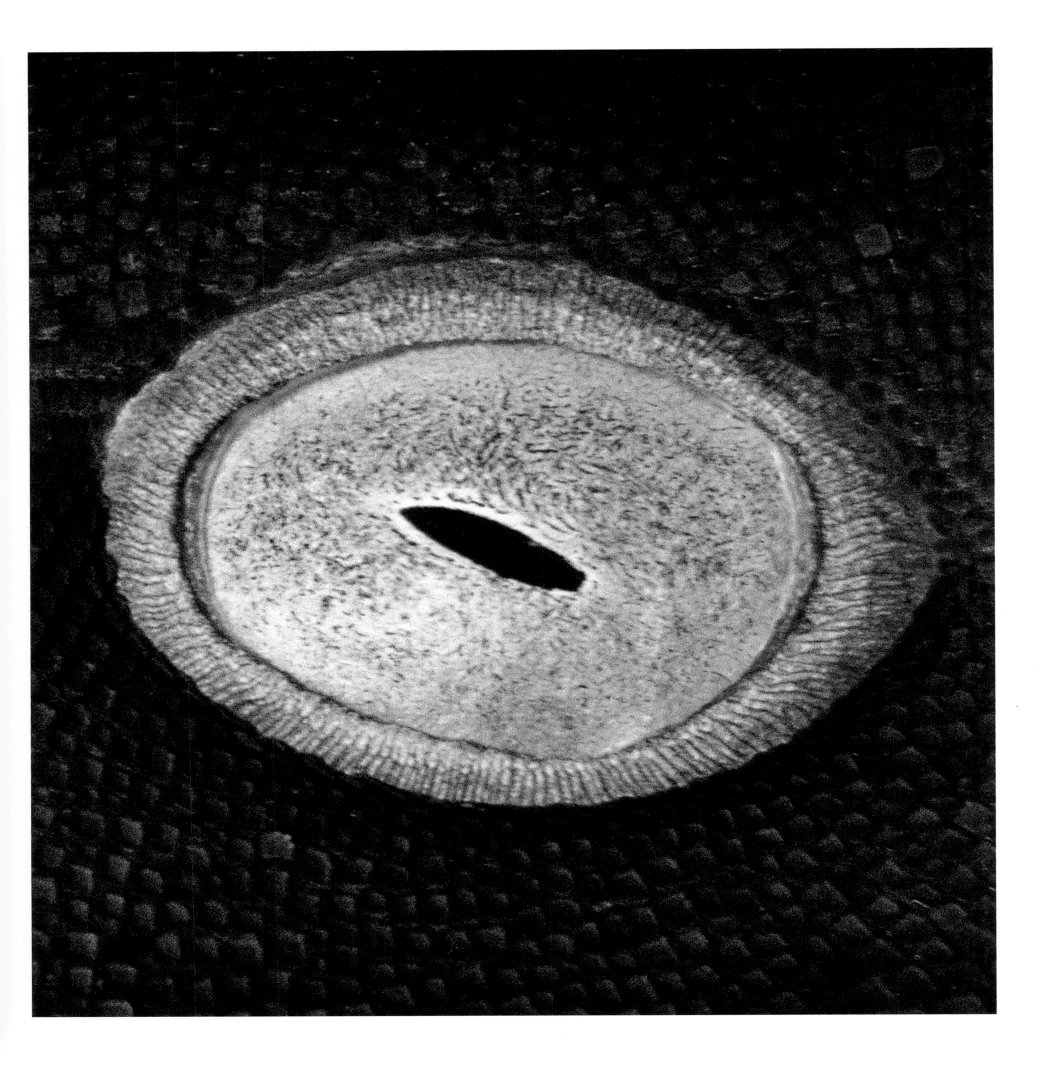

HAMLET SIZE 4 INCHES (10.16CM).
DETAIL SIZE 1½ INCHES (3.81CM).

BONAIRE, NETHERLANDS ANTILLES, CARIBBEAN; 70 FEET (21.3M) DEEP.

This fish is a member of the sea bass family, of which about a dozen different species can be found in the Caribbean. Scientists have been debating for years whether these are in fact different species, or one species (*Hypoplectrus unicolor*) with different colourings and markings.

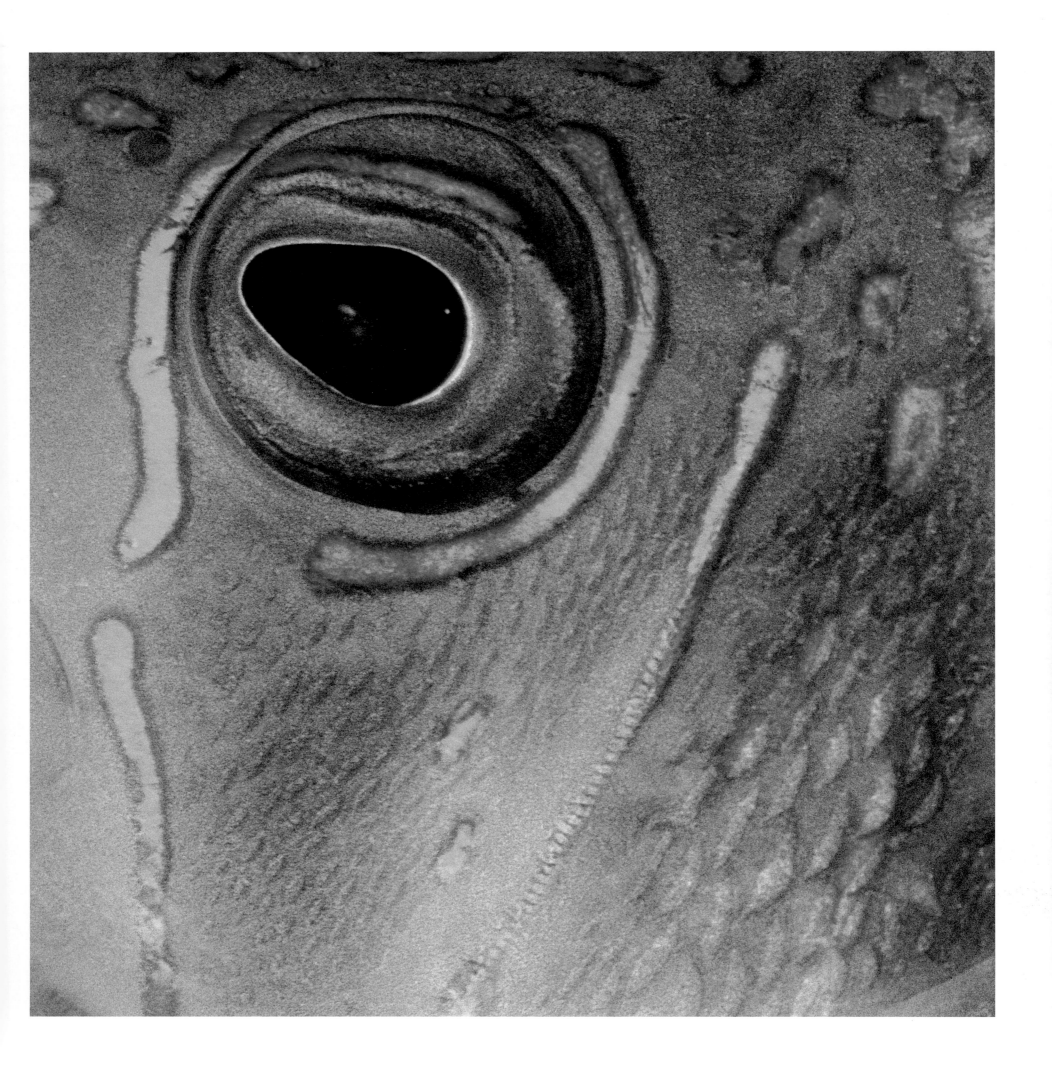

DETAIL OF A STOPLIGHT PARROTFISH
Sparisoma viride

PARROTFISH SIZE 14½ INCHES (36.59CM)
DETAIL SIZE 2 INCHES (5.08CM).

BONAIRE, NETHERLANDS ANTILLES, CARIBBEAN; 50 FEET (15.2M) DEEP.

It is not always easy to identify correctly the different species of parrotfish, because juveniles, intermediates and females are all different from adult males. The adult Stoplight Parrotfish is a lot easier to identify because of the bright yellow spot at the upper corner of the gill cover and the pink stripe just below it.

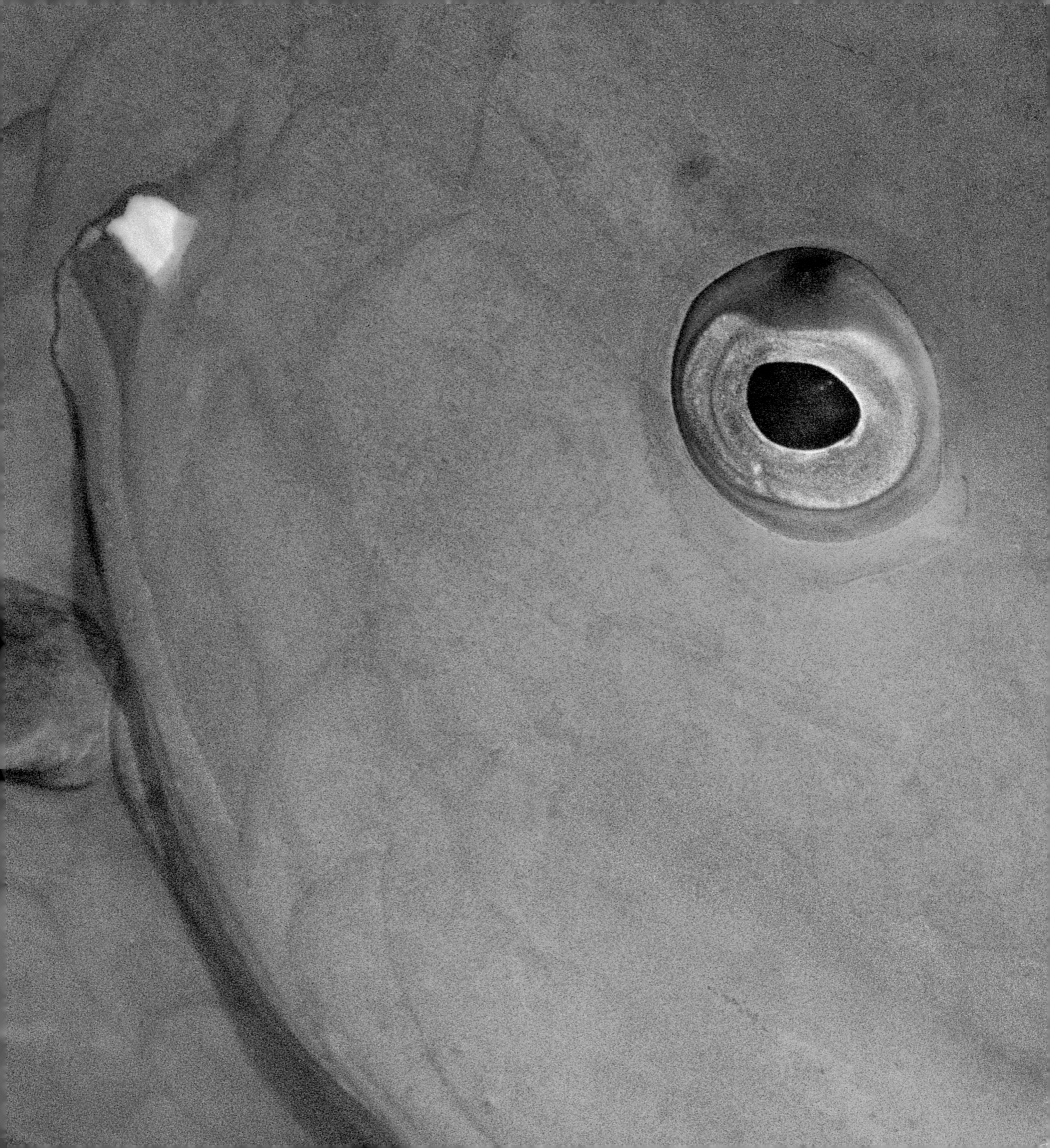

POLYCLAD FLATWORM
Pseudobiceros bedfordi

FLATWORM SIZE 1⅛ INCHES (2.79CM).
DETAIL SIZE ½ INCH (1.27CM).

LAYANG–LAYANG ATOLL, SOUTH CHINA SEA, MALAYSIA;
85 FEET (25.9M) DEEP.

At first glance flatworms can easily be mistaken for nudibranchs, but they lack the external gills. They have a much flattened oval body and exhibit dazzling colour patterns to warn predators that they are toxic or distasteful. Worms on the coral reef come in many different shapes and forms. Some are fixed to the reef and others, like the flatworms, can move. Their locomotion is achieved by sliding across a self-secreted mat of mucus.

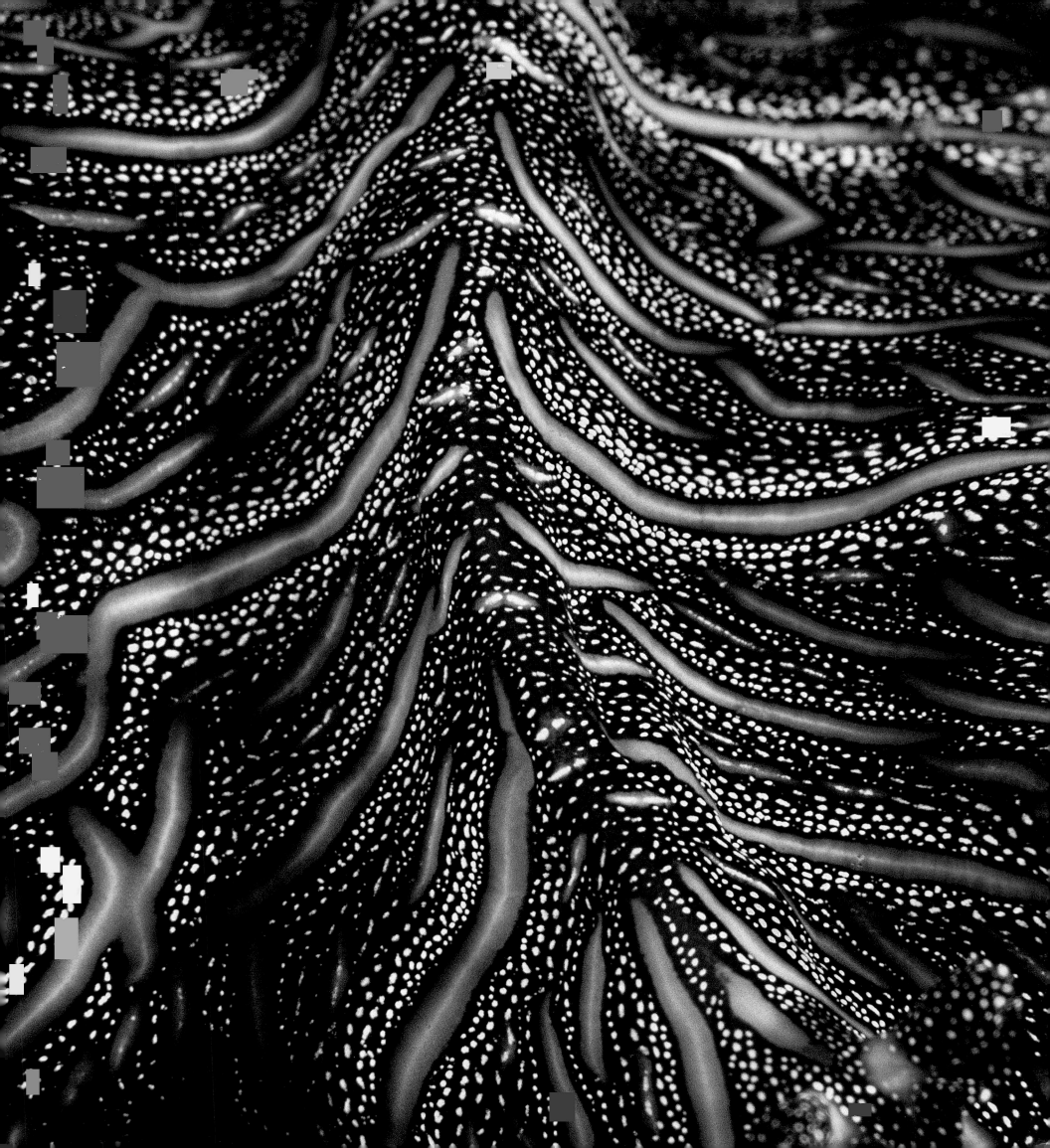

Strongly resembling plants, these creatures are genuine animals, though of a primitive kind. They take their colour from pigment and, as do coral polyps, from algae symbiotically living in their body tissues. An Ascidian has two openings, an incurrent and an excurrent one. A continuous stream of water is drawn in through the mouth and is expelled through the smaller aperture, as seen in this picture. Food includes bacteria and phytoplankton.

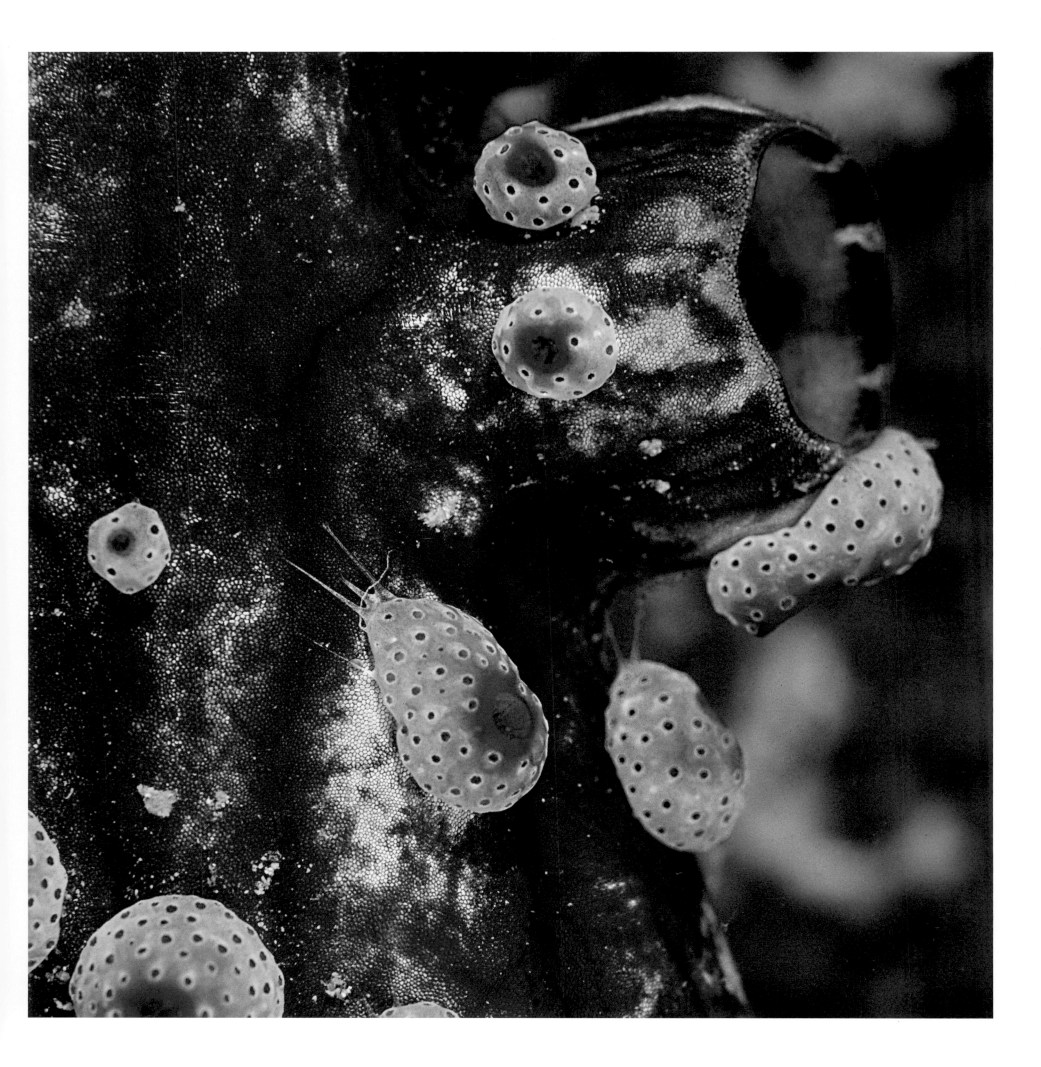

DETAIL OF A HORSESHOE LEATHERJACKET
Meuschenia hippocrepis

LEATHERJACKET SIZE 12 INCHES (30.48CM).
PICTURE SIZE 3 INCHES (7.62CM).

KANGAROO ISLAND, SOUTH AUSTRALIA; 70 FEET (21.3M) DEEP.

The Horseshoe Leatherjacket is a schooling species widely found in southern Australia. It took a while before this beautiful member of the triggerfish family got used to me. Every few minutes I managed to get a little bit closer and then swam away as if I was not interested. Finally I was so close that I was able to photograph different parts of its body.

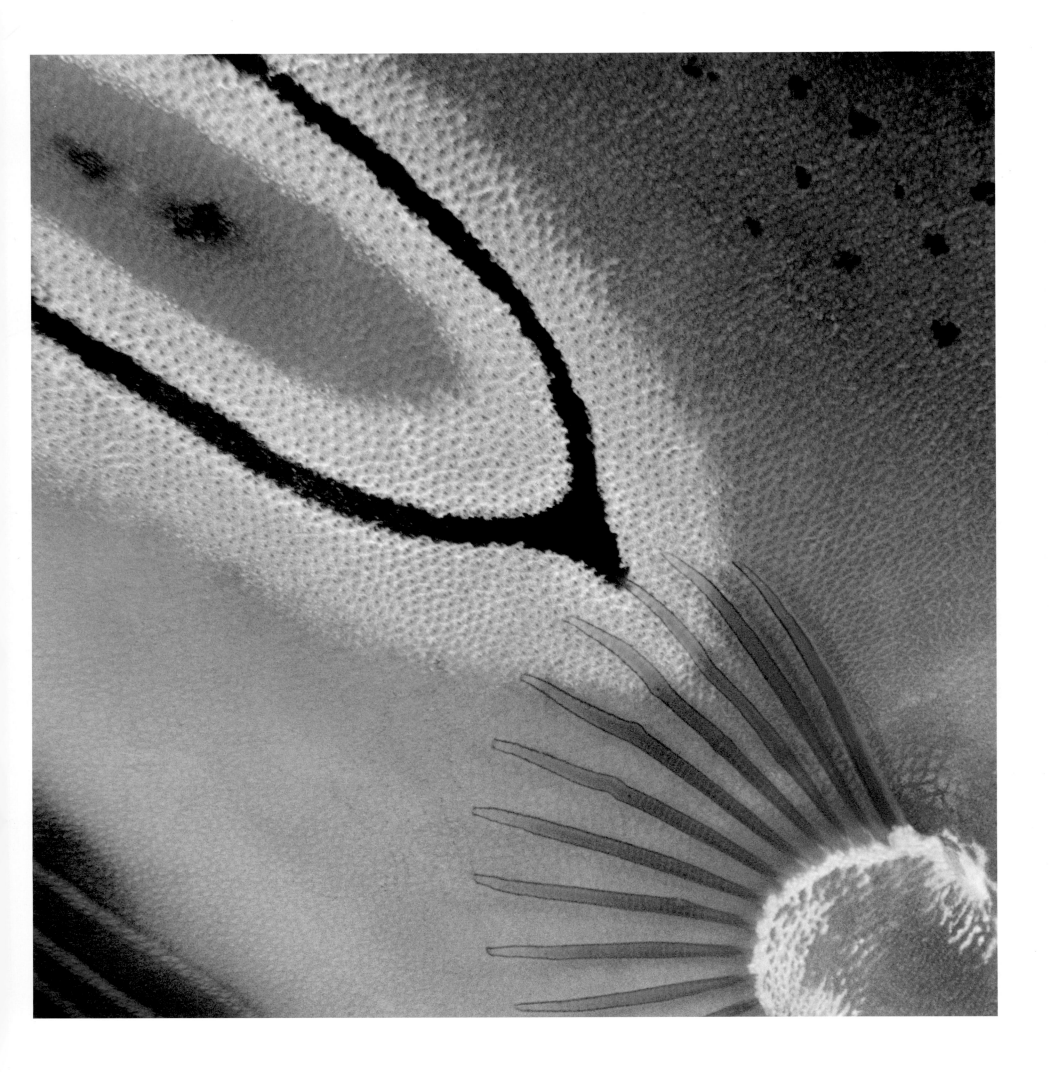

WRASSE SIZE 18 INCHES (45.72CM).
SIZE OF THE EYE ¼ INCH (0.76CM)

KANGAROO ISLAND, SOUTH AUSTRALIA; 50 FEET (15.2M) DEEP.

The Senator Wrasse is a common territorial wrasse, found on reefs in shallow water. The colour combinations in their eyes are amazingly beautiful. This is the eye of a male.

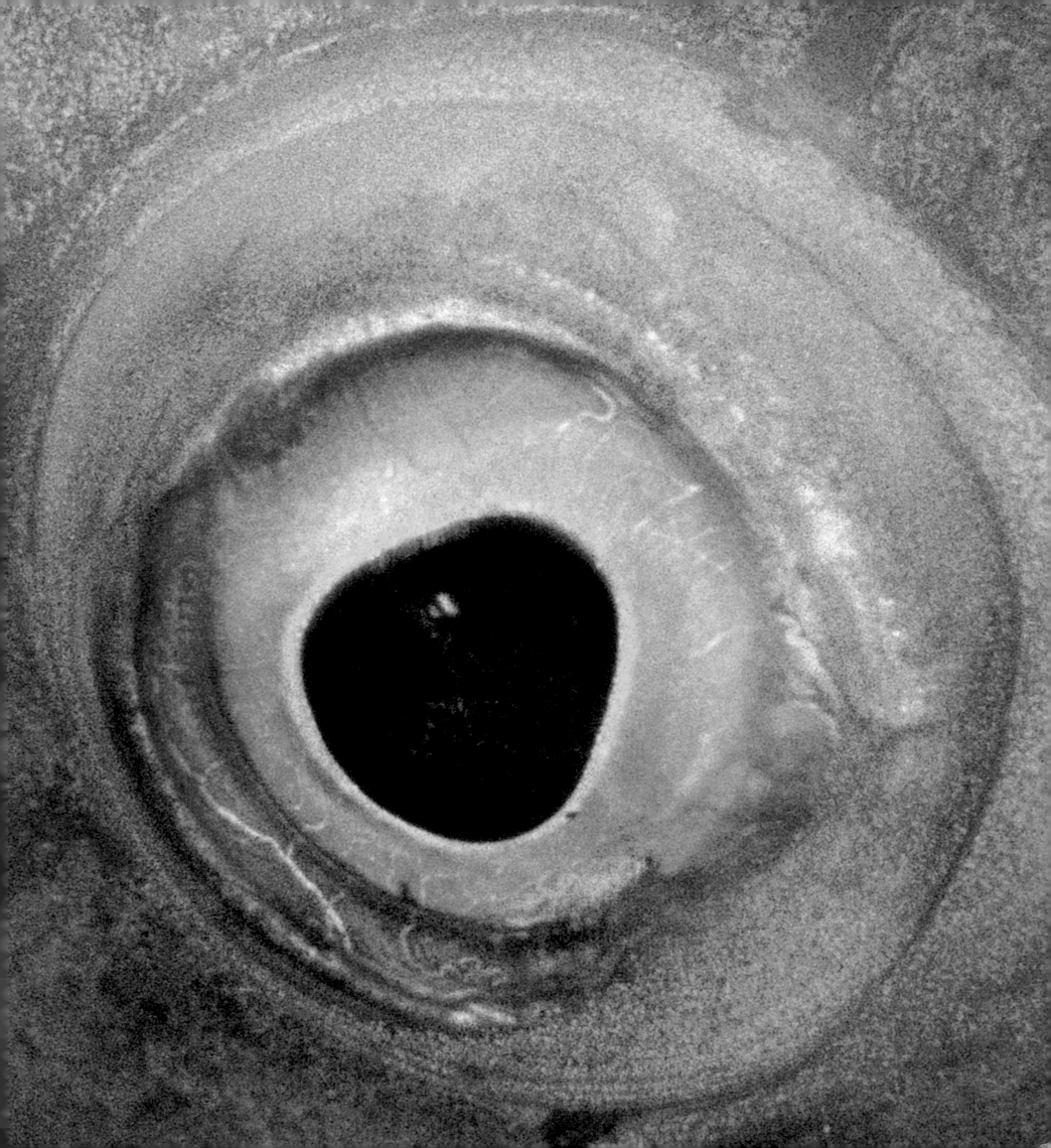

A member of the seahorse family, this elusive creature thrives where water temperatures range from 53.5° to 68°F (12° to 3o°C), and where plants populate the undersea environment. The Dragon has leaf-like appendages on its snout, head and body and is well camouflaged among the algae and seaweeds. Without Jim Thistleton I would never have found these amazing fish.

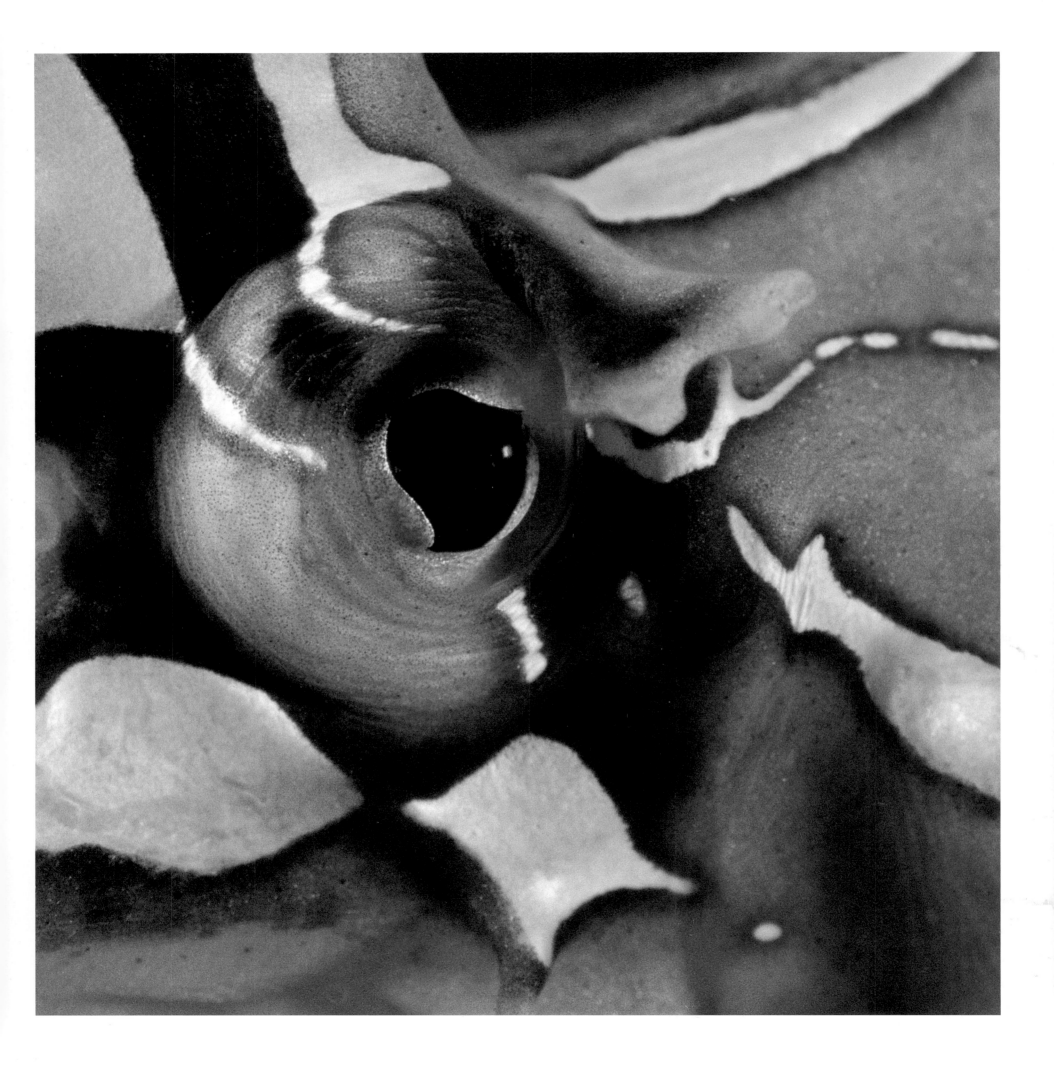

DETAIL OF A LEAFY SEA DRAGON
Phycodurus eques

LEAFY SEA DRAGON SIZE 16 INCHES (40.64CM).
PICTURE SIZE 1¹/₂ INCHES (3.81CM).

KANGAROO ISLAND, SOUTH AUSTRALIA; 55 FEET (16.8M) DEEP.

Finding the Leafy Sea Dragon, though difficult enough, is easier than taking its picture. These fish habitually turn their heads away from the camera. Consequently, the photographer needs to stay with the fish as long as possible, without moving or blowing too many bubbles. Usually the Dragon will relax after 20 minutes and start feeding on tiny mysid shrimp (sea lice). The feeding action consists of fast forward or downward movements of the head. It is possible to take quality images only when the Dragon is in this position.

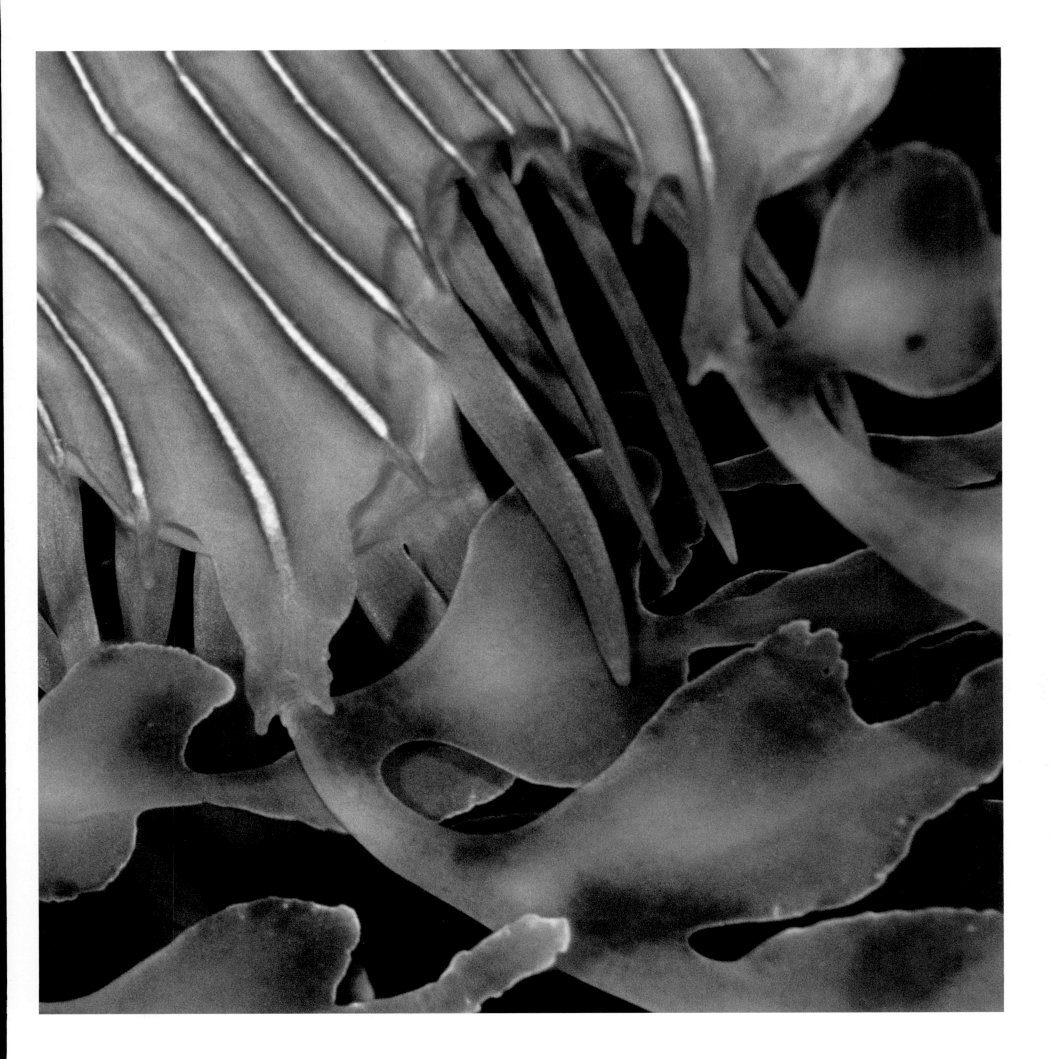

ORANGE CUP CORAL

Tubastraea coccinea

POLYP SIZE ¾ INCH (2.03CM).
PICTURE SIZE 3 INCHES(7.62CM).

BONAIRE, TOWN PIER, NETHERLANDS ANTILLES, CARIBBEAN;
20 FEET (6.1M) DEEP.

Bonaire's Town Pier is the place to be if you want to enjoy an explosion of colour. But you have to be there at night when all these beautiful cup corals are "blooming". Actually, these nocturnal flower-like polyps are plankton-eating animals.

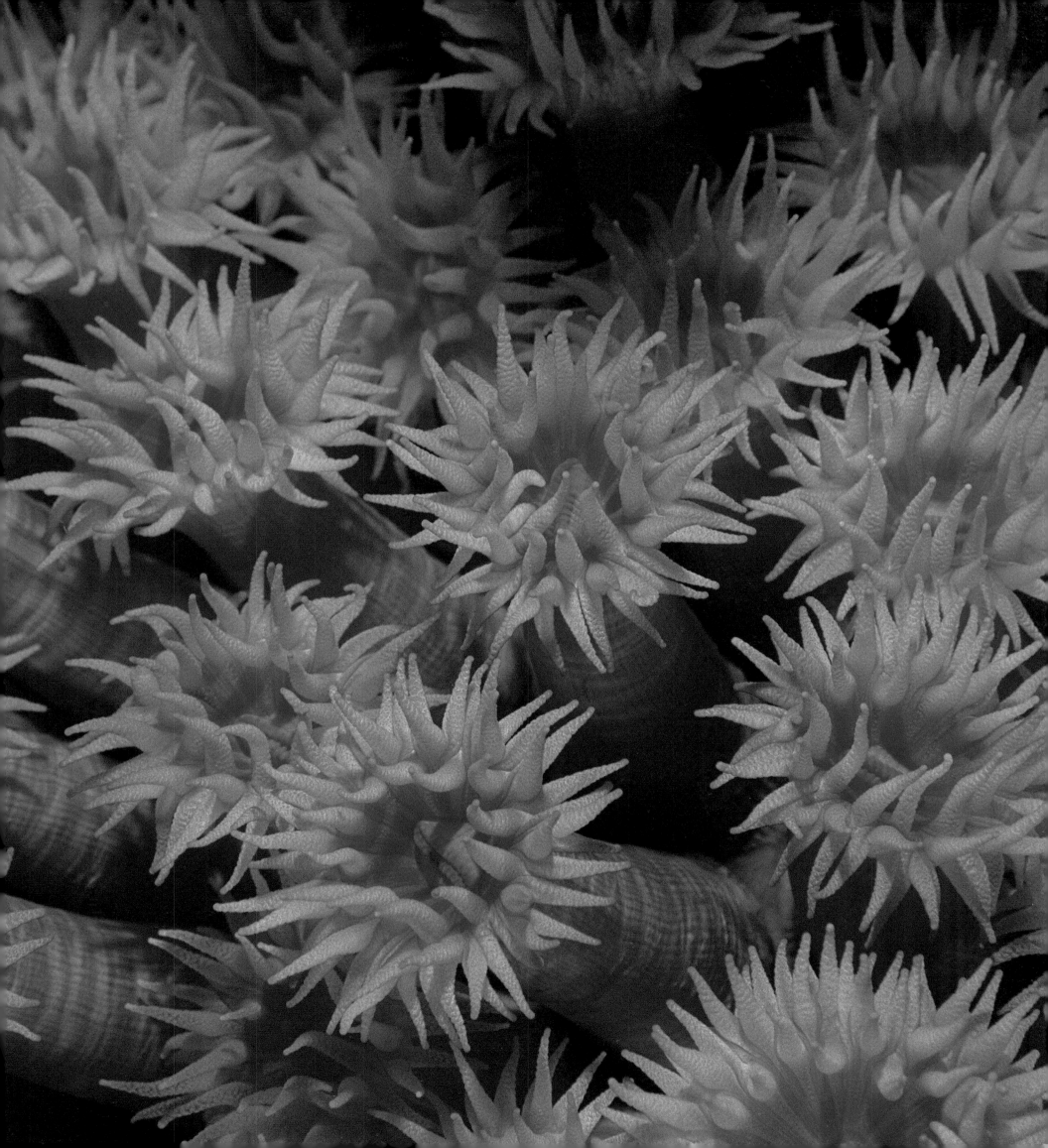

DETAIL OF A FEATHER STAR OR CRINOID
Oxycomanthus bennetti

CRINOID SIZE 7 INCHES (17.78CM).
PICTURE SIZE 2 INCHES (5.08CM).

LEMBEH STRAIT, NORTH SULAWESI, INDONESIA; 65 FEET (19.8M) DEEP.

Crinoids belong to the same phylum as sea cucumbers, starfish and sea urchins, the *Echinodermata*.
These animals are usually mistaken for plants or flowers by laymen. The word Crinoid is derived from the Greek *"krinon"*, meaning sea lily. Sea lilies are best known from palaeontology. Crinoids have a long stem and at first glance seem immobile, but they can walk (crawl) as well as swim.

194

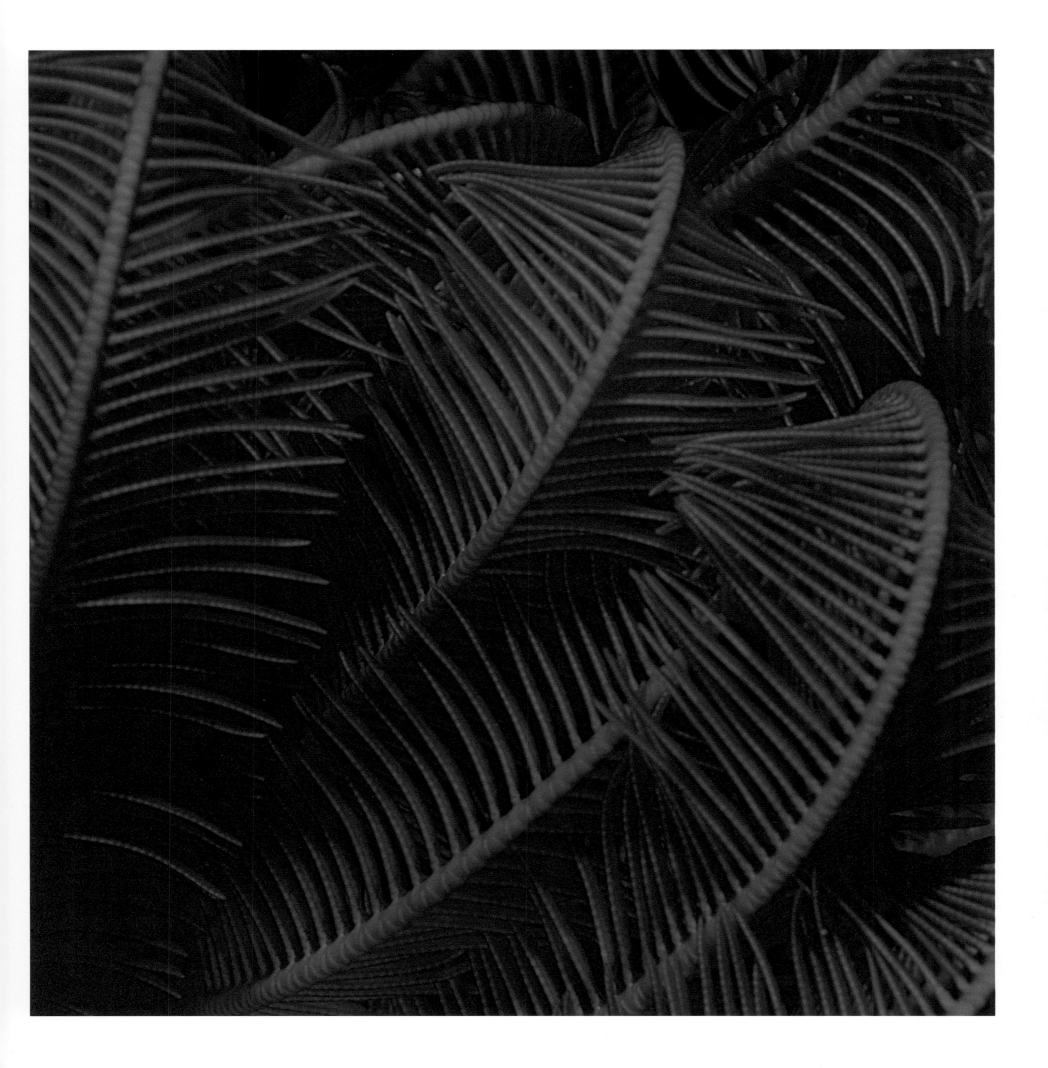

OCTOPUS SIZE 15 INCHES (38.1CM).
SIZE OF THE EYE ¼ INCH (0.76CM).

ARUBA, CARIBBEAN; 9 FEET (2.7M) DEEP.

During a night dive on Aruba's west coast, I discovered a small octopus. Its body was spread in the manner it uses to catch prey. It must have found this activity more important than my non-threatening presence, because I was able to come close enough to capture its eye.

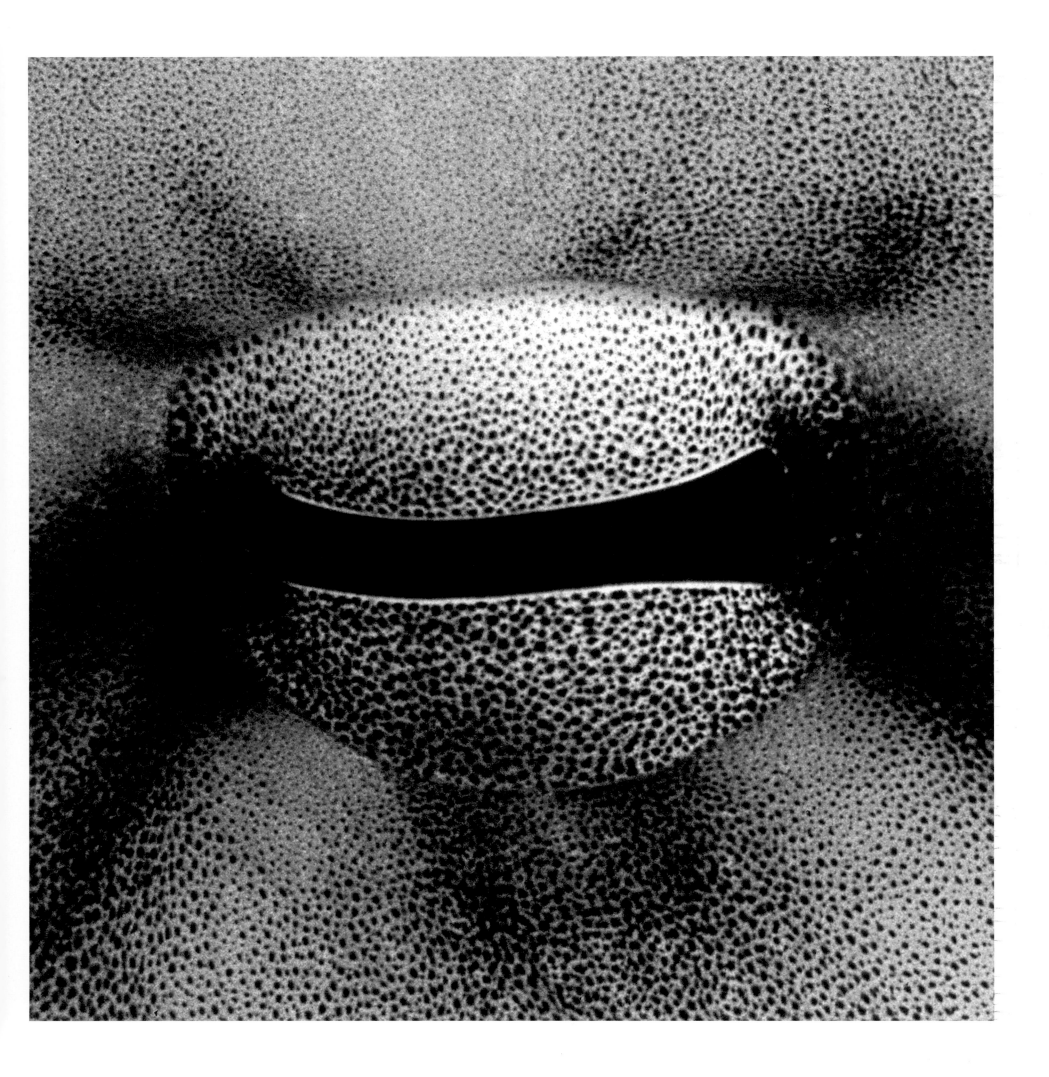

CROCODILE FLATHEAD EYE
Papilloculiceps longiceps

FLATHEAD SIZE 20 INCHES (50.8CM).
SIZE OF THE EYE $\frac{1}{2}$ INCH (1.27CM)

LEMBEH STRAIT, NORTH SULAWESI, INDONESIA; 26 FEET (7.9M) DEEP.

The Crocodile Flathead's camouflage is first-class.
It is hard to spot because it adapts perfectly to its sandy surroundings when lying on the bottom in shallow waters. So as to attract less attention, it has "decorated" its eye with a kind of drape. A short forward explosion suffices when a potential prey approaches.

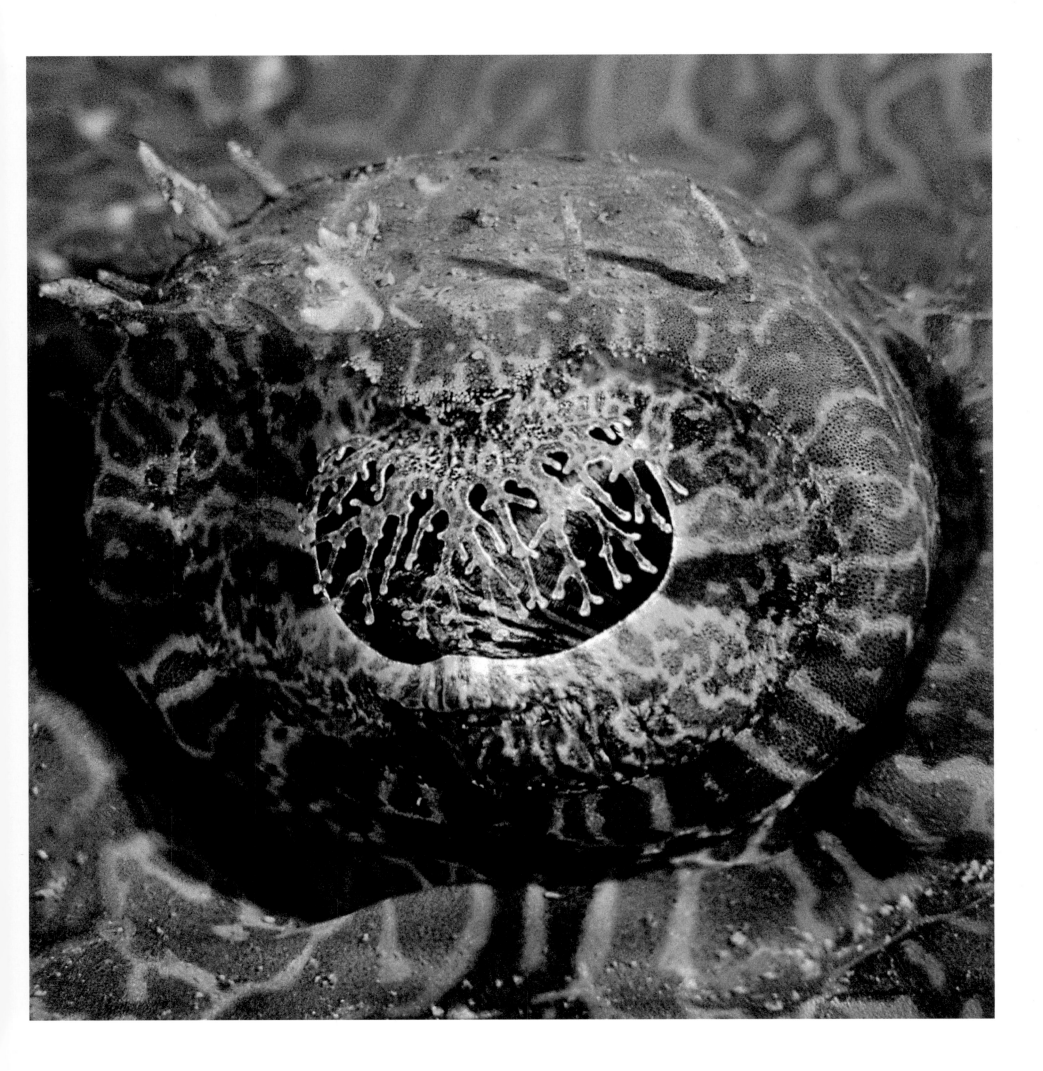

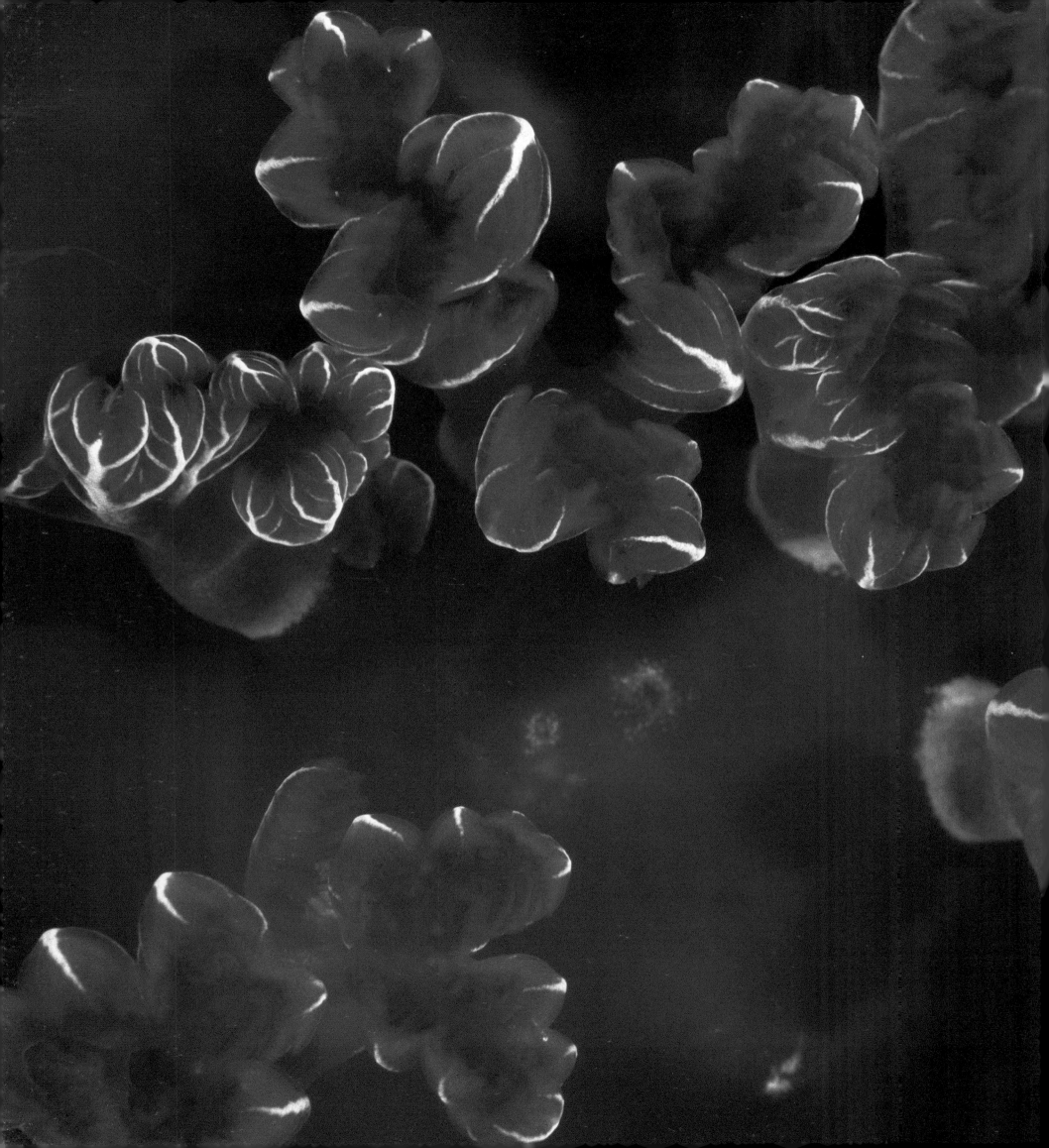

GILLS OF A SPANISH DANCER
Hexabranchus sanguineus

SPANISH DANCER SIZE 12 INCHES (30.48CM).

DETAIL SIZE 1 INCH (2.54CM).

MARSA ALAM, RED SEA, EGYPT; 55 FEET (16.8M) DEEP.

Although its average size is 12 inches (30 centimetres), this nudibranch can get as big as 16 inches (40 centimetres). The bright red colour and the six gills as seen in this picture are characteristic.

AMPHIPOD ON THE MANTLE OF A HIPPOPUS CLAM
Cyproidea sp. | *Hippopus hippopus*

AMPHIPOD SIZE $1/8$ INCH (0.25CM).
PICTURE SIZE 3 INCHES (7.62CM).

SANGALAKI, SULAWESI SEA, INDONESIA; 32 FEET (9.8M) DEEP.

Amphipods living on coral reefs are very small members of the Crustacea, a large but quite unknown order of which more than 8,000 species have been described. By now, animals of more than 10 inches (25 centimetres) long have been discovered in the deep sea. They have different types of habitats varying from coral reefs to muddy sediments.

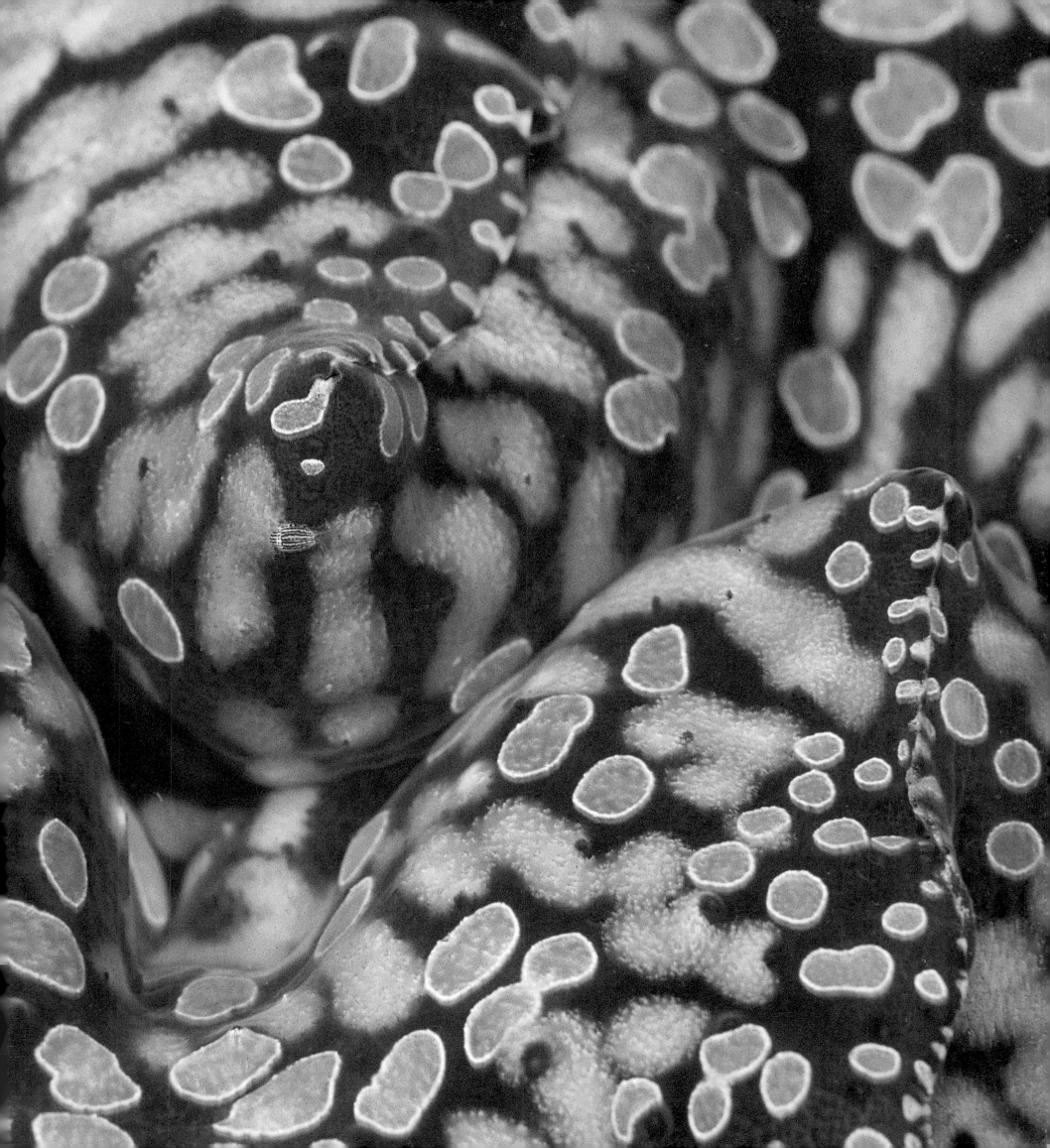

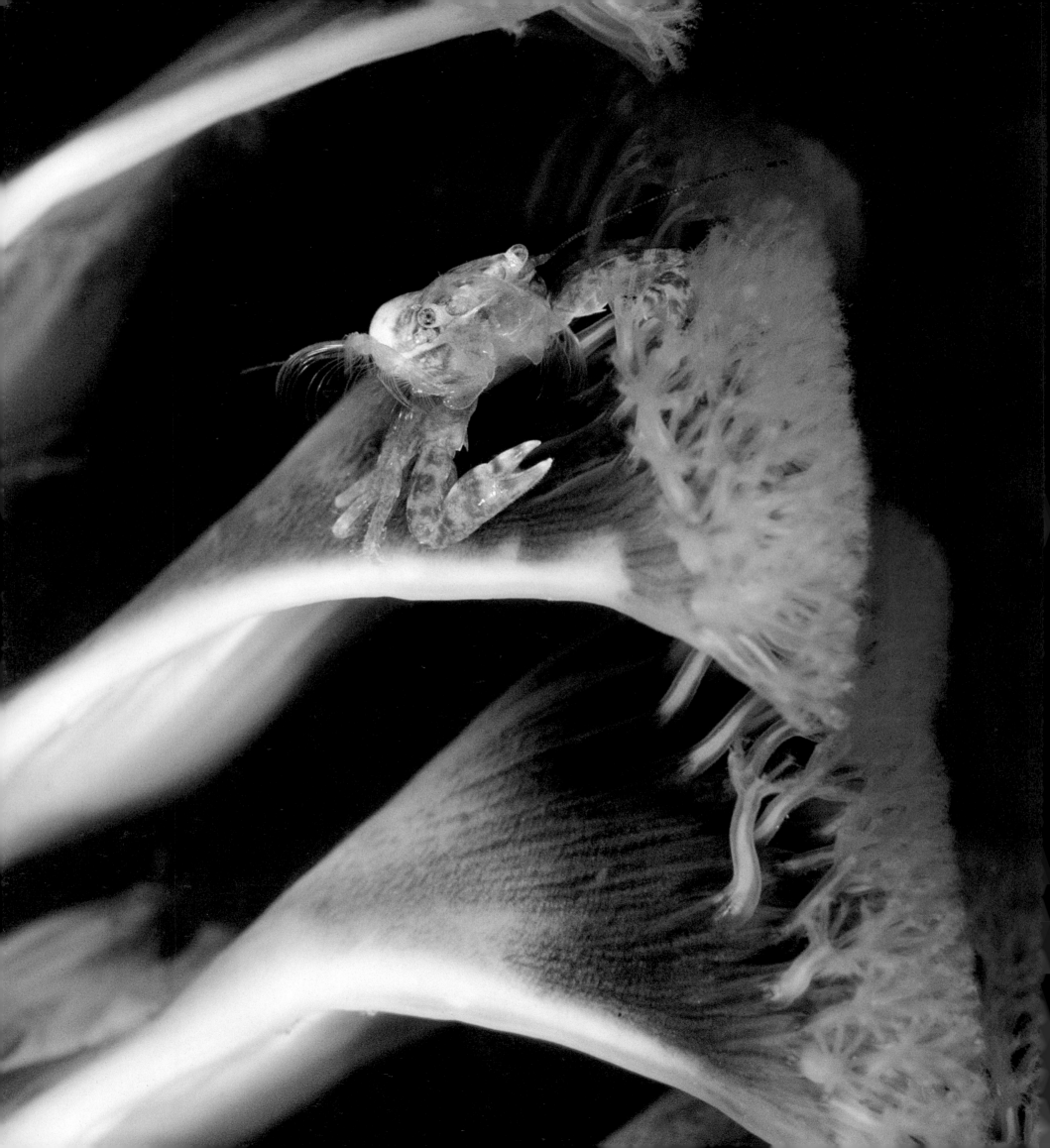

◄ **PORCELAIN CRAB ON A SEA PEN**
Porcellanella picta | Pteroeides sp.

CRAB SIZE ¹/₄ INCH (0.76CM).
PICTURE SIZE 1 INCH (2.54CM).

RINCA, NUSA KODI, INDONESIA; 26 FEET (7.9M) DEEP.

During a night dive in shallow water, I found several Sea Pens and the small Porcelain Crabs living inside them. To my surprise, I could observe how these little creatures caught plankton with tiny fans. Sea Pens are in fact solitary soft corals that live a nocturnal life. During the day they live under the sand with the crabs. Little is known about the exact form of this symbiosis.

▼ **DETAIL OF AN ORANGE-MOUTH THORNY OYSTER**
Spondylus varius

OYSTER SIZE 5 INCHES (12.7CM).
PICTURE SIZE 1 INCH (2.54CM).

SATONDA, MAGIC ROCK, INDONESIA; 98 FEET (19.9M) DEEP.

It is hard to take a photograph of this widespread Orange-mouth Thorny Oyster at close quarters since the slightest movement makes it close its shell immediately. So when approaching this creature, don't exhale bubbles and don't move. Besides, it's important to adjust the flash correctly and focus the camera in advance.

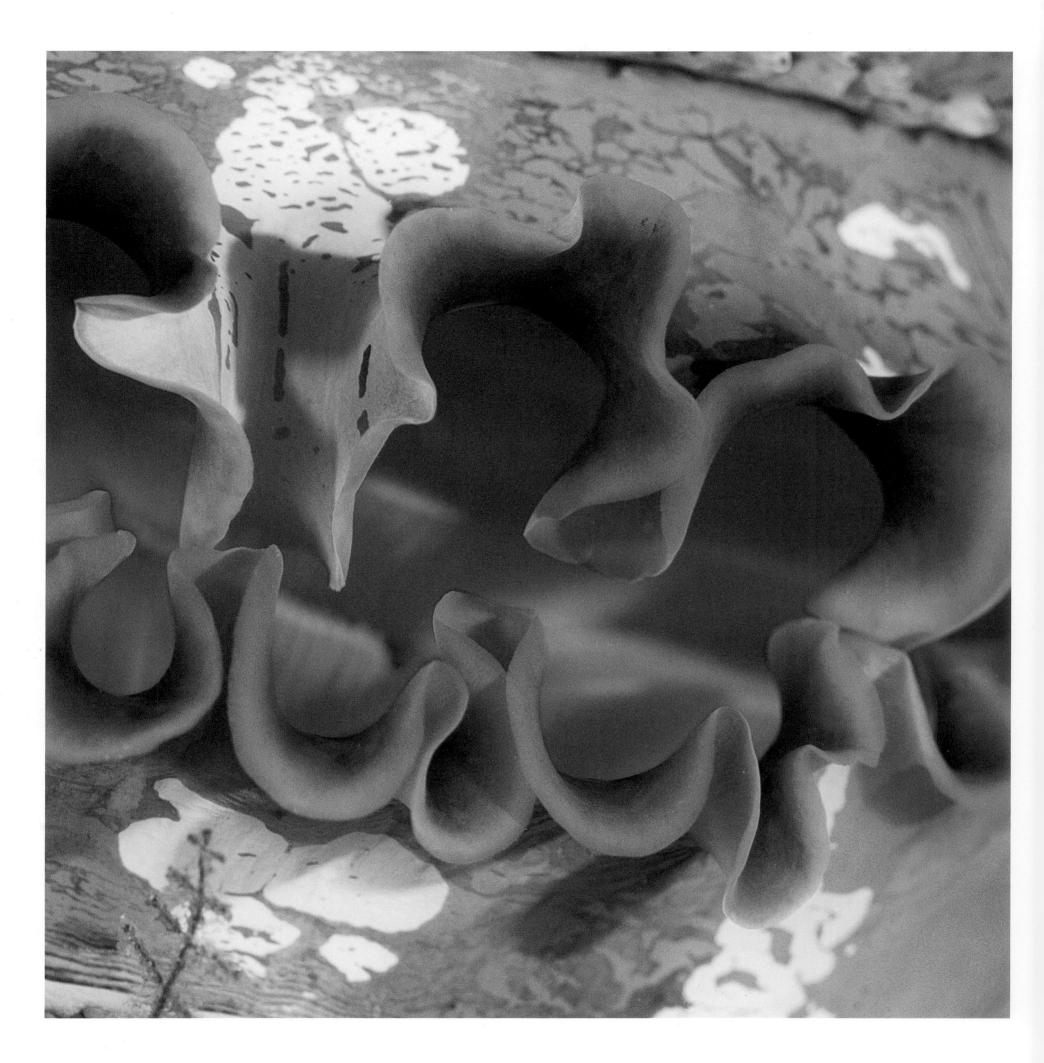

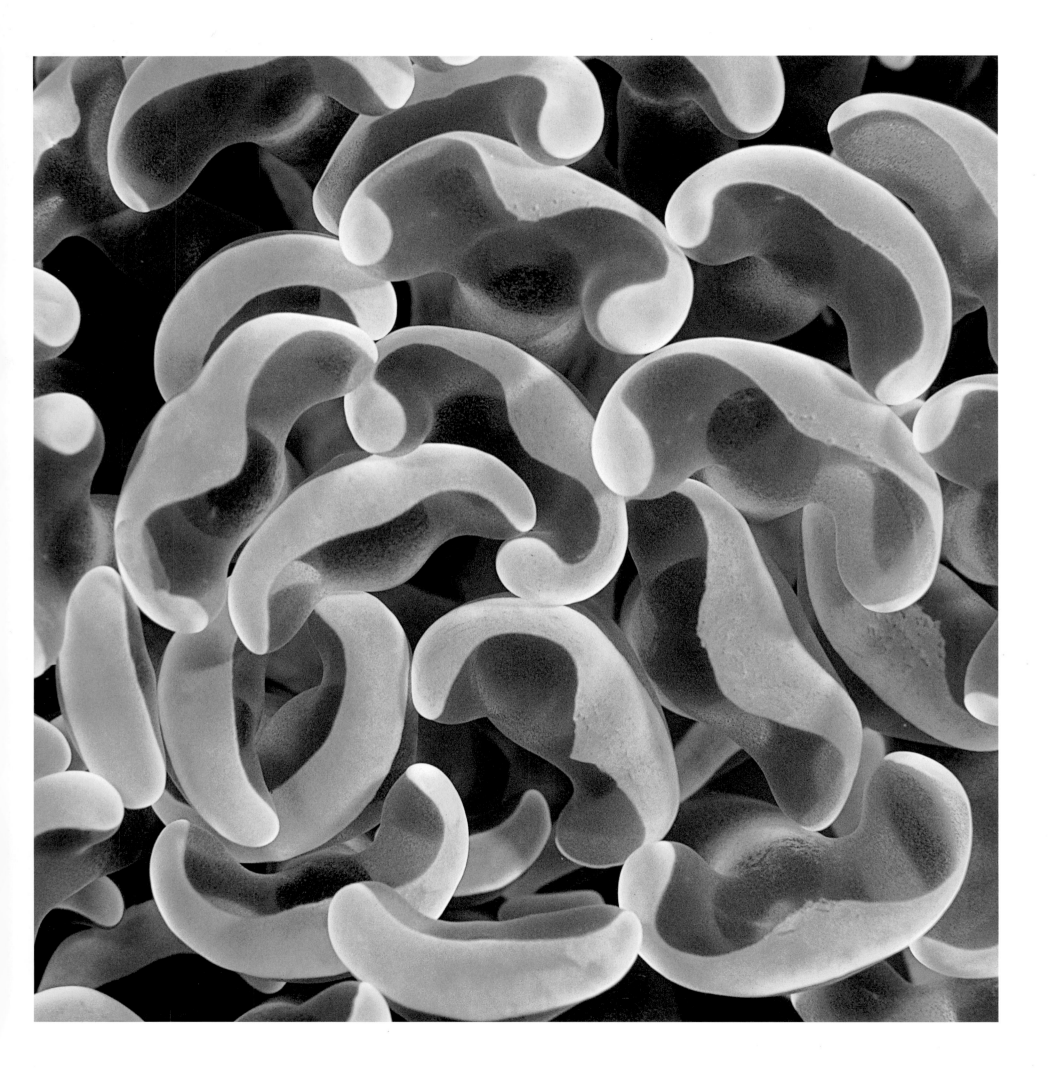

Nothing in the shape of these polyps reminds us of what we usually see when we look at coral polyps. On several occasions I found these polyps out during the day. This coral species can be found in the Indo-Pacific only.

This fragile hard coral can reach enormous dimensions. It can live so close to the water surface that it can rise above it when the tide is out and – in spite of the scorching sun – thrives in these circumstances.

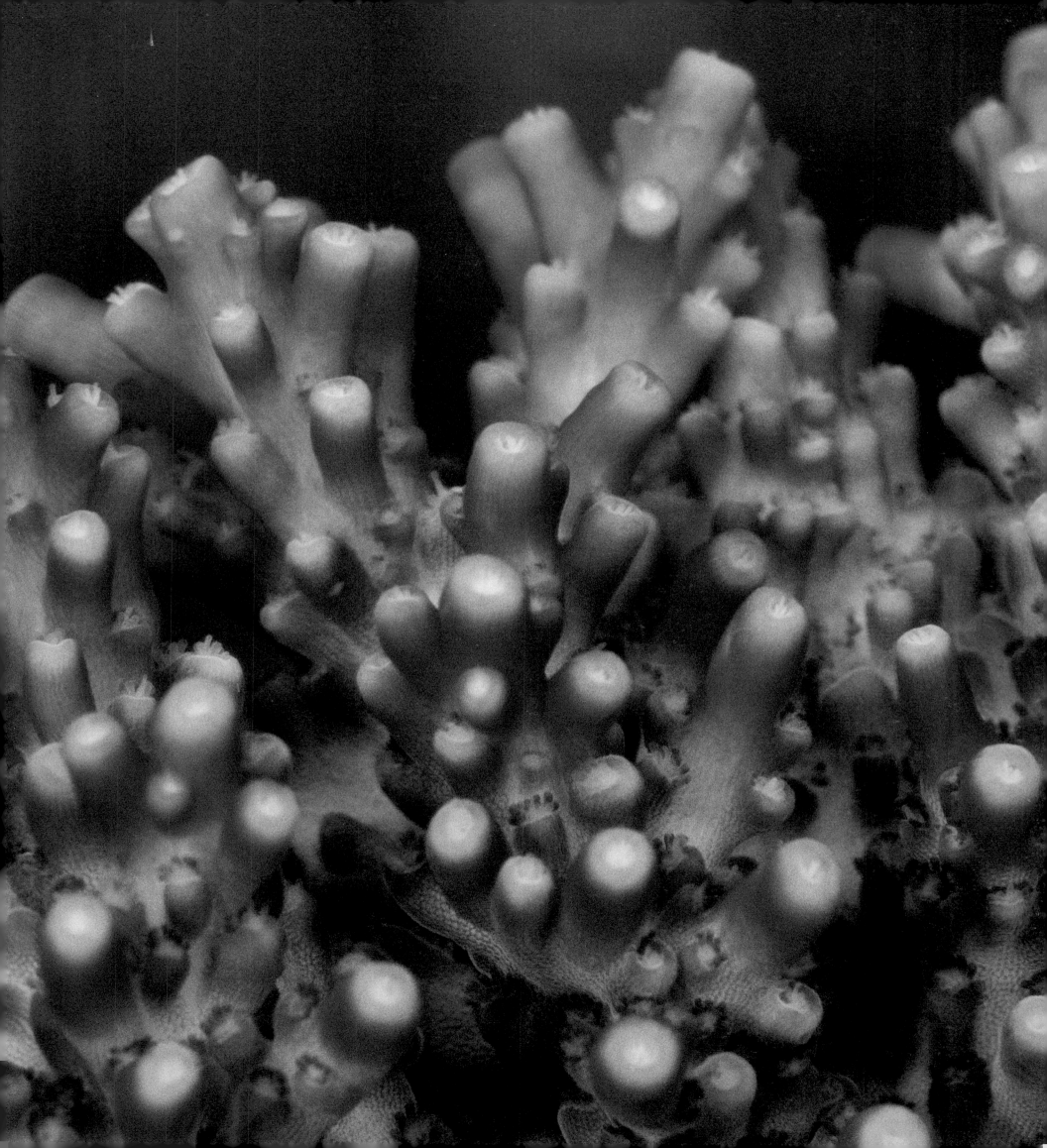

PARROTFISH SIZE 18 INCHES (45.72CM).
DETAIL SIZE 1½ INCHES (3.81CM).

MARSA ALAM, RED SEA, EGYPT; 40 FEET (12.2M) DEEP.

More beautiful than an artist's painting are the colours and the way they merge into one another, sometimes stopping abruptly and contrasting sharply. This is a detail of an adult male's tail.

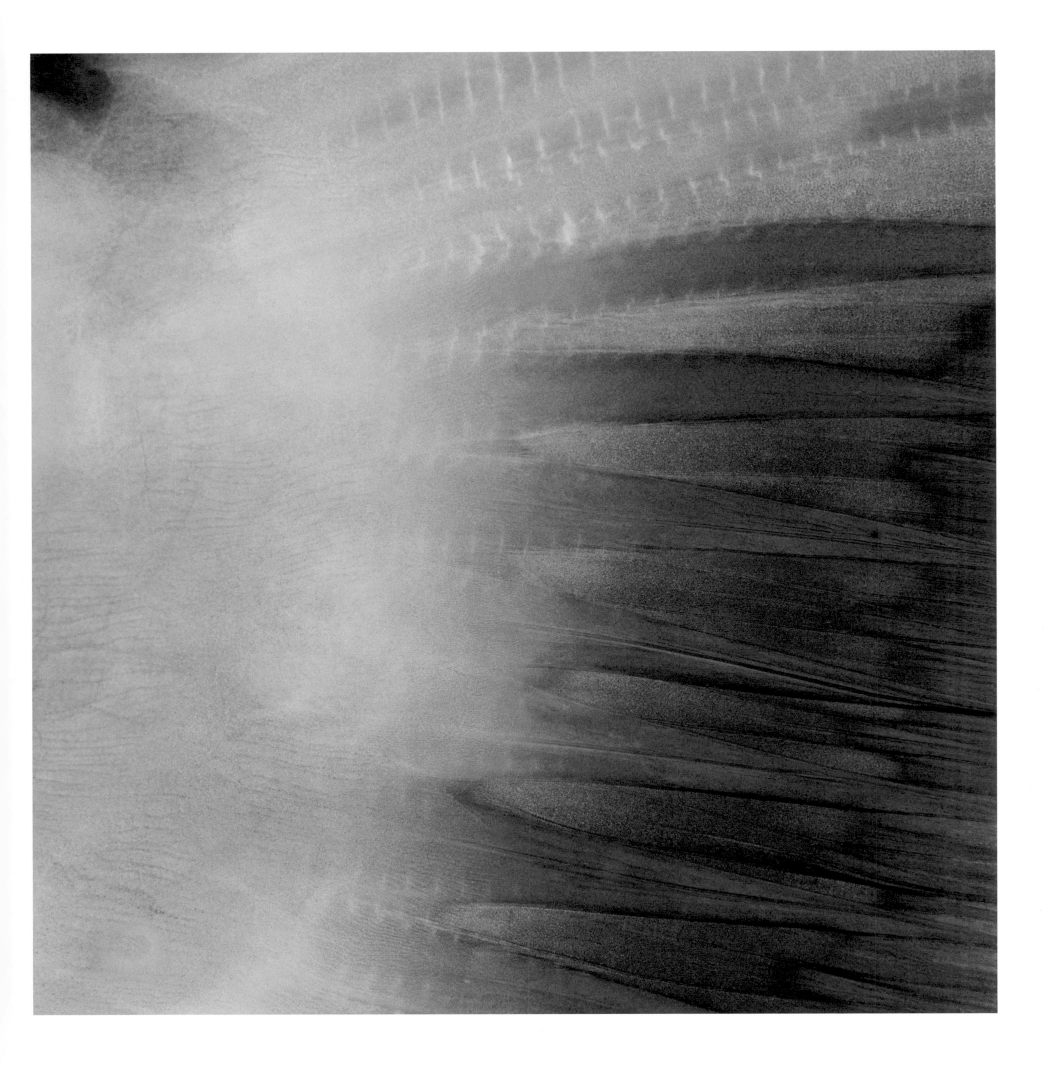

DETAIL OF A STONY CORAL WITH RETRACTED POLYPS
Pachyseris rugosa

PICTURE SIZE 2 INCHES (5.08CM).

ELPHINSTONE REEF, RED SEA, EGYPT; 80 FEET (24.4M) DEEP.

This hard coral forms plates on rocks, following the shape of those rocks. These plates can grow to 3 feet (1 metre) wide. The polyps that appear at night are transparent white.

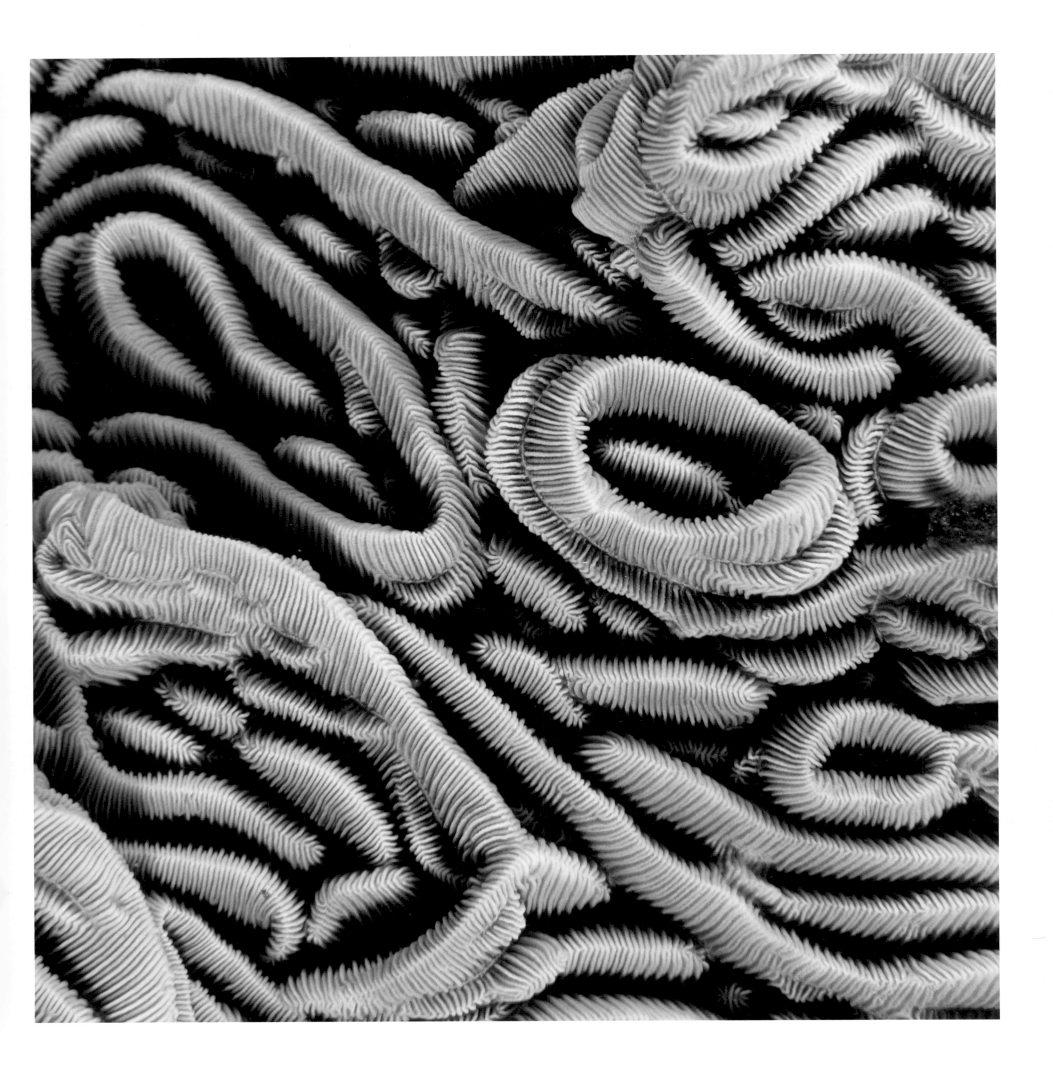

Mountainous Star Coral is a frequently seen Stony Coral in the Caribbean. The colonies can reach enormous sizes, up to 20 feet (6 metres) high in Bonaire's waters.

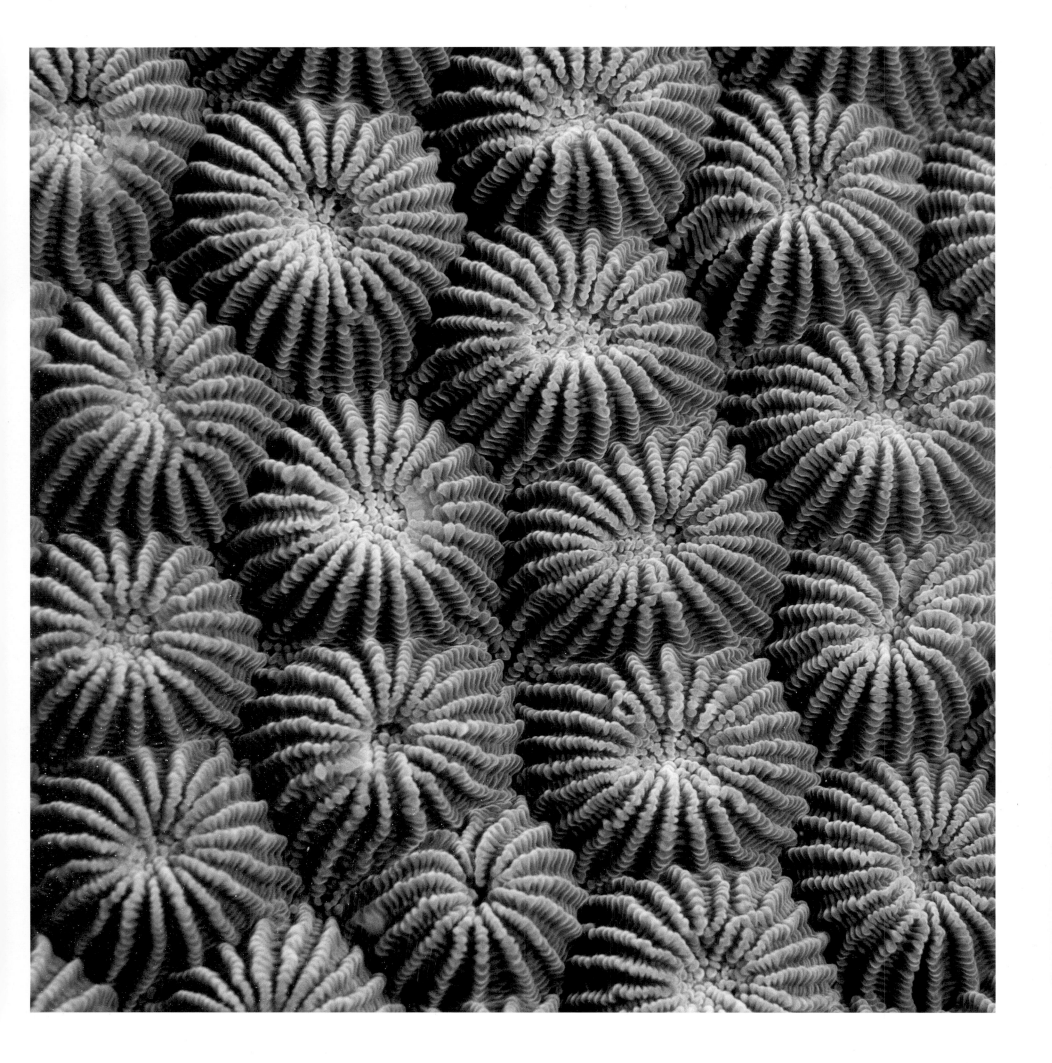

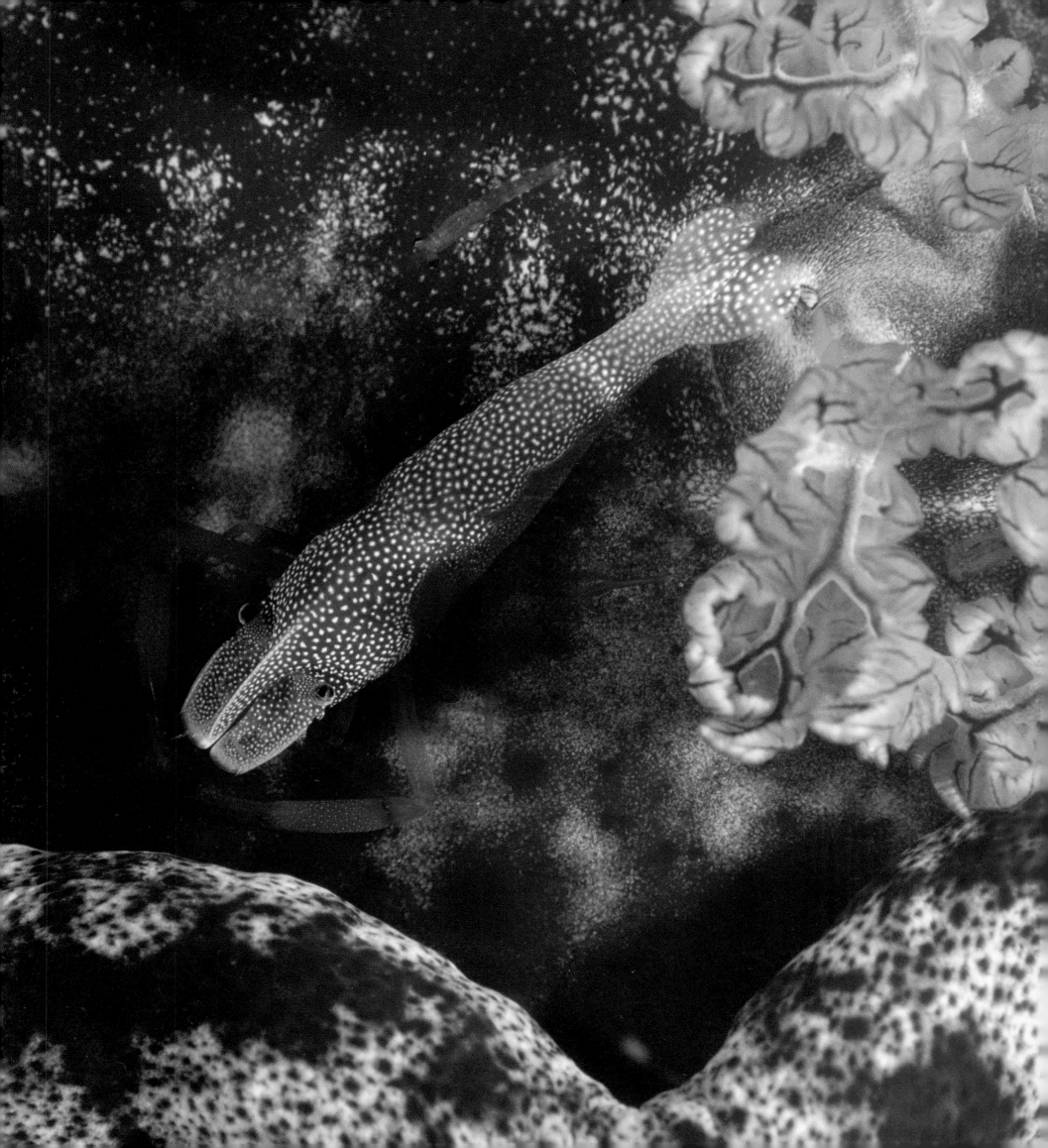

SPANISH DANCER SIZE 12 INCHES (30.48CM).
SHRIMP SIZE ½ INCH (1.27CM).

WEST TIMOR, INDONESIA; 46 FEET (14M) DEEP.

During a night dive I discovered a large, swimming nudibranch. Its beautiful movements remind one of a flamenco dancer, hence its name. When after a while the creature landed on a sandy bottom, I discovered the perfectly camouflaged, tiny shrimp on its back.

CRESCENT–TAIL BIGEYE EYE
Priacanthus hamrur

BIGEYE SIZE 12 INCHES (30.48CM).

SIZE OF THE EYE $3/4$ INCH (2.03CM).

SHARM EL SHEIKH, RED SEA, EGYPT; 75 FEET (22.9M) DEEP.

The name Bigeye is explained when you see the large eye, necessary because it is a nocturnal animal. If you have ever dived or snorkelled at night over a reef and caught a big eye in the glare of your light, you have probably been surprised to find its eye dramatically reflected back at you like a night time encounter with a "stop sign". This is thanks to a layer of tapeta (*Tapetum lucidum*) made of special guanine crystals inside the eye. This tapeta improves their night time vision enormously by reflecting light back through the retina, doubling the brightness.

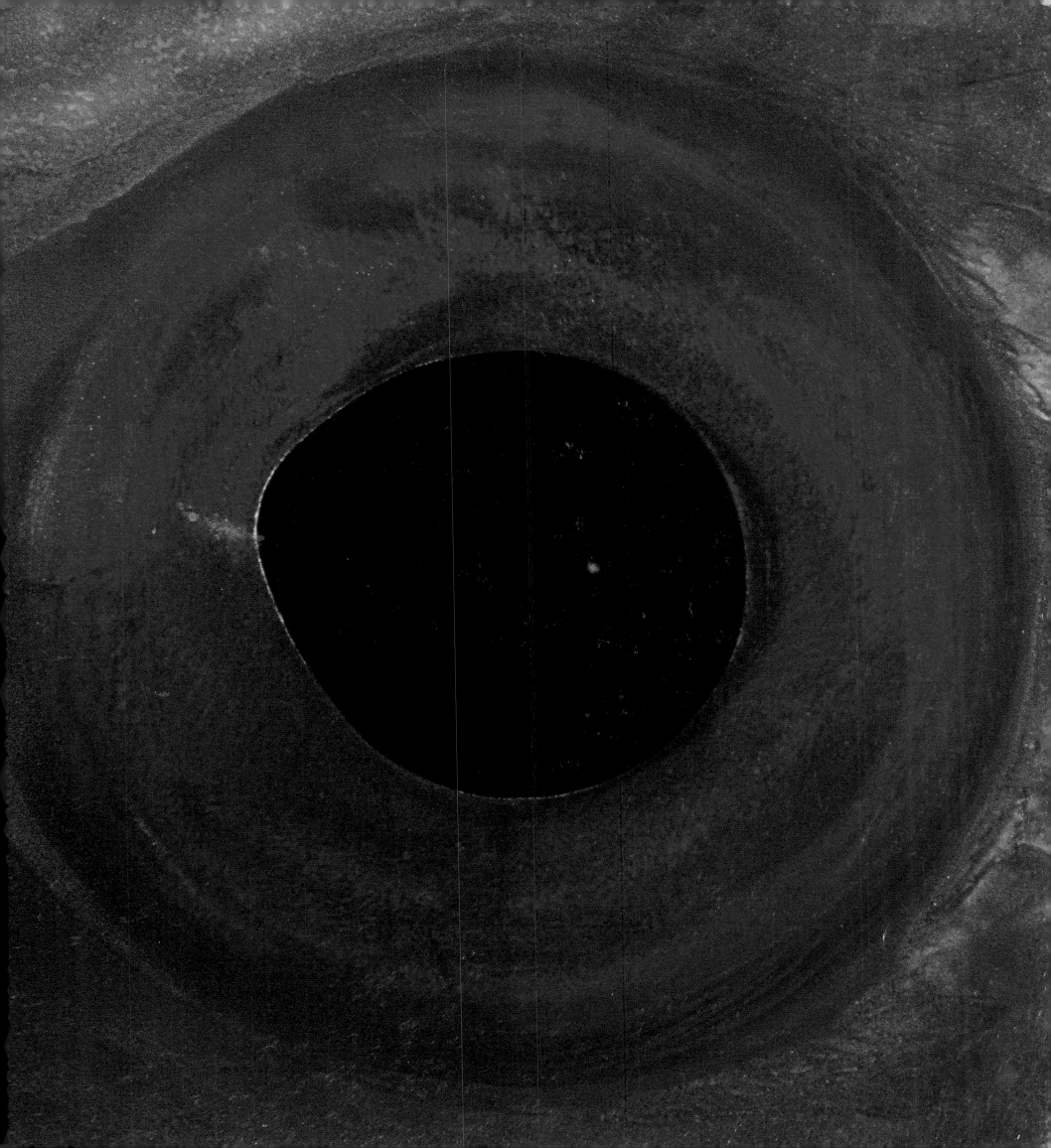

BLUE GORGONIAN OR SEA FAN WITH A BRITTLE STAR
Anthelia flava | *Ophiothrix* sp.

PICTURE SIZE 3 INCHES (7.62CM).

SIMILAN ISLANDS, THAILAND; 90 FEET (27.4M) DEEP.

Only once have I found this rare blue soft coral – between two gigantic boulders in the waters around the Similan Islands. By far the majority of soft corals are red, pink or yellow. Brittle Stars belong to the group of starfish which forage only at night. When one of its arms breaks off, it will gradually regenerate.

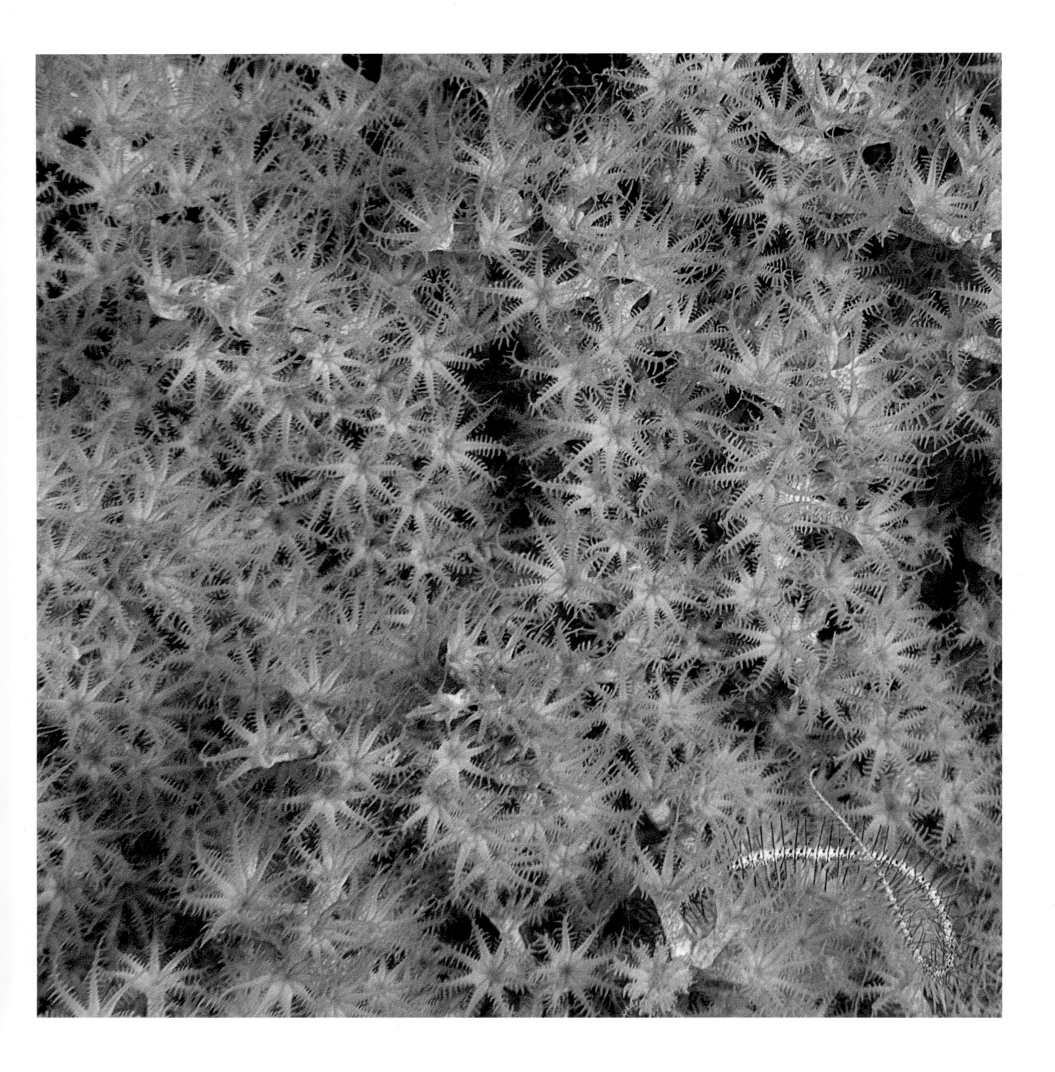

MULBERRY SEA ANEMONE MOUTH

Phlyctenanthus australis

ANEMONE SIZE 4 INCHES (10.16CM).

DETAIL SIZE $^3/_4$ INCH (2.03CM).

KANGAROO ISLAND, SOUTH AUSTRALIA; 60 FEET (18.3M) DEEP.

Like a bright red jewel, the Mulberry Sea Anemone is easy to see as it stands out from the greenish-yellow seaweeds between which it lives. It is endemic to South Australia.

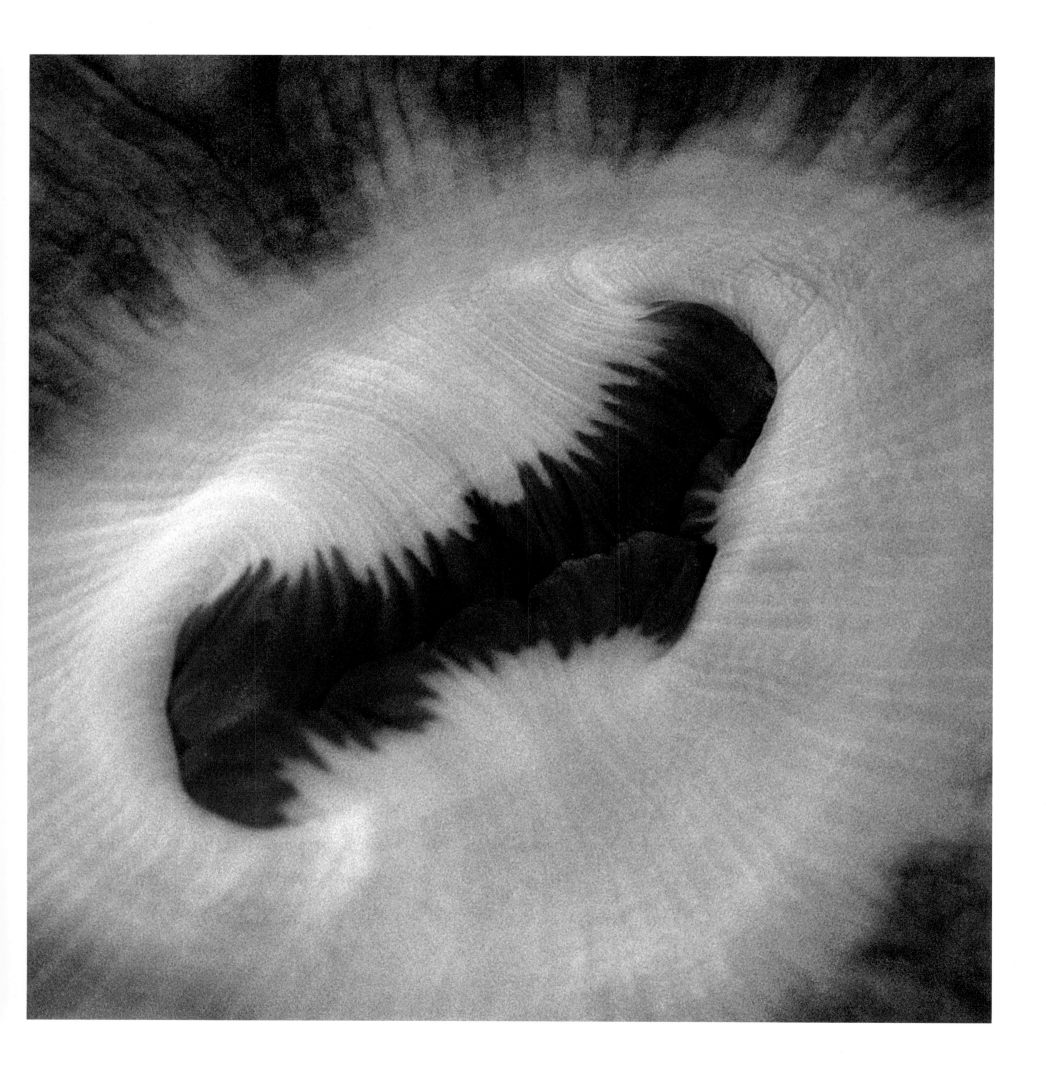

SOFT CORAL WITH BRITTLE STAR
Dendronephthya sp. | *Ophiothrix* sp.

PICTURE SIZE 4 INCHES (10.16CM).

D'ENTRECASTEAUX ARCHIPEL, FERGUSSON ISLAND,
PAPUA NEW GUINEA; 80 FEET (24.4M) DEEP.

At night, Brittle Stars become active in search of food. In between the polyps of this soft coral they are relatively safe from predators. They produce a slimy mucus that helps to trap micro-organisms and detritus. Although closely related to starfish, they differ in several important respects. For instance, both starfish and Brittle Stars have a mouth on the underside of their central discs, but the brittle star has no separate anus!

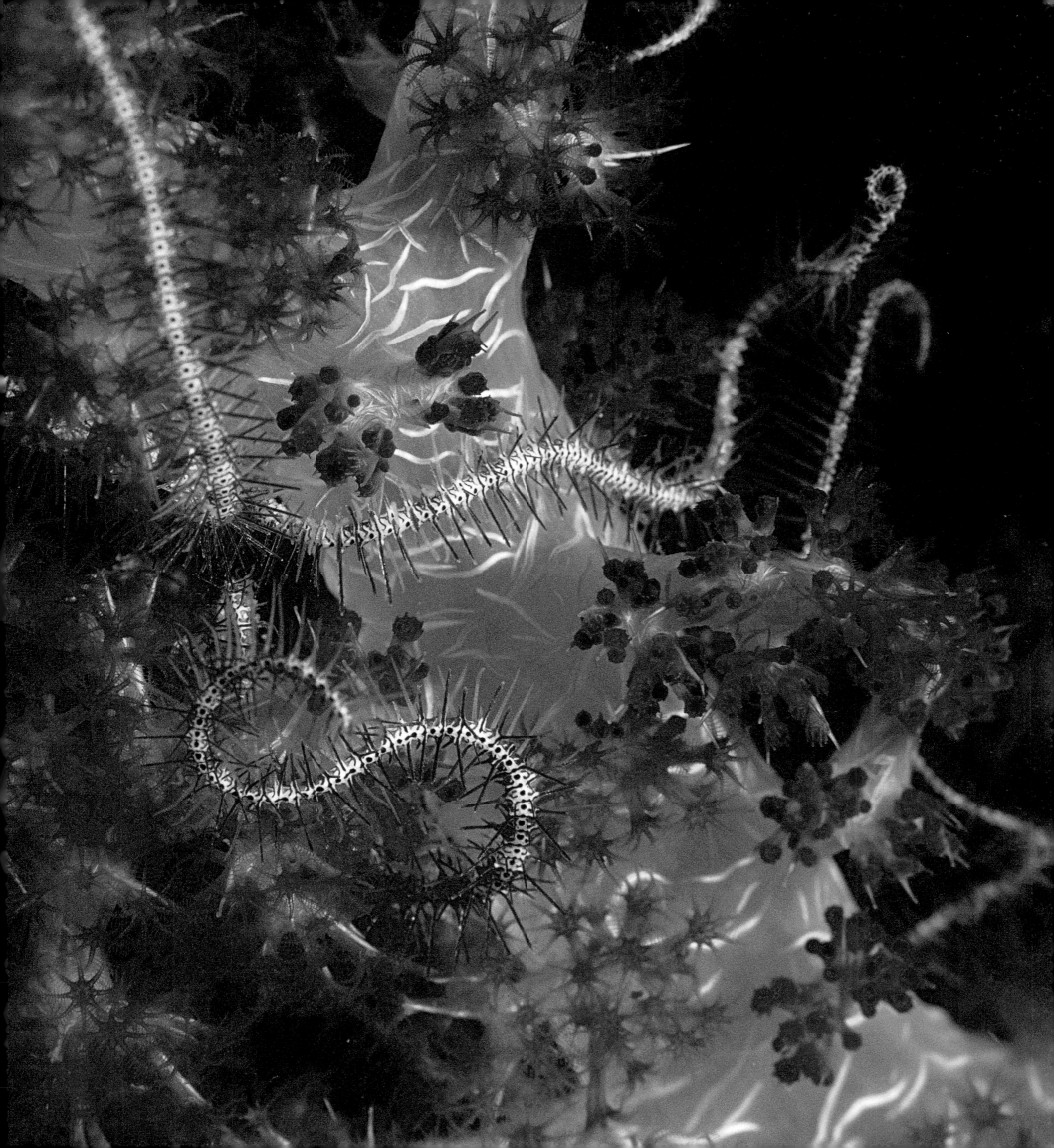

COLEMAN SHRIMP ON A FIRE URCHIN
Periclimenes colemani | Asthenosoma varium

SHRIMP SIZE ³/₄ INCH (2.03CM) FEMALE, ⁵/₈ INCH (1.42CM) MALE.
URCHIN SIZE 6 INCHES (15.24CM).

LEMBEH STRAIT, NORTH SULAWESI, INDONESIA; 90 FEET (27.4M) DEEP.

Almost always in pairs, Coleman Shrimp live exclusively on the poisonous Fire Urchin. They occupy a patch which they clear of the sea urchin spines and tube feet. The female is the larger of the pair. The shrimps are insensitive to the toxin on the sea urchin's spines.

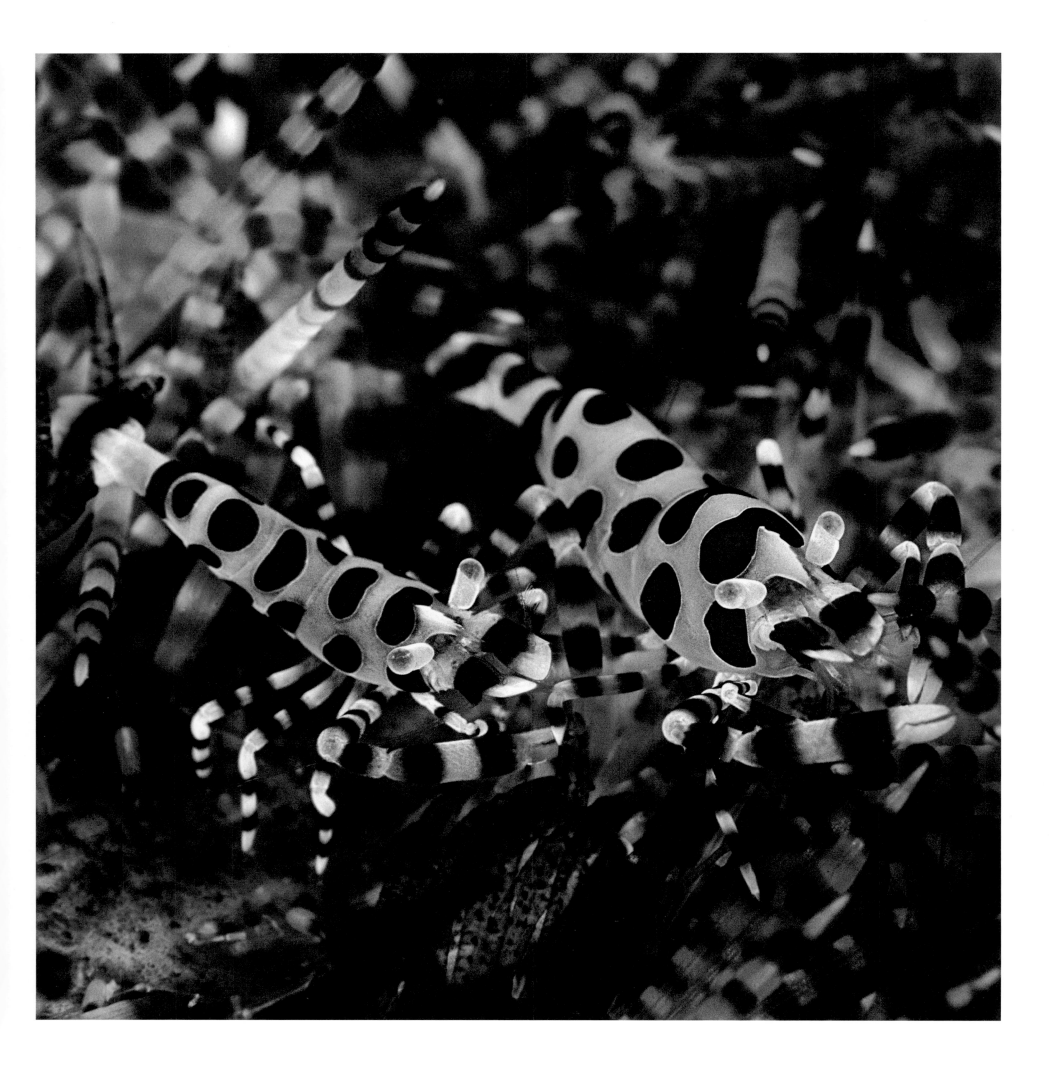

Queen Parrotfish eye

Scarus vetula

PARROTFISH SIZE 18 INCHES (45.72CM).
SIZE OF THE EYE $3/8$ INCH (1.02CM).

BONAIRE, NETHERLANDS ANTILLES, CARIBBEAN; 40 FEET (12.1M) DEEP.

A rich range of blue colours can be found in the small eye of this parrotfish. For many people their most lasting impressions of a coral reef are closely linked to the memory of vividly coloured reef fish darting in and out of the reef. While we know that fish have excellent vision, we don't know if they can see colours. Colour vision is rare in the animal kingdom, even on land, where it is shared only by primates, birds, lizards and turtles. In fish the cones in their eyes, responsible for daytime vision, contain several different pigments which suggests that they do see some colours, though strongly biased to blues and greens.

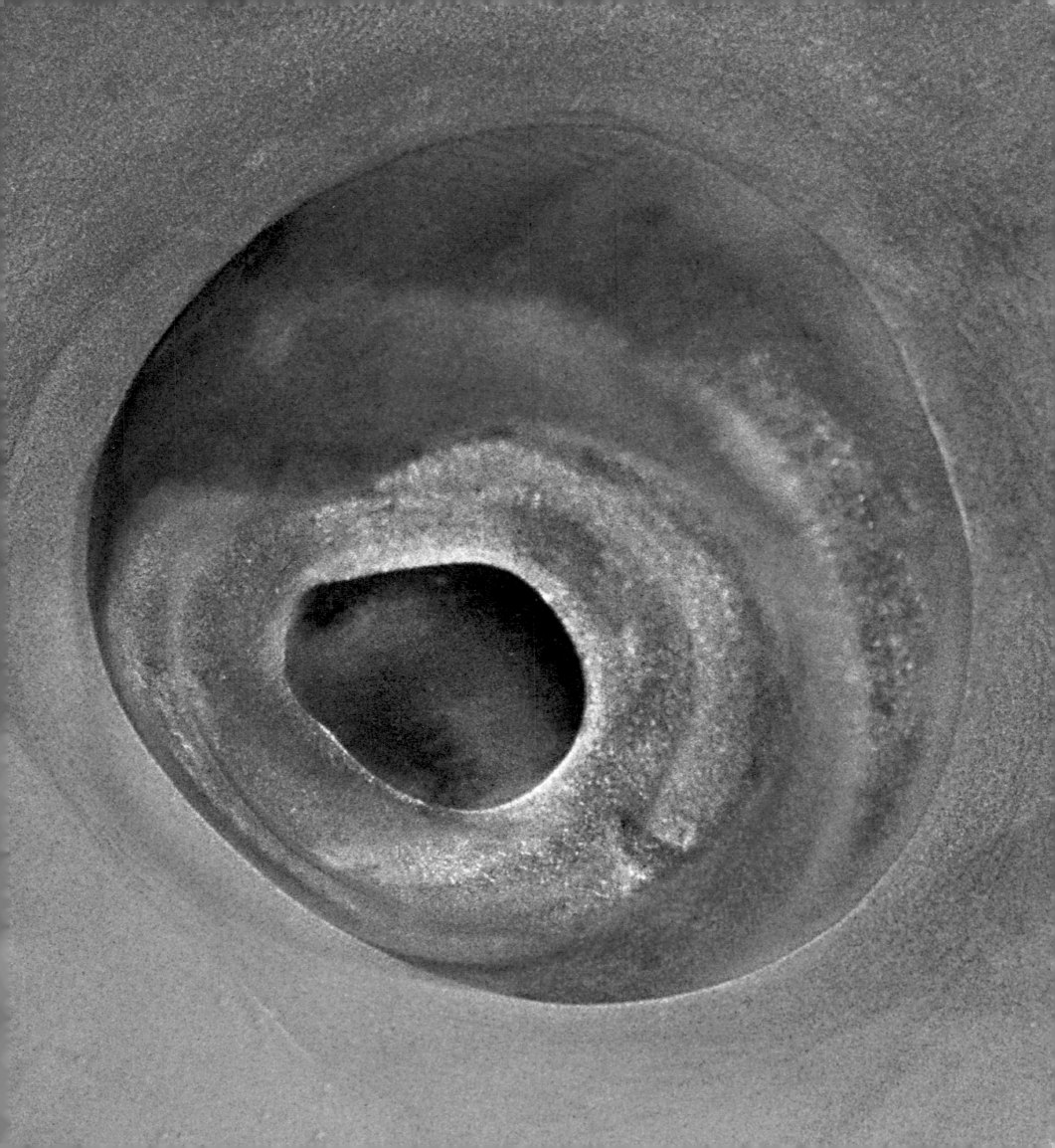

TRUMPETFISH EYE
Aulostomus maculatus

TRUMPETFISH SIZE 2 FEET (60.96CM).
SIZE OF THE EYE ¼ INCH (0.76CM).

BONAIRE, NETHERLANDS ANTILLES, CARIBBEAN; 55 FEET (16.8M) DEEP.

In order to appear invisible to a potential prey, a Trumpetfish will sometimes swim safely with parrotfish or other non-carnivorous fish. The Trumpetfish then bends its straight body into the same shape as the other fish's back. Curiously enough, its host doesn't seem to mind. When prey is close enough, it will be caught by the camouflaged Trumpetfish in a flash.

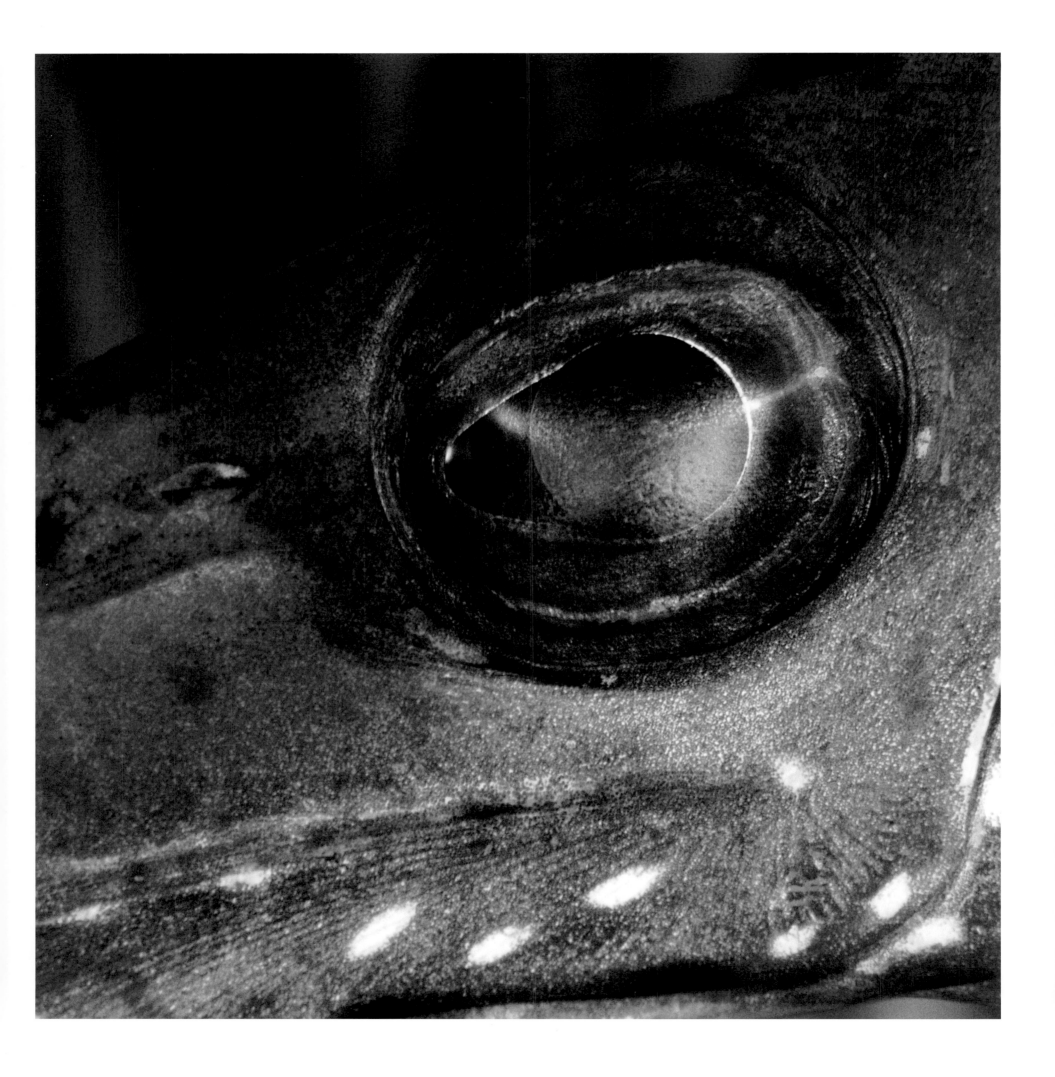

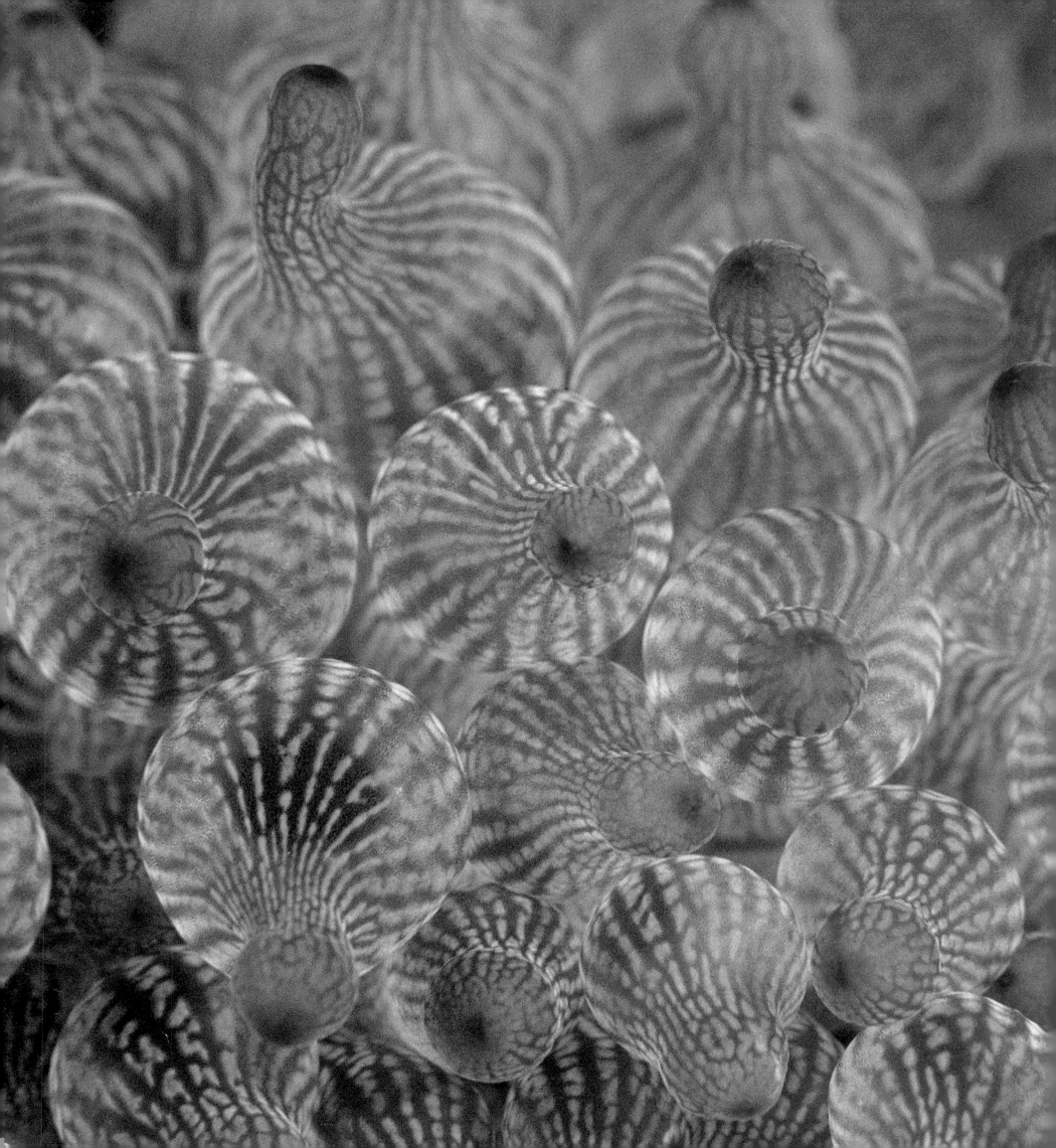

ANEMONE'S TENTACLES
Entacmaea quadricolor

ANEMONE SIZE 4 INCHES (10.16CM).
PICTURE SIZE 2 INCHES (5.08CM).

NEW BRITAIN, BISMARCK SEA, PAPUA NEW GUINEA;
60 FEET (18.3M) DEEP.

The water-filled, half-inch tips of this harmless looking anemone are amply equipped with nematocysts which inject a vicious poison into their attacker when touched.

DETAIL OF THE EYED SEA CUCUMBER
Bohadschia argus

SEA CUCUMBER SIZE 18 INCHES (45.72CM).
DETAIL SIZE 1 INCH (2.54CM).

D'ENTRECASTEAUX ISLANDS, PAPUA NEW GUINEA; 20 FEET (6.1M) DEEP.

Though their name suggests otherwise, sea cucumbers are animals. The species shown here lives in shallow waters on sandy bottoms. It draws in sand and lives on the organic matter inside, secreting the indigestible residue.

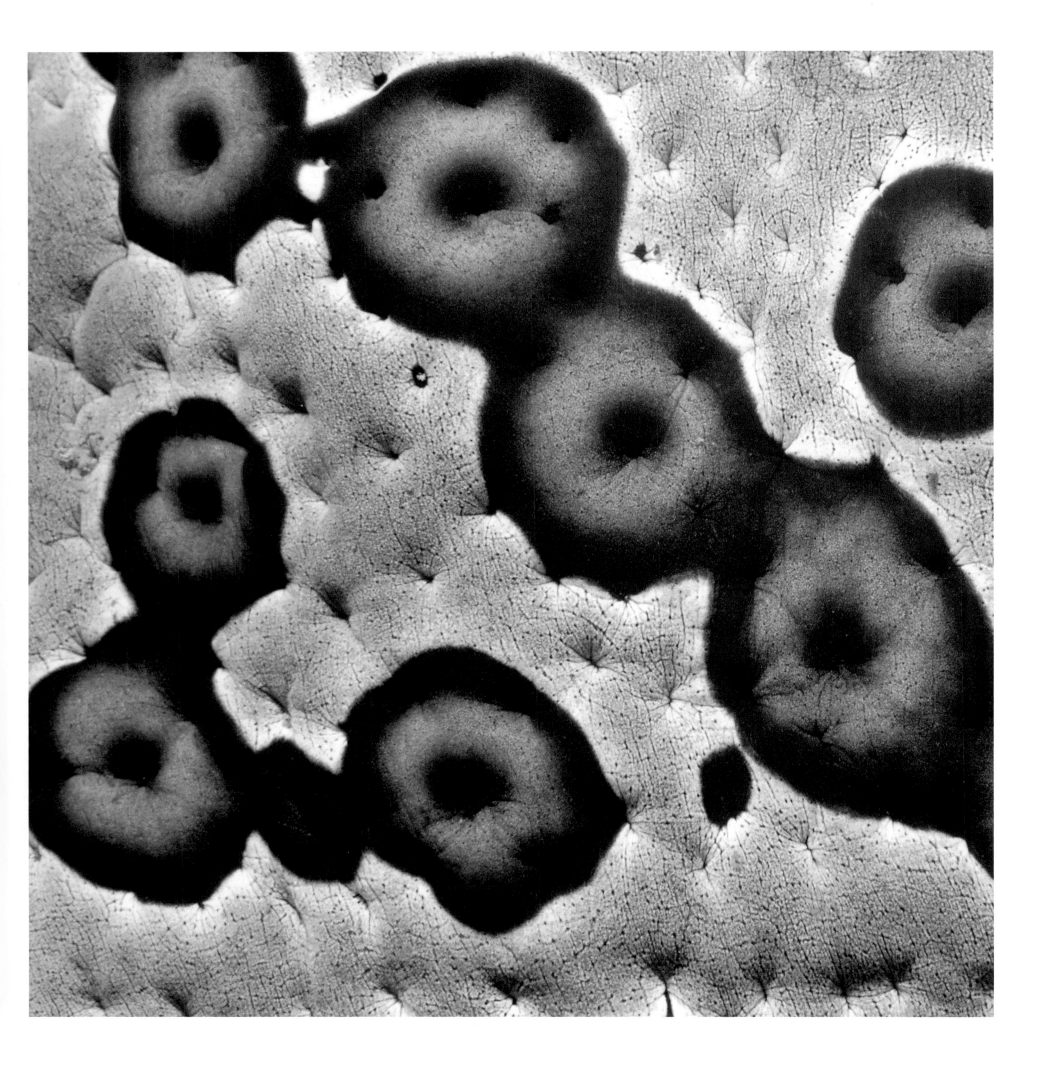

MIDNIGHT SEA PERCH EYE
Macolor macularis

SEA PERCH SIZE 18 INCHES (45.72CM).
SIZE OF THE EYE ½ INCH (1.27CM).

SIPADAN, MALAYSIA; 85 FEET (25.9M) DEEP.

Not surprisingly, scientists have found that the pigments in the fish's eyes are perfectly matched to the "bluish" spectrum of light in tropical seas. For fish, blue is not just blue, its minute variations are their entire world. Because the pigments in their eyes are so finely tuned to their watery world, at dawn and dusk the background appears "bright" allowing them to clearly distinguish everything else in the water.

All reef fish show this adaptation and scientists believe that it is a critical factor in their survival. Fish clearly know it too and this accounts for the mass exodus you can witness on any reef just before dusk as the reef fish spectacularly dive for cover just at the time when they are most visible and most vulnerable to predation.

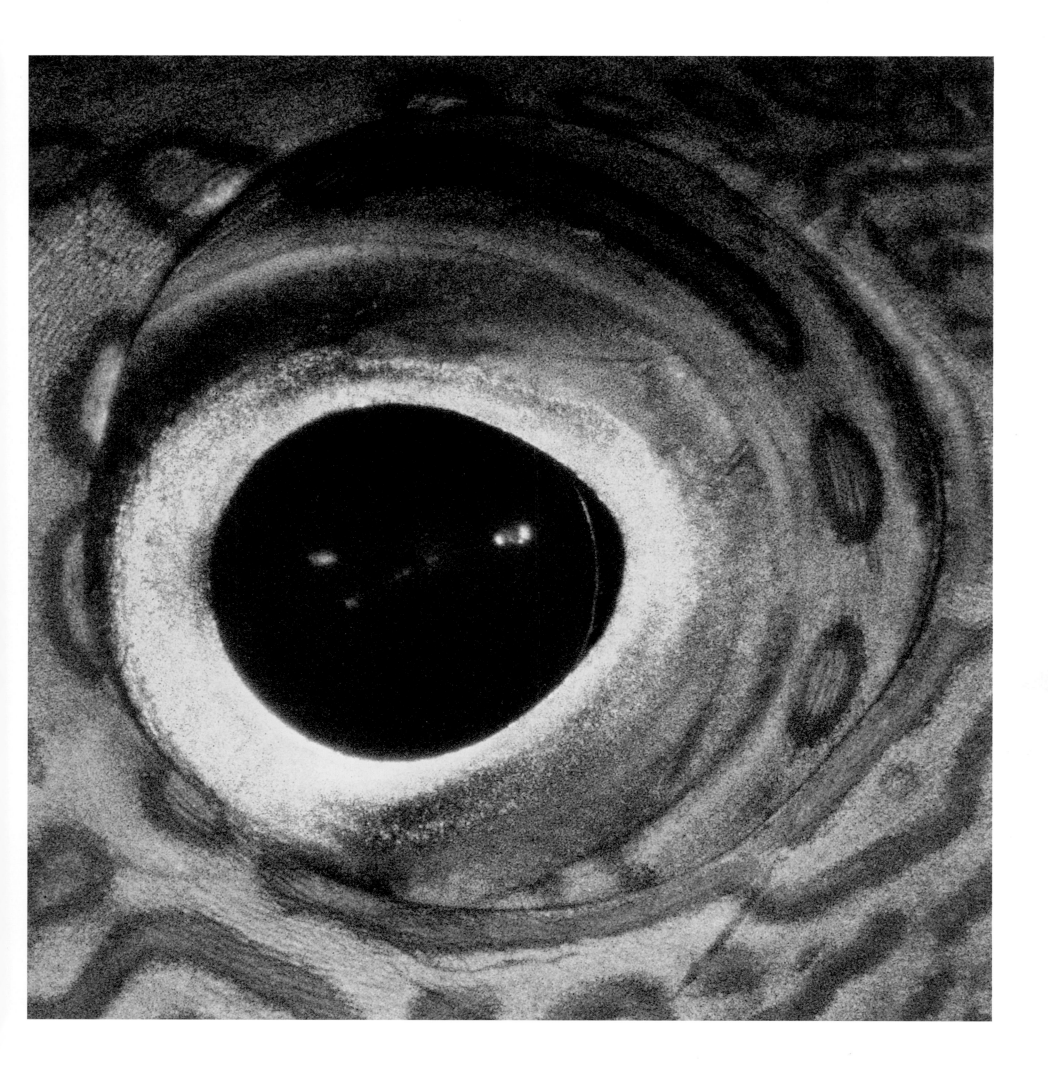

I have been looking for one of these for quite a while. Whenever I saw a large Barrel Sponge I would examine it extensively for these "aliens". This unusual little lobster lives exclusively on these large sponges; however, due to their tiny size, and because their colour is almost the same as the sponge's, they are very difficult to spot.